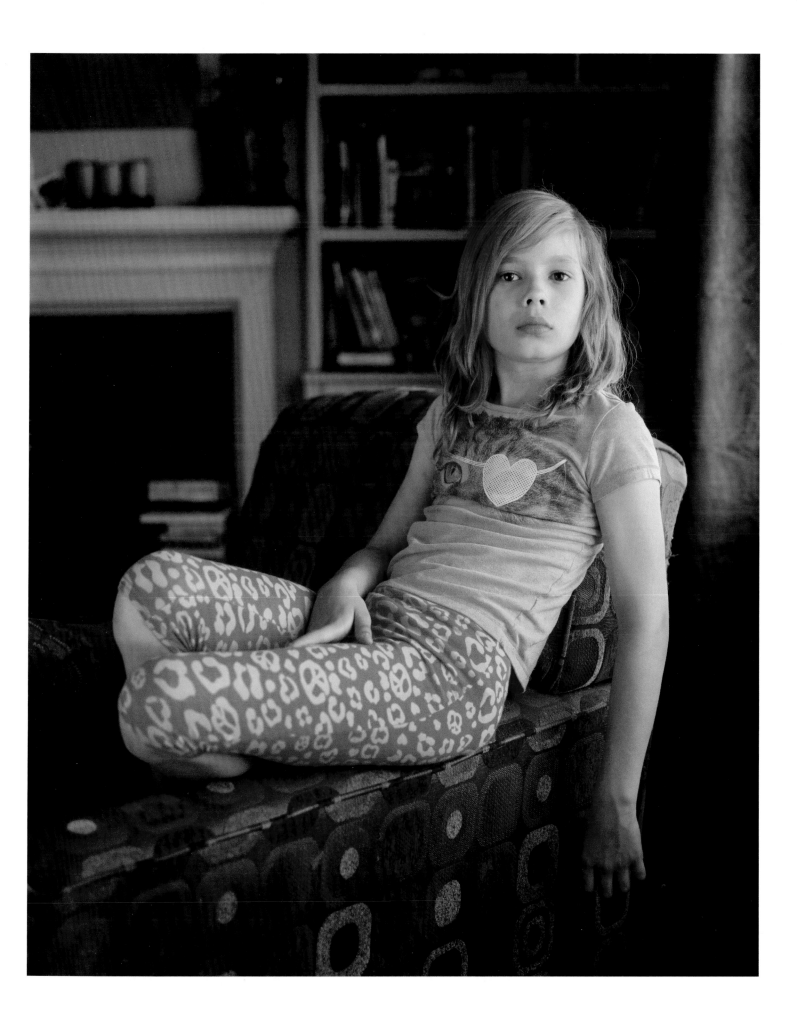

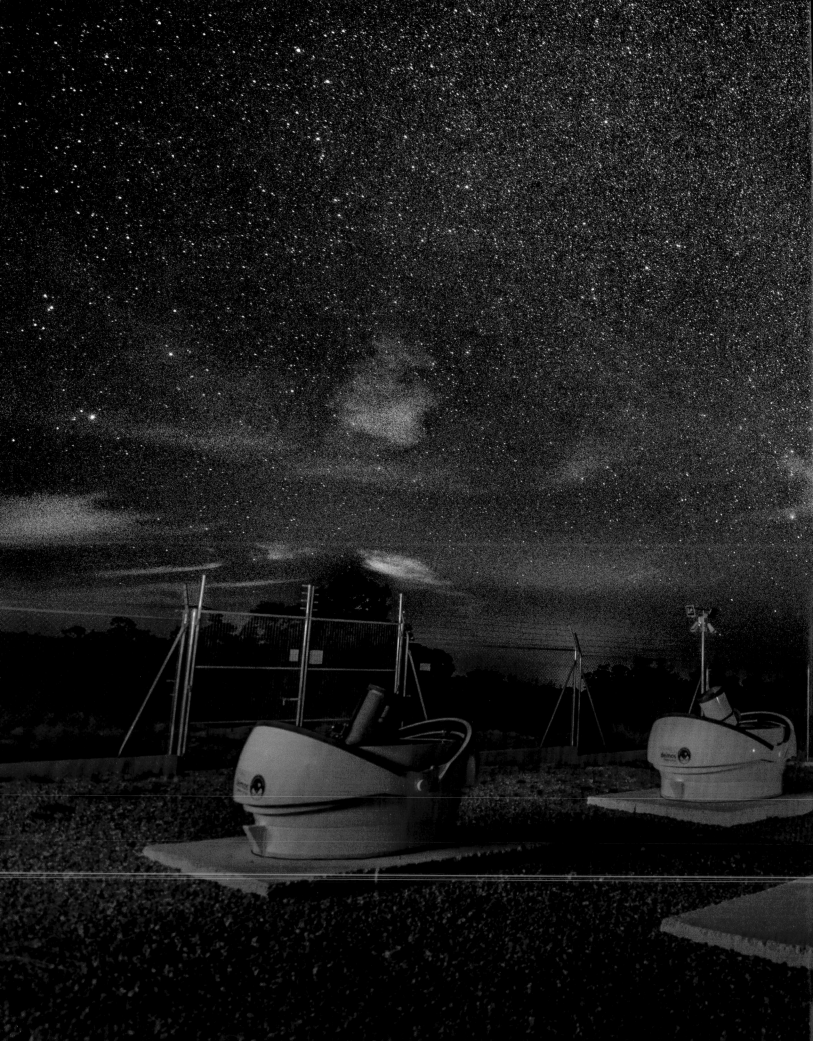

THE 21ST CENTURY

PHOTOGRAPHS FROM THE IMAGE COLLECTION

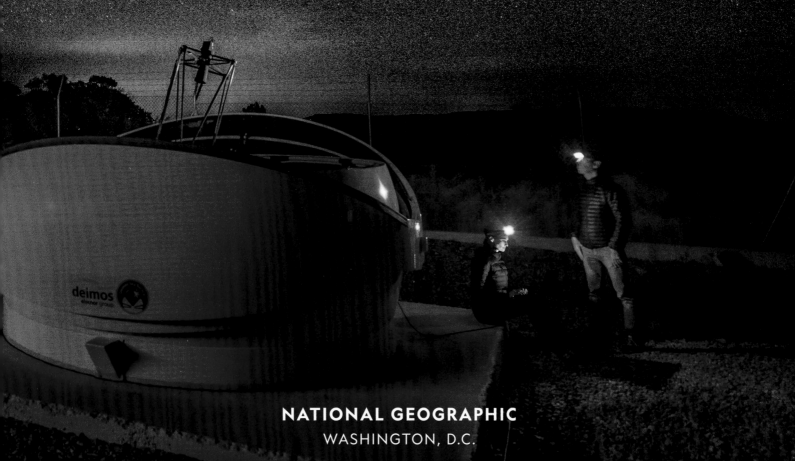

NATIONAL GEOGRAPHIC

WASHINGTON, D.C.

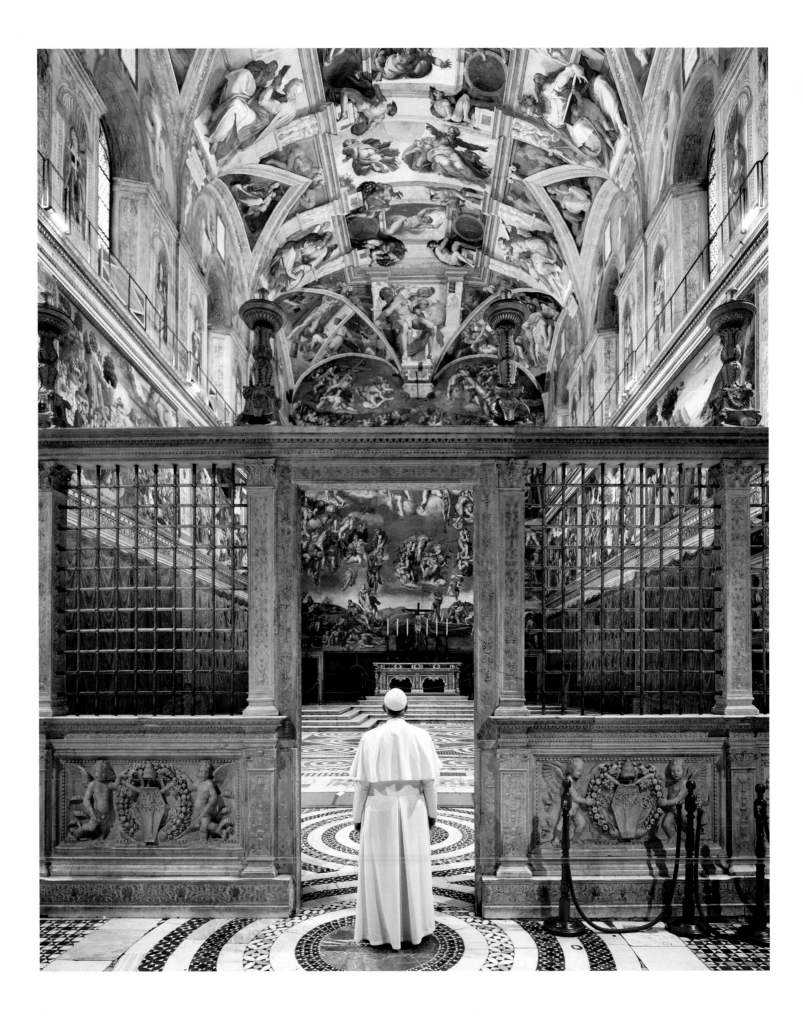

CONTENTS

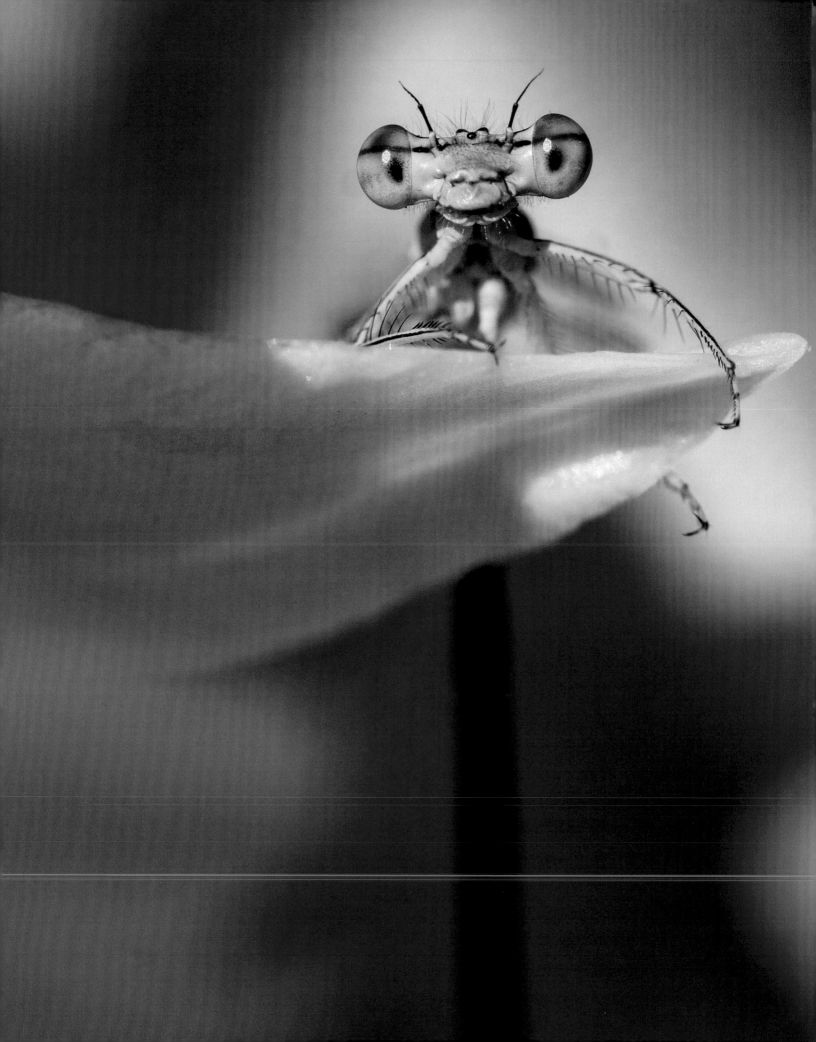

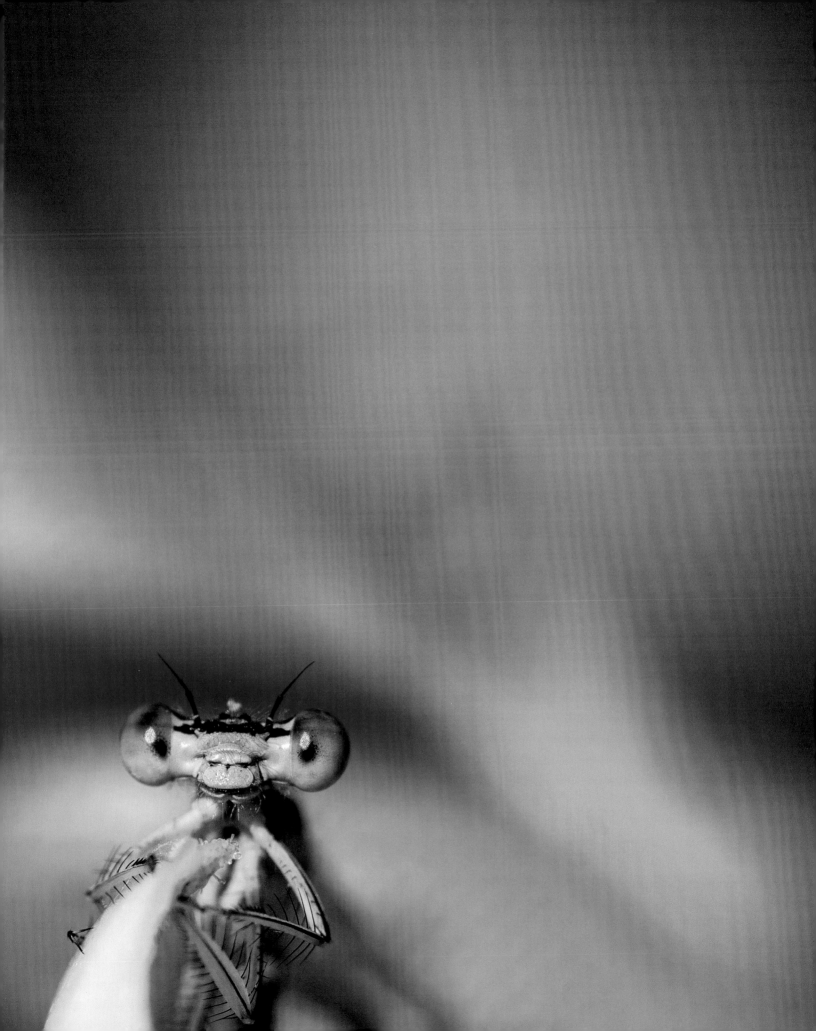

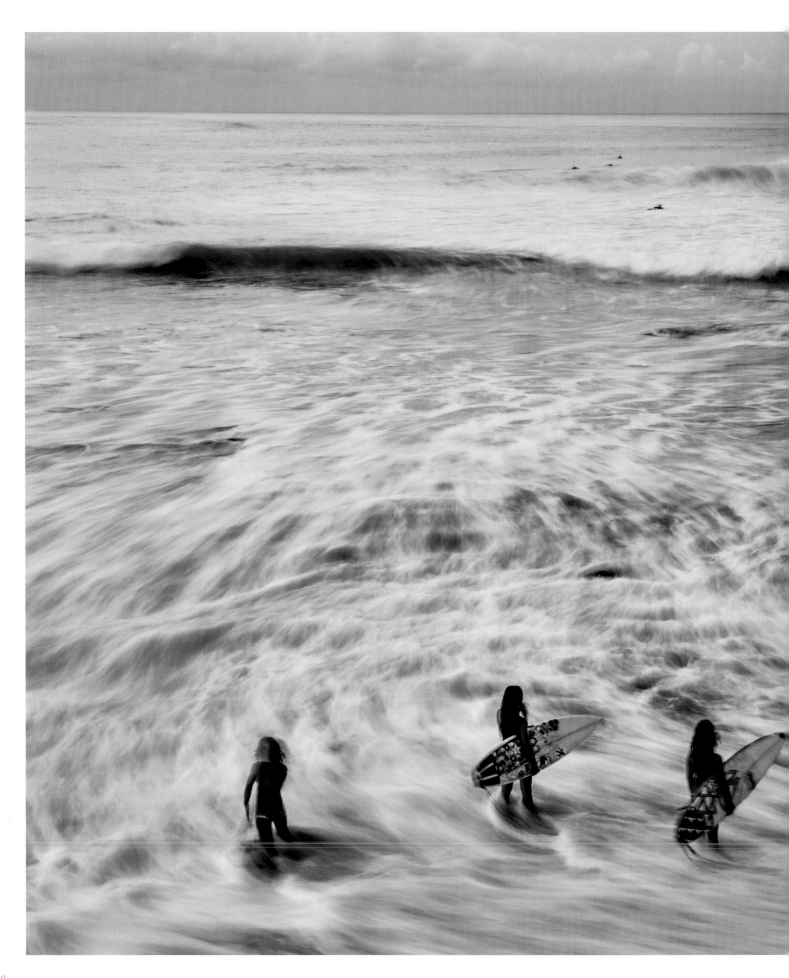

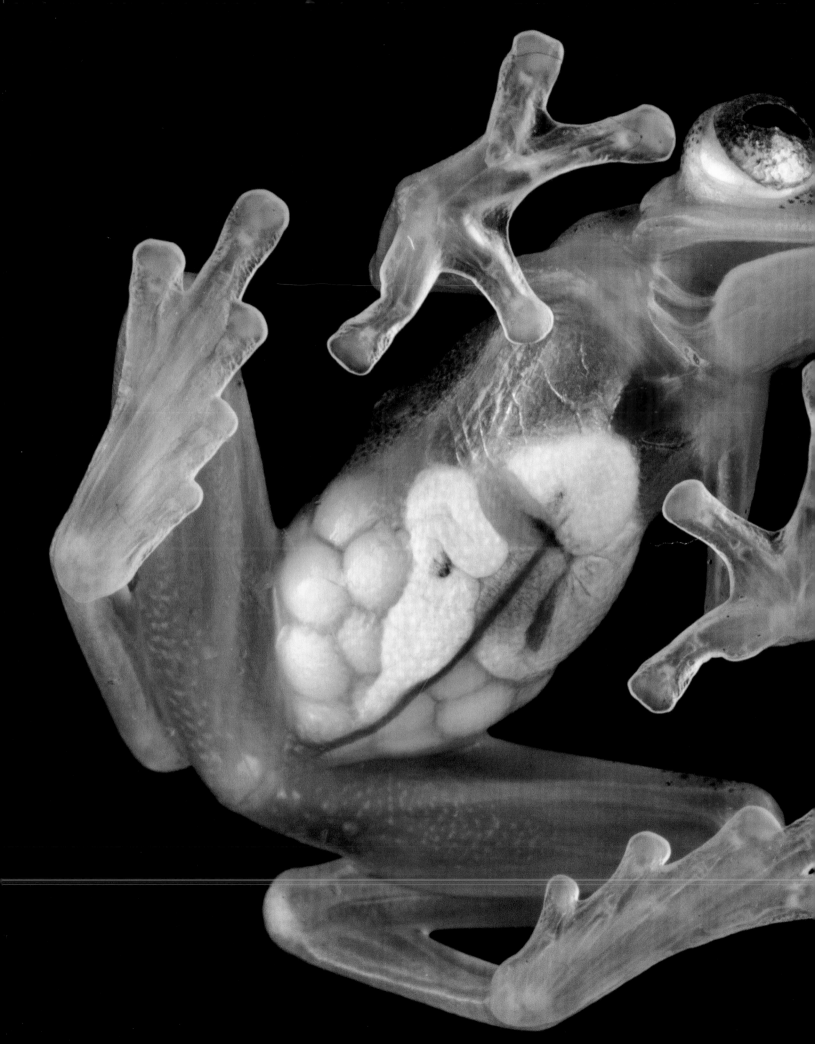

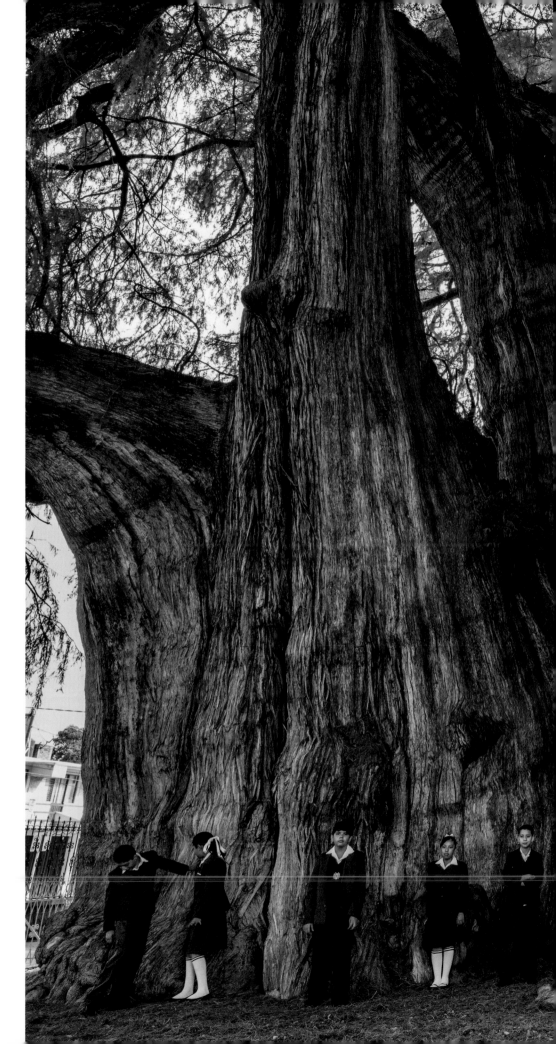

Opposite

2014 I DIANE COOK AND LEN JENSHEL

Santa María del Tule, Oaxaca, Mexico
Students stand in front of a Montezuma
cypress known as El Árbol del Tule, consid-
ered by some the largest tree in the world.
Measuring 119 feet (36.3 m) in circumfer-
ence and 38 feet (11.6 m) in diameter, the
tree may have been planted by an Aztec
priest 2,000 years ago.

Pages 10-11

2016 I JAIME CULEBRAS

Costa Rican Amphibian Research Center
You can see the internal organs of glass
frogs through the transparent skin of their
stomachs. The purpose of this frog's trans-
lucency is currently unknown.

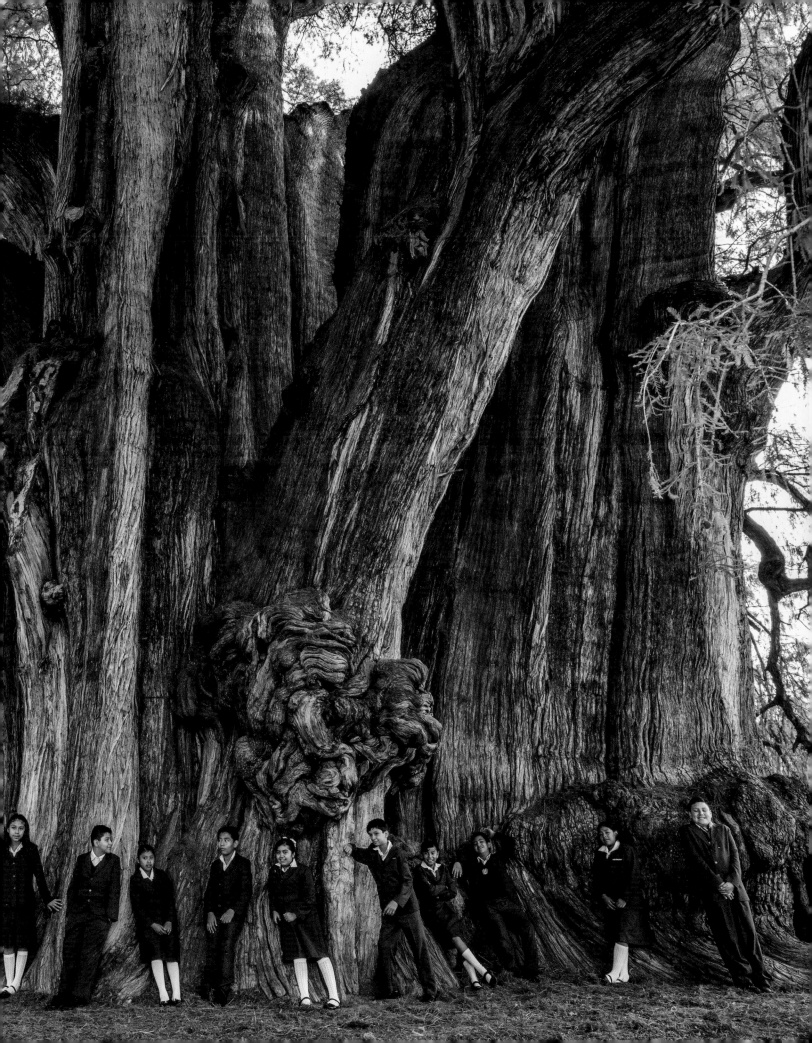

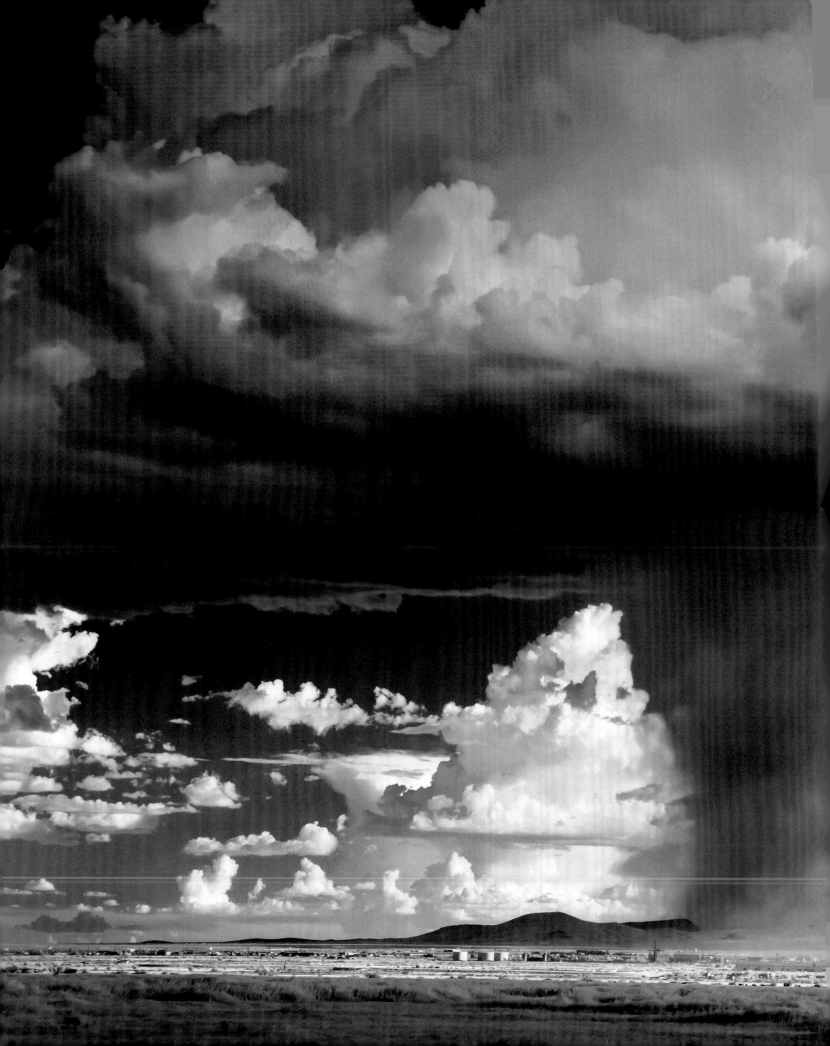

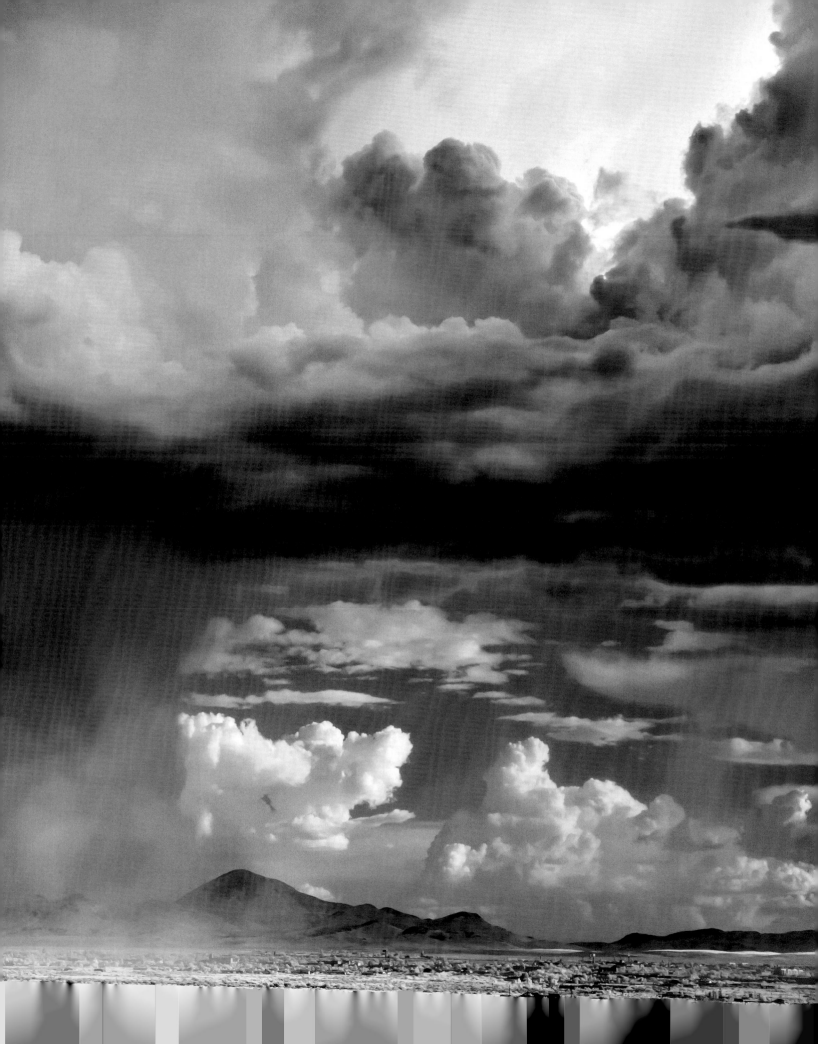

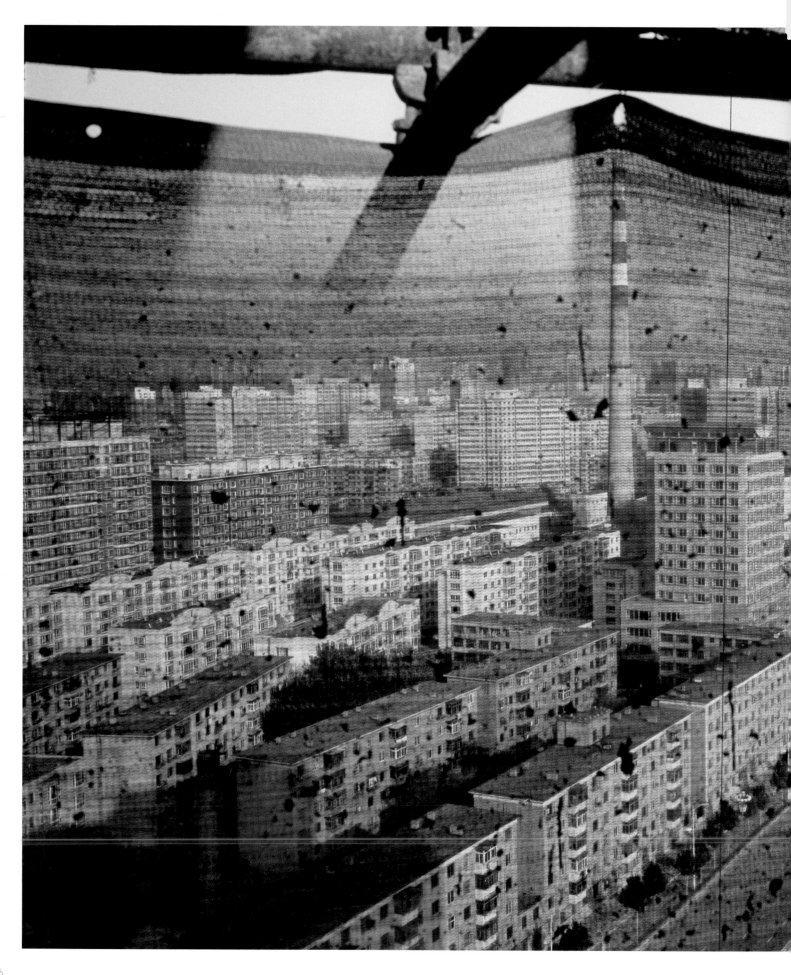

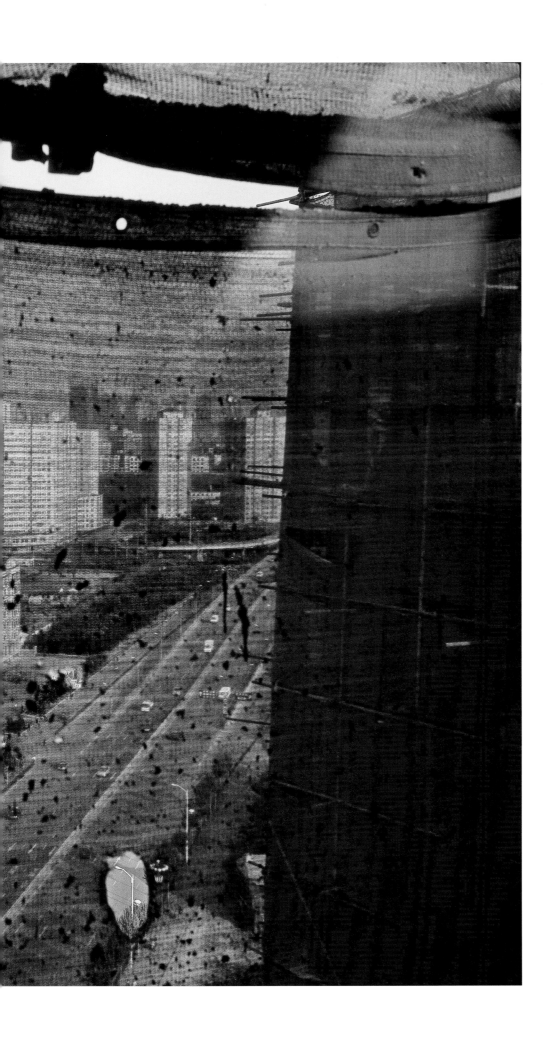

Opposite
2005 I FRITZ HOFFMANN
Manchuria, China
A lone smokestack looms over the Tiexi Industrial District, where housing blocks have replaced defunct factories in an effort to clear the air in Shenyang, one of China's most polluted cities.

Pages 14-15
2012 I MITCH DOBROWNER
Lordsburg, New Mexico, U.S.
Resembling a mushroom cloud, a monsoon thunderstorm drops a deluge on the desert. The base of this cloud may hang some two miles (3.2 km) above the ground.

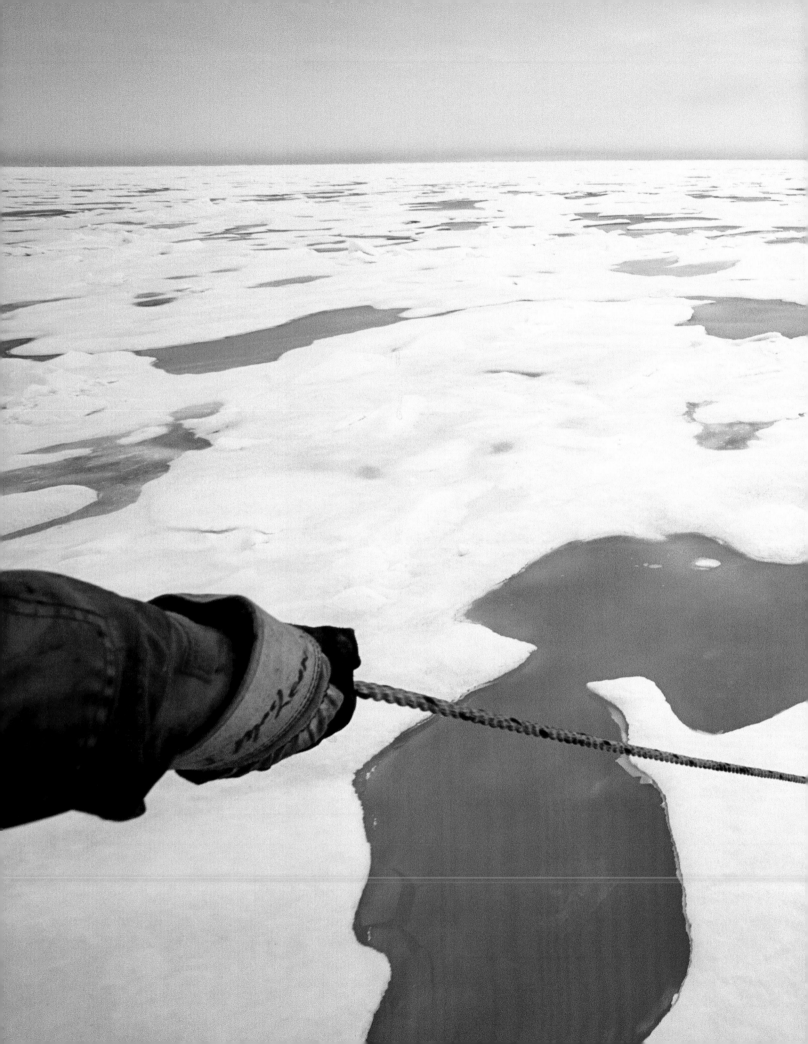

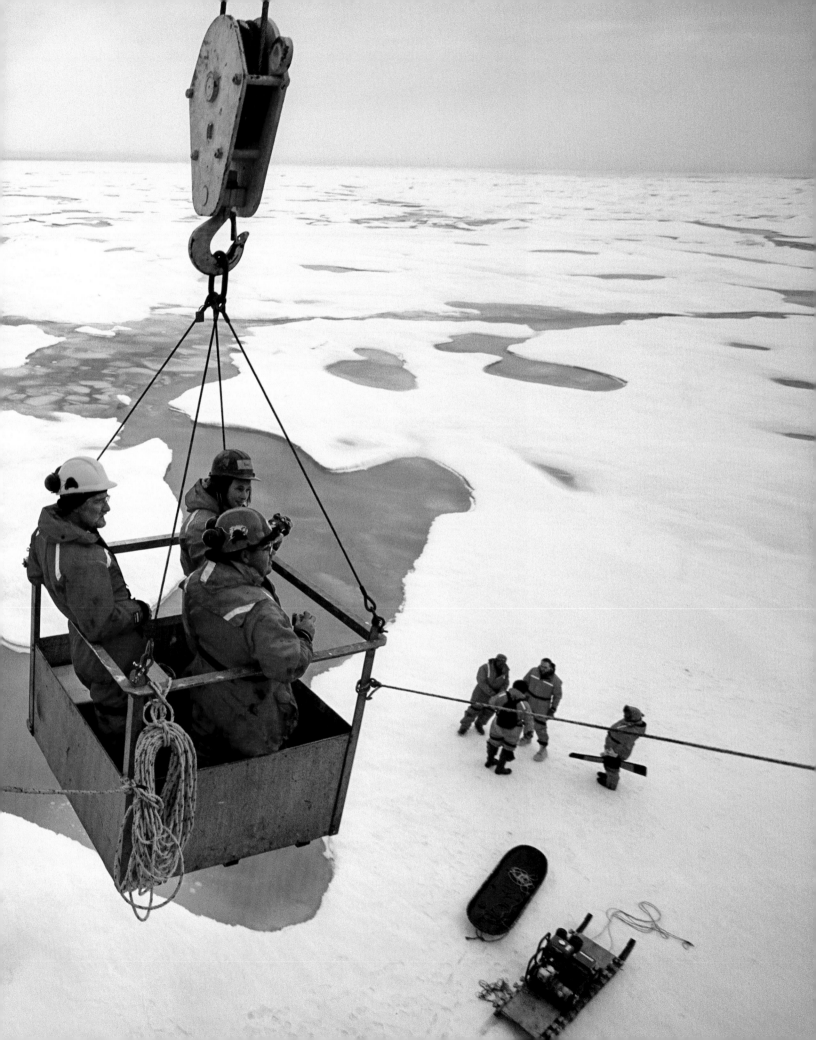

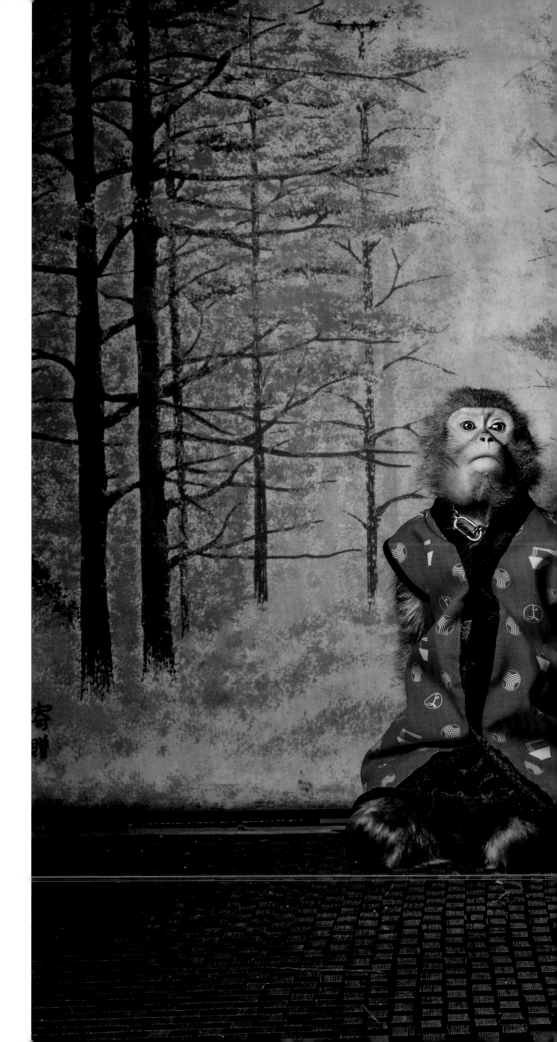

Opposite
2017 I JASPER DOEST
Utsunomiya, Japan
Captive Japanese snow monkeys model papier-mâché masks for a restaurant audience, an example of the trivialization and commercialization of a species long revered as a messenger of the gods.

Pages 18-19
2002 I PAUL NICKLEN
Canada Basin, Arctic Ocean
Researchers in survival suits hitch a ride to a snow-crusted sheet of sea ice strung with blue melt ponds. Measuring properties of the ice and meltwater will give them a baseline to assess future changes.

Pages 22-23
2010 I CARSTEN PETER
Democratic Republic of the Congo
An expedition member walks on the cooled lava floor, turned red by the reflected glow of a lake, of a caldera in the Nyiragongo volcano.

Page 24
2020 I JON HENRY
Houston, Texas, U.S.
A mother poses with her son, holding him in a position of death as a symbol of Black trauma in the United States, while her other children stand behind them.

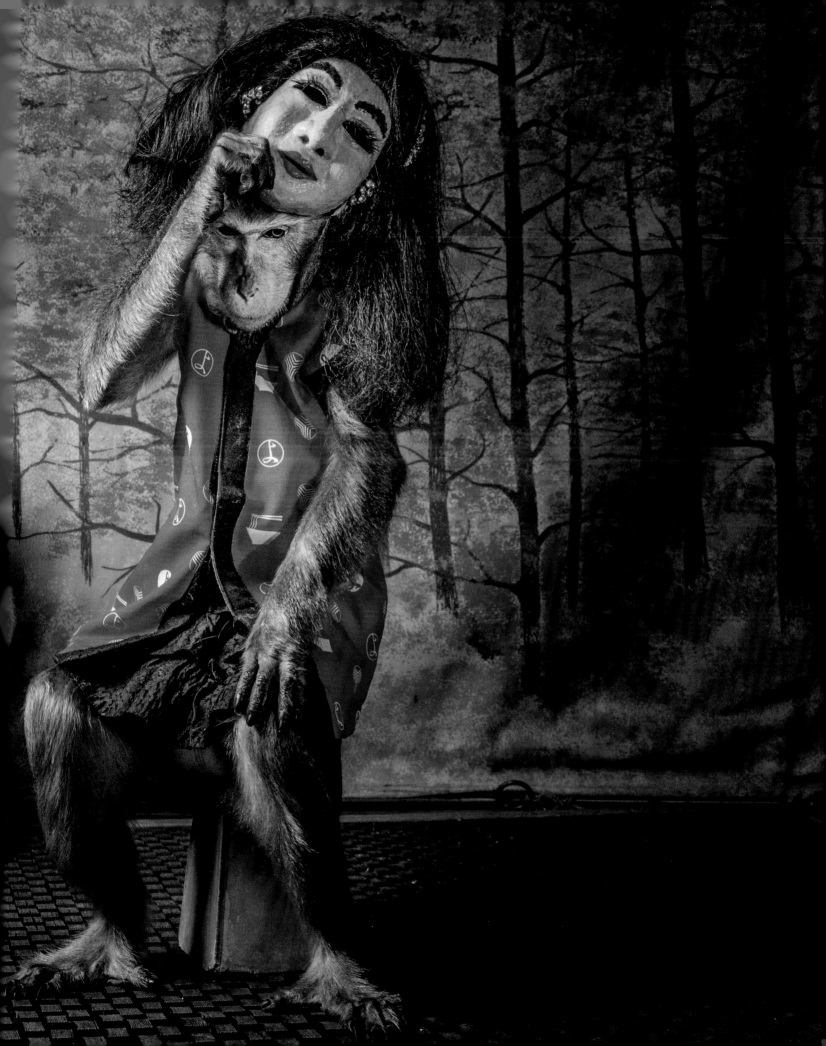

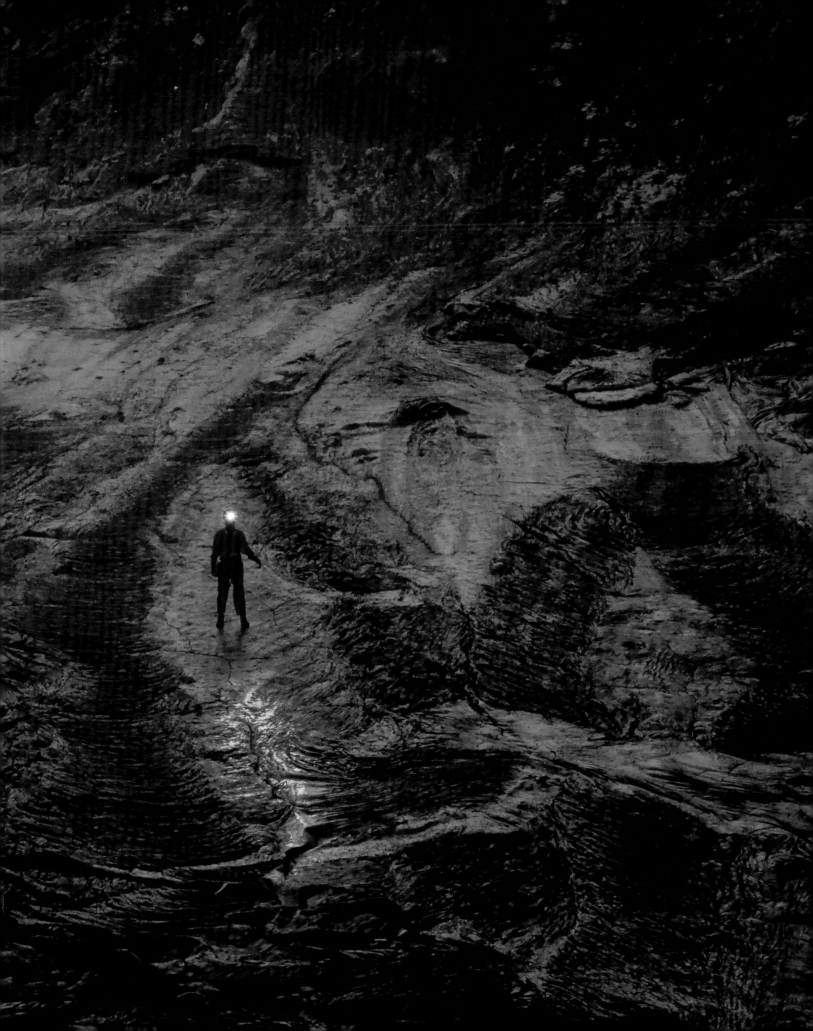

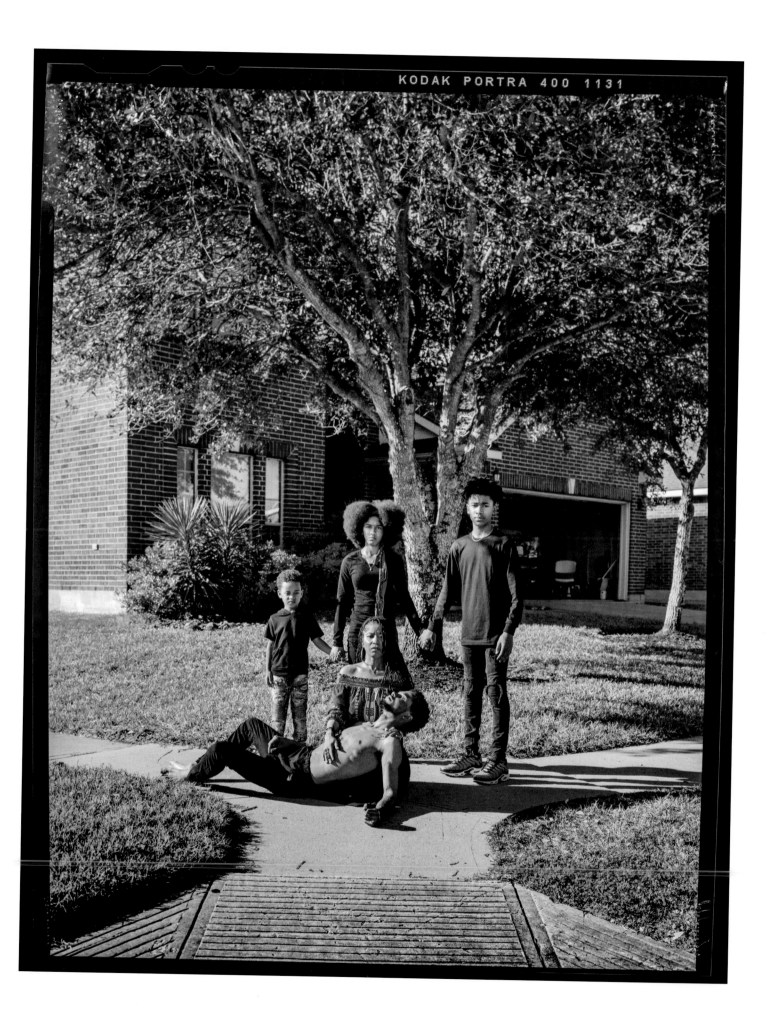

KODAK PORTRA 400 1131

24

FOREWORD

SUSAN GOLDBERG

EDITOR IN CHIEF, NATIONAL GEOGRAPHIC

For more than 133 years, the National Geographic Society has been committed to exploring the planet and revealing its wonders. That mission has inspired National Geographic since the first issue of its magazine published in October 1888. Yet in that first issue, not a single photograph enlivened its pages.

That's hard to imagine now. Although the National Geographic name and yellow border today are synonymous with outstanding photography and visual storytelling, pictures, before our founding, had been associated more with "vulgar" publications than serious ones. As a result, the magazine's first visual—a relief map of North America—didn't appear until its third issue; the first "real" photograph, a scene from nature, wasn't published until 1890.

My, how things have changed. Our photographic archives, formally called the National Geographic Image Collection, now hold tens of millions of images, including 11.5 million photographic artifacts in our vault and more than 50 million images on our digital servers. This year, almost two million more images will come into the Collection.

It's hard to imagine photography on that scale, and all that it can document. Then again, it was hard to imagine the cataclysms, crises, milestones, and breakthroughs of recent years until we lived through them.

Such history-making times require photography's unblinking gaze, recording events in ways both inspirational and sobering. It was that realization that led to a gathering of National Geographic's leaders early in 2021. We looked back at all that had occurred in 2020 alone—itself worth a book. Then, we began discussing all that had transpired in the two decades since the year 2000. As we talked, a challenge took form:

We needed to depict the first 21 years of the 21st century, using National Geographic documentary images.

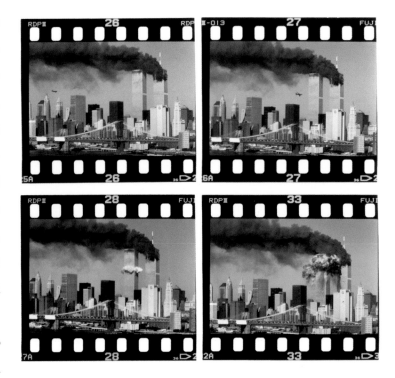

This book is the response to that challenge. It's essentially "a shared history told through photography," in the words of Whitney Johnson, who leads our visual teams on platforms ranging from print to Instagram to TikTok.

The photographers who work for National Geographic, with an almost irrational dedication, will do what they must to document the revolution, the transplant, the tidal wave, the summit, the pandemic—all the real-time ingredients of history. After the first plane hit the first World Trade Center tower in New York City on September 11, 2001, Robert Clark ran up seven flights of stairs to his building's roof, in time to capture a remarkable, four-frame series of the second plane hitting the second tower (above). After that, Clark later recalled, "I kept shooting, stopping only to change film. The roof of my building started to fill up; people cried and hugged and stared in disbelief. My first clear thought was that I was watching the world change."

Clark's four-frame series became famous, iconic—to the point, he once said, that "the importance of the images made me uneasy." When he does think of the images, he finds, "the memories of that day will flood in."

Just listening to Clark talk about his photography that day no doubt makes the memories of 9/11 flood in for all of us. But no matter what kinds of subjects our photographers

document, I have always found it inspirational to ask them why they do what they do. Here are thoughts from some of them:

"Photography is a weapon against what's wrong out there. It's bearing witness to the truth." —Brent Stirton

"You want to reveal what life is like; to show things we may never fully understand." —Lynn Johnson

"A lot of the things I shoot are out in beautiful, immaculate landscapes that people have rarely visited. I've always seen my role as to kind of bring that back for people. Photography can also give a person a new perspective on their own context in the world. It's exploration on so many different levels." —Jimmy Chin

"When it comes to photography, I always say that a good story takes us somewhere we haven't been before. It has the power to undo assumptions. It has the power to imagine something different from what we've been given from our own realities." —Hannah Reyes Morales

"My pictures are about making people realize we've got to protect those who can't speak for themselves." —Michael "Nick" Nichols

"So many of us walk along in prison our whole lives, and some of us are lucky enough to find whatever it is that we need to get our freedom. For me photography has done that." —Wayne Lawrence

A shared history told through photography. I can think of no one better than National Geographic's photographers to draft a visual history of these eventful, unforgettable times.

It's no small feat for a single volume to encapsulate 21 years. I'll admit I may be biased, but for me this book achieves that. I encourage you to let its photographs pull you through time, page by page. Each one invites us to reflect on our world, and on what difference we might make in it. ◼

CHAPTER ONE
2000-

2005

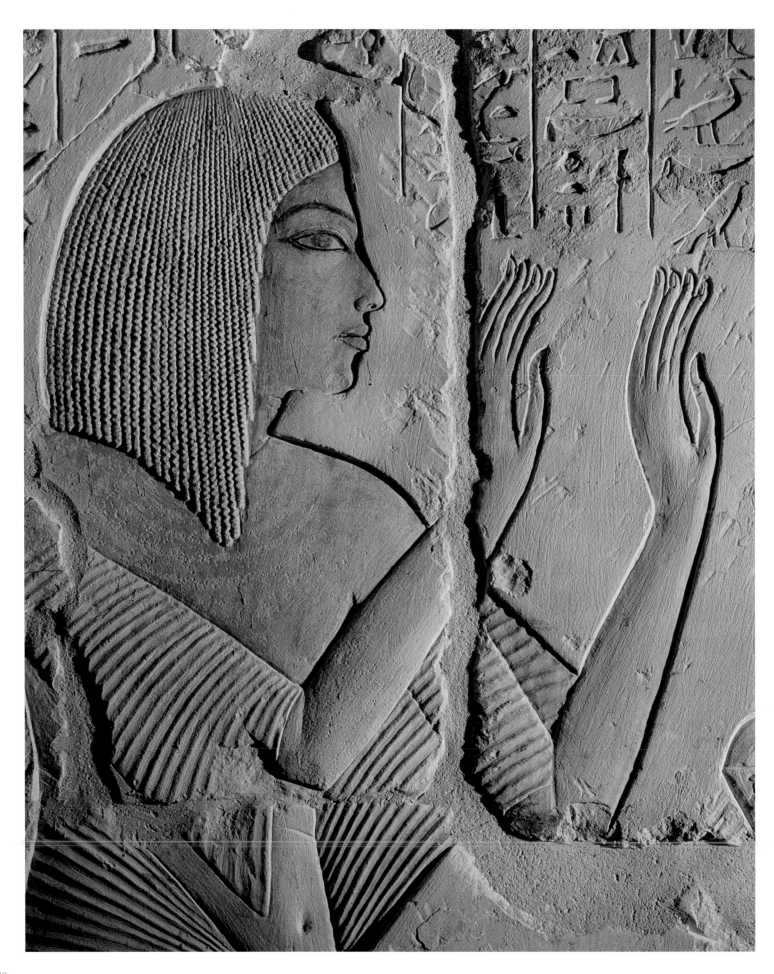

THE CENTURY

began with fears that now seem so naive: Would the clocks all stop at midnight? We danced away the night and awoke to the absence of crisis—a joy shattered nine months later as Y2K became 9/11 and our techno-fears turned to outright terror. Still, the clocks did keep running, through tragedy and loss. Time moved on, and the beauty of nature, the fascination of ingenuity, love and lust and human kindness pulled us along into the years to come.

Morning fog still sifted through the treetops. Ghost crabs still sashayed across the sand. Macaques patiently groomed one another. Cranes conducted their courtship prance. Meerkats mirrored our own attitudes: watchful and amused, wary and always ready to scamper.

History anchored us as we united to shape the future. Pharaohs of millennia past stood motionless as dictators of the present day toppled. We reflected upon past traumas: Chernobyl, Tibet, world wars, the Holocaust. As our numbers kept increasing, we built houses chockablock—yet we found ways to make this more crowded life just as meaningful, playing and praying together. Panoramas of beauty still stretched out on every continent.

The makers among us reminded us to stop, look, and wonder. Some reveled in crafting lines and colors inspired by centuries past: the graceful arcs of a Turkish fishing vessel and the beaded elegance of Mexican finery. Even new technologies were art to our eyes: Carbon fibers weave around each other; fiber optics glow with promise; a newly discovered molecule, intricately symmetrical, brings our attention to the atomic level. Art and nature merge as scientists ply their knowledge and imagination to face a worsening climate crisis. Blankets comfort alpine slopes, protecting them from warming and melting.

By the end of these five years, light beams shine forth from the place where horrors once happened. With the mingled emotions of fear, courage, and hope, we play and dance, we embrace and come together. ■

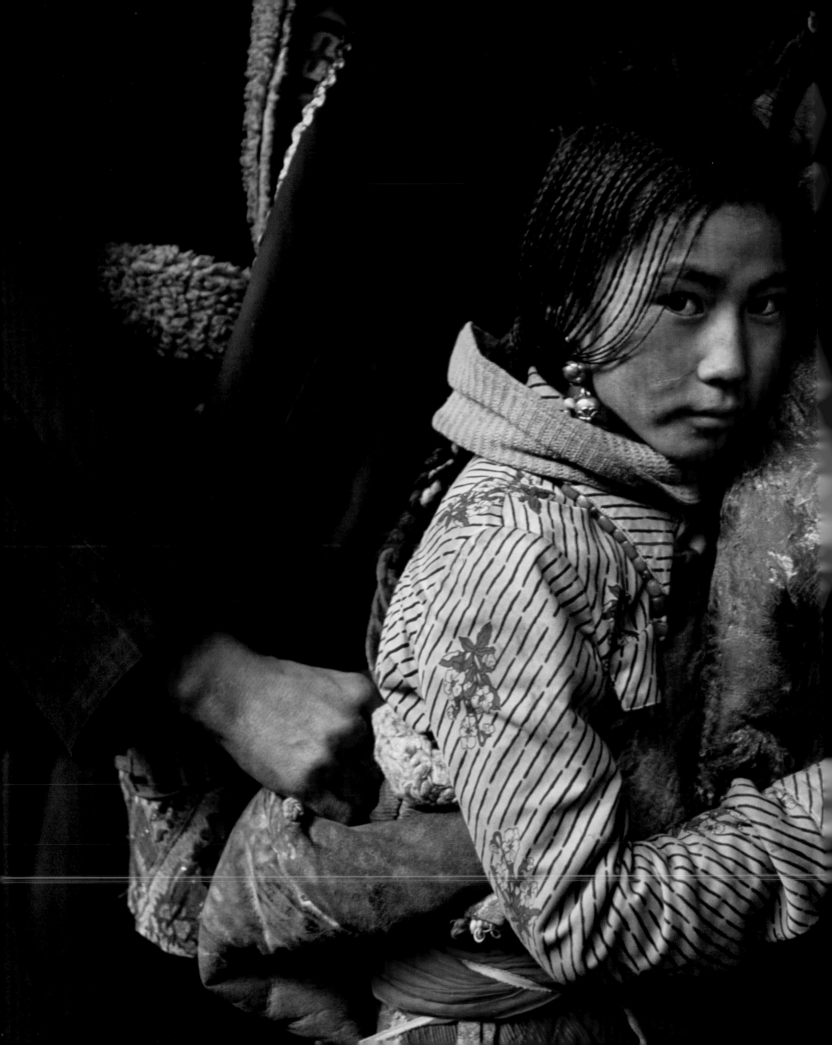

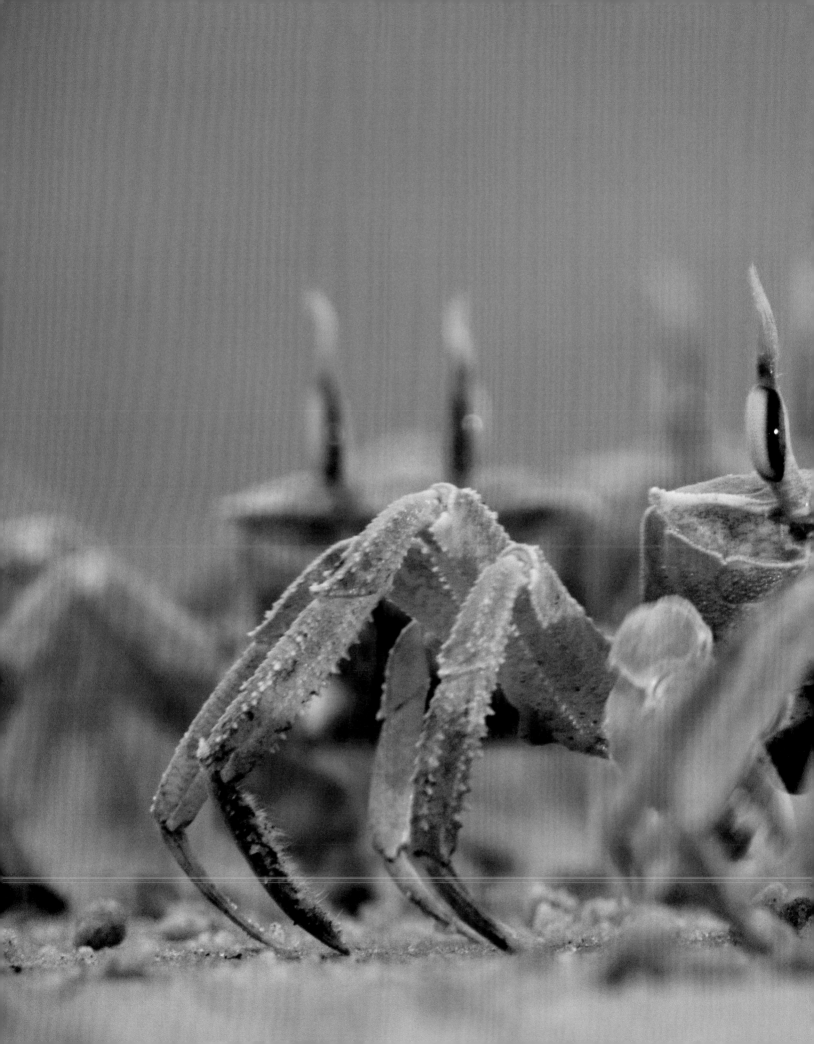

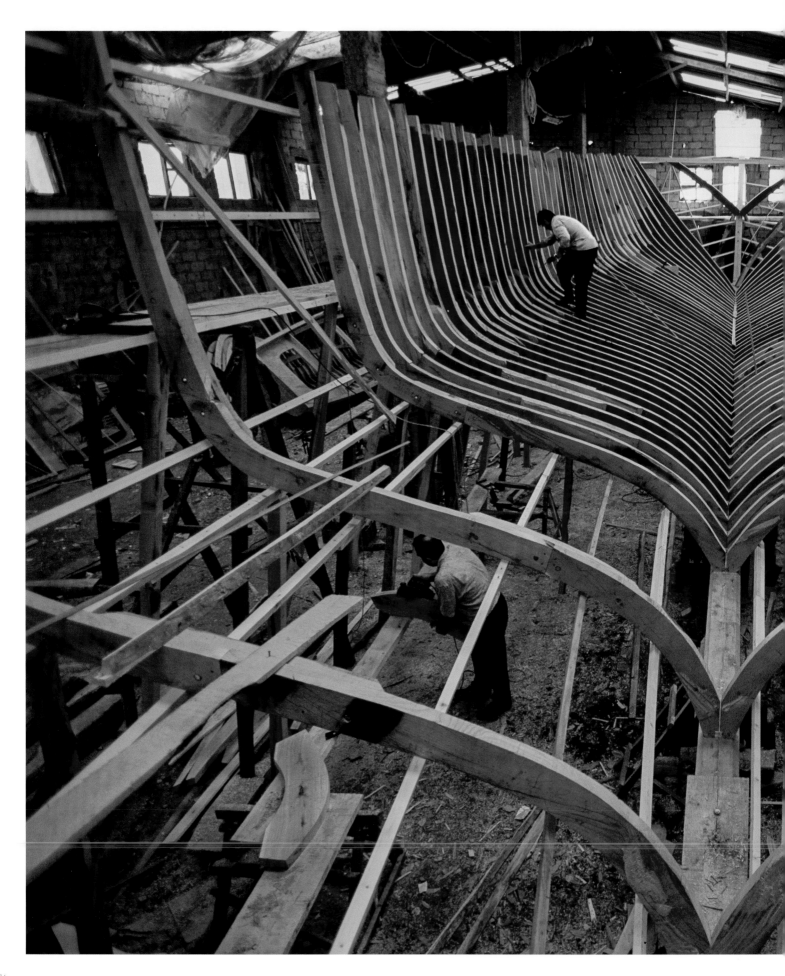

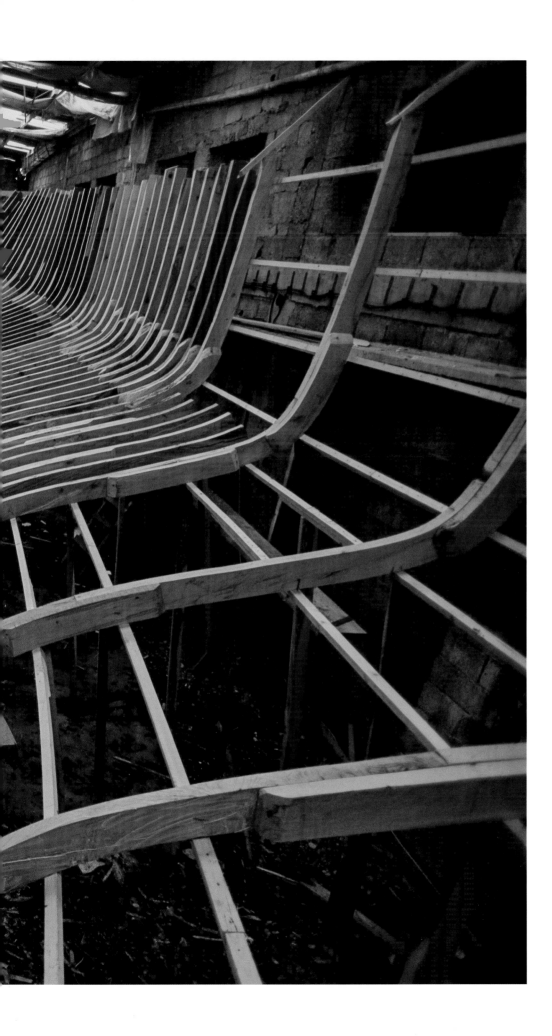

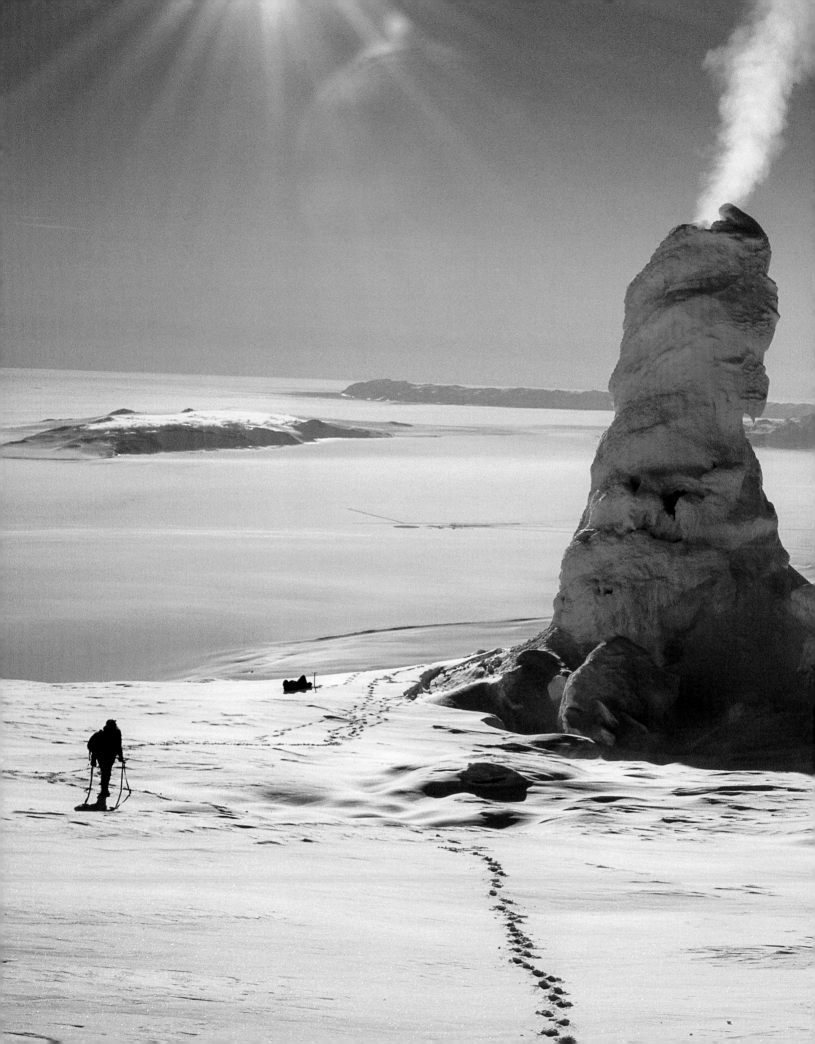

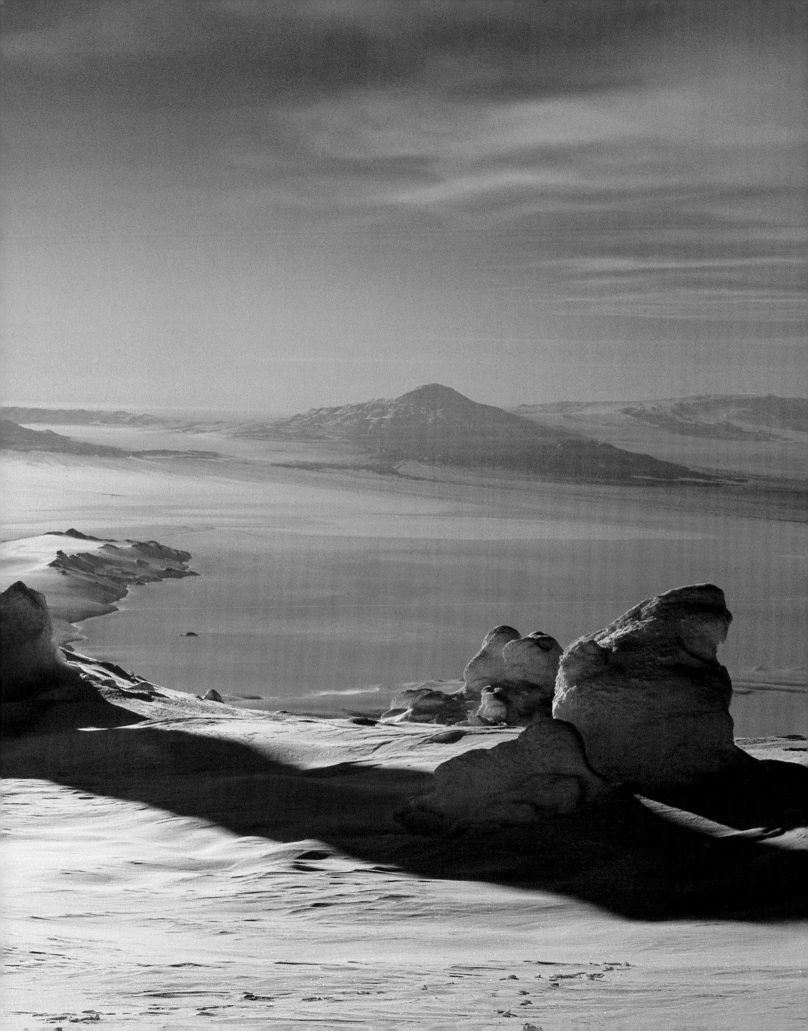

2000 I KAREN KASMAUSKI
Falls Church, Virginia, U.S.
Streamers descend on graduating seniors at a high school in Virginia. In two reflections of a changing nation, half the school's students were born outside of the United States across 70 different countries, and in 2018 the school renamed itself Justice High School, discarding its old Confederate Army namesake.

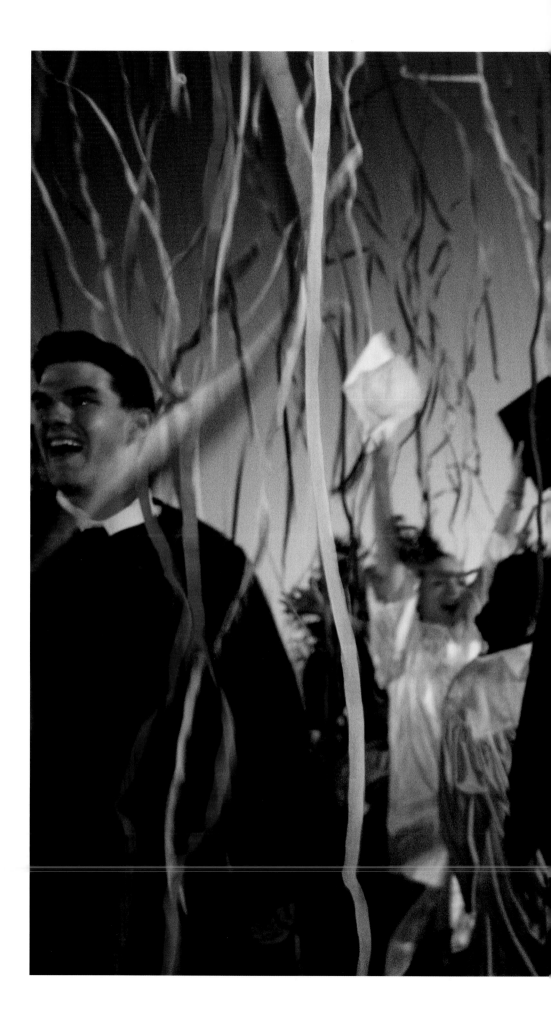

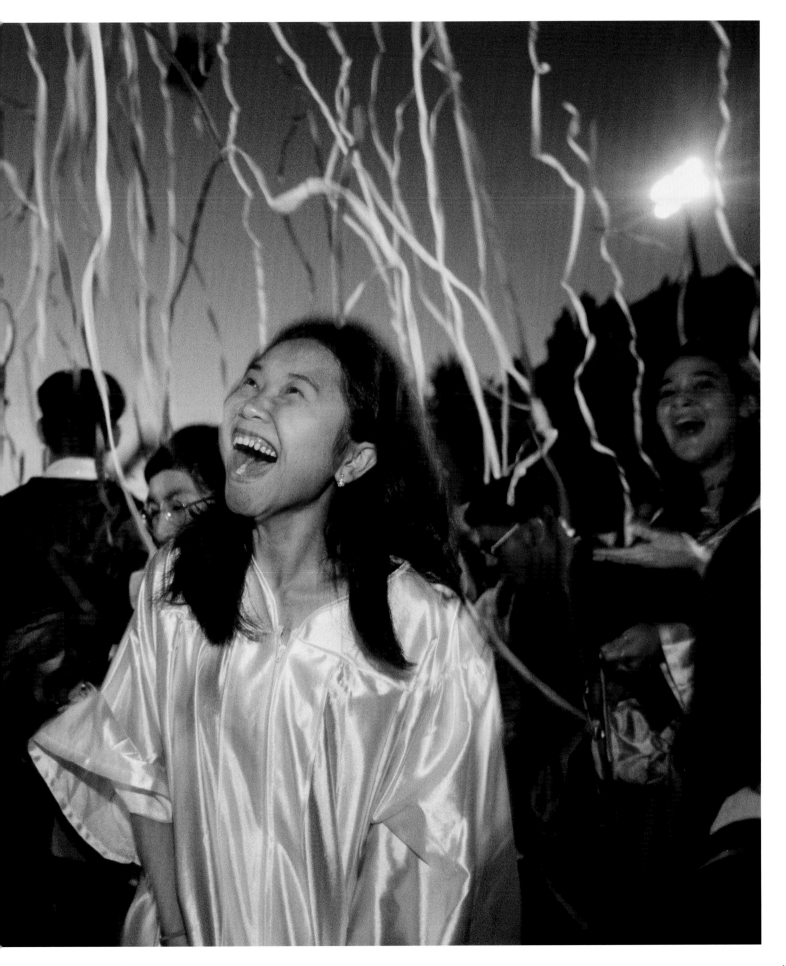

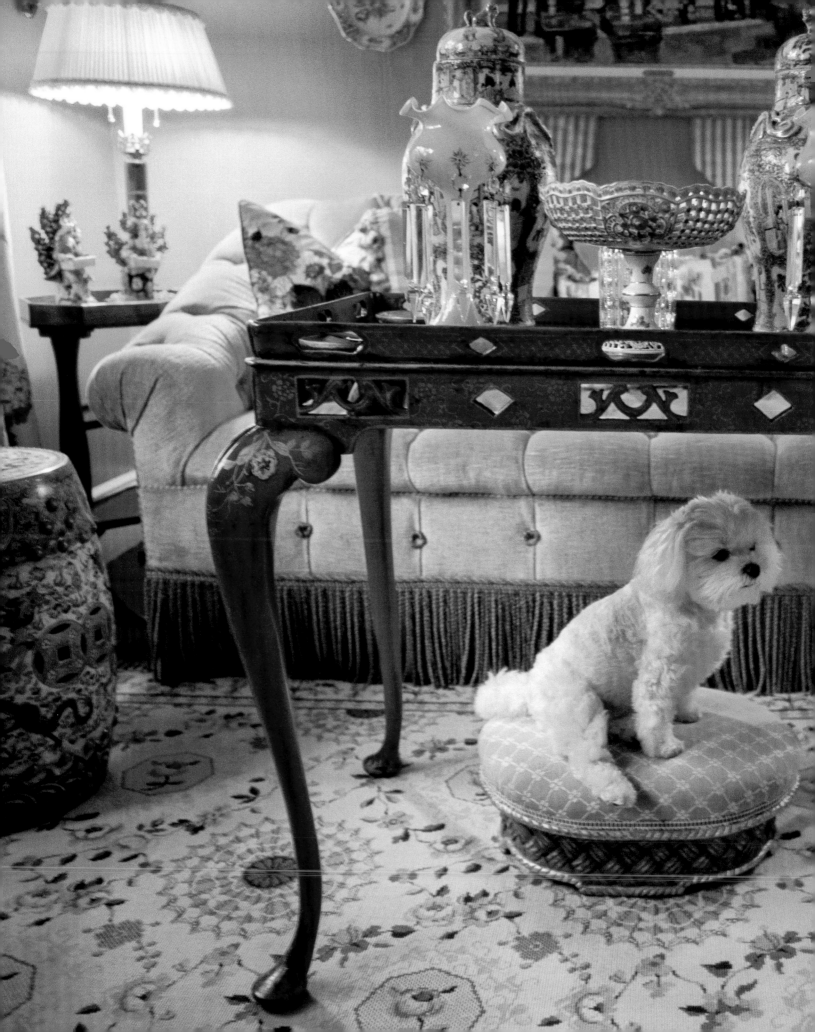

2000 I RICHARD OLSENIUS
New York City, New York, U.S.
Tiffy, a Maltese, leads a plush life on
Manhattan's Upper East Side, a symbol
of our love for our canine friends.

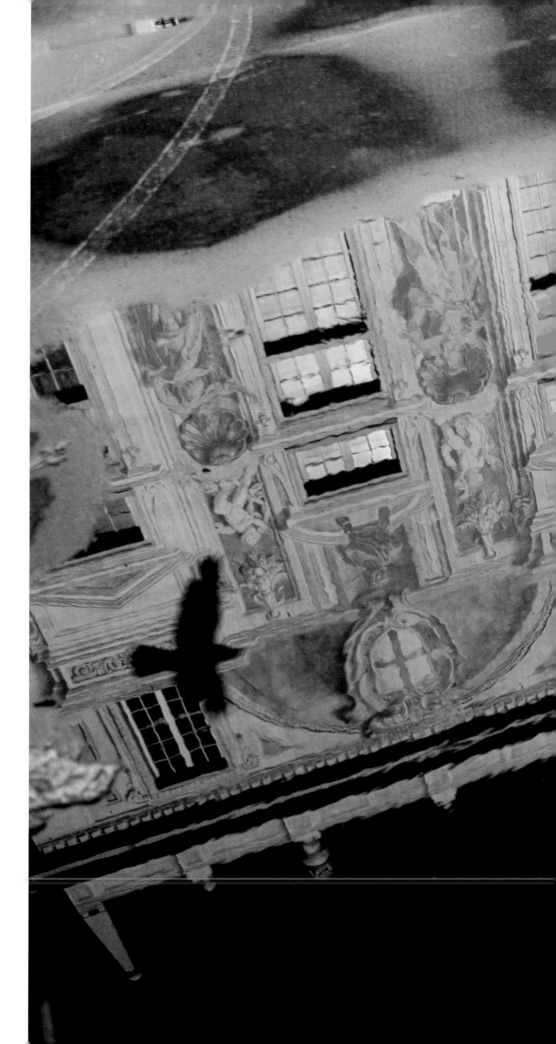

Opposite
2000 I MICHAEL YAMASHITA
Genoa, Italy
Palazzo San Giorgio is reflected in a puddle of water. Legend says the palace was once used to imprison Marco Polo after his return from eastern travels in the 13th century.

Pages 46-47
2001 I MATTIAS KLUM
Kalahari Desert, South Africa
Propped up on kickstand-like tails, meerkats start each day with a sunbath, soaking away the chilly desert nights. These small members of the mongoose family live in groups as large as 40 animals.

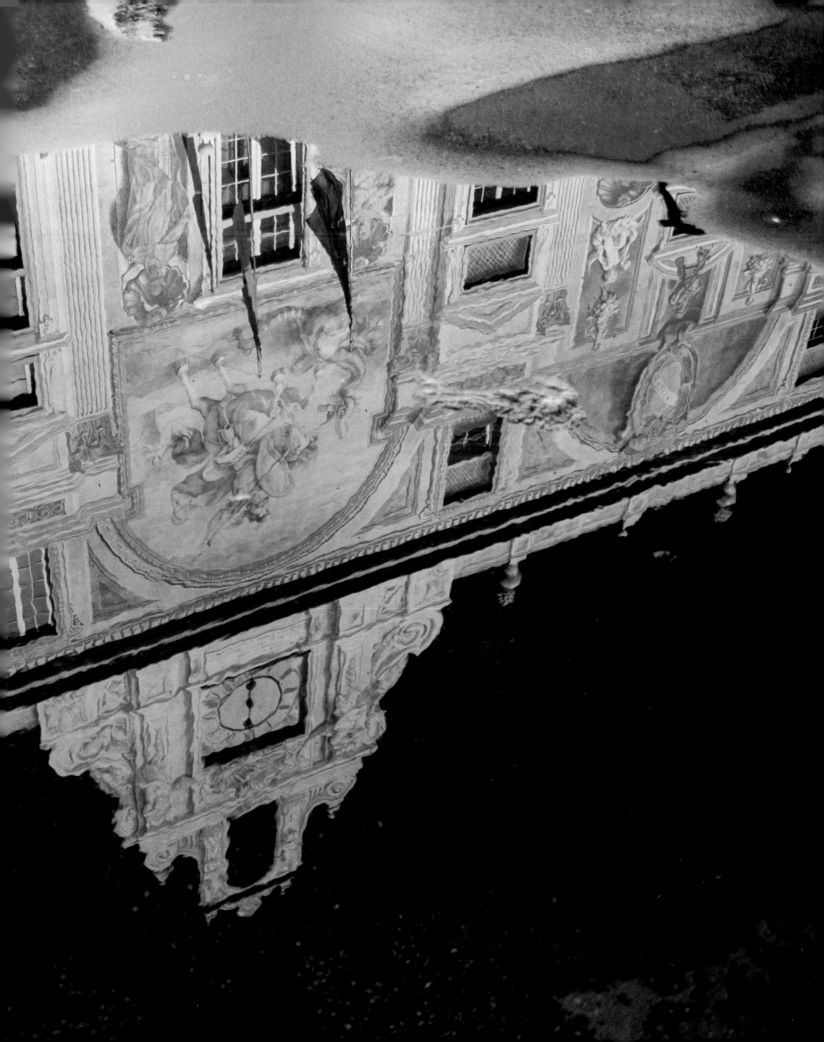

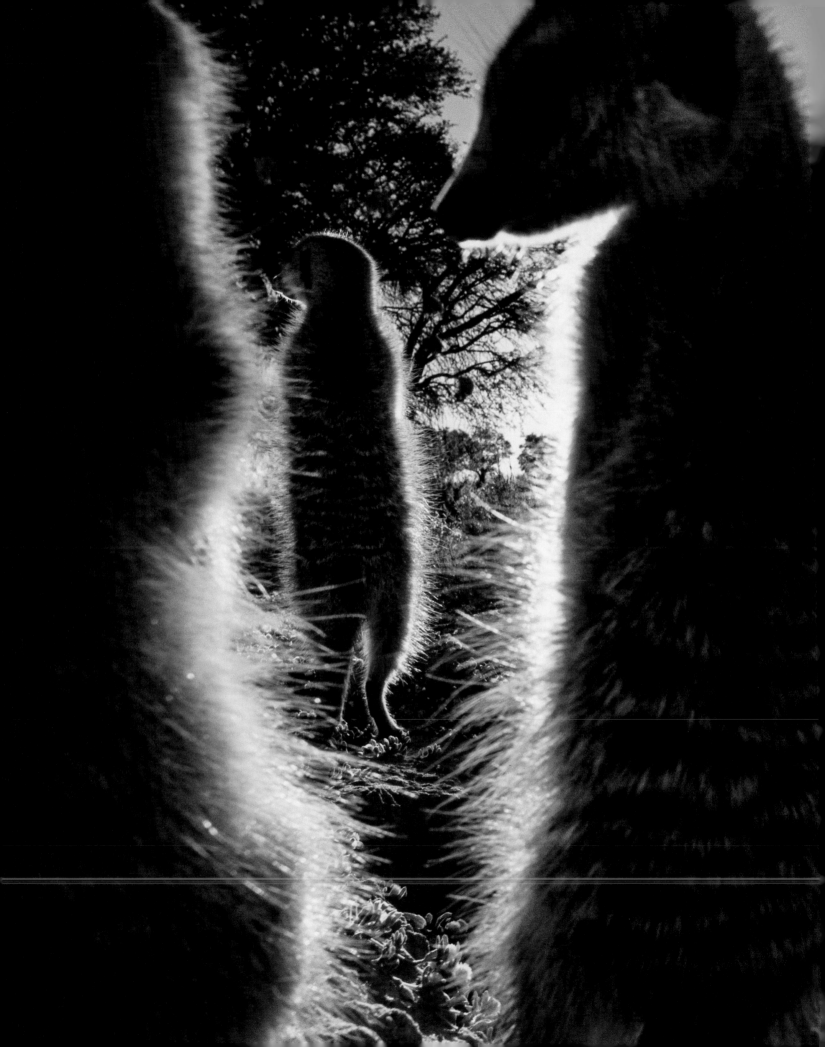

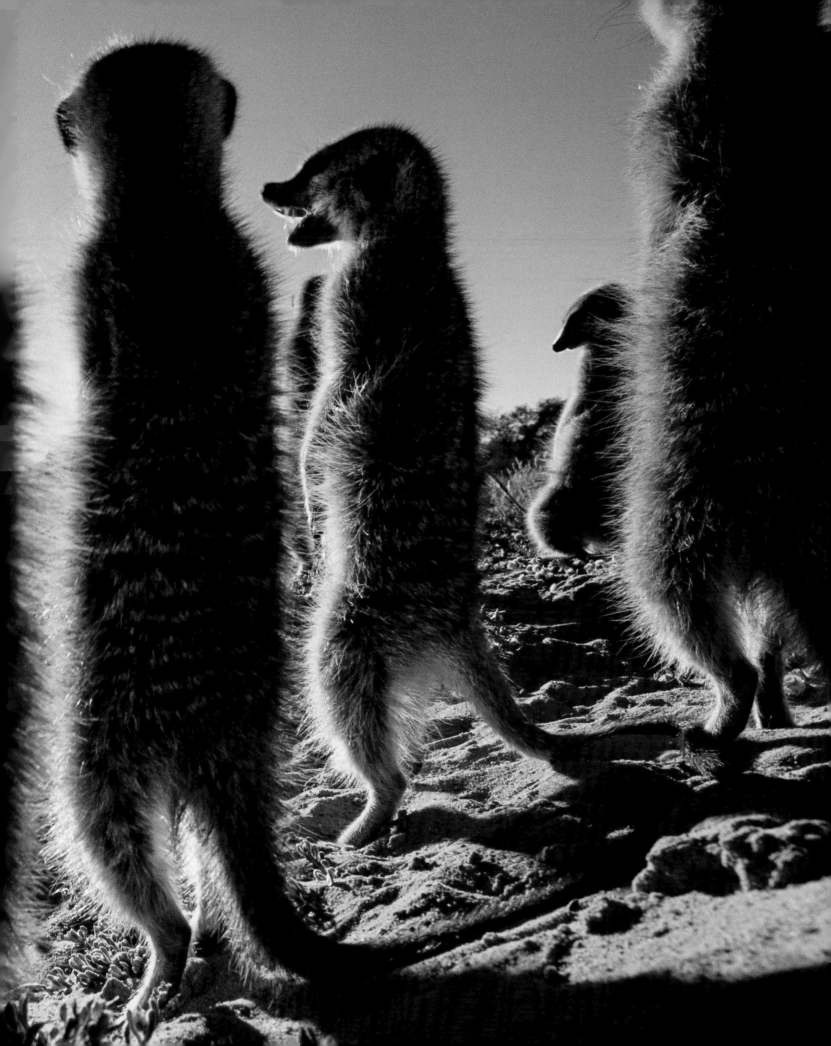

SARAH LEEN

I t all began as an assignment for a story about skin—a scientific look at all aspects of the skin we live in. One aspect was artificial skin, the kind used for burn victims, as well as the use of silicon to create realistic masks and prosthetics used for everything from Hollywood movies to people who have been disfigured.

I contacted an English company to make a face mask that I could photograph. I hired a model who went to their location, had her face cast, and then the mask was made from silicon. She flew to the U.S. to bring us the mask. She told me she thought the mask looked like her mother.

I photographed her and the mask in the photo studio at the National Geographic headquarters. I set up cloth backdrop and used lights to photograph her and the mask in many different positions. But my photo editor, Kurt Mutchler, was not satisfied with the results. So I pivoted from my plan and stopped trying to include the model in the image. Instead, I had her hold the mask in front of the backdrop. When I saw it like that, I felt something magical happen. Here she was holding and looking at her own face. It became something more than it had been; now it was a symbol for identity and how much our faces represent us to the world. The photograph became the cover for that issue of the magazine. ∎

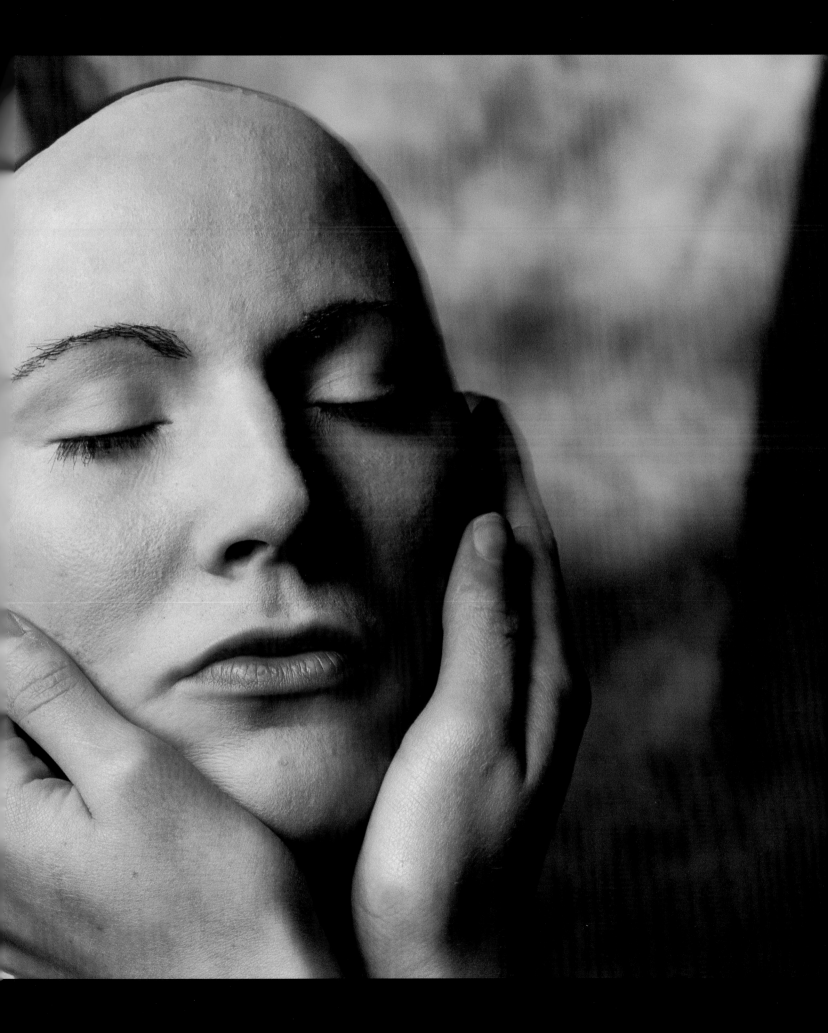

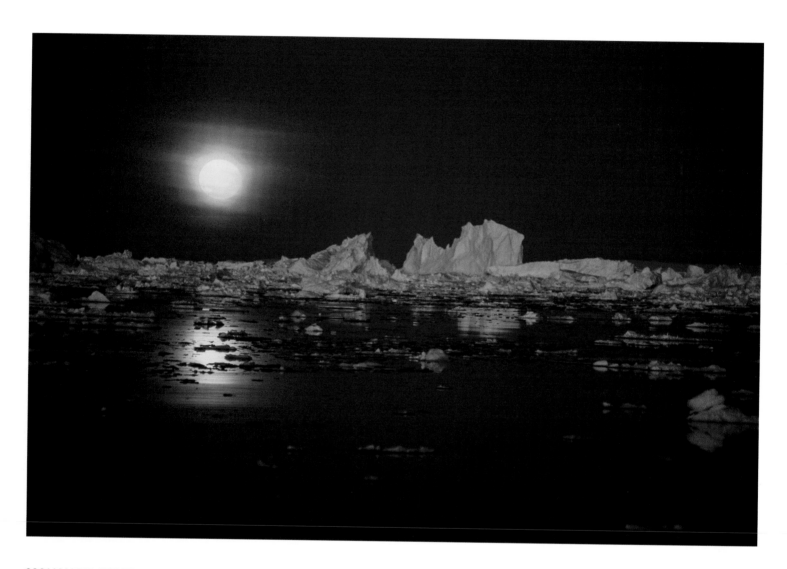

2001 I MARIA STENZEL
Antarctica
In late summer, the moon casts an orange
reflection on the ice-choked waters of
Antarctica, known as one of the darkest
places on Earth.

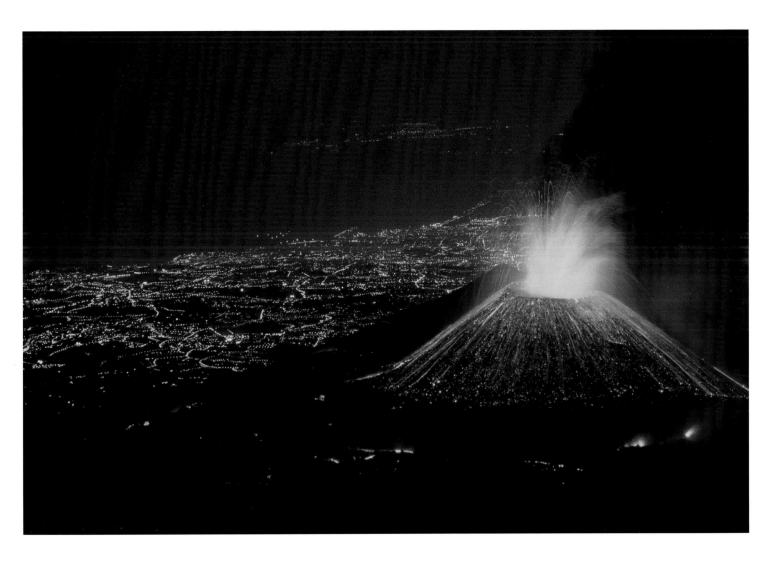

2001 I CARSTEN PETER
Sicily, Italy
A fiery cone on Mount Etna upstages Sicily's night sky—and the city lights of Catania outstretched below—during an eruption.

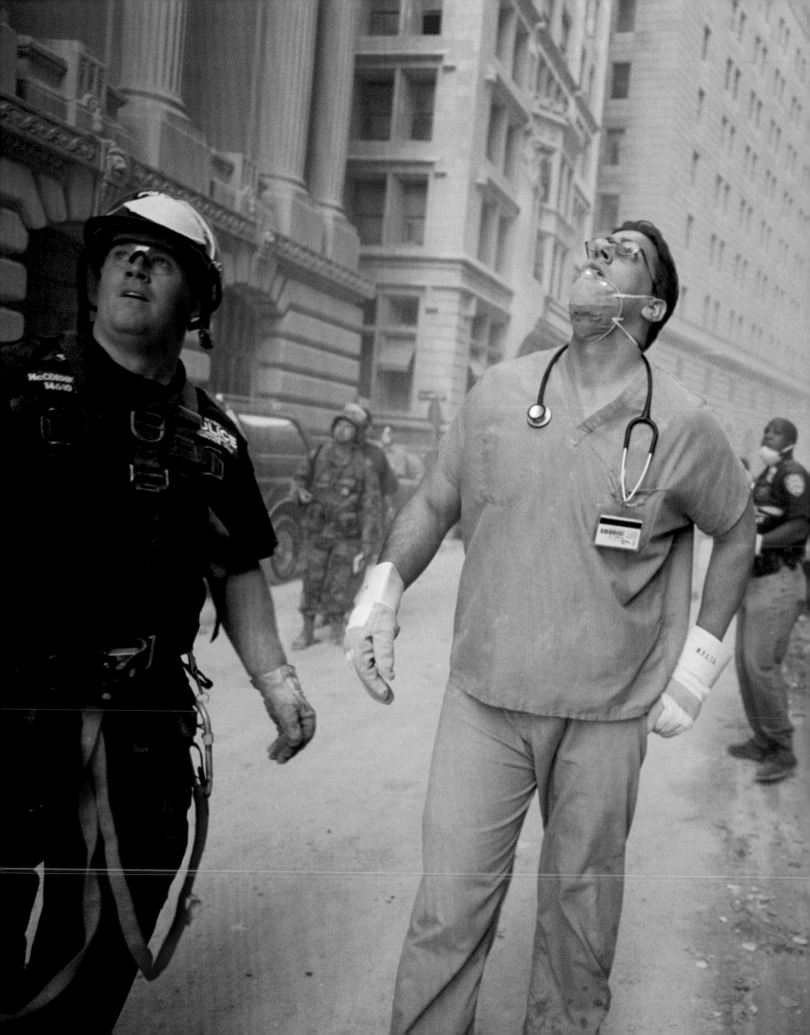

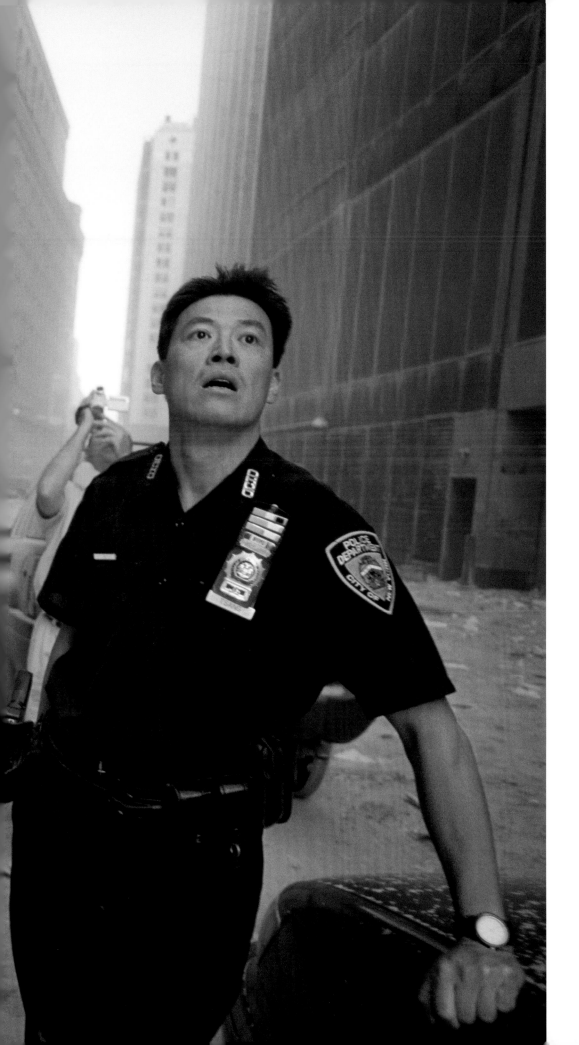

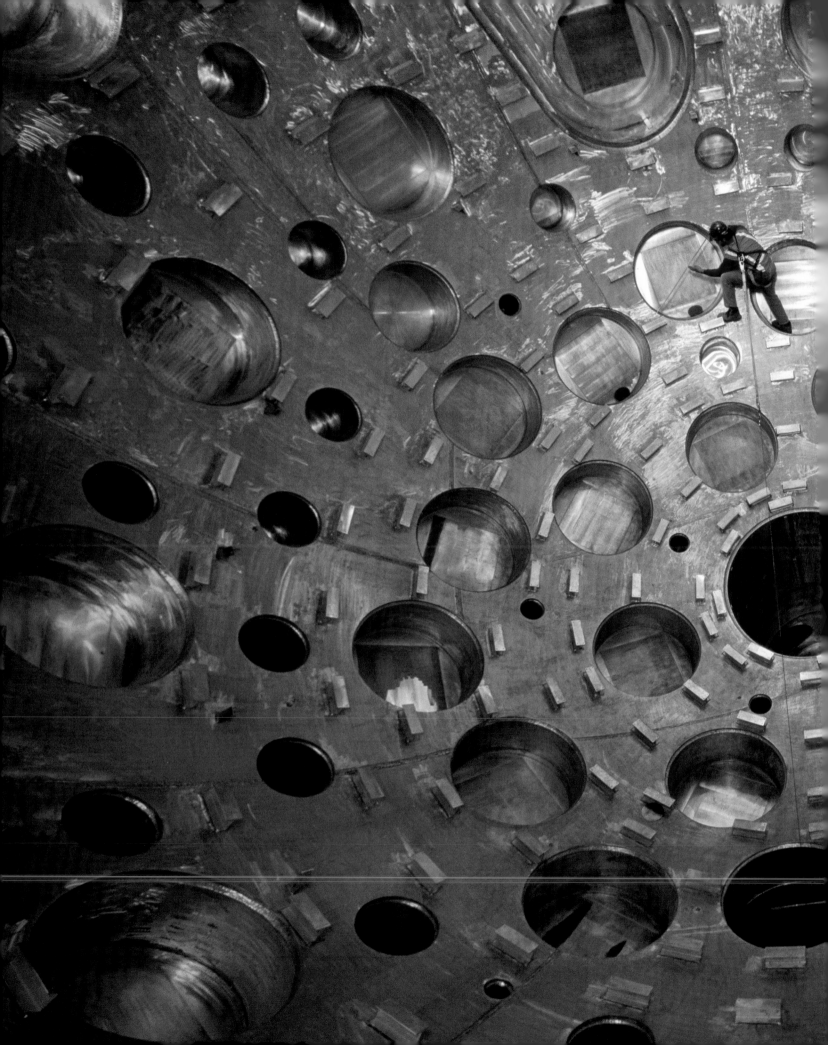

2001 I AMY TOENSING
Loíza Aldea, Puerto Rico
Drumbeats drive Gina Avilés as she
dances to bomba music, a heavily per-
cussive music originated more than two
centuries ago by enslaved Africans
brought to work on local sugar
plantations.

2001 I JOE MCNALLY
Holmdel, New Jersey, U.S.
When fiber-optic strands are pulsed with
infrared light, these modern magic wands
can transmit as many as 10 million phone
conversations at once through a single cable.

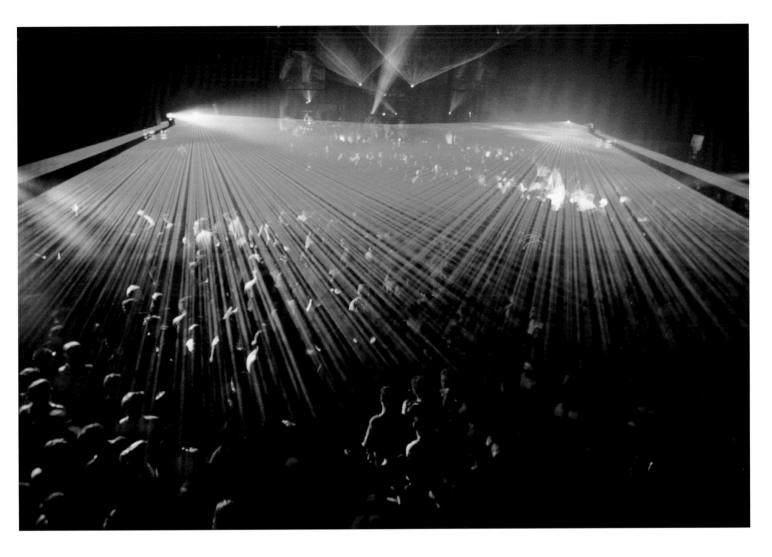

2001 | JOE MCNALLY
Austin, Texas, U.S.
A storm of colored laser lights flashes over
dancers at a rave. Scanners, filters, fog
machines, and computerized color mixing
help create the sprays of light.

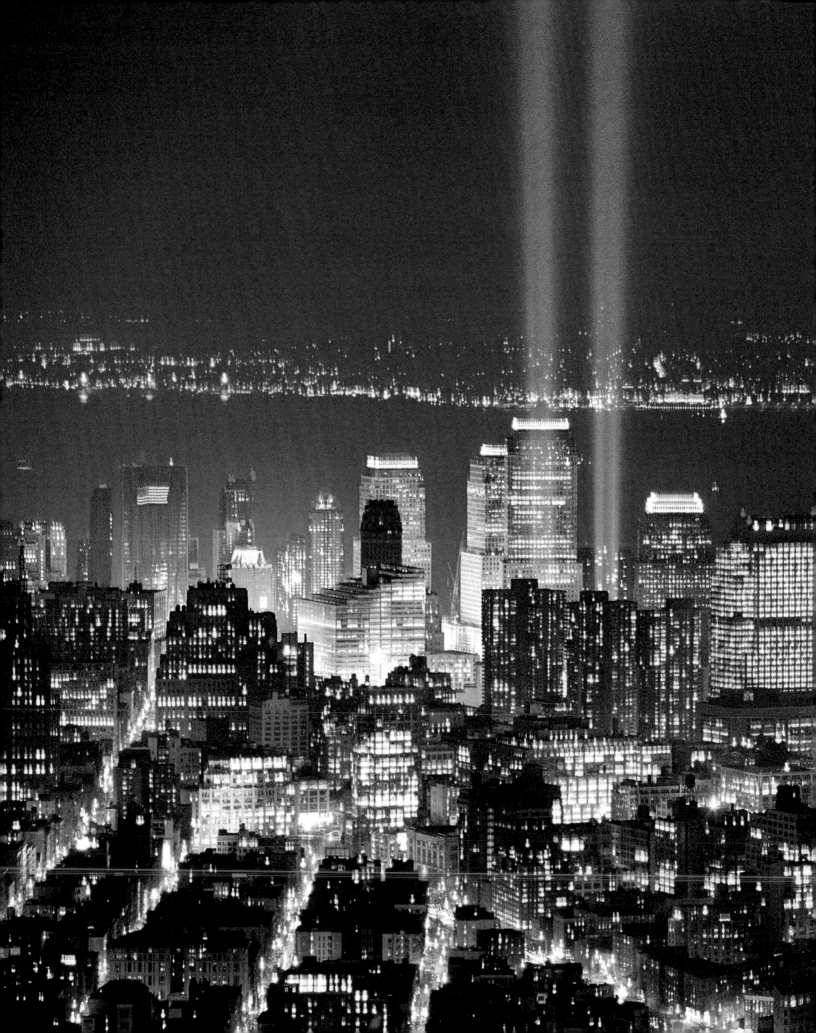

Opposite
2002 I IRA BLOCK
New York City, New York, U.S.
Twin beacons rise just beyond the Tri-
beca neighborhood, marking the spot
where the twin towers once stood and
commemorating Manhattan's darkest
and bravest hour.

Pages 62-63
2002 I PAUL NICKLEN
Canada Basin, Arctic Ocean
Cold, blue gloom greets a tethered
diver as he scans the base of a multi-
year ice floe—some eight feet (2.4 m)
thick—laced with channels housing
myriad life-forms.

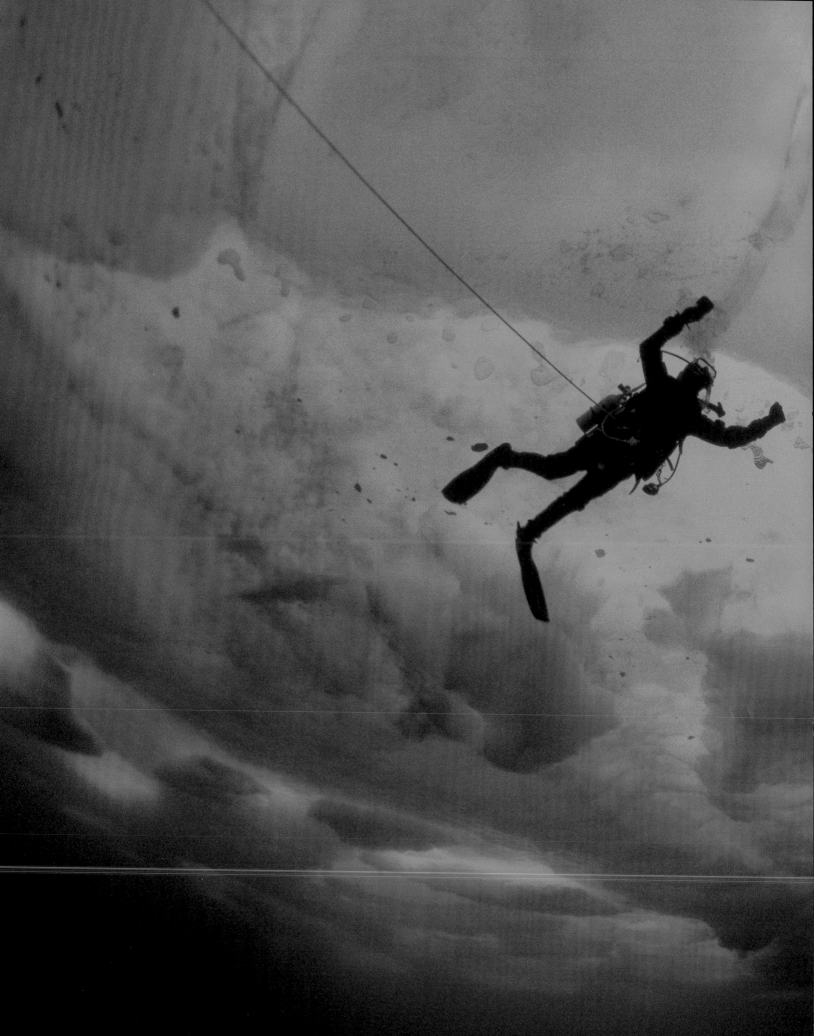

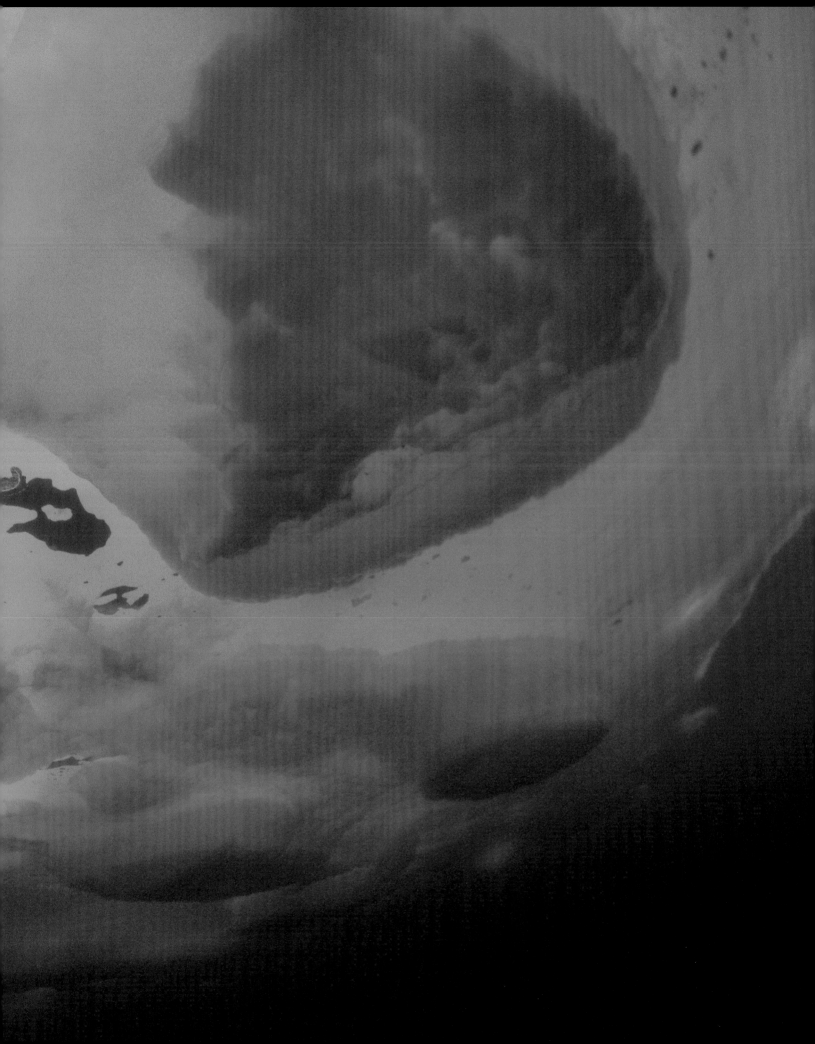

2002 I RANDY OLSON
Karima, Sudan
A wedding celebration brings men home to Karima, a northern village. After a month or two, they will return to the capital city of Khartoum or leave to work as migrant laborers in the richer nations of the Persian Gulf.

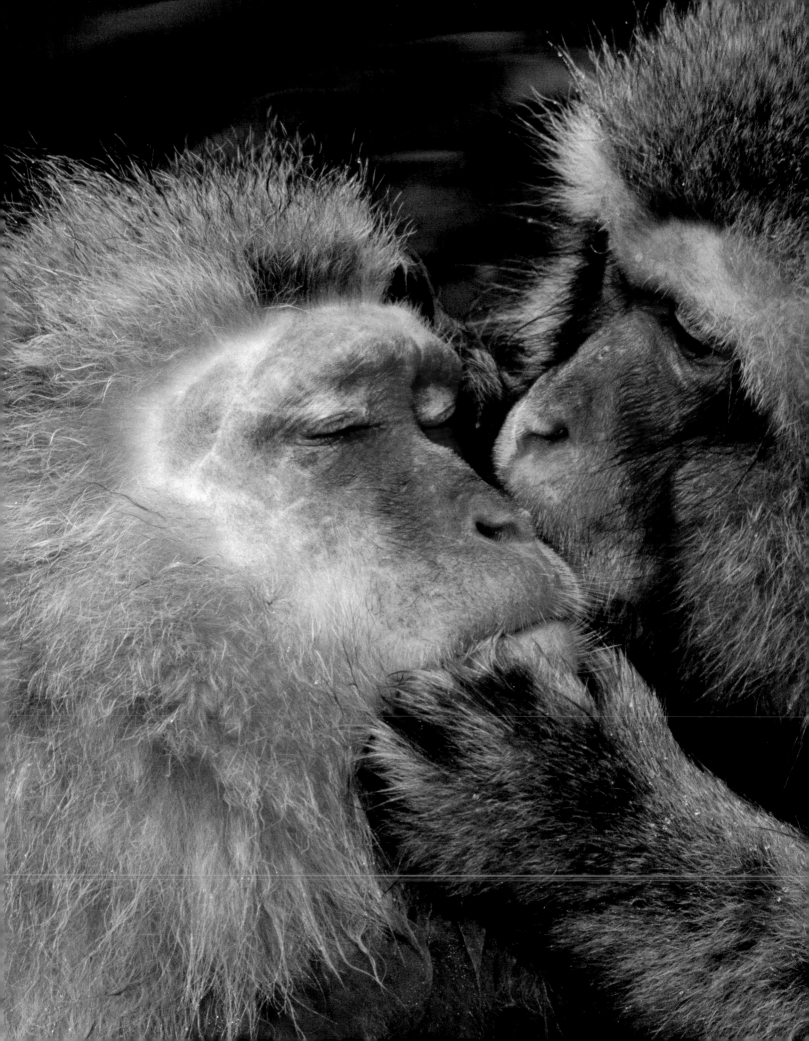

2002 I TIM LAMAN
Honshu, Japan
Japanese macaques, or snow monkeys, groom each other while soaking in a hot spring in the Nagano Prefecture.

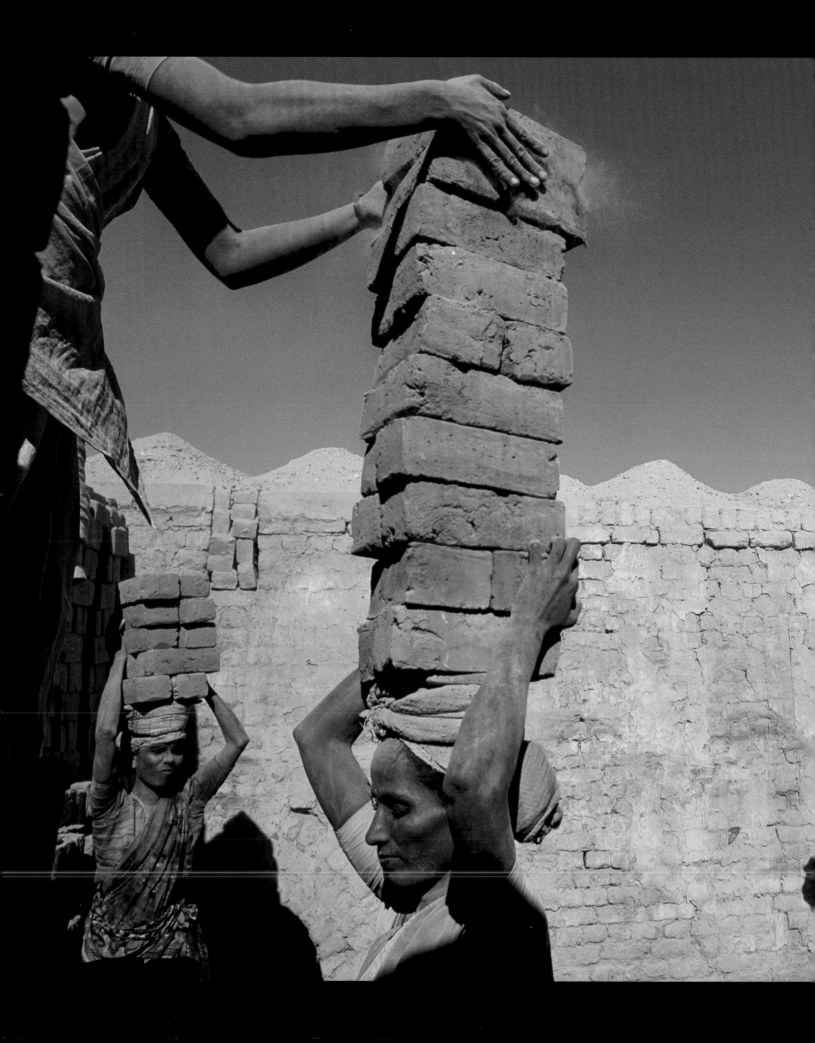

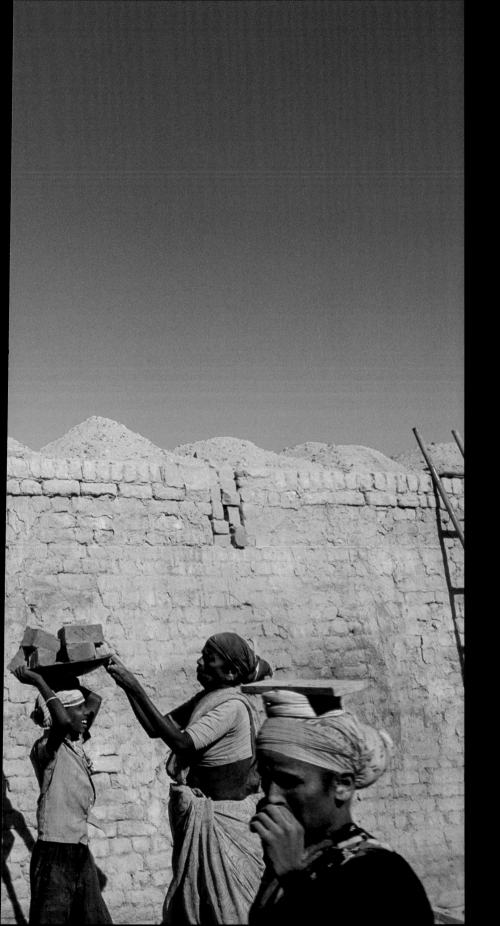

THROUGH
THE LENS

JODI COBB

It was a scorching day in Bihar, India, at least 110 degrees Fahrenheit (43.3°C) under a cloudless sky. The heat only added to the misery of the women balancing dozens of bricks on their heads, especially because they were not free to leave.

It was 2003 and my mission was to expose the tragedy of 21st-century slavery worldwide for National Geographic. I spent a year in 12 countries on six continents, exposing not just labor abuses, but sex trafficking, agricultural slavery, child labor, organ trafficking, and illegal adoptions. At the time, it was estimated there were 27 million slaves worldwide—and it has only gotten worse.

My heart broke every day. I confronted the inhumanity of the traffickers while showing the plight of their victims and the efforts of their saviors. These are real slaves: bought and sold against their will, held captive, brutalized, exploited for profit. The debts that hold these brick kiln workers in bonded labor are particularly insidious, as they can be passed on to their children for generations.

Words can describe the horrors I saw, but a photograph can tear at your heart. You search the woman in the foreground's face for clues to the stoicism, courage, and strength required to bear that load day after day. You can put yourself in her place. A photograph can make you care. It can make you want to change the world. ■

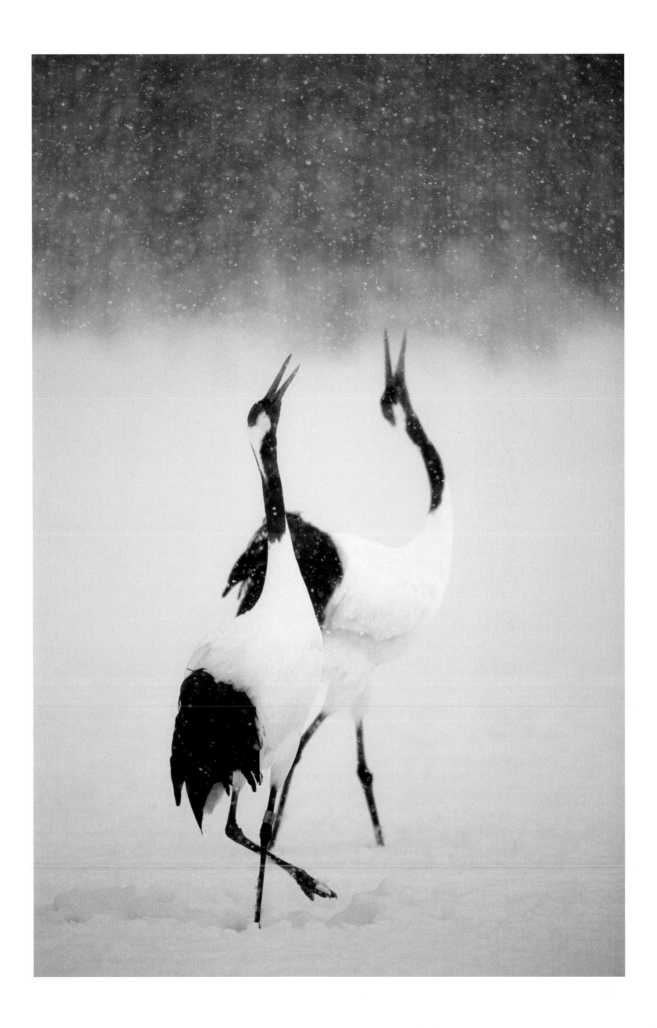

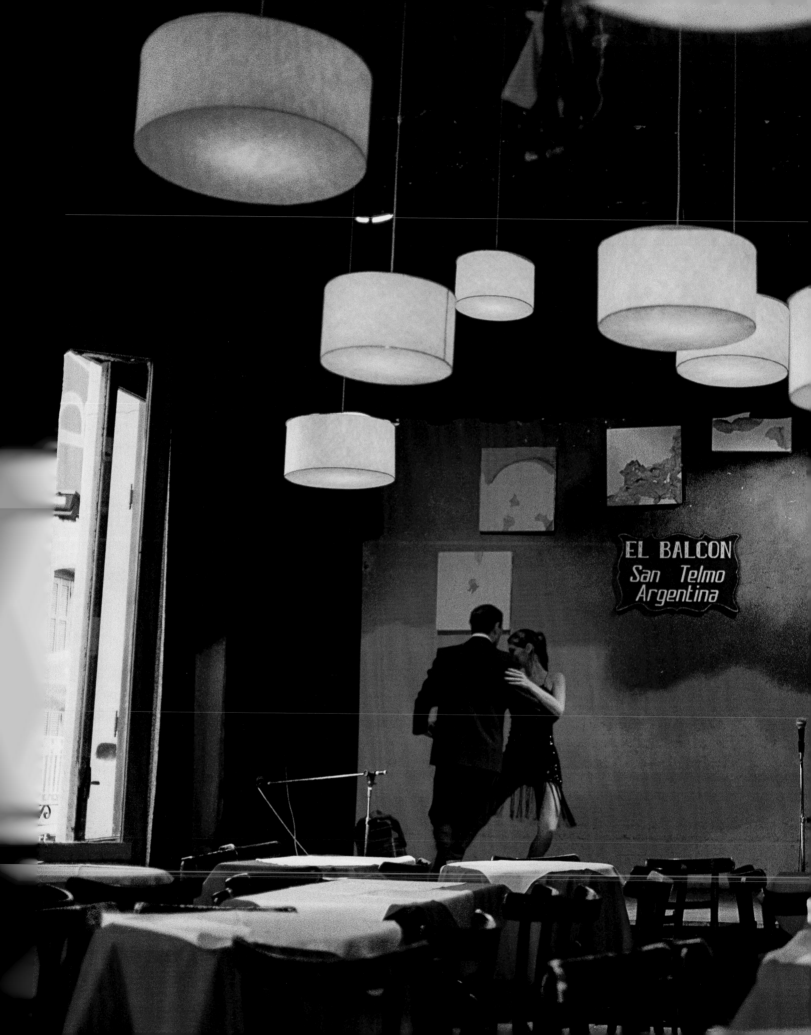

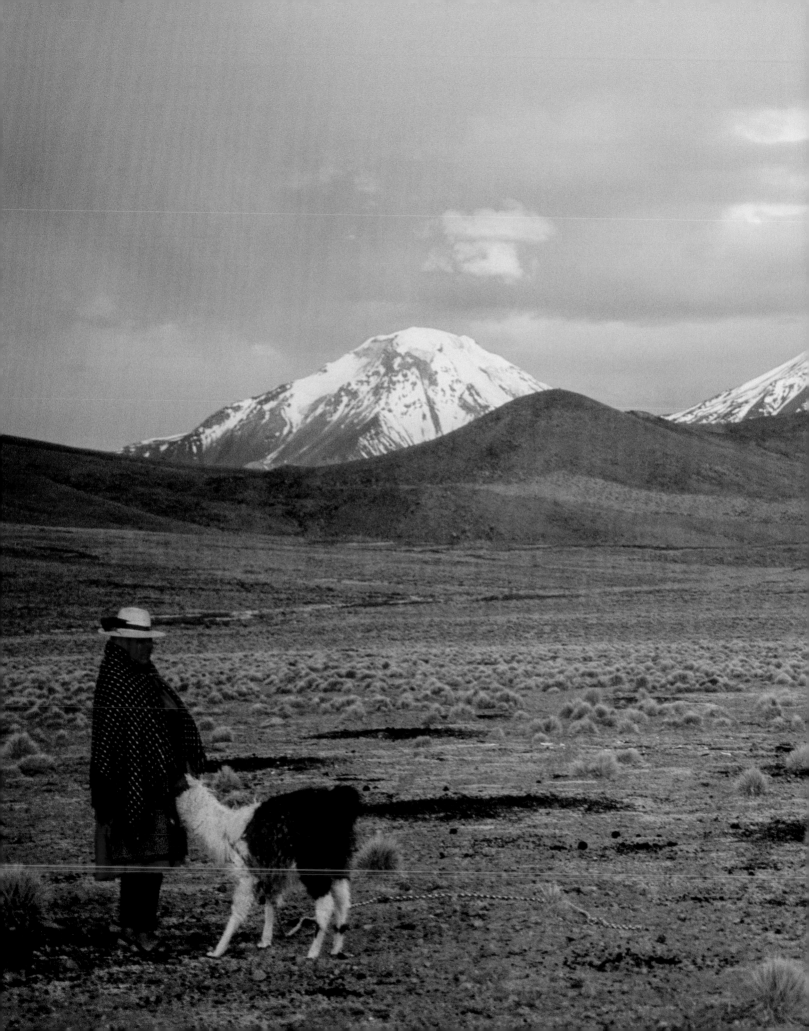

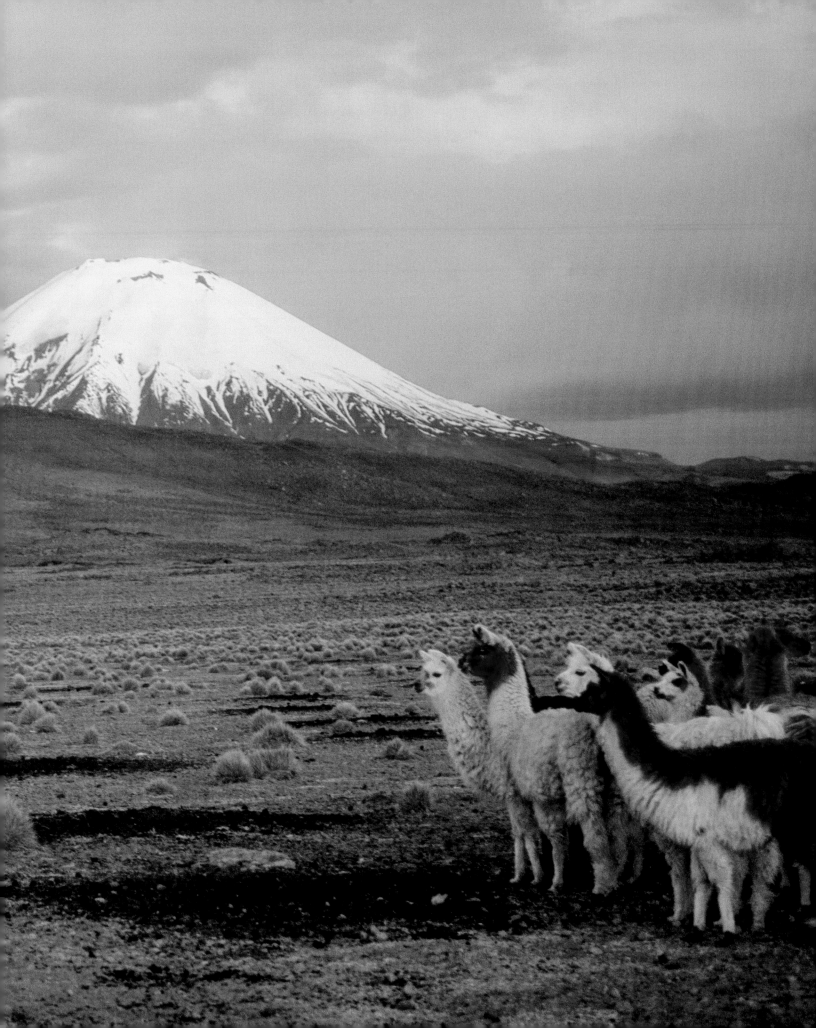

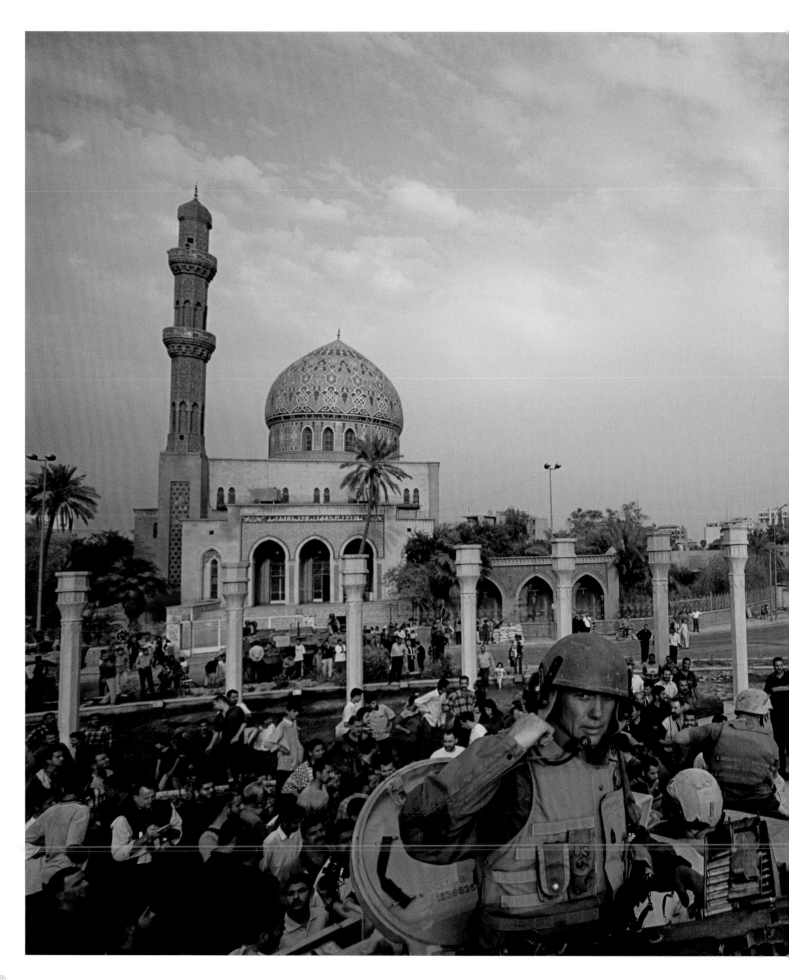

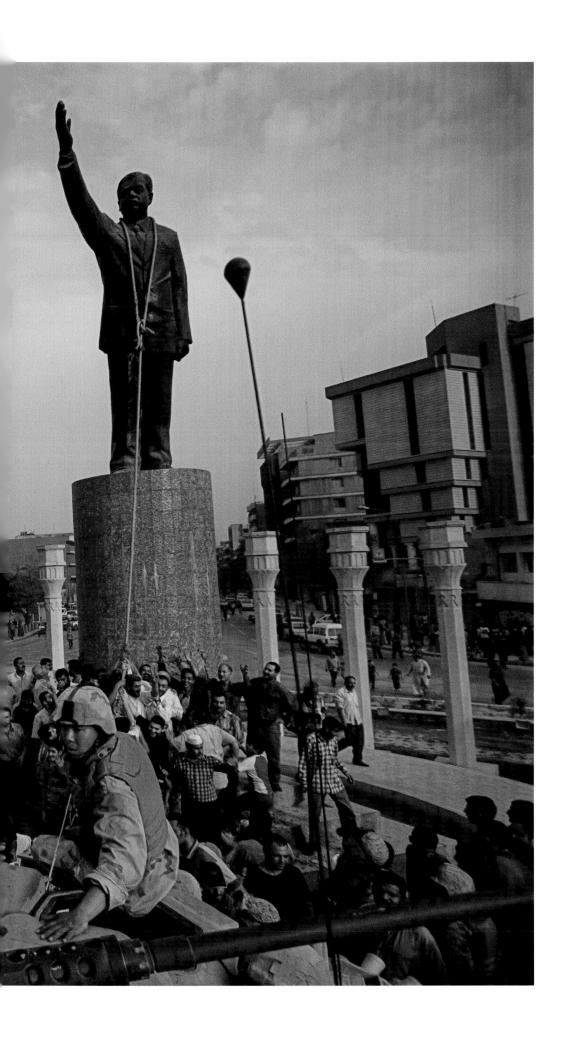

Opposite
2003 I ALEXANDRA BOULAT
Baghdad, Iraq
One hundred or so citizens gathered in Firdos Square to topple a statue of Saddam Hussein. When pulling on a rope around his neck didn't work, U.S. marines with an American tank offered help.

Pages 78-79
2003 I DAVID DOUBILET
Okavango Delta, Botswana
Nighttime beneath the lilies brings a host of species to life, including the quicksilver streaks of a school of juvenile silver robbers.

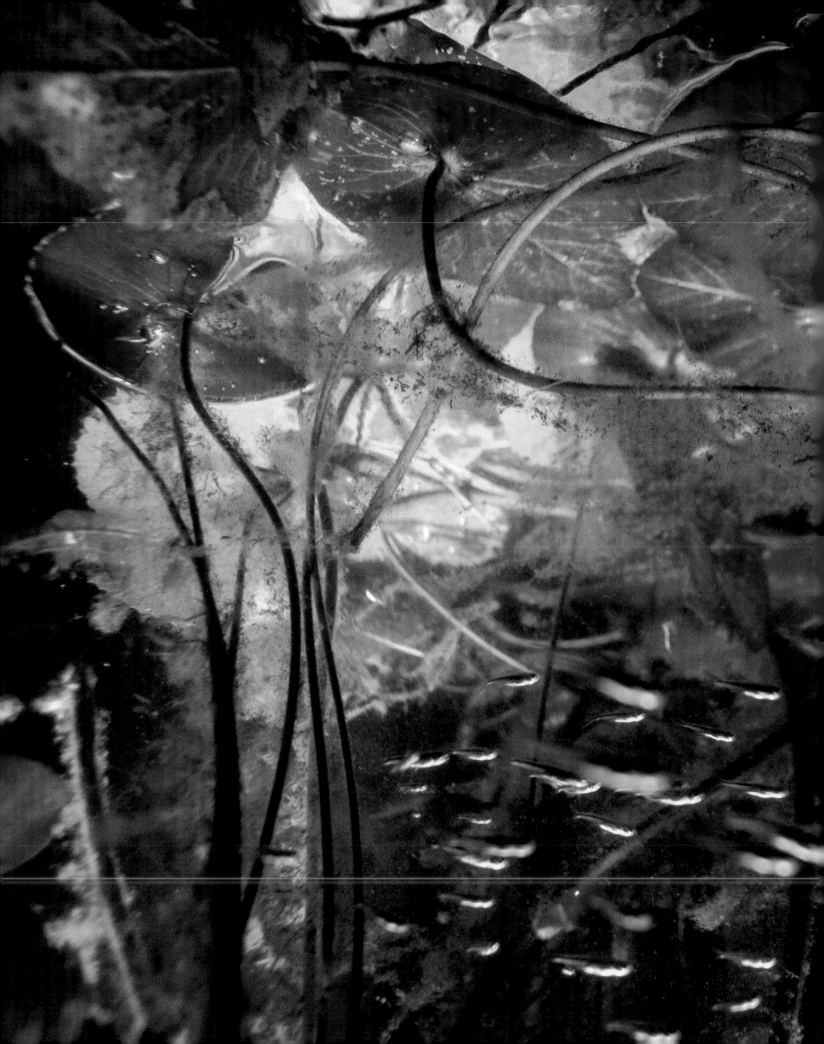

Opposite

2002 I PENNY DE LOS SANTOS

Laredo, Texas, U.S.

A Mexican-American debutante poses for a photograph before her presentation at Laredo's Martha Washington Colonial Ball and Pageant, an annual celebration of George Washington's birthday.

Pages 82-83

2003 I CARSTEN PETER

Danakil Depression, Ethiopia

Disks of travertine ring a 12-foot-wide (3.7 m) hot spring.

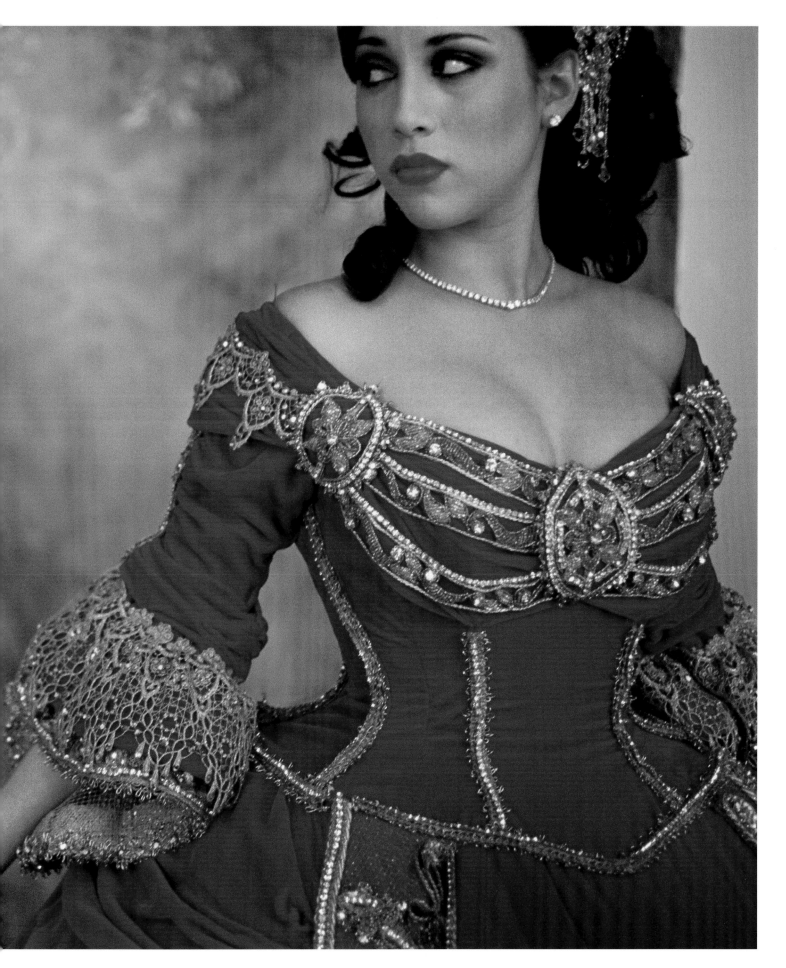

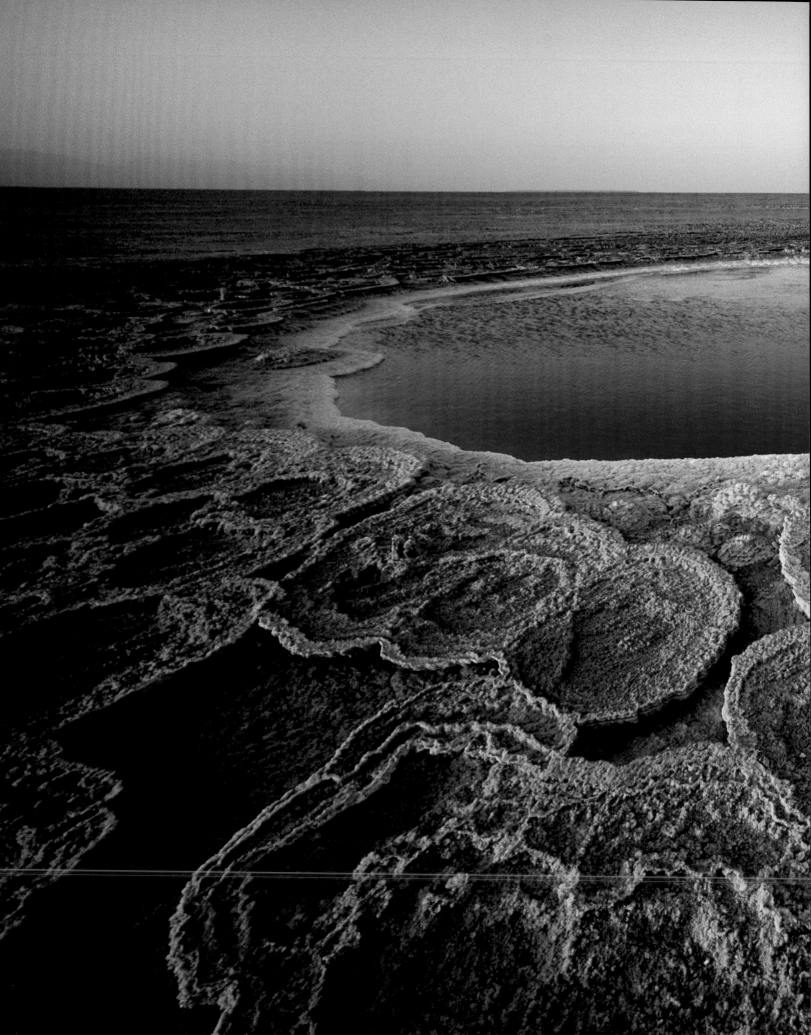

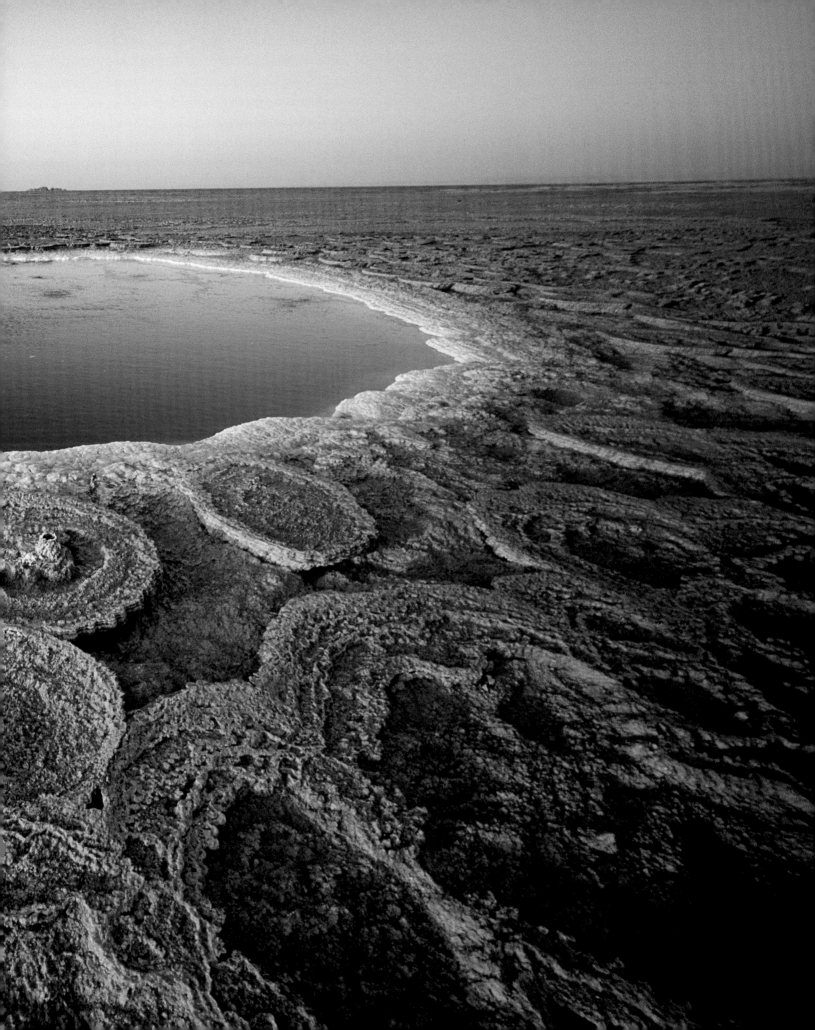

2003 I MELISSA FARLOW
Mud, West Virginia, U.S.
Lorene Caudill packs photos from her home as she and her husband prepare to move away from the stress, dust, and blasts coming from the Hobet 21 mine next door.

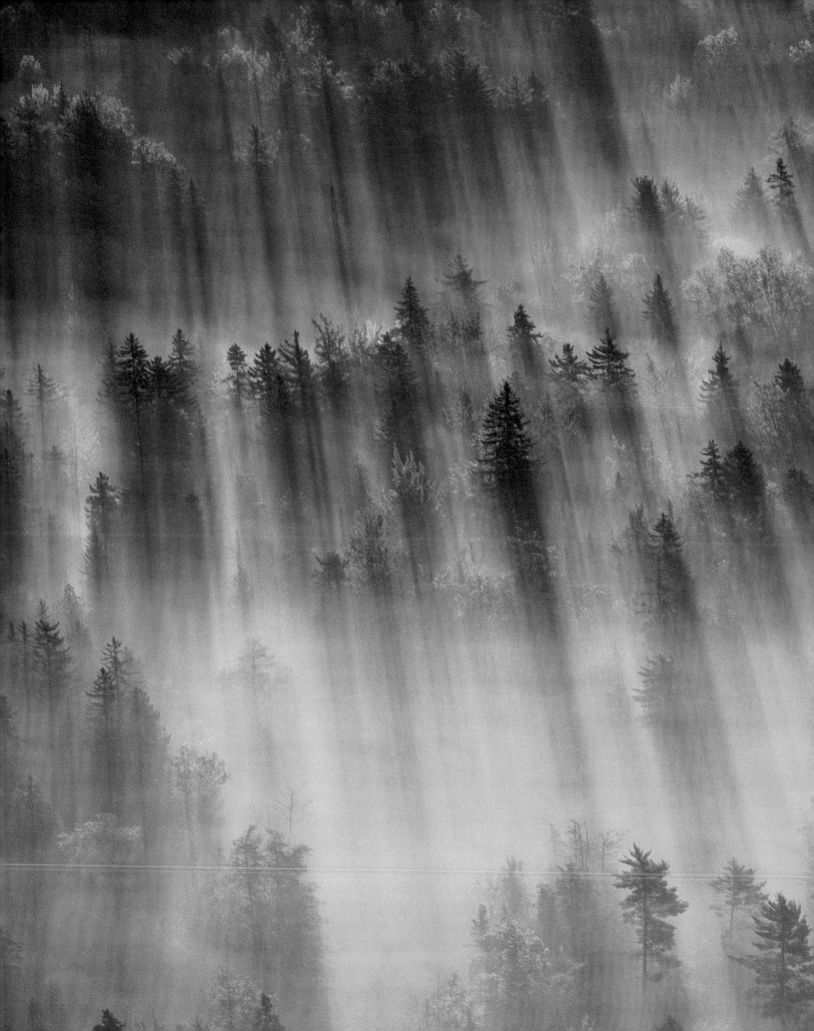

2003 I MICHAEL MELFORD
Acadia National Park, Maine, U.S.
Bright days and cold nights ignite brilliant foliage displays across the coastal mountains, deep lakes, and rocky coves of Acadia, the first national park established east of the Mississippi.

THROUGH
THE LENS

MICHAEL YAMASHITA

I was in Xiahe, in China's Gansu Province, shooting Losar, the Tibetan New Year, at the Labrang Monastery for my *National Geographic* story about Marco Polo.

The monks on this cold January morning were gathering for a debate and prayer session. I first approached the seated monks on the ground, shooting them from behind with a temple in the background. I pushed the envelope by edging closer and closer, trying to get a better angle on the multitude of monks. I shot a few frames before being chased away by novices carrying big sticks to whack those, like me, who ventured too close.

I searched for a second location out of harm's way but still in front of the monks to show their faces. As I climbed the hill above the temple, it began to snow. And by the time I reached the top, the snow was beating down heavily. I squeezed off several more frames using a telephoto zoom to focus in tight on the huddled mass of monks, all seemingly oblivious to the weather.

Thanks to the white snow reflecting light everywhere, each monk's face was highlighted as if I had flashed everyone individually, resulting in a multitude of faces and expressions that pop against their dark crimson robes. ■

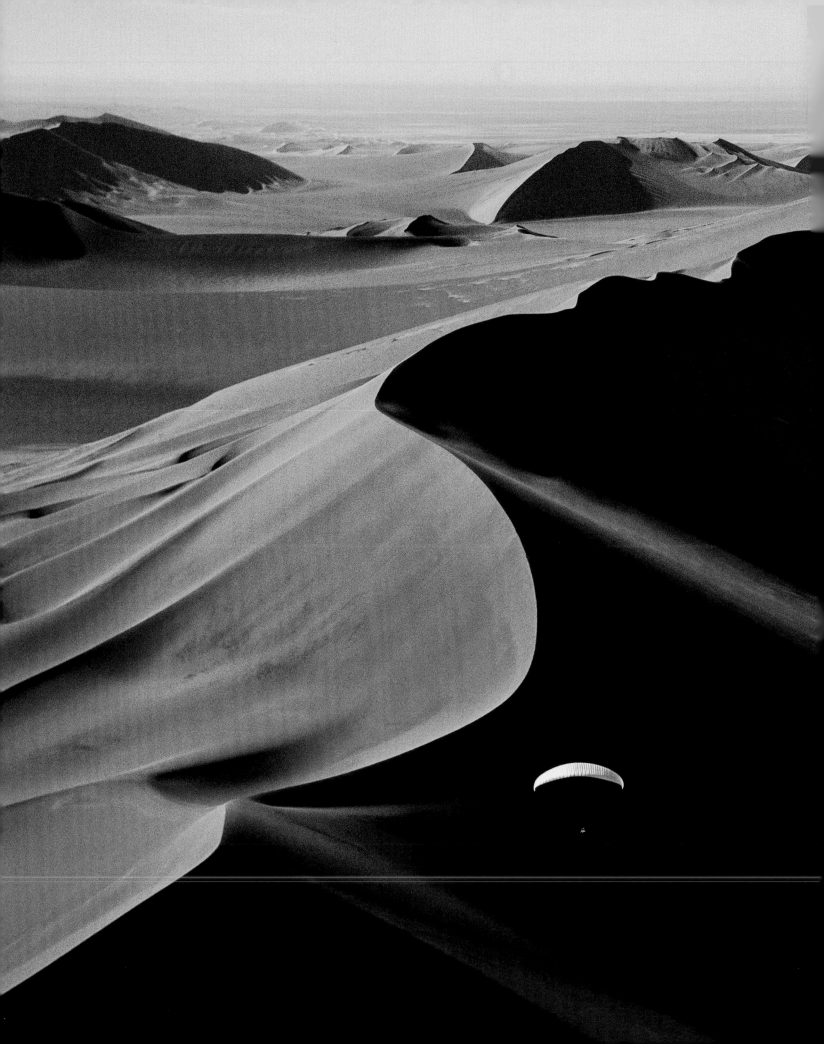

Opposite
2003 I PETER ESSICK
Atlanta, Georgia, U.S.
Kids cool down during a heat wave in
Atlanta's Centennial Olympic Park.
Scientists say average temperatures in
Georgia could rise as much as 9°F (5°C)
over the next century.

Pages 90-91
2003 I GEORGE STEINMETZ
Dasht-e Lut, Iran
Appearing small in juxtaposition with
the sweeping sand dunes, a champion
paraglider soars over the Lut Desert.

Pages 94-95
2004 I TOMASZ TOMASZEWSKI
Moldavia, Romania
Minutes from the highway but centuries
from modern Europe, a farmer leads his
cow past a rustic hay wagon and his dog.

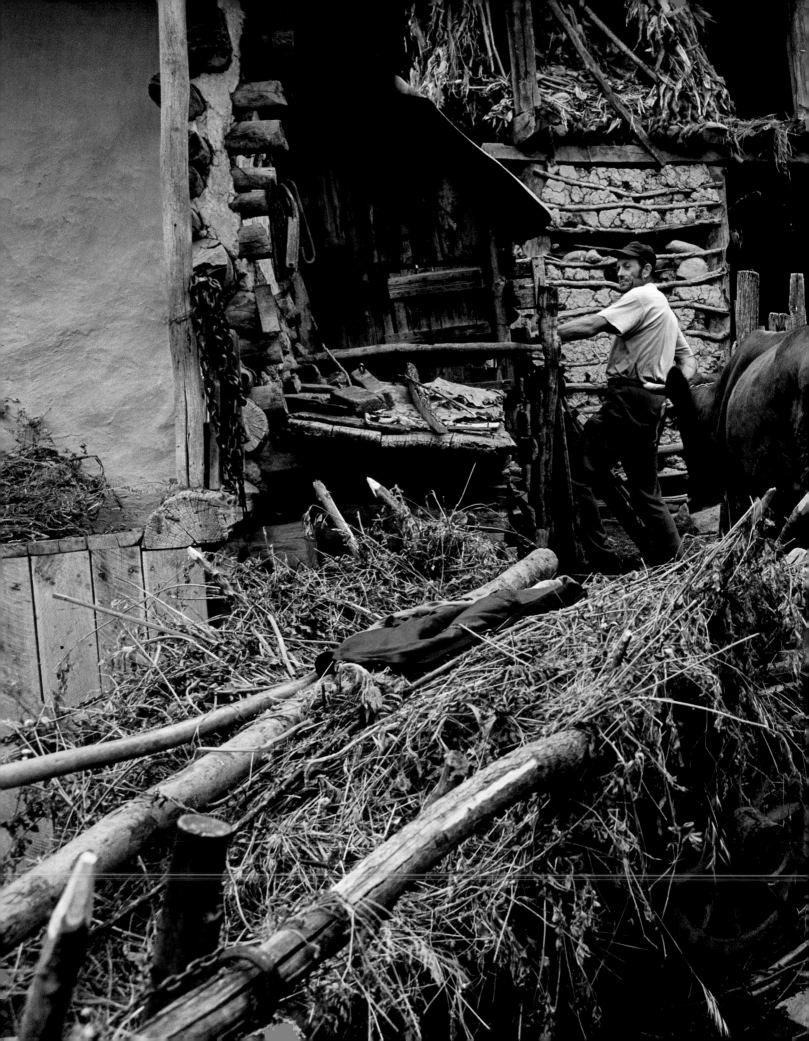

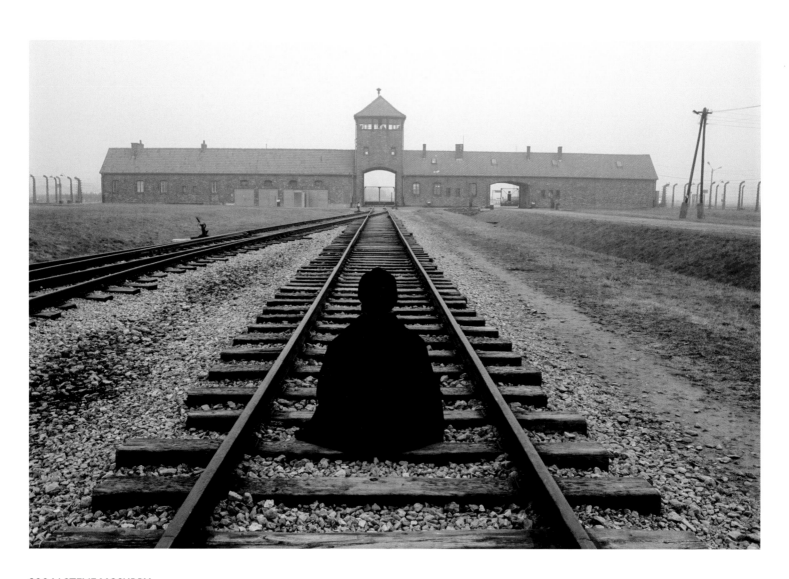

2004 | STEVE MCCURRY
Oświęcim, Poland
Bearing witness to the Holocaust,
Grover Gauntt meditates during an annual
Buddhist-led retreat to the Auschwitz-
Birkenau death camp, where more than a
million people, mostly Jews, were killed.

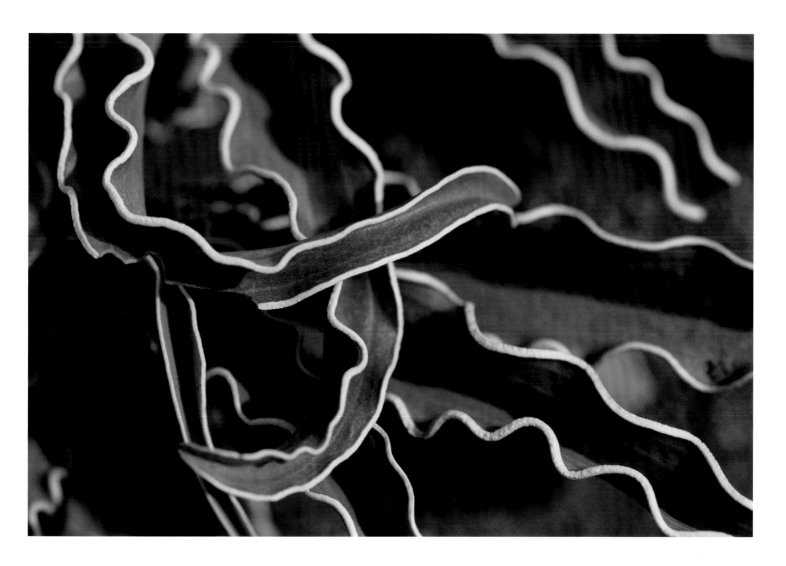

2004 I CARY WOLINSKY
Moab, Utah, U.S.
The curly leaves of a desert elkweed
crisscross, appearing as artwork against
barren red sand.

2004 I TOMASZ TOMASZEWSKI
Moldavia, Romania
Passions stir during a festival for the
patron saint of Vladnic village as a
young couple embraces in front of a
lace-curtained doorway.

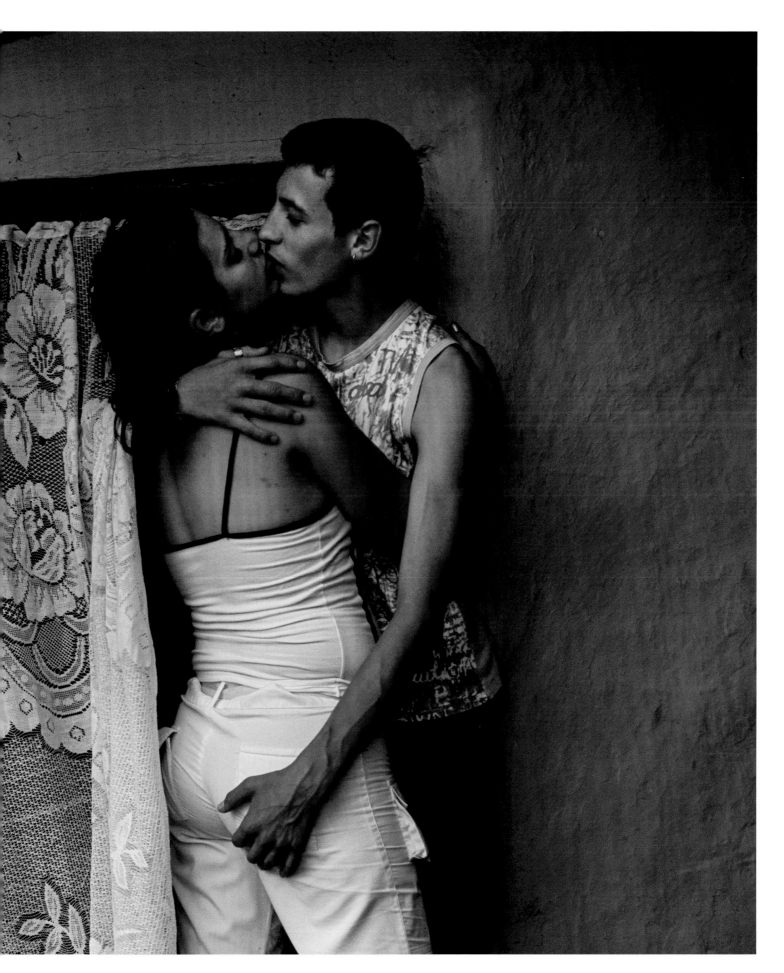

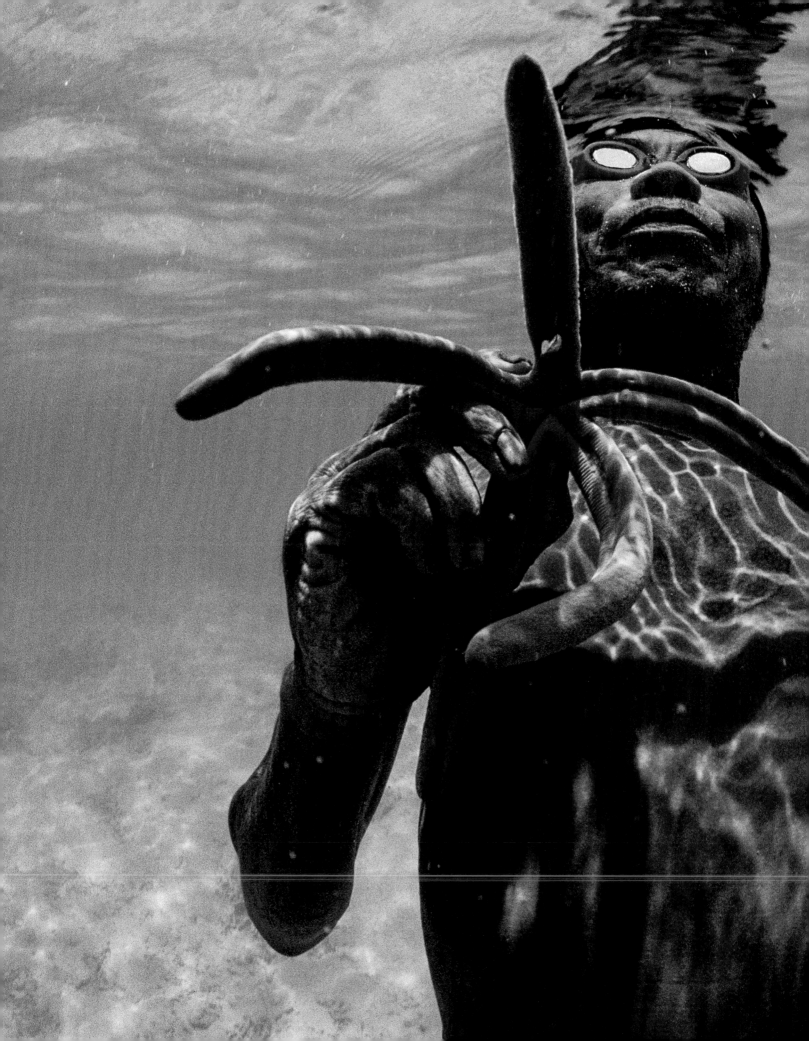

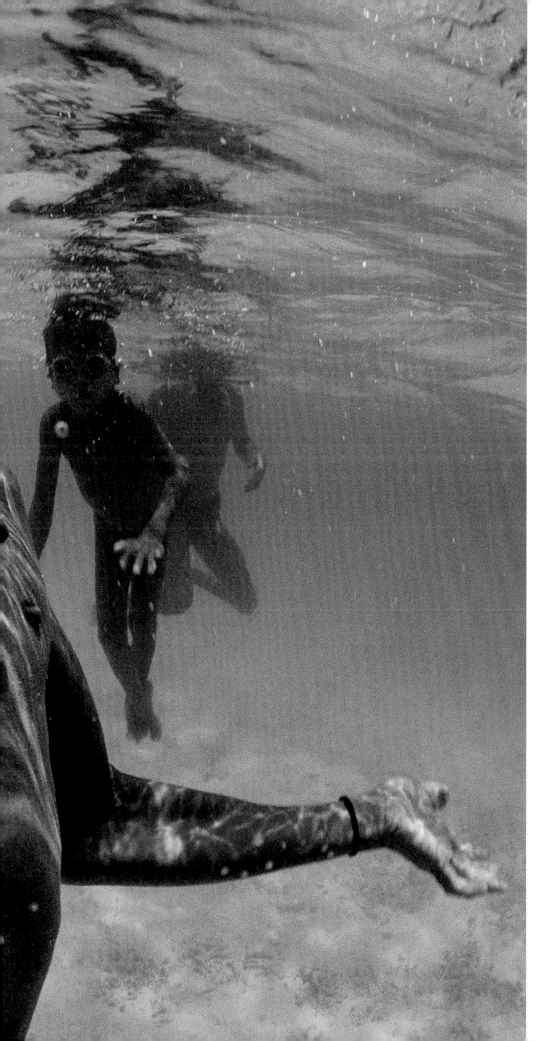

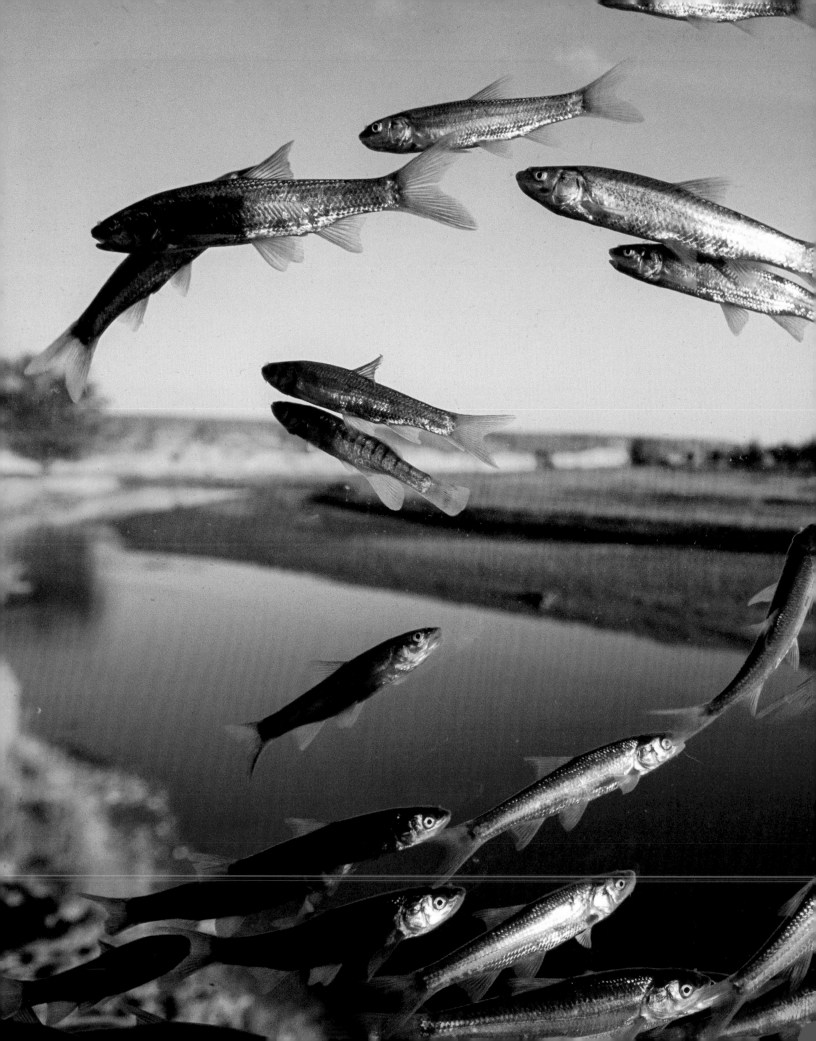

Opposite
2004 I JOEL SARTORE
Buffalo, Wyoming, U.S.
Minnows in an aquarium appear to fly over Wyoming's Powder River just outside their glass-enclosed home.

Pages 106-107
2005 I MARK THIESSEN
Bonneville Salt Flats, Utah, U.S.
Nobel laureate Richard Smalley (1943–2005) poses before a model of the buckyball molecule he discovered, which spurred his interest in carbon nanotubes, the most efficient electrical conductors ever made.

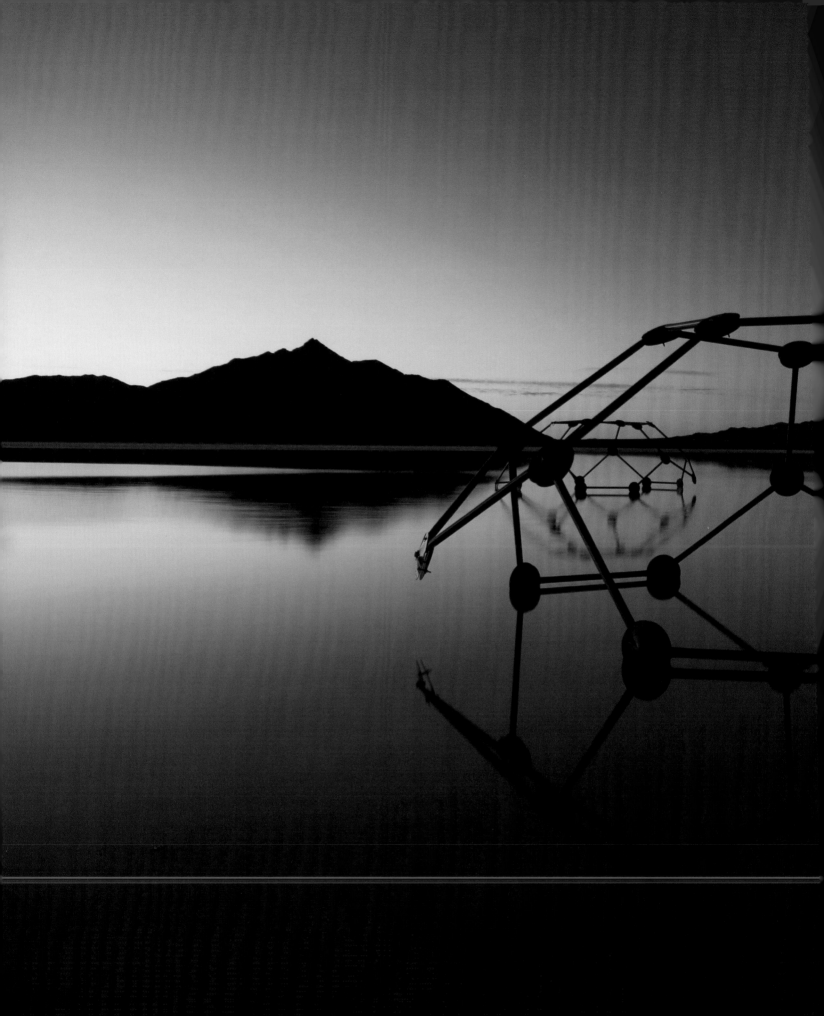

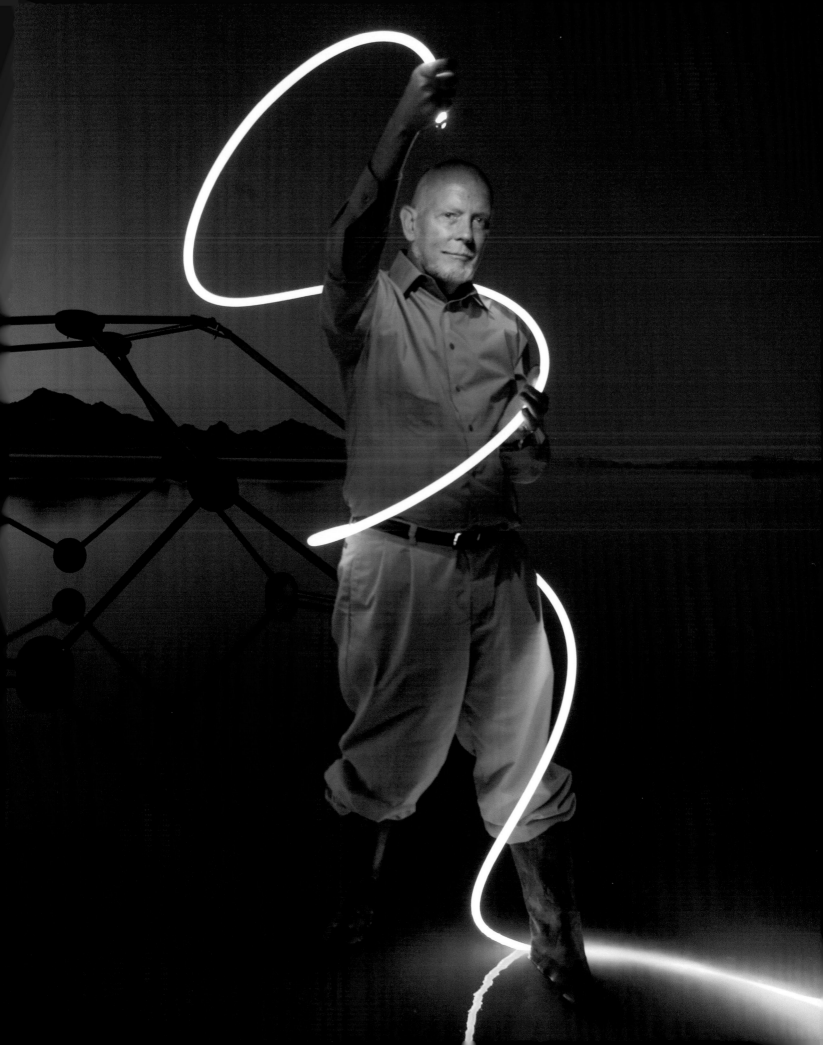

GEORGE STEINMETZ

As part of an assignment crossing the world's largest sand sea—one bigger than France, Belgium, and Holland combined—I visited Shibam, Yemen, an ancient fortified city of mud towers and a UNESCO World Heritage site.

The tallest building in the city is maybe eight stories high, and all the buildings are made entirely of mud and local palm wood. When you walk on the floor of these buildings, it's like walking on the surface of a drum.

Using my motorized paraglider, I flew over Shibam, attempting to get an elevated view of the whole city and a look down onto the city streets. In 2004 there were no drones. I was using film. When you worked with film, you didn't know if you got the shot until you got home, so I buzzed above the city multiple times trying to get the picture.

What I captured was a hidden world, never seen this way even by the people living within the city's walls. You can see the rooftops, maintained with a plaster made of limestone and used for drying laundry or sleeping on hot nights—or for protecting the city when needed. You can see that some of the houses were decaying, appearing almost to be melting back into the earth. And in the center is the mosque—the widest building in all of Shibam. There are hardly any cars within the narrow labyrinth that was intentionally made to better defend the city.

From above, the buildings look almost like high-end luxury resorts, but it's really the resorts that are imitating medieval wisdom. ∎

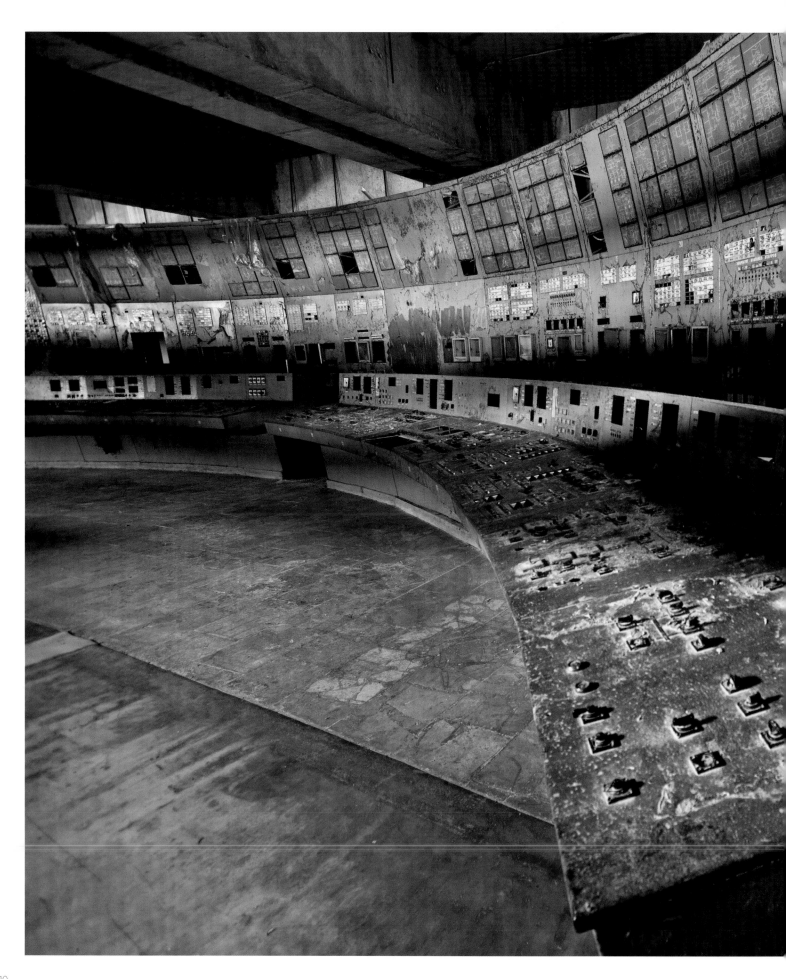

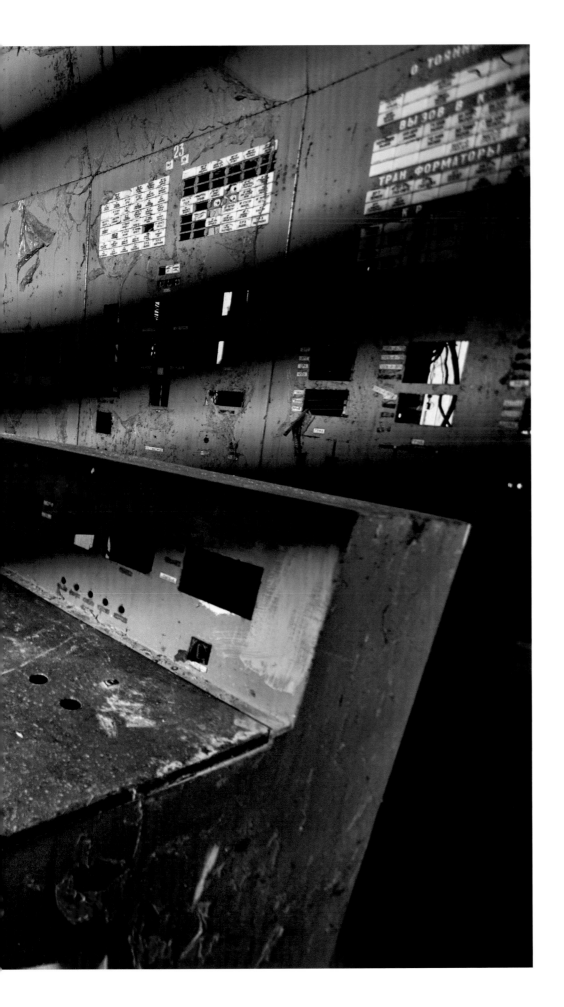

Opposite

2005 I GERD LUDWIG

Chernobyl, Ukraine

In 1986, operators committed a fatal series of errors in the control room of reactor number four, seen here 20 years after the explosion at Chernobyl.

Page 112

2005 I BRIAN LANKER

San Francisco, California, U.S.

Modern, Cuban, and African dance styles interweave in "A Piece of White Cloth," as performed by Patricia West Sotelo of the Alayo Dance Company.

Page 113

2005 I MICHAEL NICHOLS

Grand Canyon National Park, Arizona, U.S.

During the winter, only a small trickle of water spills through the Silver Grotto, a natural amphitheater that has been carved by floodwaters.

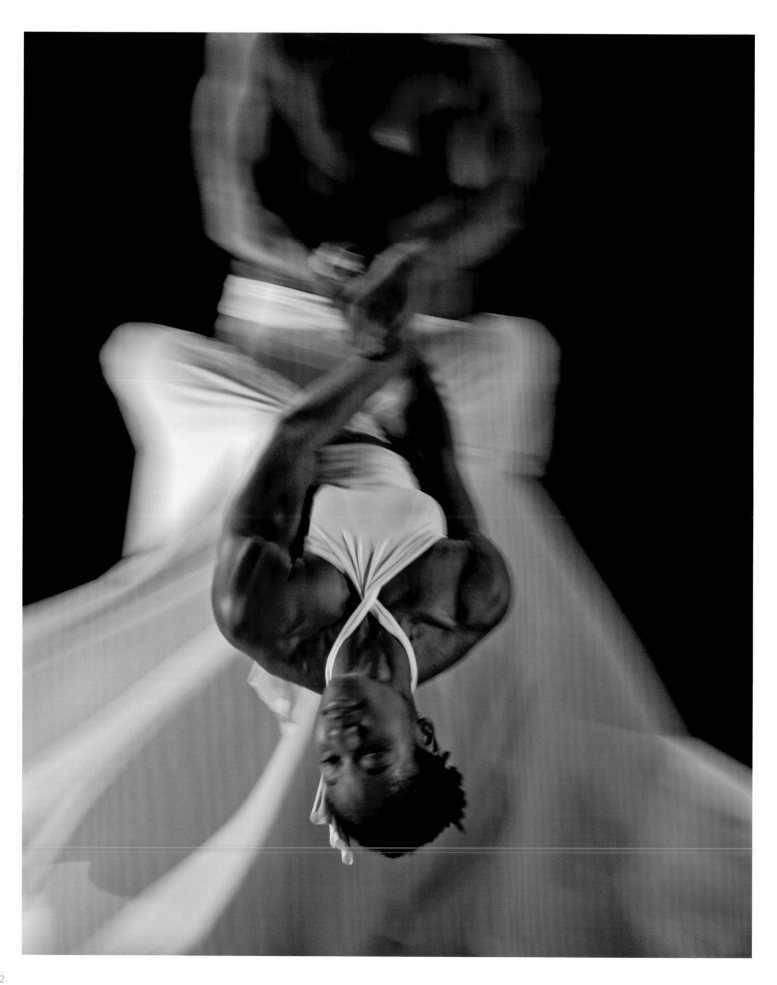

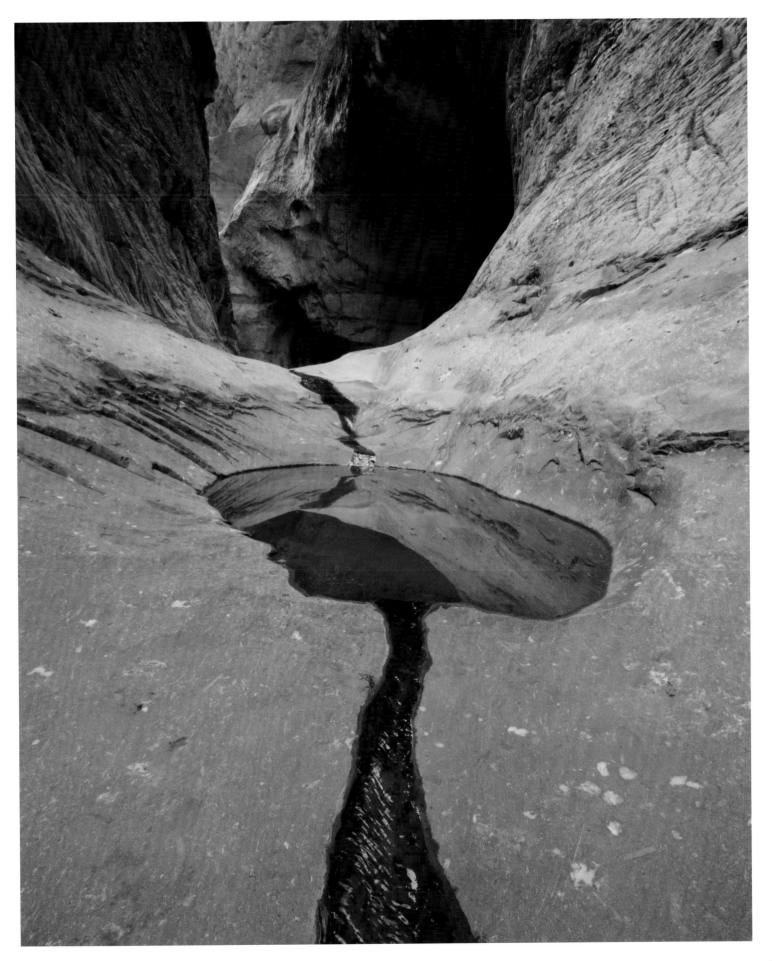

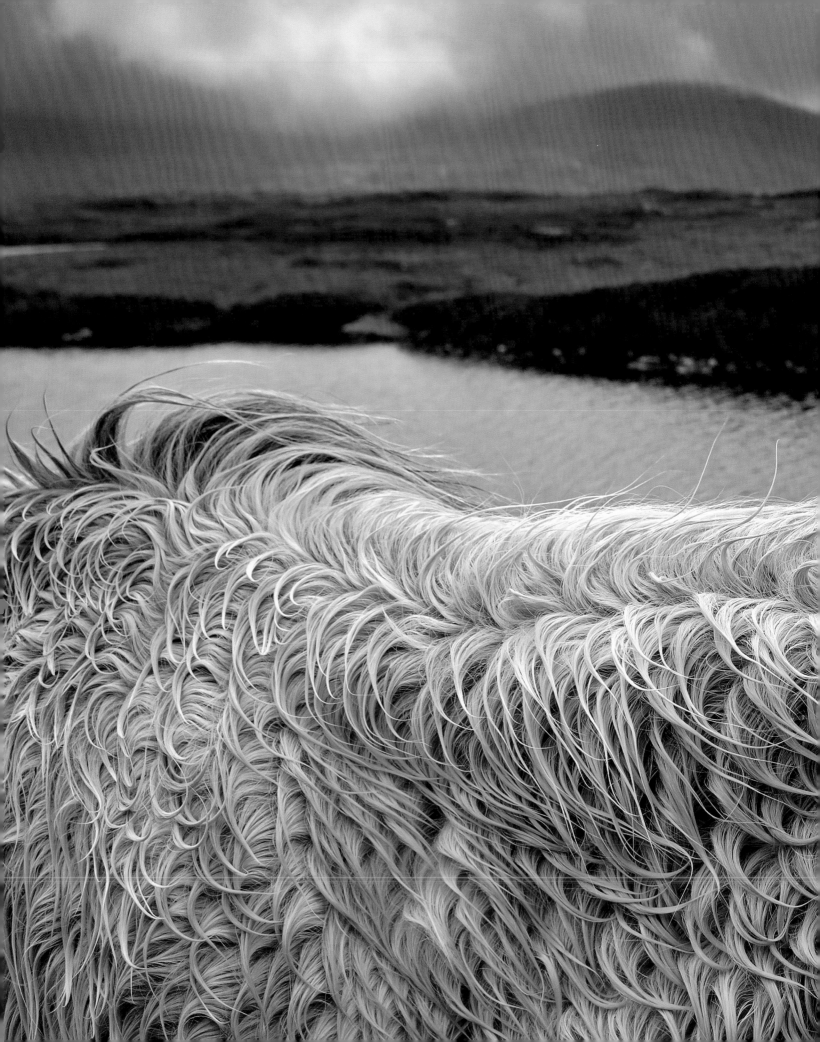

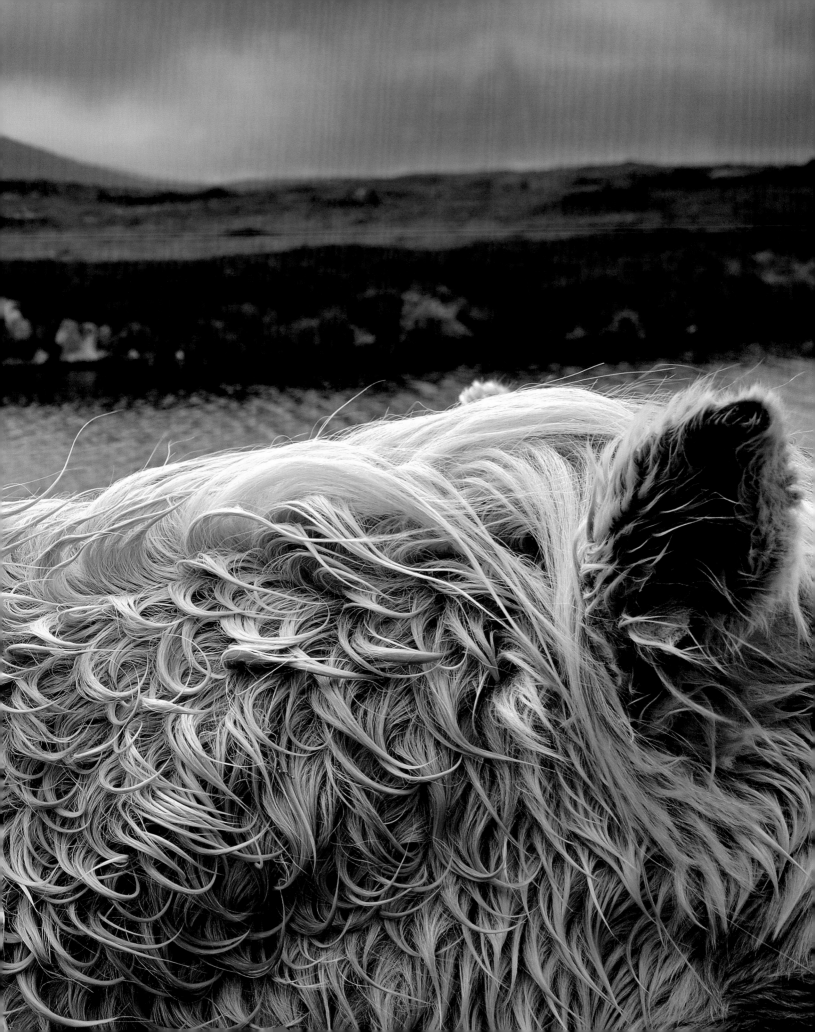

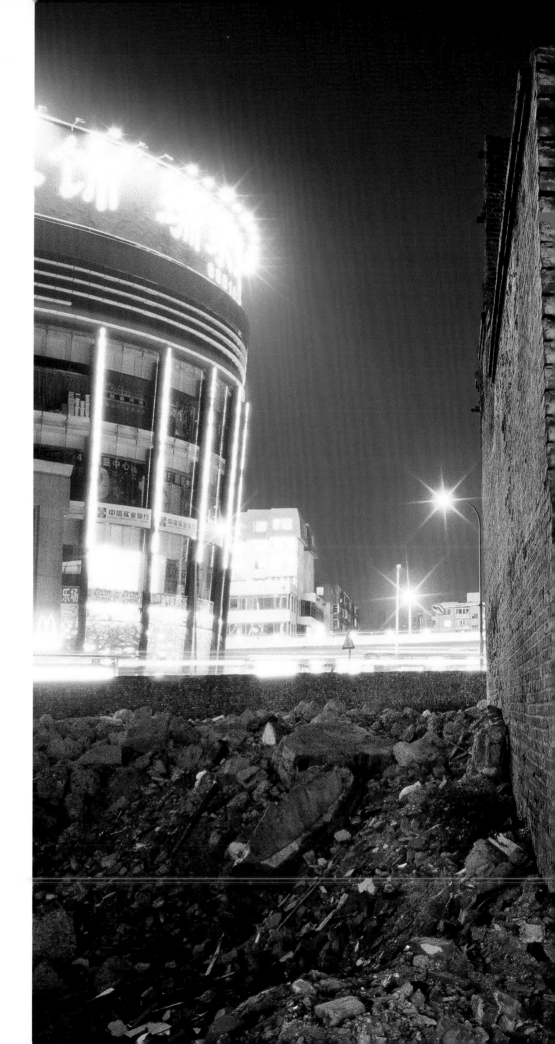

Opposite
2005 I FRITZ HOFFMANN
Manchuria, China
Besieged by the glare of new stores, a man stands sentinel at the last house on a plot in central Dalian, protesting the government's refusal to compensate the neighborhood's replacement fairly.

Pages 114-115
2005 I JIM RICHARDSON
South Uist, Scotland
The tangled coat of a Shetland pony stands up to the wind on the Scottish island, a harsh area of mostly rock and bog.

Pages 118-119
2005 I MARK THIESSEN
Dallas, Texas, U.S.
Demonstrating their strength, carbon nanotubes stretched between copper wires support a ladybug—more than a million times the nanotubes' own weight.

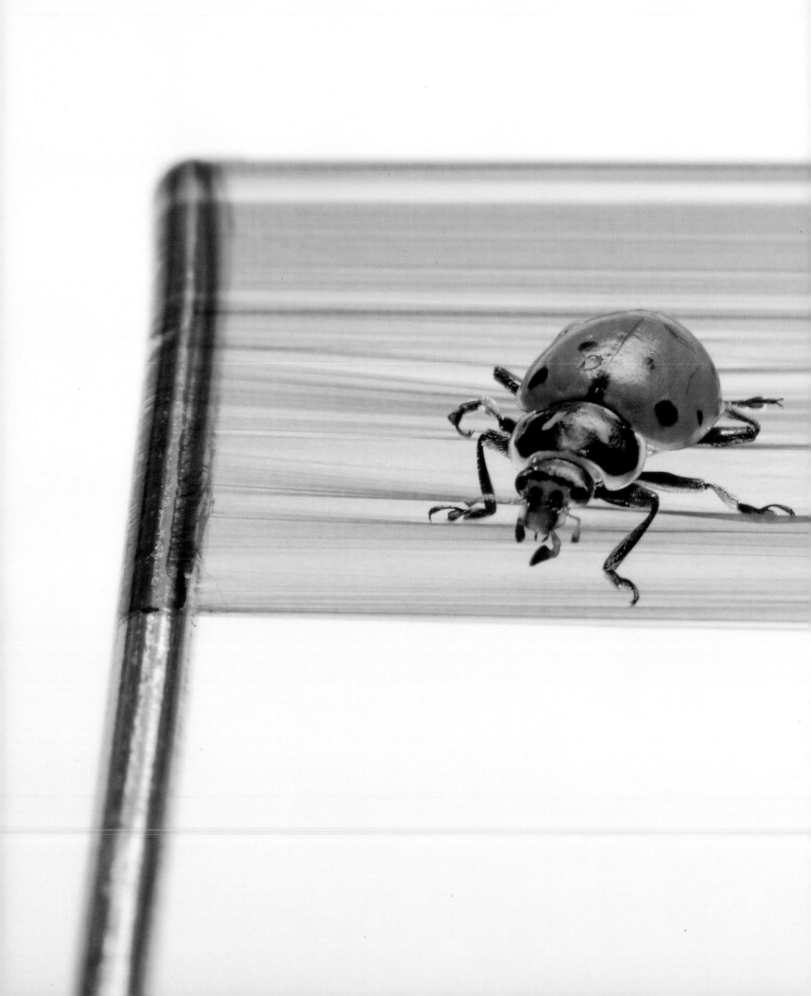

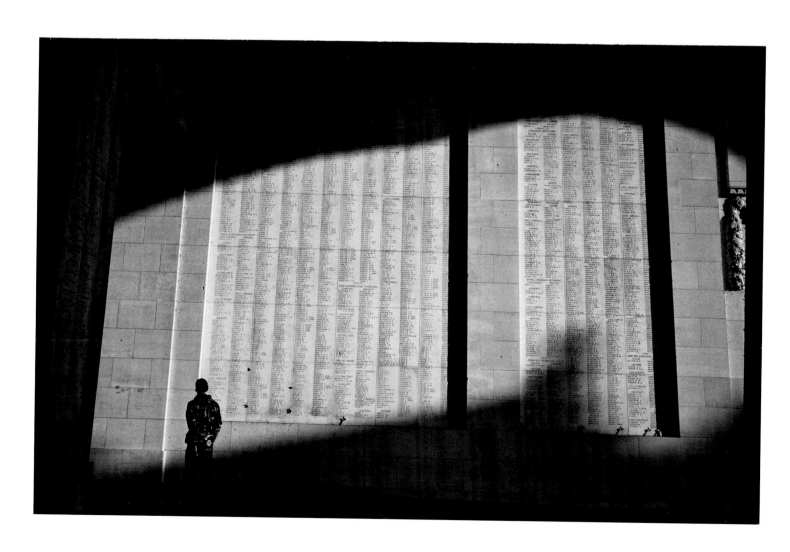

2005 I MAGGIE STEBER
Ypres, Belgium
An air force cadet from the Royal Netherlands
Military Academy reads some of the names
carved on the Menin Gate, honoring 54,896
of those killed and missing in World War I.

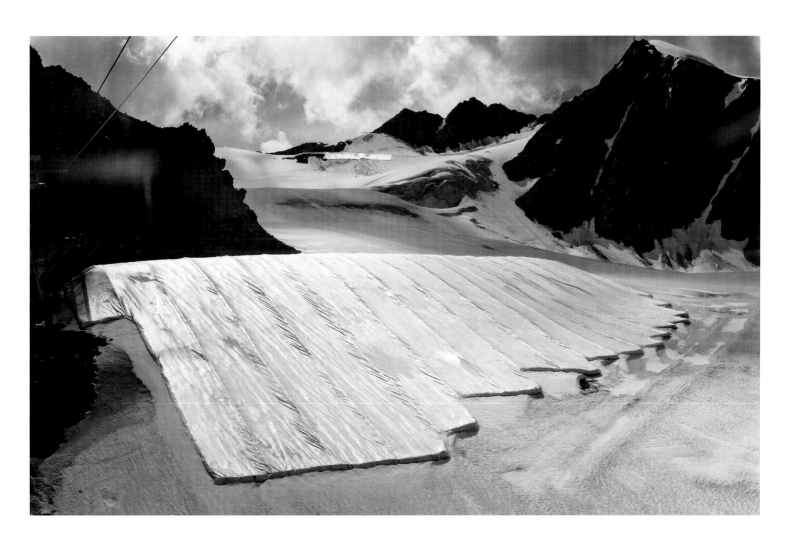

2005 I MELISSA FARLOW
Tyrol, Austria
Draping a ski slope on Austria's Pitztal Glacier, synthetic blankets reflect solar radiation to slow summer melting. If current warming trends continue, the remaining glacier could vanish by 2100.

AI LOV YOU

SEI UNICA,
STRAORDINARIA
E FANTASTICA!

Lo so che non fa n...
torni che ve...
prime pagi...

IL MINISTERO
DELLA SANITA
CONFERMA I
RISULTATI
DELL'ESAME
CARDIOLOGICO
...po le indagini della
...missione Scientifi...
...Ministero della San...
...ha confermato
...ufficialmente che il
...cuore batte solo pe...

2005 I JODI COBB
Florence, Italy
A lone woman at a café reads a greeting card disguised as a newspaper. A phonetic rendering of "I love you" is the headline, proclaiming the sender's devotion.

CHAPTER TWO

2006

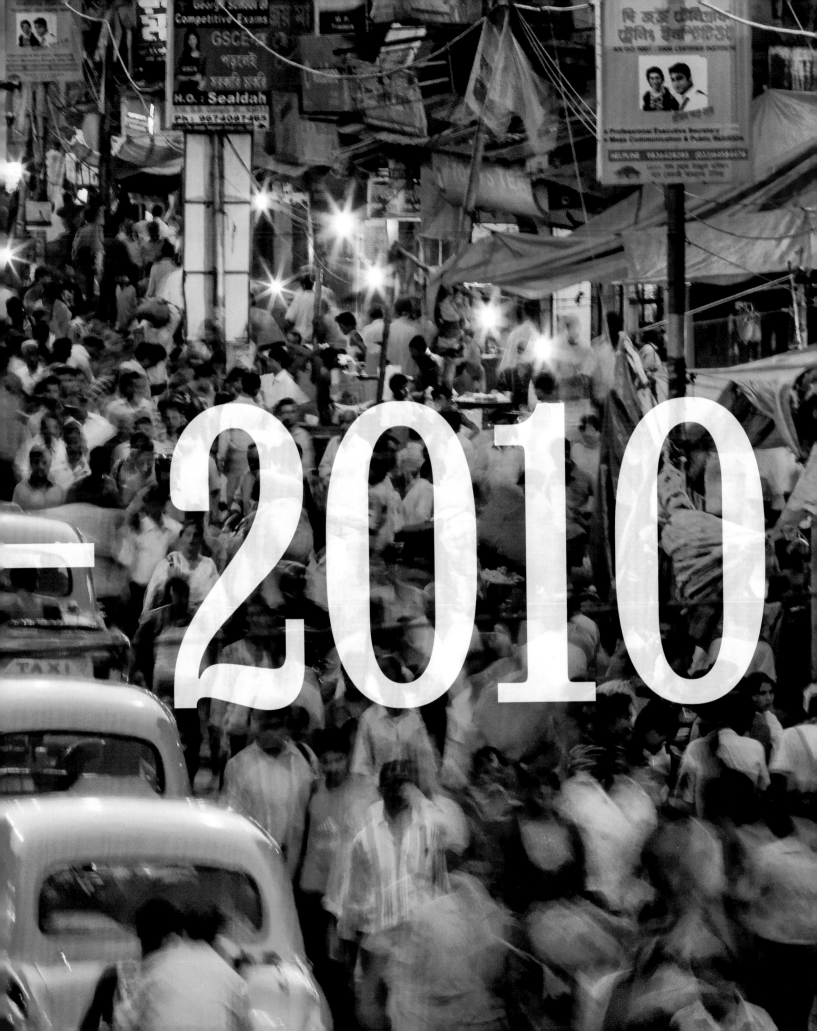

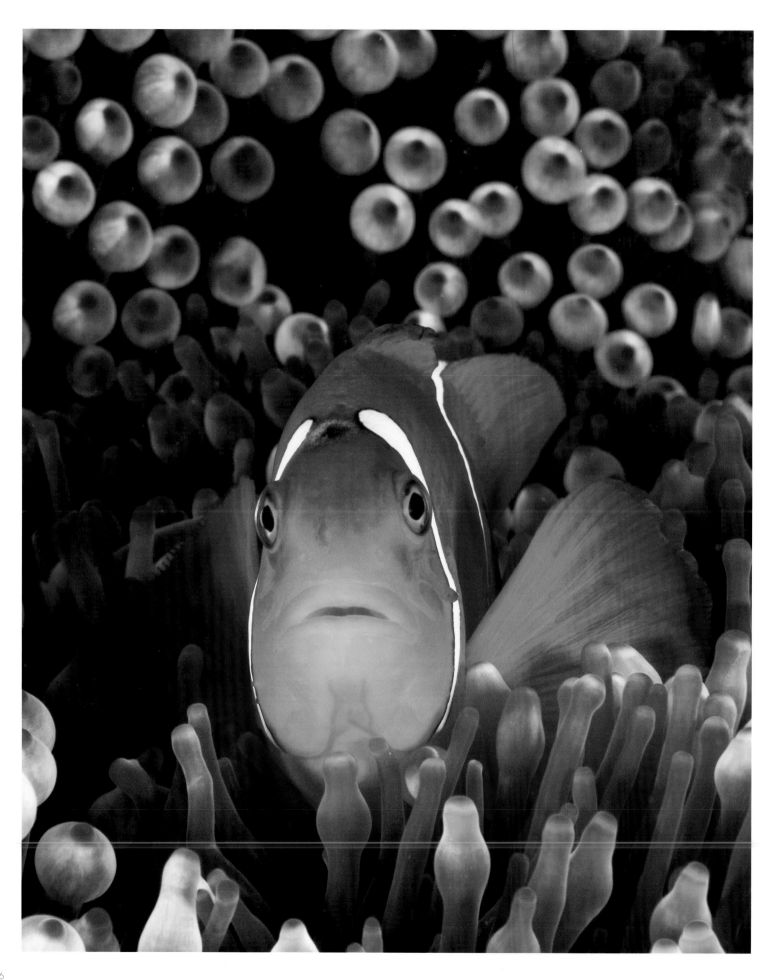

NATURE LOOKED in on us and reminded us of

her power and vulnerability in these years. We dove deeper, repeating old habits and learning new ways. We took greater care to discern the intricacies of creatures who inhabit the planet; we took greater measures to care for our own. Ancient practices were fading, along with the art and language that carried them. We yearned for deeper roots. Whatever persisted—plants and animals, history and tradition—increased in heartfelt value.

More than ever, we were coming to recognize the limits of our human view of the world. It was as if we gazed through a veil, as if slant sunlight offered only half the illumination we needed, as if each day was framed by the ruins of the past. The grace of unpeopled moments helped us find our way, in the wise eyes of a chimpanzee, in the steady gaze of a viper, in the golden fronds of autumn, in the hopeful scuttle of a turtle hatchling returning to the sea.

Urgent obligations came more sharply into view as we realized our role in helping the planet survive. Rain and rivers, rocks and mountains—all grew dearer as the lights and noise and hubbub and stuff of the material world crowded in on the landscape. Could we promise that we would not crowd out the least species, that little red-spotted darter that made its home in Appalachian springs? Could we keep the world safe enough for birds of paradise to bow and preen, for elephants to play?

We craved the long view—we feared our own missteps—we slept, we leaped, we braved the fire to save the flag. We pinned our human cocoons on the sheerest cliff and found hope in the ever-present joy of our children. Arms raised, we readied ourselves for the end—or a new beginning. We found leaders to believe in. We worked and watched, we hoped and prayed. ■

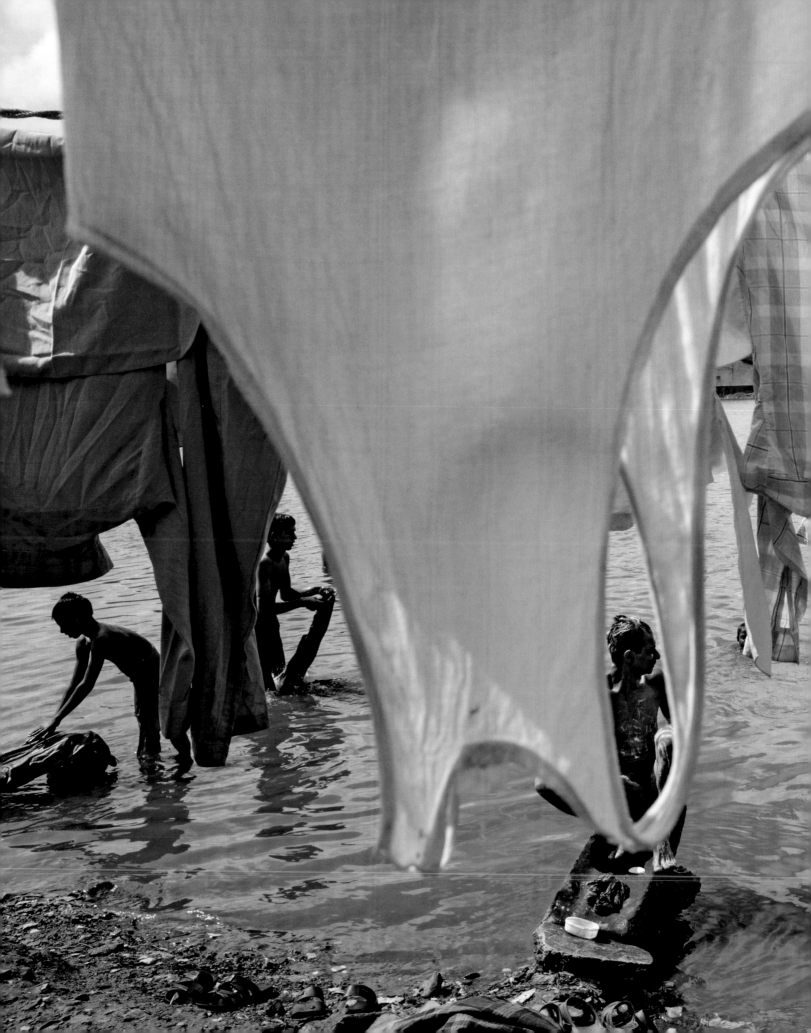

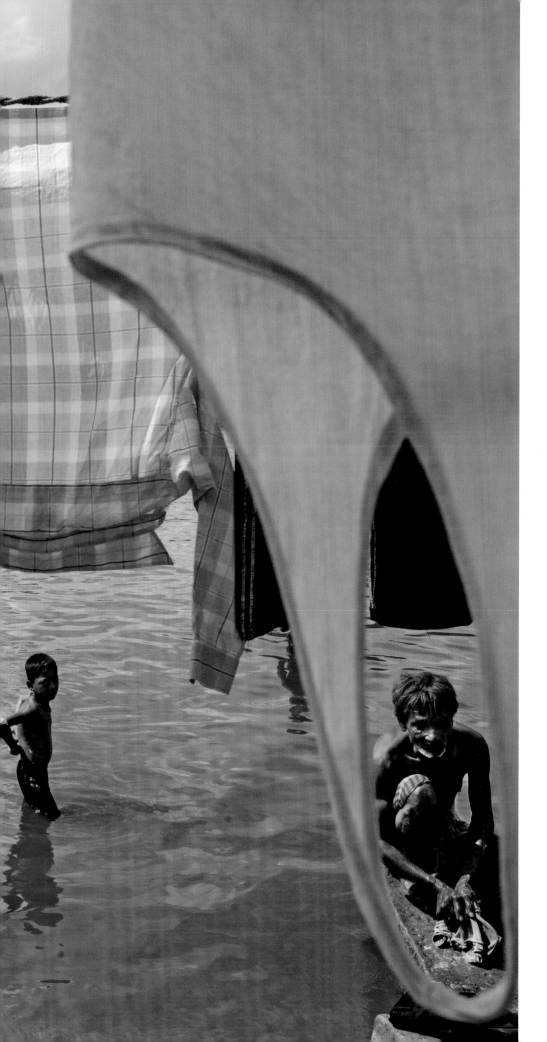

Opposite
2006 I JOHN STANMEYER
Kolkata, India
Launderers do wash for Kolkata businesses in a pond's rocky shallows, one of the many places in the city where malarial mosquitoes breed.

Pages 124-125
2010 I RANDY OLSON
Kolkata, India
As the world hit seven billion in population, Kolkata, India, throbbed with some 16 million residents, reflected in steaming streets crammed with vendors, pedestrians, and taxis.

Page 126
2009 I DAVID DOUBILET
Cairns, Queensland, Australia
An anemonefish, better known as a clownfish, hides in its sea anemone host on Three Sisters Reef.

2006 I DAVID LIITTSCHWAGER
Hawaiian Islands, U.S.
A sunburst in blues, this jellyfish relative, a blue
button, isn't one organism, but many, joined at
a gas-filled hub that keeps the colony afloat. Its
stunning pigment blocks ultraviolet rays.

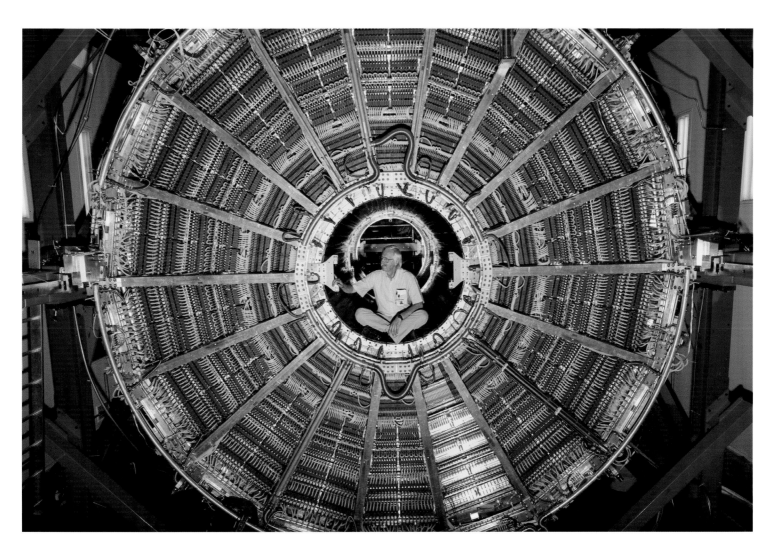

2006 I MARK THIESSEN
Geneva, Switzerland
A complex nest of cables in the Time Projection Chamber—a key element of the ALICE experiment at the Large Hadron Collider—surrounds the tracking device's technical coordinator.

2006 I ALEX WEBB
Amazon River Basin, Brazil
Bikers ride past and linger in front of
a drugstore amid quiet city streets
at dusk.

Opposite
2006 I IAN NICHOLS
Republic of the Congo
An alpha-male chimpanzee gazes from his spot in the trees in the Goualougo Triangle's rainforest, part of Nouabalé-Ndoki National Park.

Pages 136-137
2006 I STEPHEN ALVAREZ
New Britain Island, Papua New Guinea
A spelunker carefully steps across the waterfall where the Ora River gushes from a nearby cave. With few places to pool, New Britain's ceaseless rains drain underground, gathering in powerful rivers.

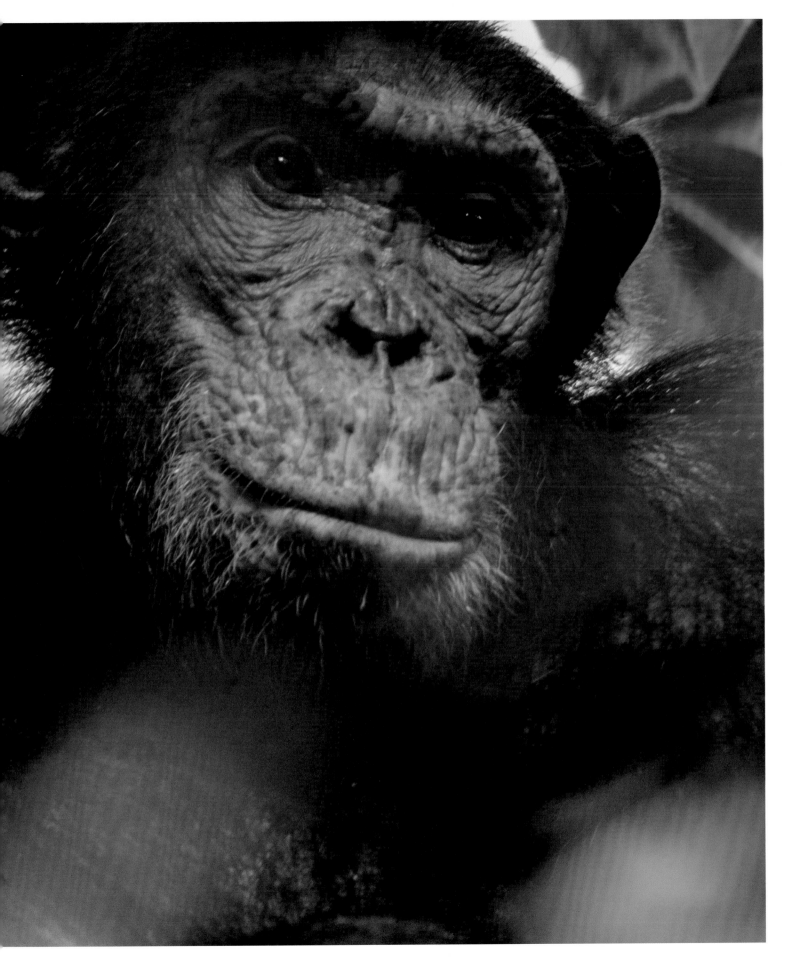

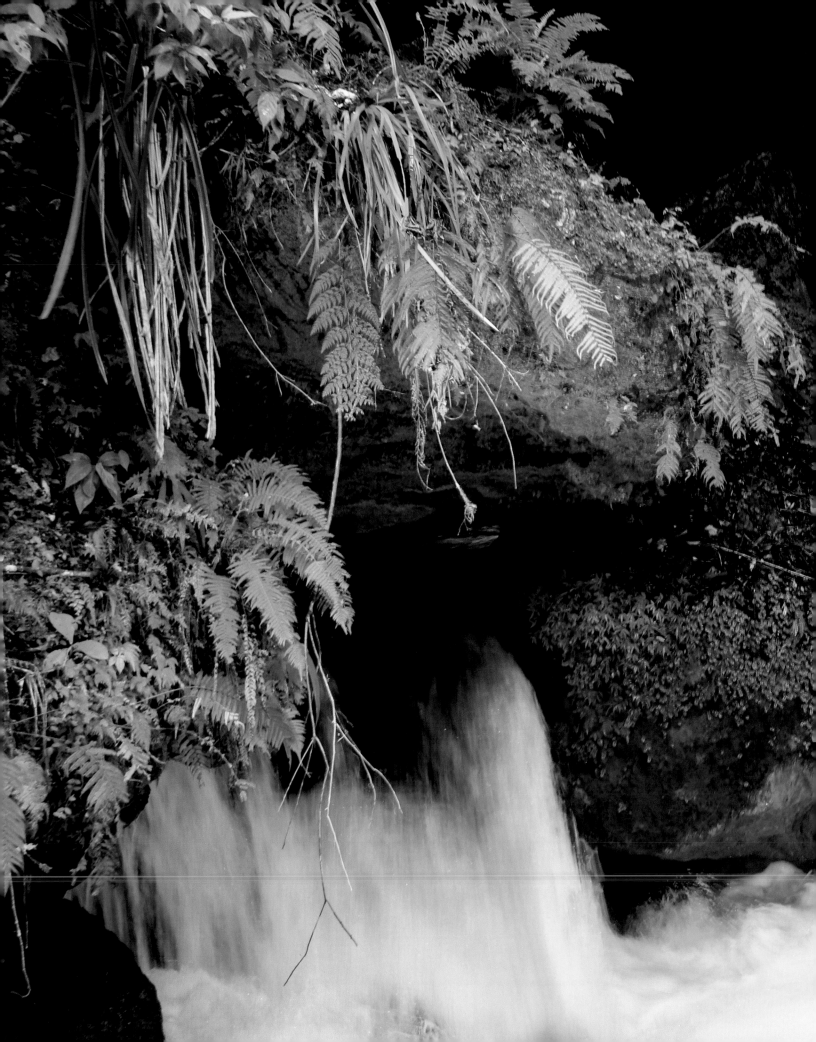

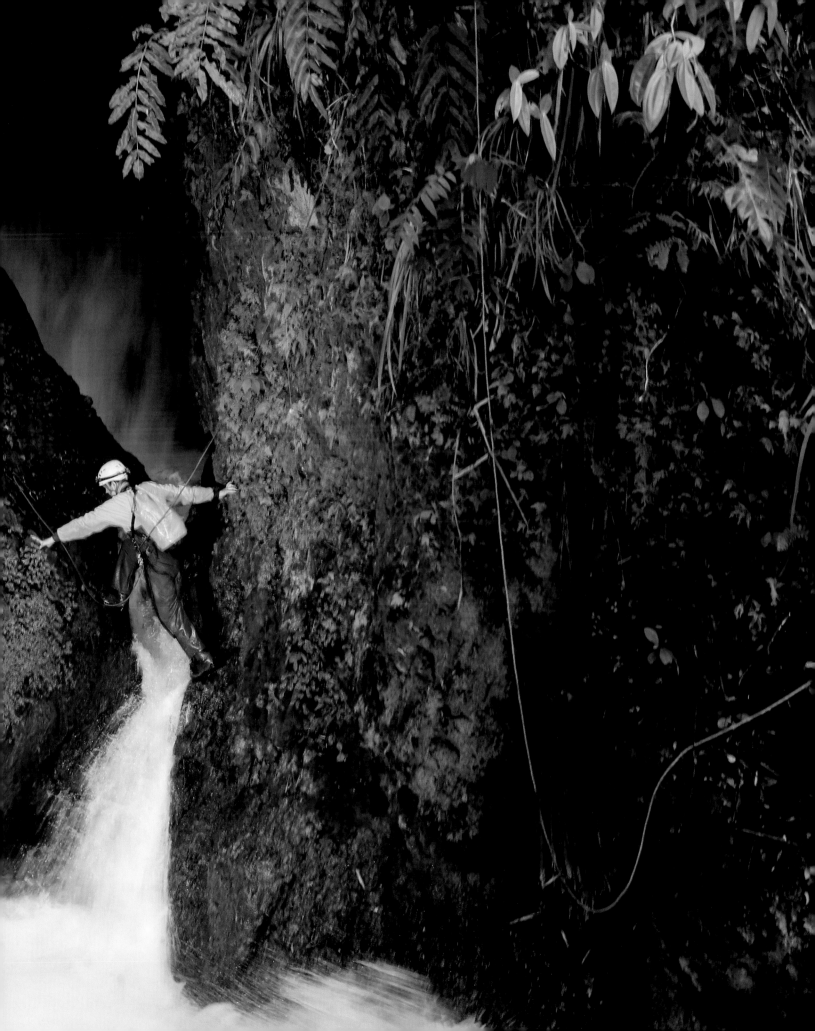

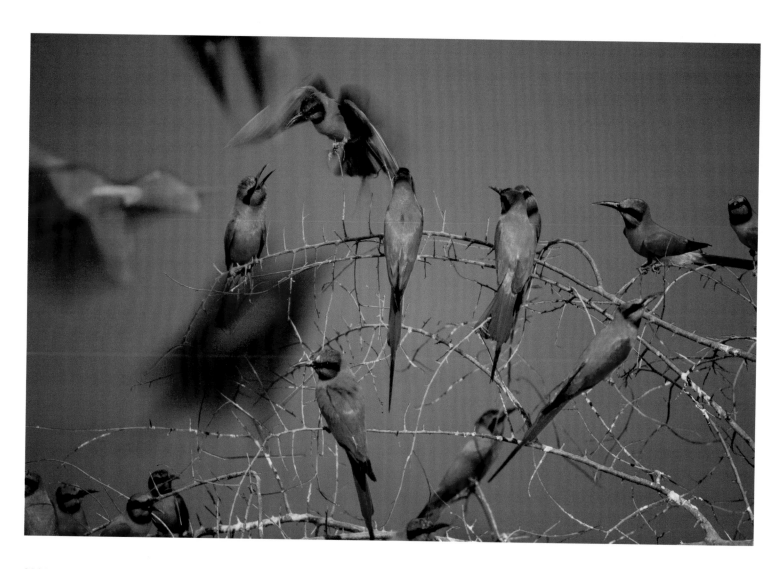

2006 I MICHAEL NICHOLS
Zakouma National Park, Chad
A colony of carmine bee-eaters gather
on thin branches near their nests, which
are holes burrowed into a cliff along the
Tinga River.

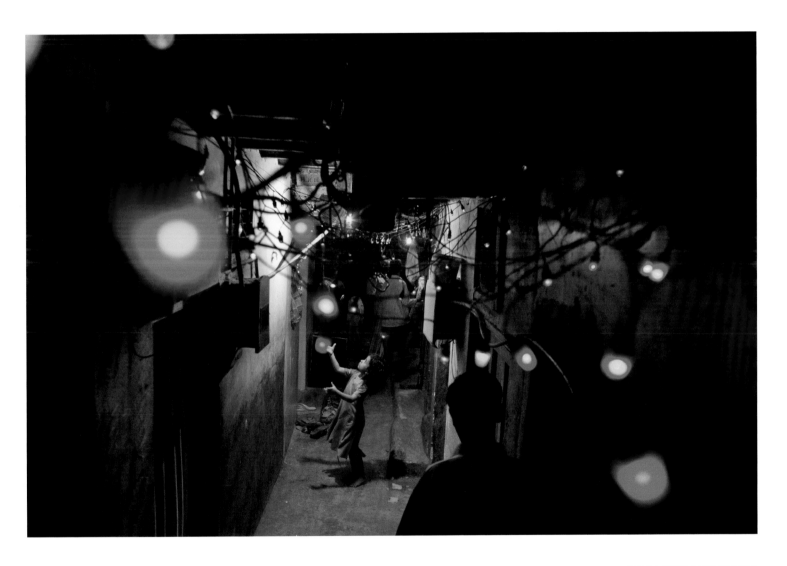

2006 | JONAS BENDIKSEN
Dharavi, India
A barefoot child finds enchantment in a
string of red lights, hung for a wedding in
a Mumbai slum.

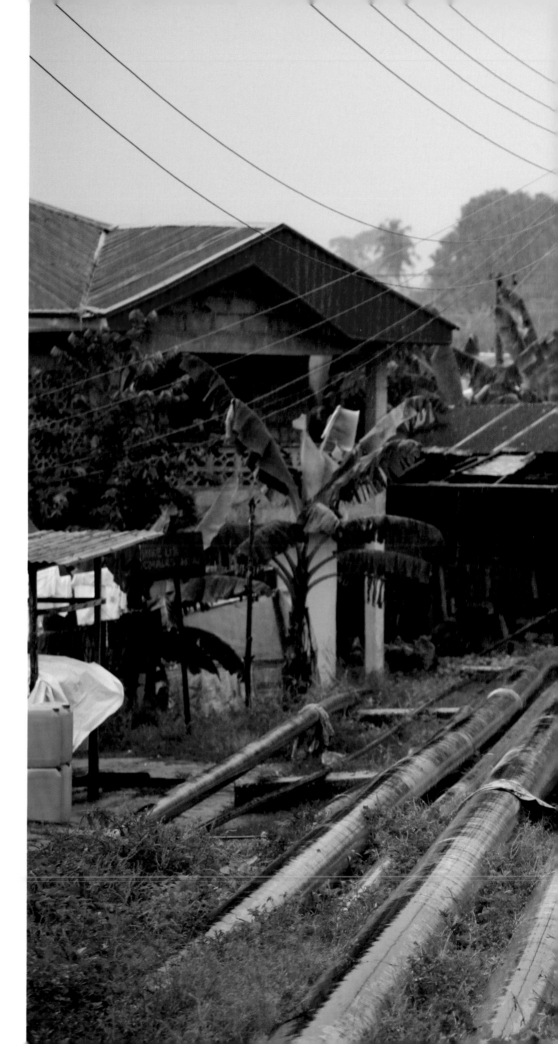

2006 I ED KASHI
Okrika, Nigeria
Oil leaves its mark in Okrika, from a
company umbrella to a trail of pipelines
coiling through the town.

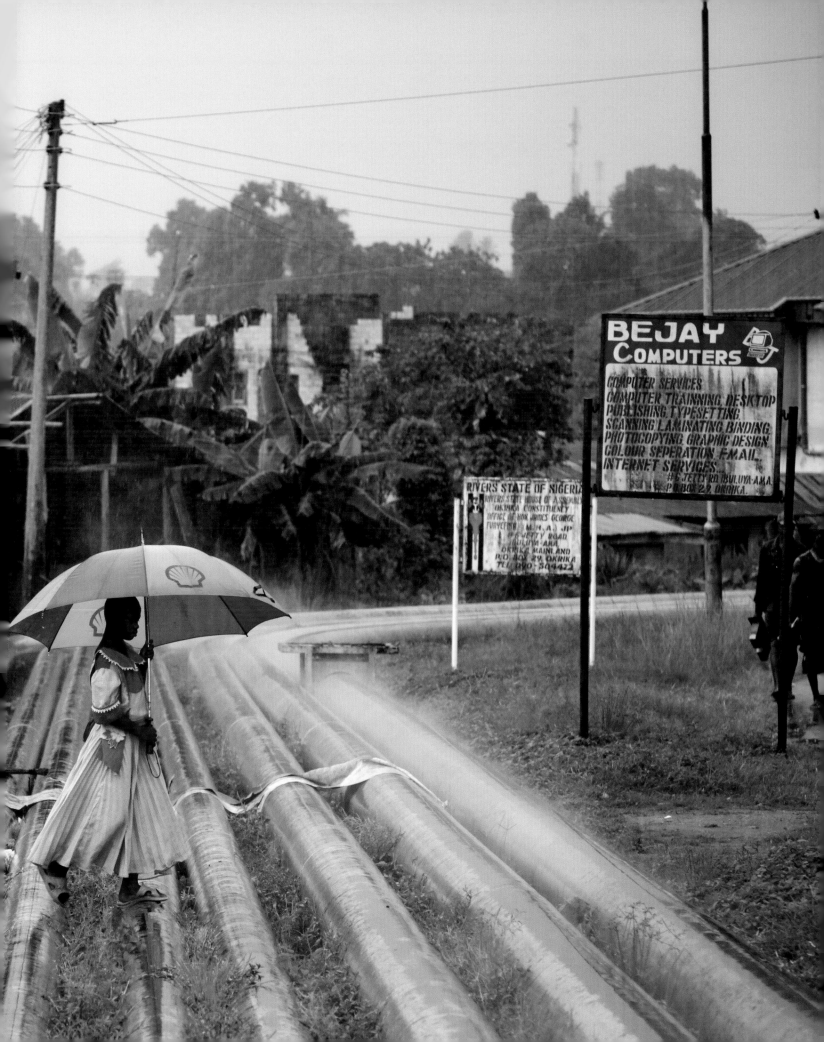

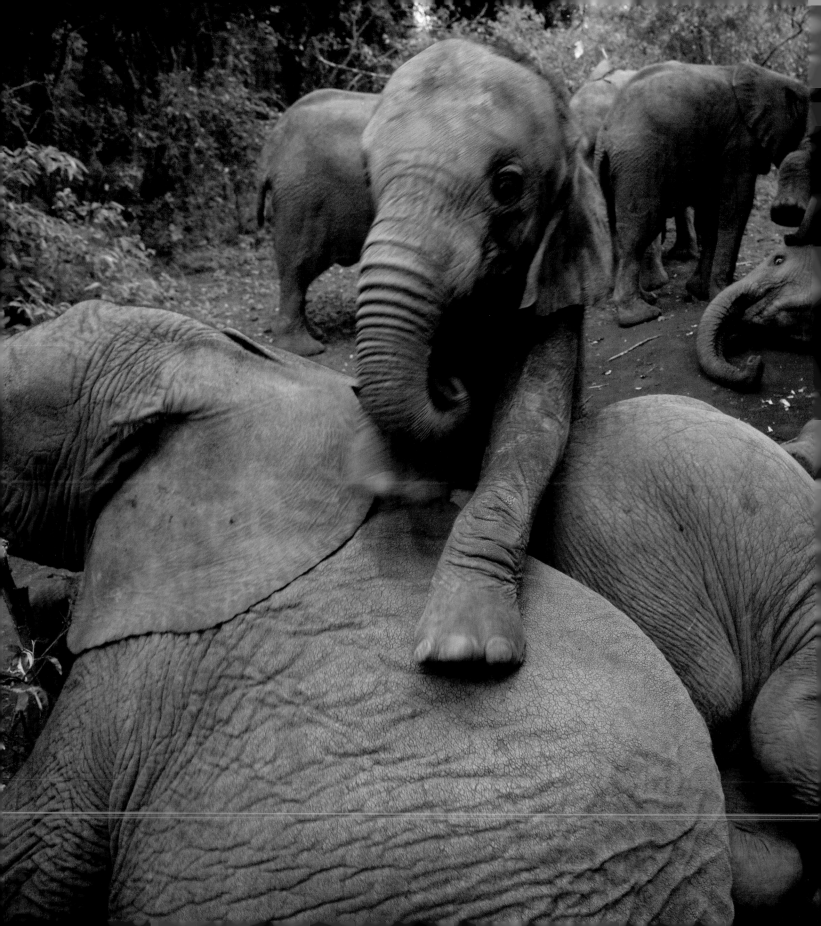

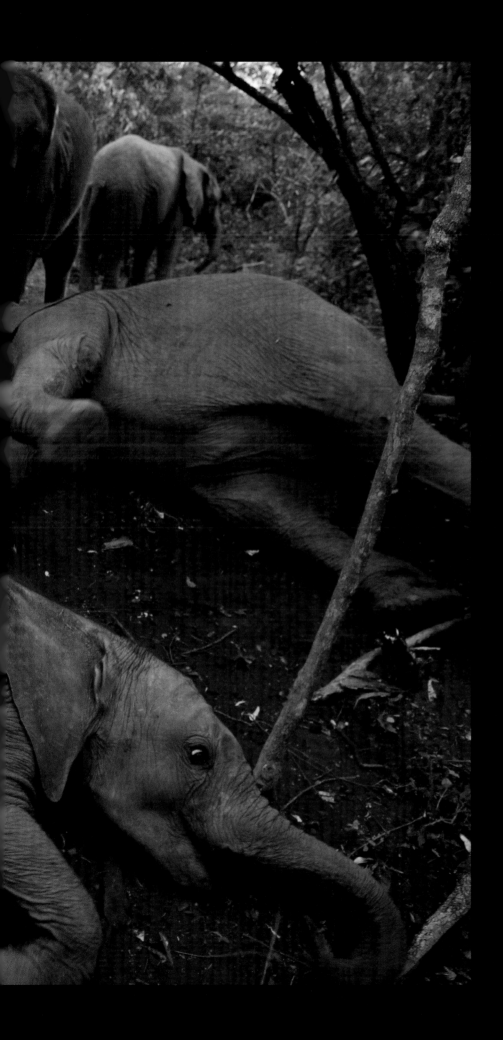

MICHAEL NICHOLS

At the Sheldrick Wildlife Trust's Nairobi Nursery for elephants in Kenya, I felt as if I was among a group of wild elephants and the adult females were caring for the youngsters. Except I was with a group of orphan elephants being stewarded by humans.

The adults were two-to-three-year-old females that in the wild would still be infants, or maybe toddlers. Those toddler elephants are lying down to let the one-year-olds play on them. The innate elephant social structure is so strong they cannot resist it, and the older females become guides.

This is what is most evident among these orphaned elephants: The humans are just what I said—stewards. The elephants do the heavy lifting. The older females make it immediately OK for a rescued orphan by providing reassurance and comfort. The elephants do not crave human attention; they want pachyderm love.

In fact, as I took this picture, it was as if I was not there, which is what I prefer. ∎

Opposite
2006 I MARK LEONG
Yiwu, China
A wholesaler takes a nap at his stall of artificial flowers at International Trade City, where prices impact retail around the world.

Pages 146-147
2007 I MICHAEL YAMASHITA
Sichuan Province, China
In an ancient Tibetan love story, a god gave a mirror polished by clouds and wind to a goddess, who dropped it. The shards created Jiuzhaigou Nature Reserve's 118 lakes, one of which—the Five-Colored Lake—is shrouded in mist at dawn.

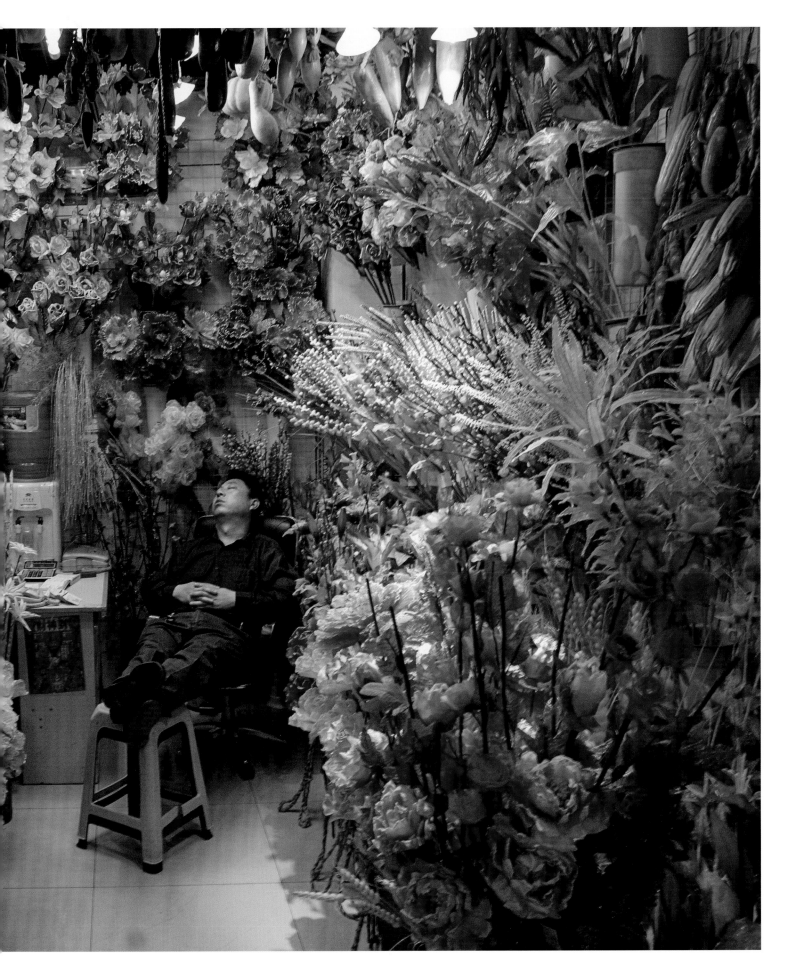

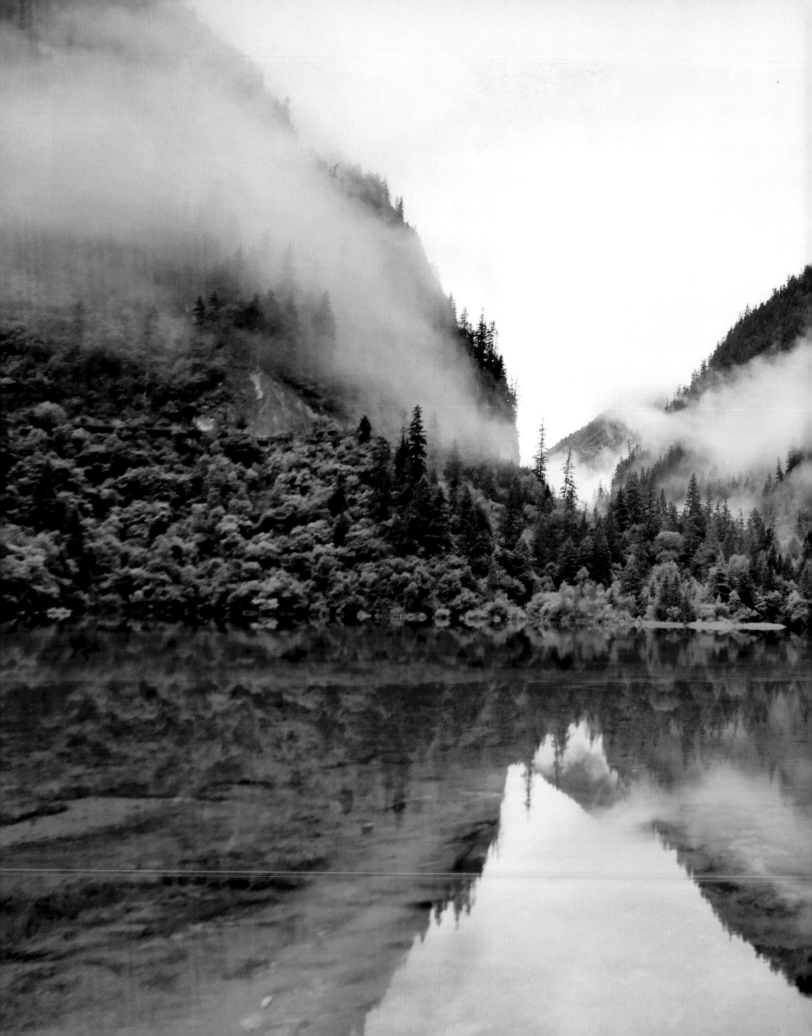

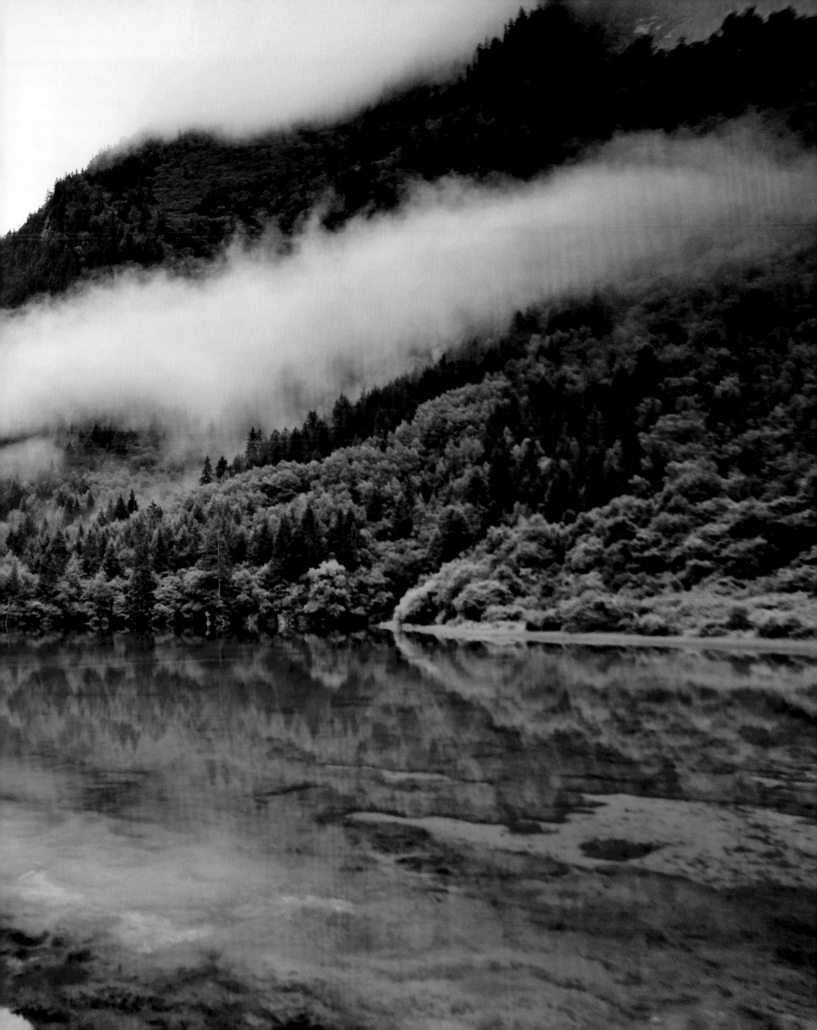

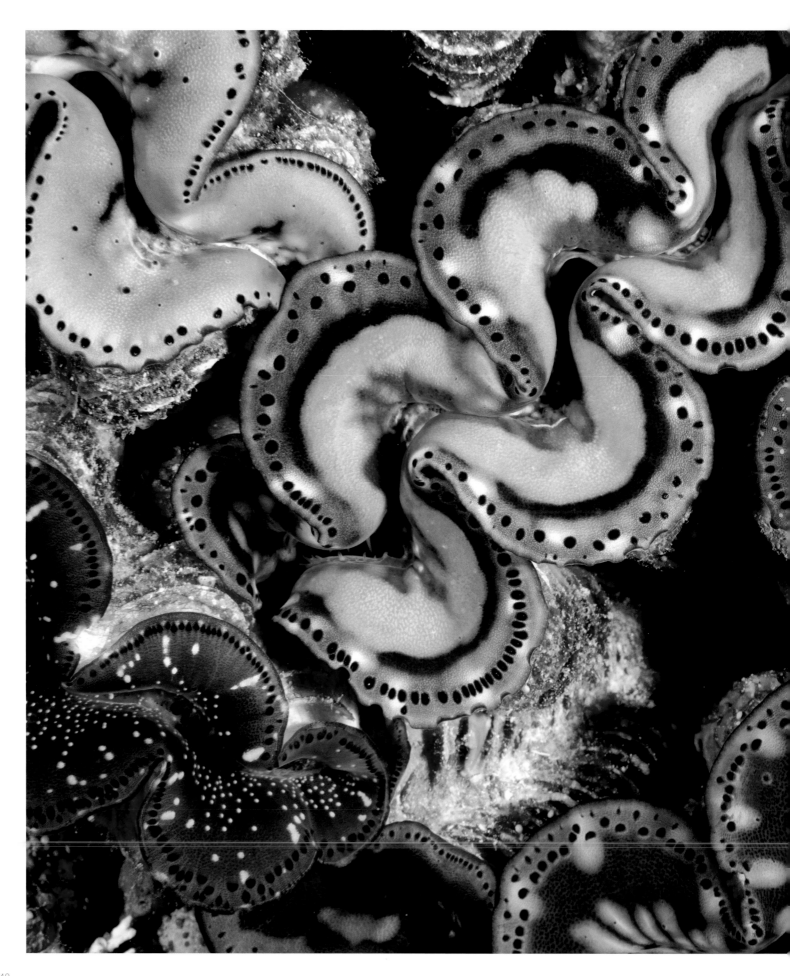

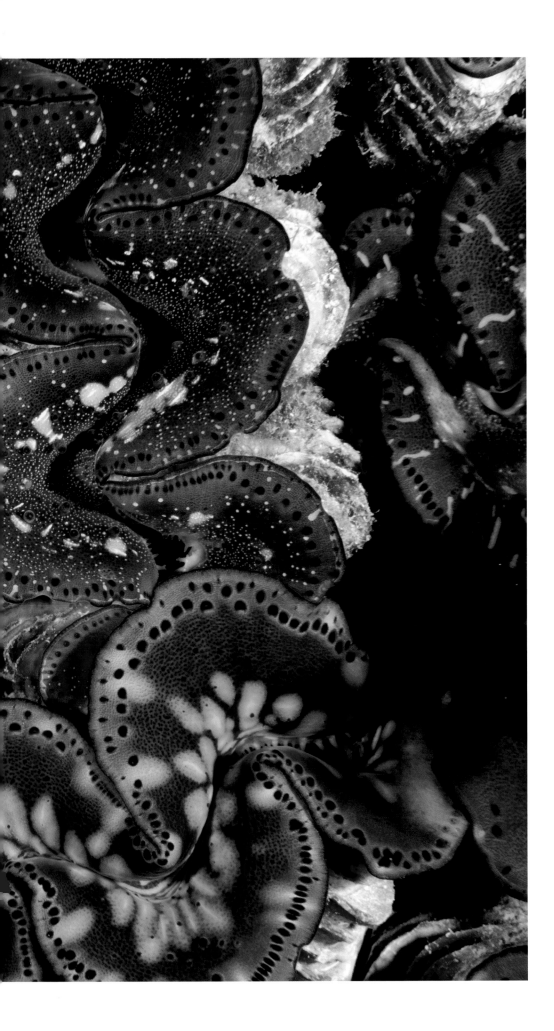

2007 | BRIAN SKERRY
Kingman Reef, Pacific Ocean
Mantles of giant clams—the largest mollusks on Earth, reaching up to four feet (1.3 m) in length and weighing up to 500 pounds (226.8 kg)—rest on Kingman Reef.

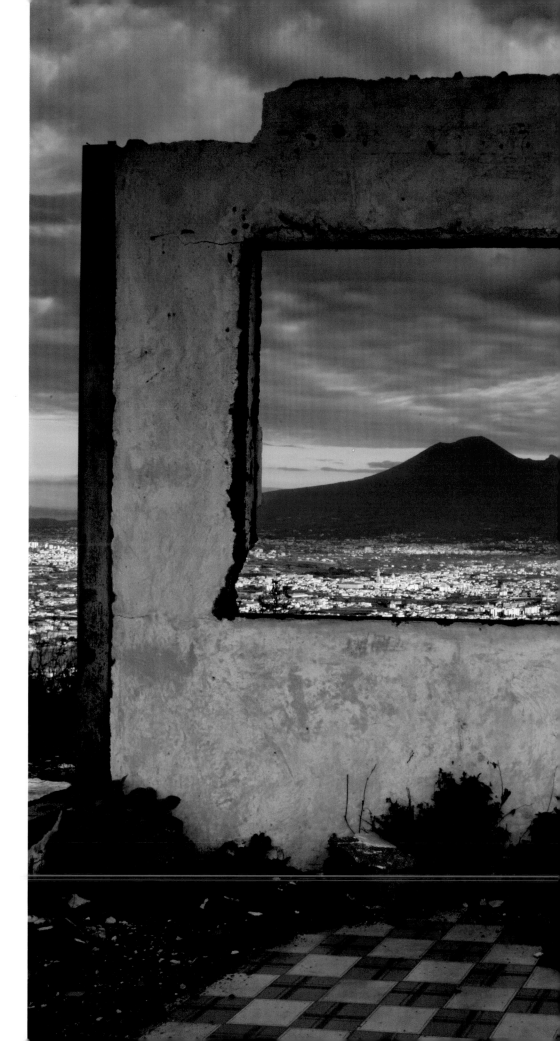

2007 I ROBERT CLARK
Lettere, Italy
The ruins of an abandoned restaurant offer a view of the future for the towns closest to Mount Vesuvius.

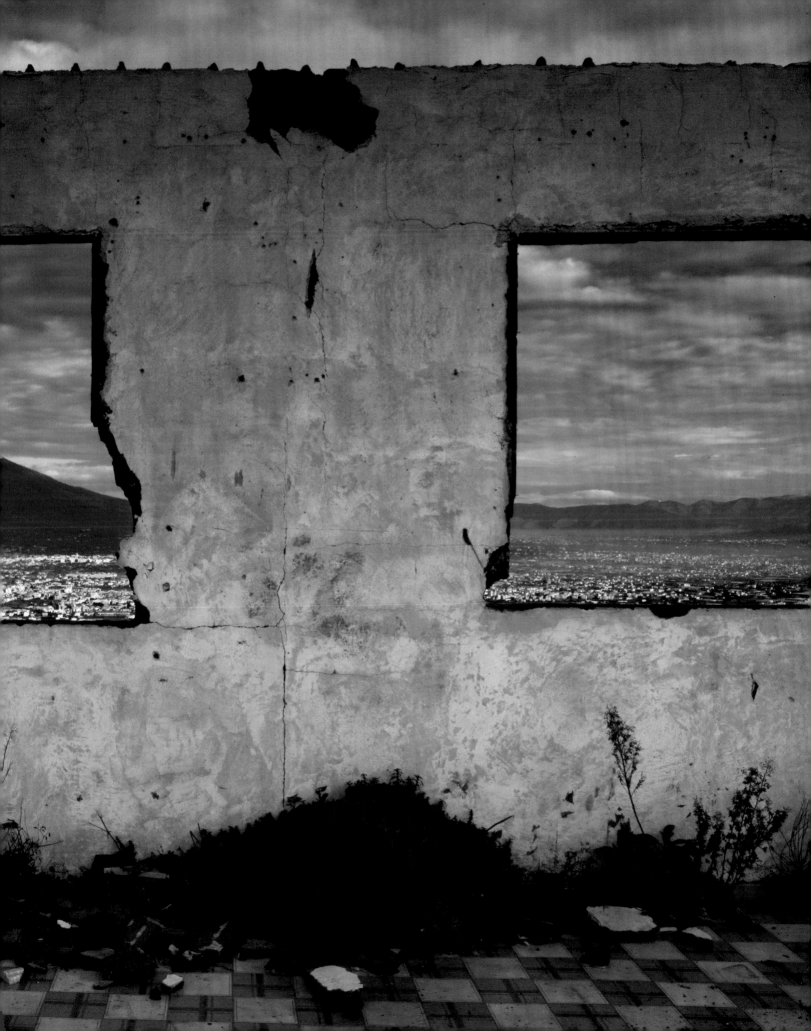

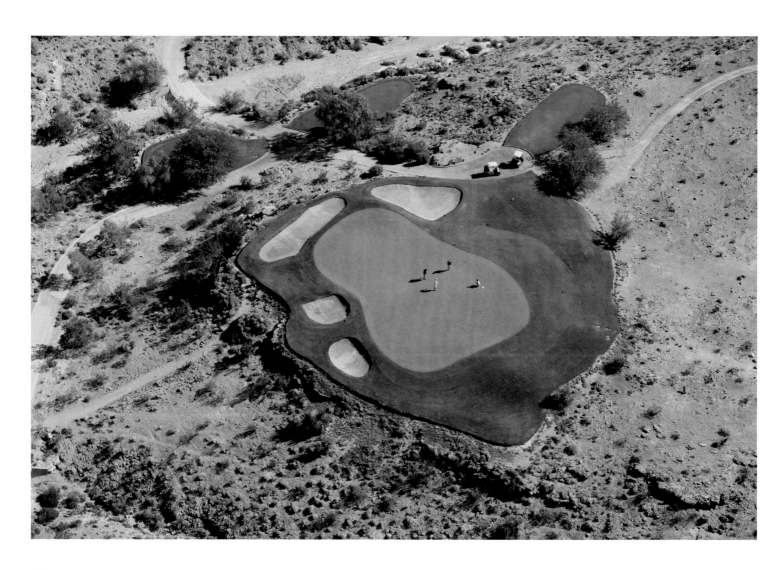

2007 I VINCENT LAFORET
Las Vegas, Nevada, U.S.
A foursome of golfers gather on a green,
enjoying a day of play on a well-watered
golf course in the middle of Nevada's
desert landscape.

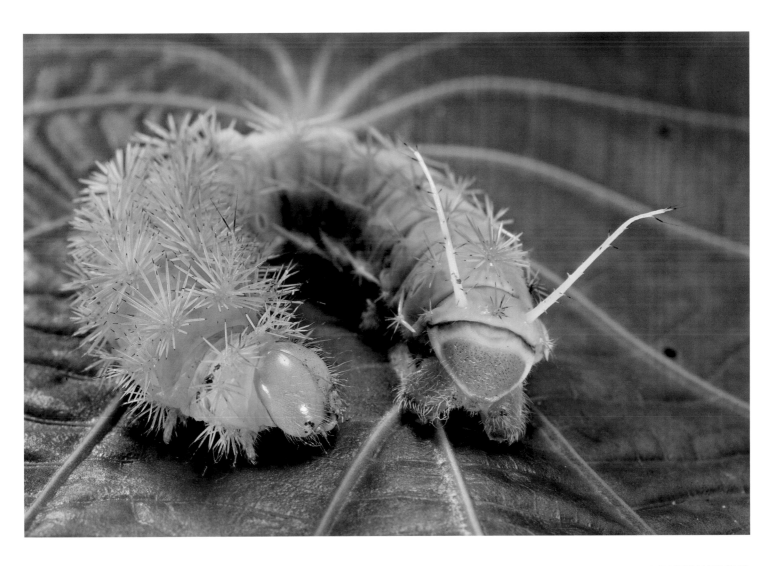

2007 | CHRISTIAN ZIEGLER
Barro Colorado Island, Panama
A silk moth caterpillar bears a false head,
including mock antennae, to lure predators
into biting its rear. If the plan fails, its real
head boasts extra spikes.

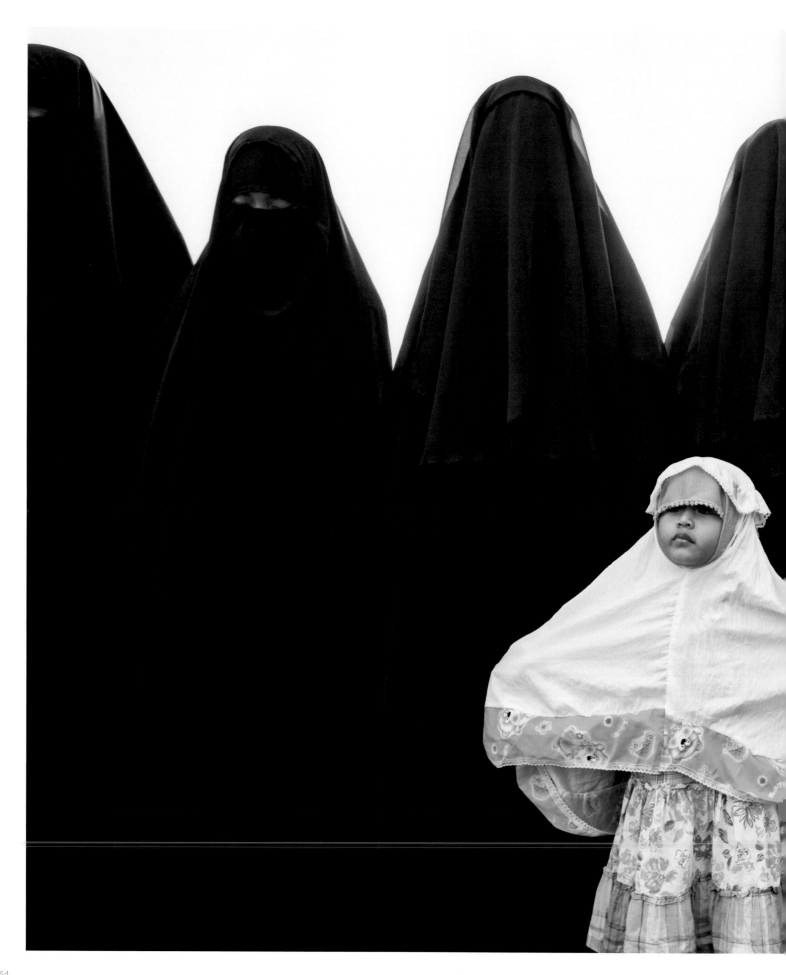

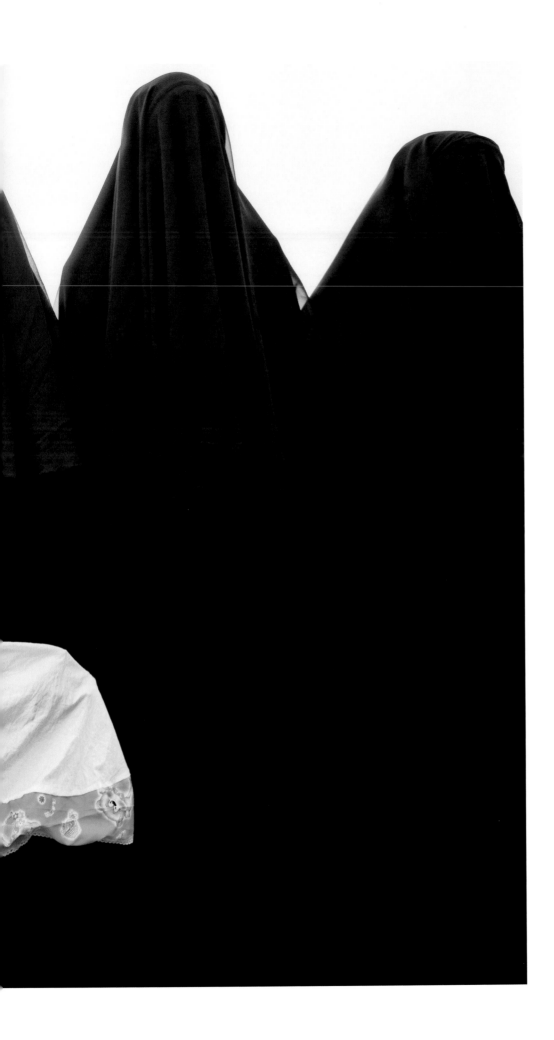

2007 I JAMES NACHTWEY
Sulawesi, Indonesia
Women of the An-Nadzir commune,
along with a young girl, gather at the
start of Islam's Feast of the Sacrifice.

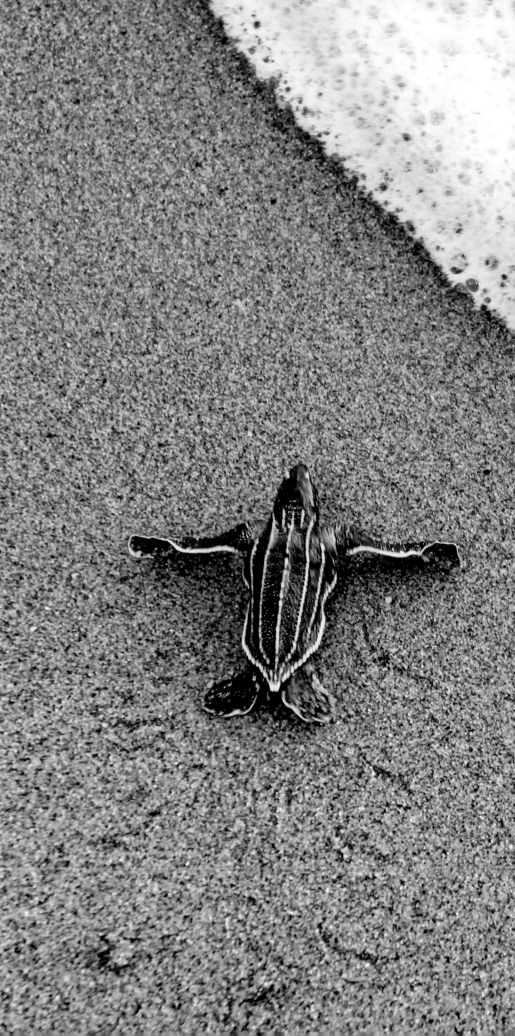

Opposite
2007 I BRIAN SKERRY
Matura Beach, Trinidad
A leatherback turtle hatchling crawls to the sea. Only one in 1,000 hatchlings will survive to maturity.

Pages 158-159
2007 I STEVE WINTER
Jammu and Kashmir, India
Local women wear *peraks,* traditional Ladakhi headdresses covered in turquoise stones.

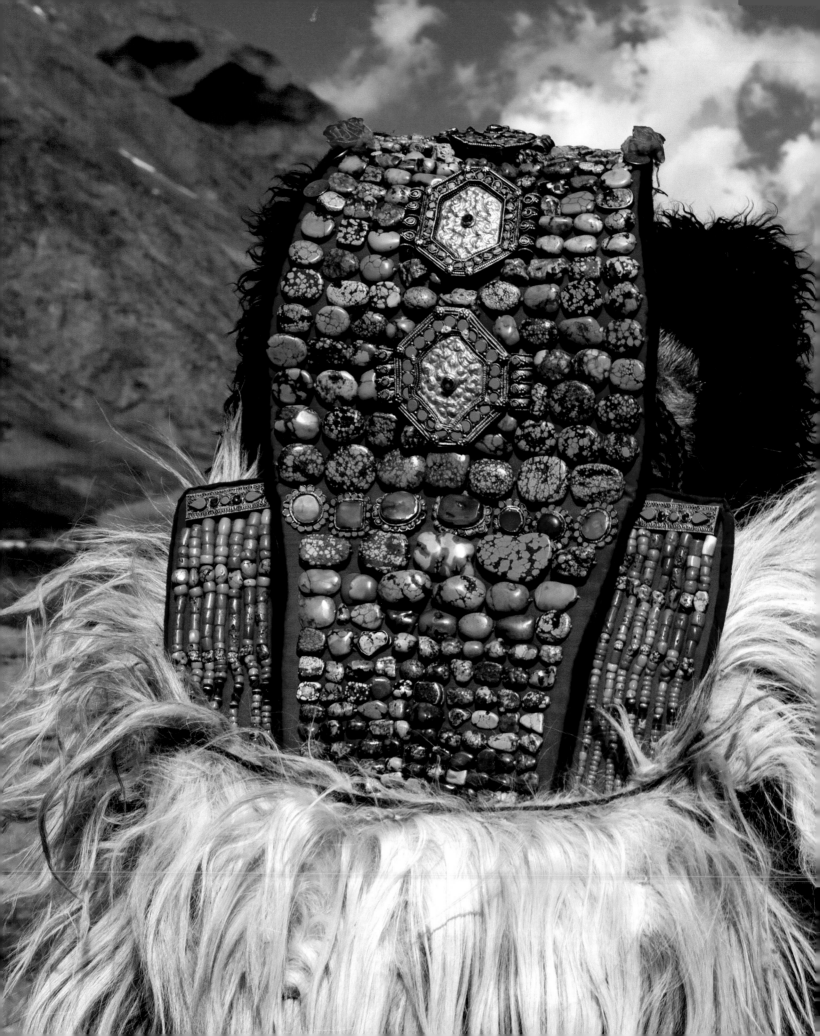

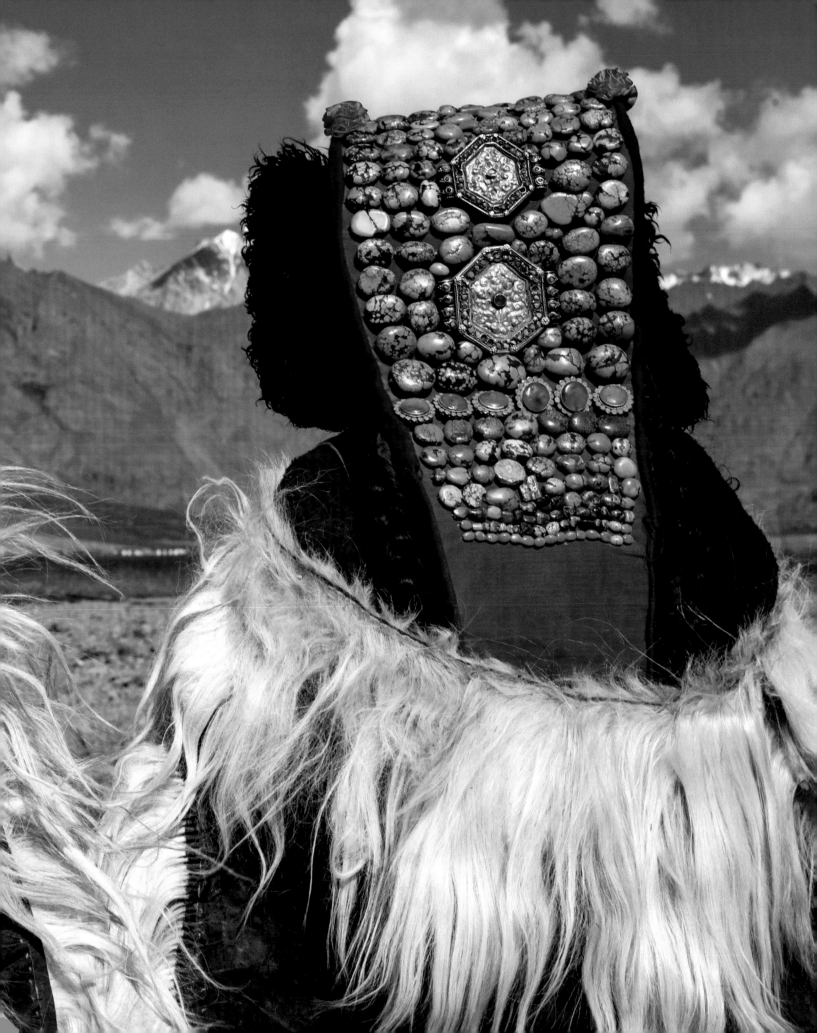

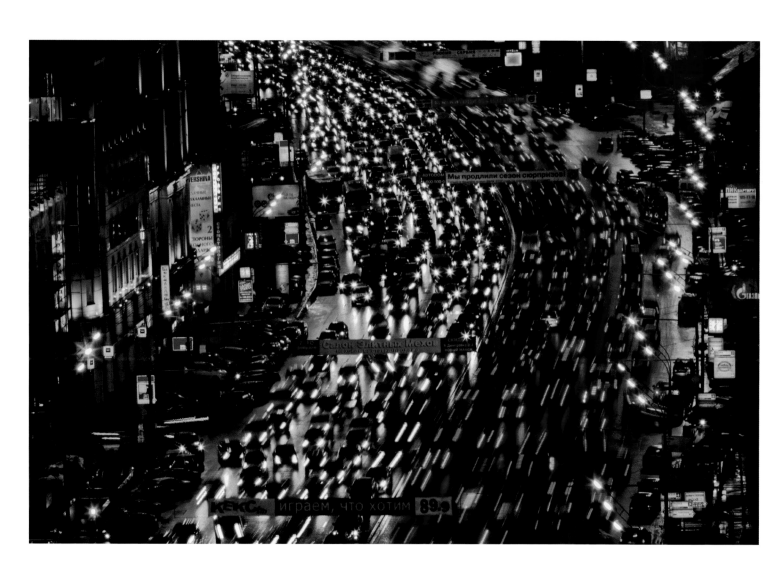

2008 | GERD LUDWIG
Moscow, Russia
Traffic grinds and snarls at rush hour on the
eight-lane Garden Ring, a far cry from the
early 1980s when homegrown Zhigulis and
Moskviches ruled nearly empty city roads.

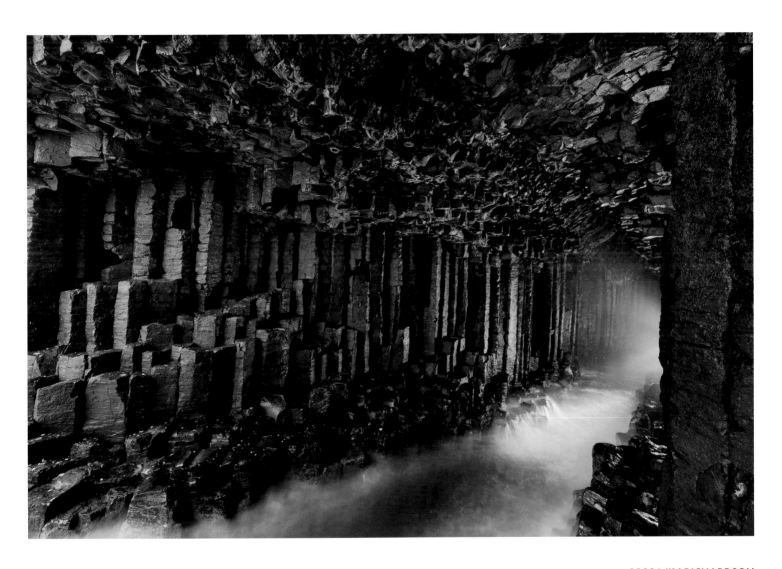

2008 I JIM RICHARDSON
Isle of Staffa, Scotland
Rank upon rank of basalt pillars line Fingal's Cave. The natural precision of the columns and the echoes of lashing waves have captivated travelers since the 18th century.

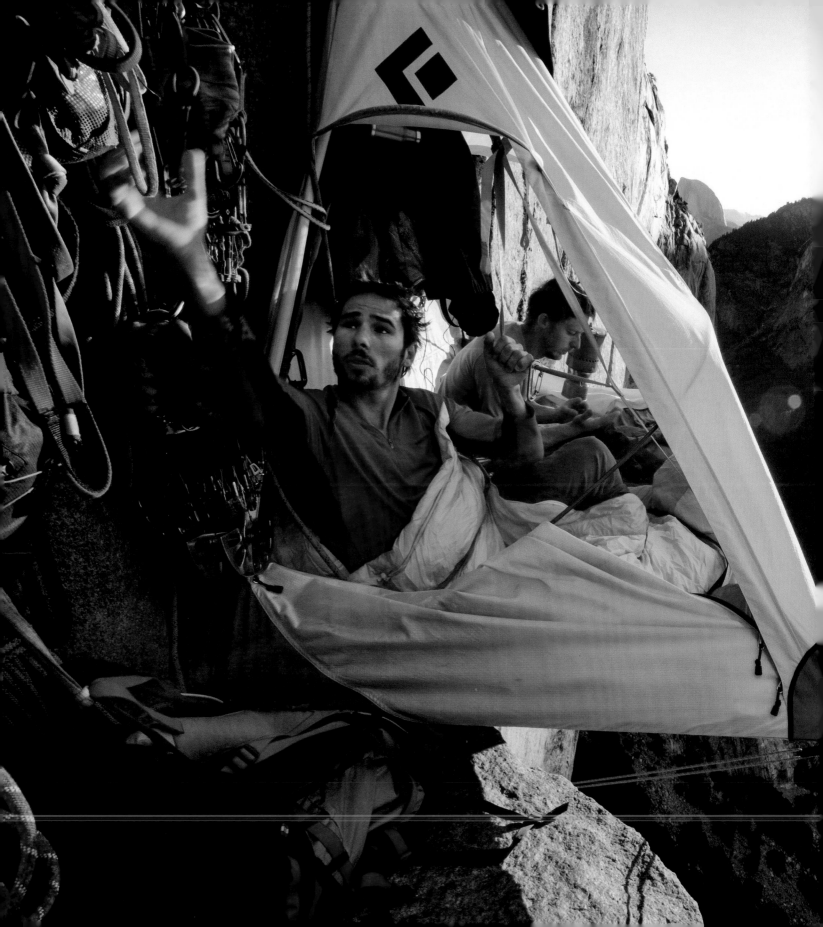

THROUGH
THE LENS

JIMMY CHIN

The biggest challenge for me when photographing climbers—while climbing myself—is trying to be creative under physical duress. You're at 20,000 feet (6,096 m) and are constantly managing risk assessment. Then you have to remember, "I should probably pull out my camera and take a photo right now." I've definitely taken a few risks to get a shot. But capturing these cutting-edge expeditions and climbs is worth it.

Here, Kevin Jorgeson and Tommy Caldwell begin an early morning from their portaledge high on El Capitan in Yosemite National Park during their early attempts at free-climbing the Dawn Wall in 2010.

On their successful attempt in December of 2014, it took 19 days of climbing for the two to reach the summit of the 3,000-foot (914.4 m) El Capitan, marking the first free ascent of a notoriously difficult section of the rock. The Dawn Wall, until then, had widely been considered too difficult for free-climbing (using just one's hands and feet, and only employing ropes and other gear to stop a fall).

Caldwell's and Jorgeson's goal was to free-climb all 32 pitches of the wall without falling or returning to the ground in between. If one of them fell while attempting a pitch, they'd have to try that individual pitch from its begin-

Opposite
2008 | JODI COBB
Venice, Italy
A costumed woman stands on the edge of the San Marco Basin. For every resident Venetian, hundreds of visitors pour into the city to savor its gilded charms.

Pages 166-167
2008 | PAUL NICKLEN
Svalbard, Norway
Inspecting a human interloper, a female polar bear noses into photographer Paul Nicklen's cabin after munching on his snowmobile seat, his camera bag, and his hat.

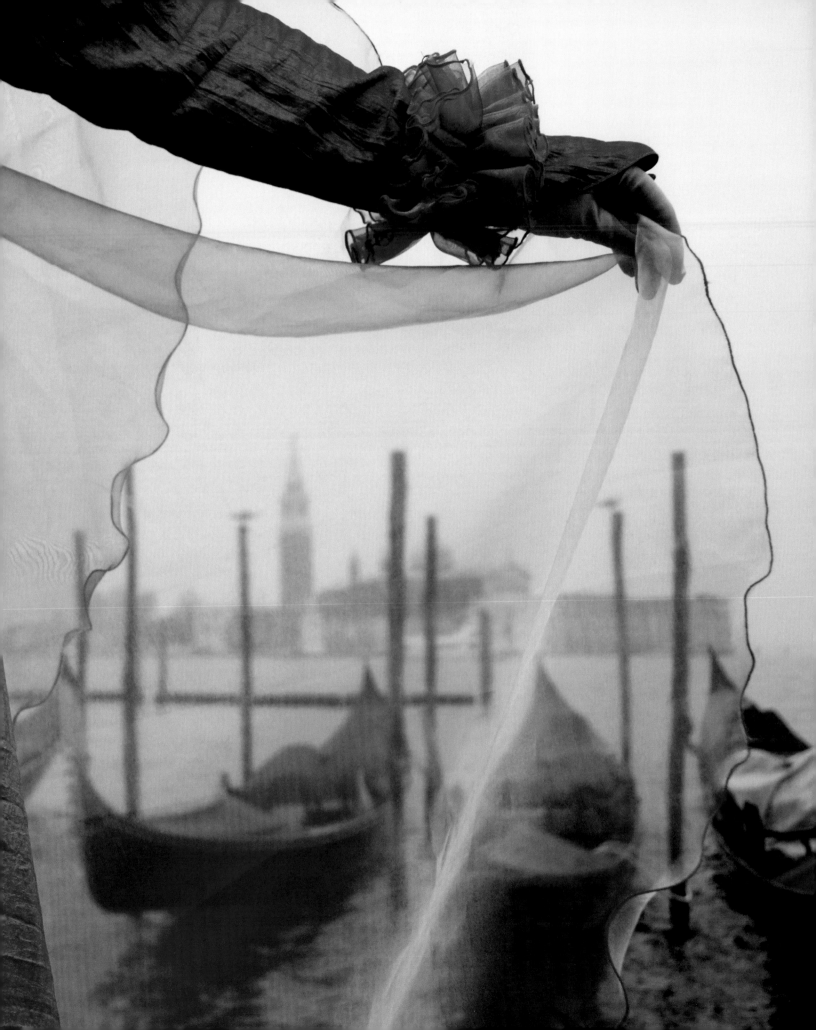

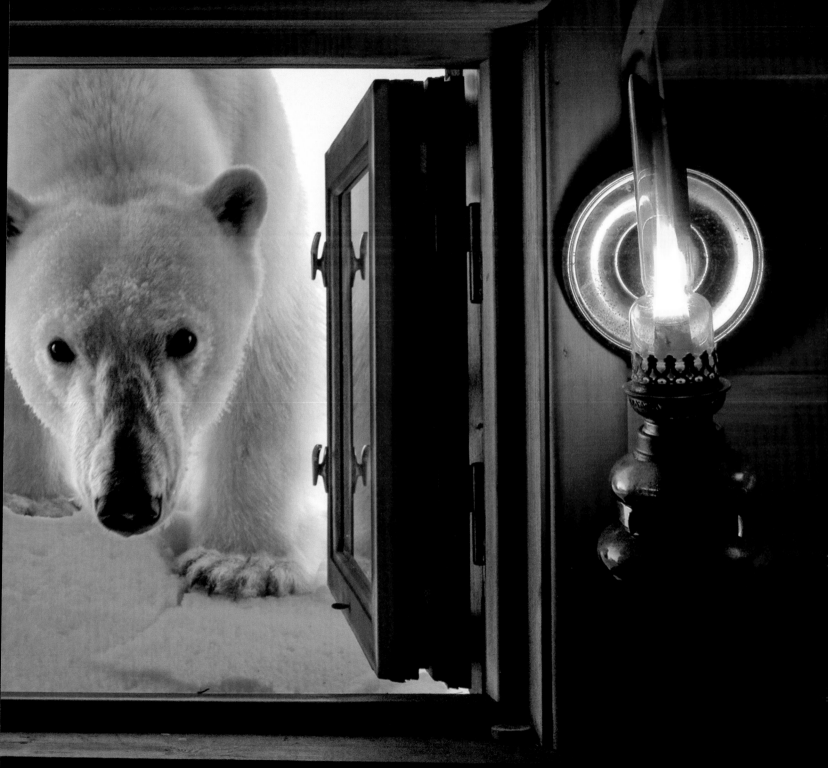

2008 I IVAN KASHINSKY
El Alto, Bolivia
A female wrestler, one of the city's beloved *cholitas*, practices jumping from the ring's top rope.

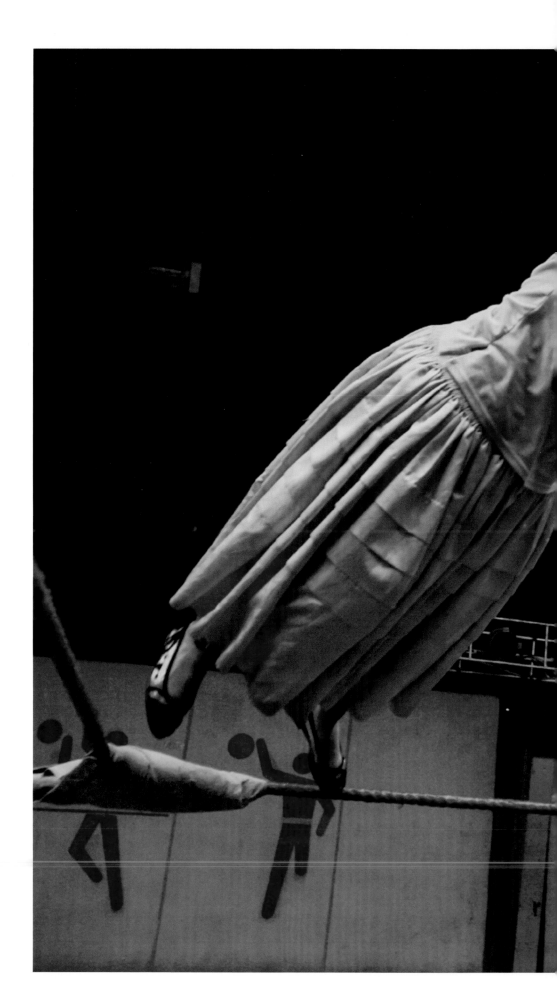

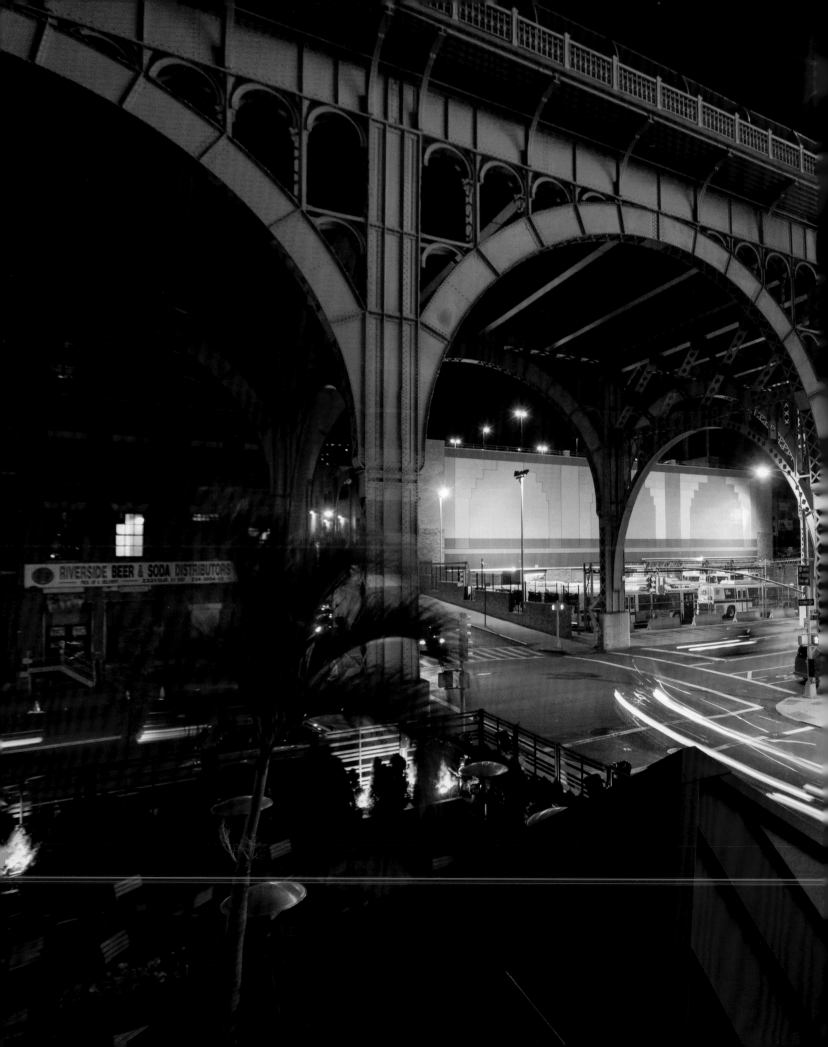

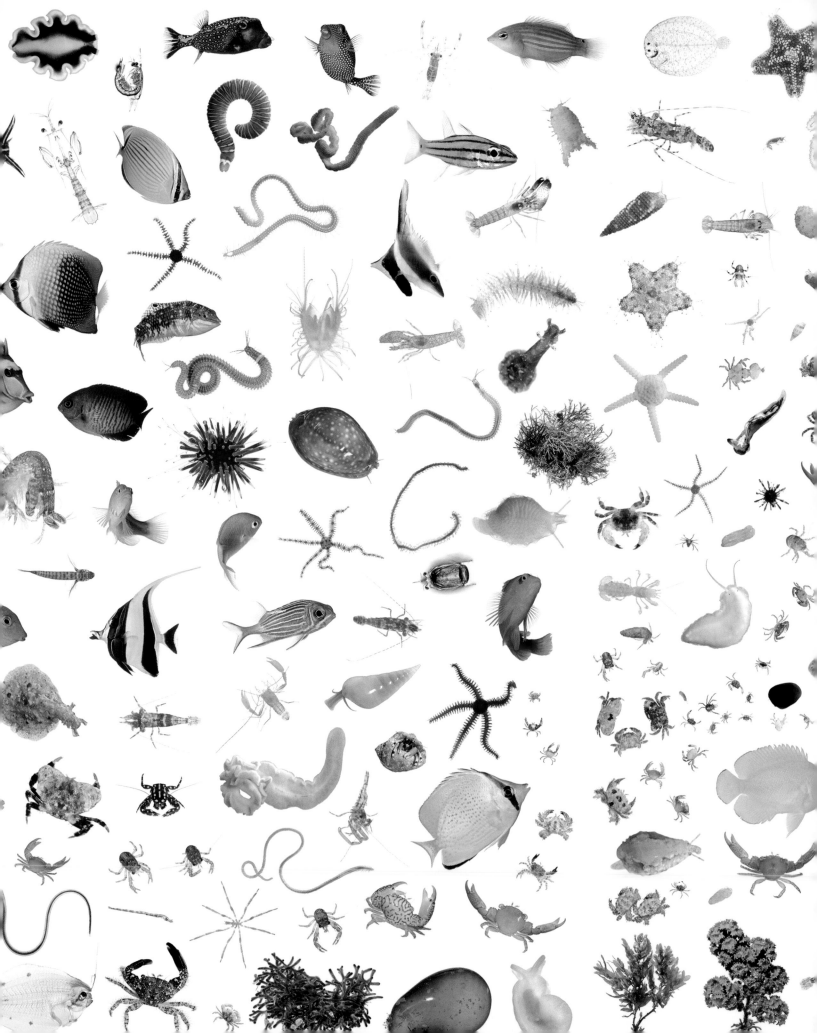

2008 | ABELARDO MORELL
Venice, Italy
Venice's Grand Canal is projected onto a wall painted in a jungle motif using a camera obscura technique. The shadow of a chandelier adds to the image's hypnotic mayhem.

2008 | MATTIAS KLUM
Borneo, Malaysia
A mangrove pit viper curls around a
branch in Sarawak's Bako National Park.

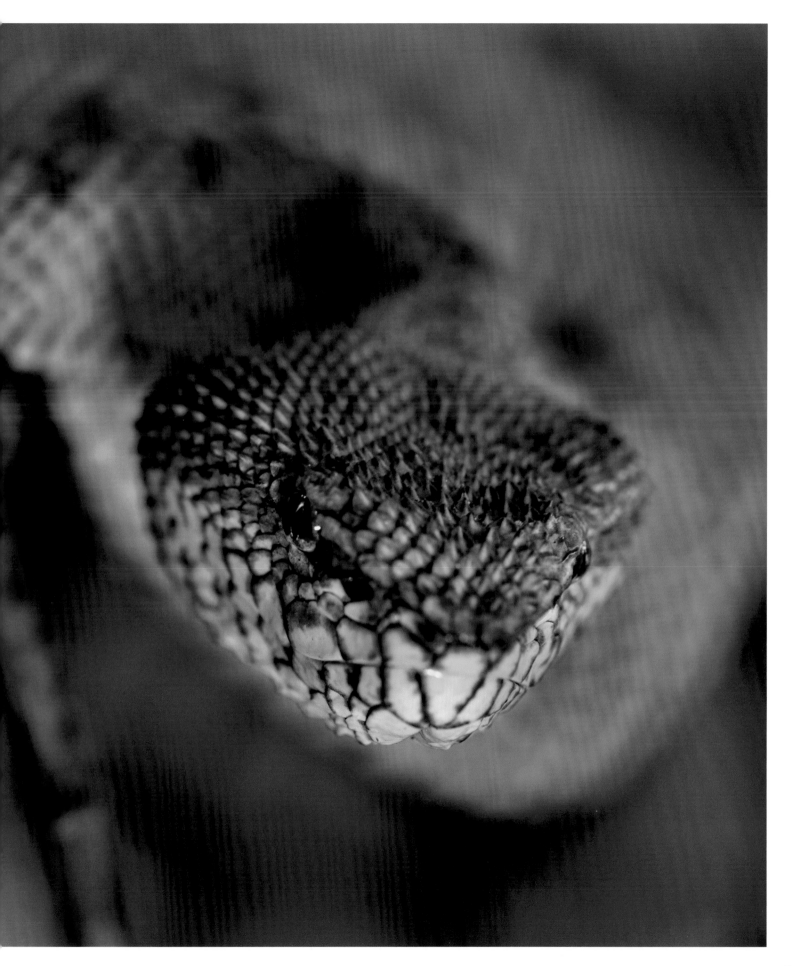

Opposite
2008 | STEPHEN ALVAREZ
Tennessee, U.S.
Caver Marion "the Goat" Smith,
a historian by profession who started
spelunking in 1966, wriggles his way
into an unexplored Tennessee cave.

Pages 180-181
2009 | FRANS LANTING
Sperrgebiet National Park, Namibia
Windblown sand fills a derelict
building in Kolmanskop, an
abandoned diamond-mining town
in the middle of the Namib Desert.

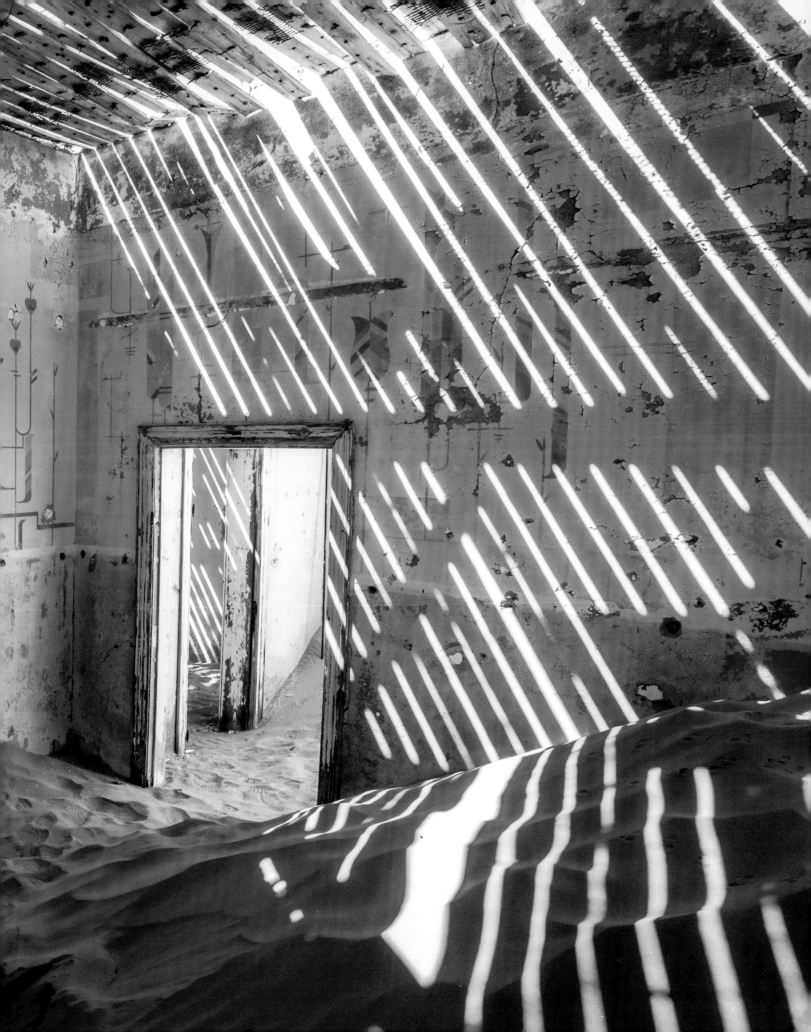

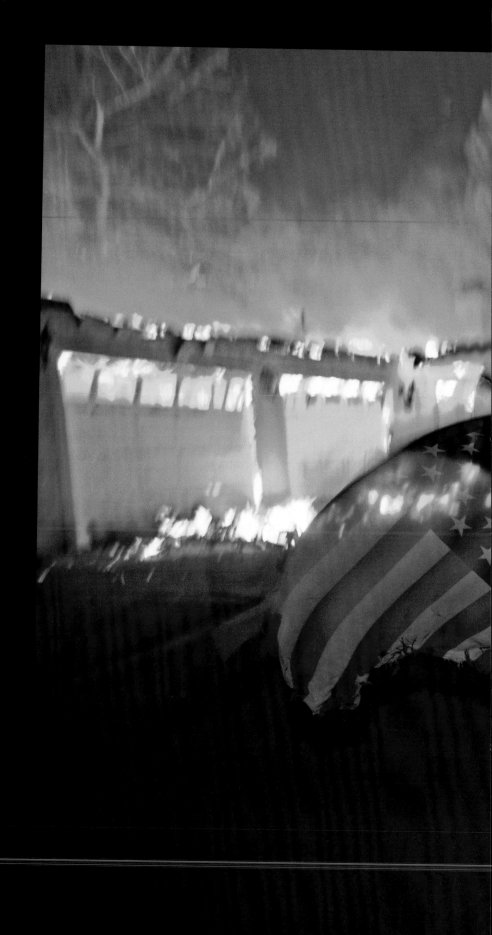

THROUGH
THE LENS

MARK THIESSEN

The hot, dry, Santa Ana winds are howling at 50 miles an hour (80.6 km/h) through the night in a neighborhood of Santa Clarita, California. Blowing embers are getting into my eyes and the smoke is causing me to cough. In front of me is a burning house with flames that roar with each wind gust. And it's just where I want to be to tell the story of the human impact of wildfires for *National Geographic*.

The front porch is pockmarked with burn holes from the blizzard of embers blowing sideways through the air, and an American flag is flying there. As I'm shooting this remarkable scene, I keep thinking to myself, "I need a person." Not likely because everyone has been evacuated.

Then, out of nowhere, I see a guy coming out of the darkness. He's wearing a dust mask. He can't believe this house is burning. I can't believe he is here. He says to me that he knows the owner of the house, and, in fact, he was here earlier in the day for a child's birthday party. He keeps walking toward the house, and I think to myself, "Here is my person!"

He sees the American flag, full of holes and flapping against the front porch roof. He grabs a ladder that is leaning against the house, climbs up, and saves the flag. Then he grabs golf clubs and a painting—anything he can find to save for his friend. I shoot all of this. ∎

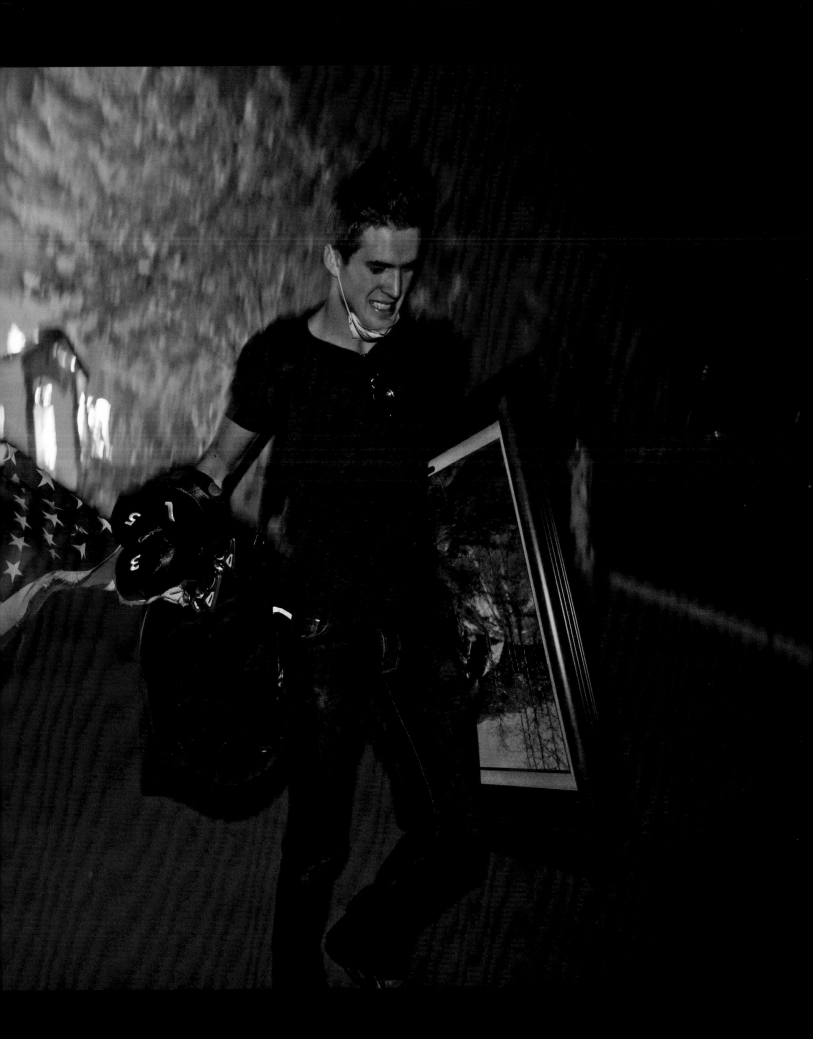

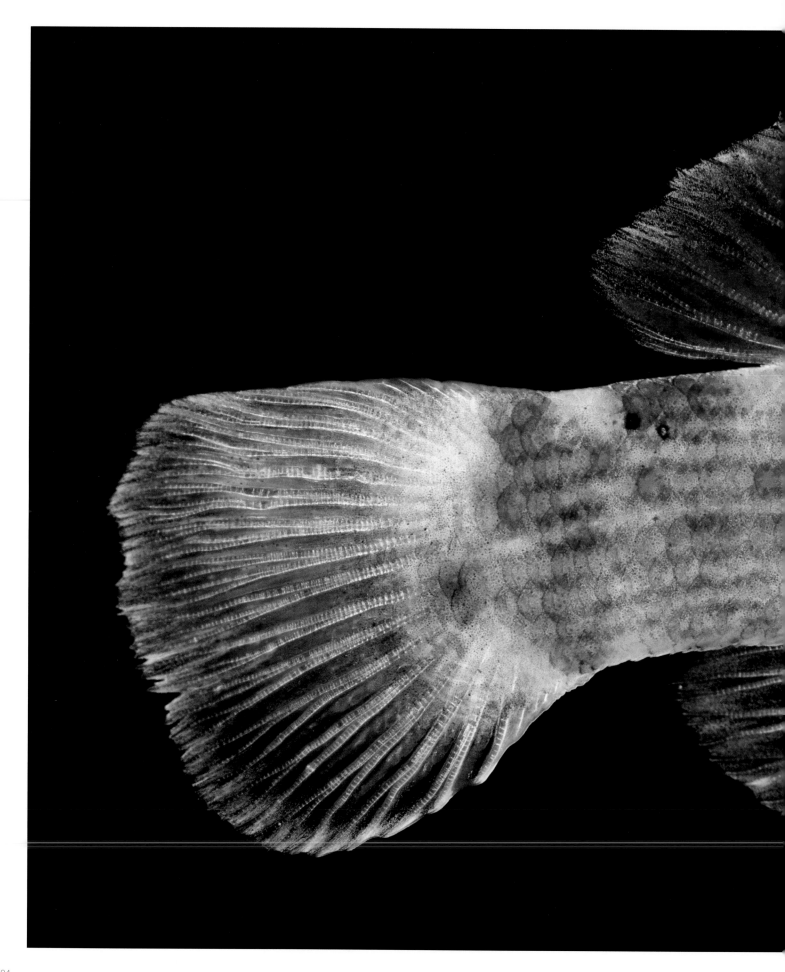

2009 I JOEL SARTORE
Knoxville, Tennessee, U.S.
The spotted darter, named for its colorful scales, is native to the Elk River in West Virginia. The species is currently listed as near threatened by the International Union for Conservation of Nature (IUCN).

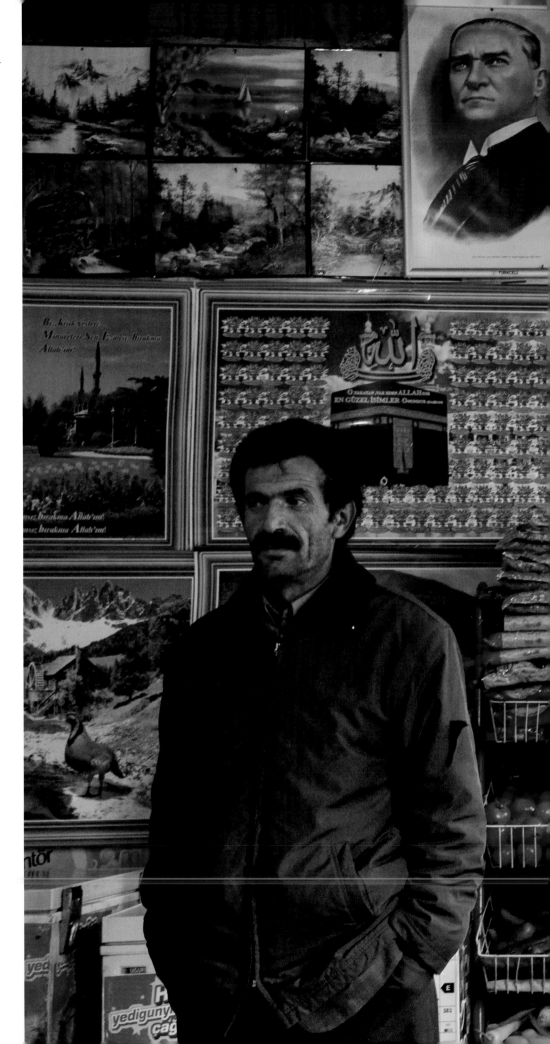

Opposite
2009 | ALEX WEBB
Karakale, Turkey
Posters of Mustafa Kemal Atatürk—
founding father of the Republic of Turkey
and its first president, serving from 1923
until his death in 1938—decorate shop
walls in a display of national pride.

Pages 188-189
2009 | MICHAEL MELFORD
Alaska, U.S.
The North Fork of the Koyukuk River cuts
through the vast red and green landscape
of Gates of the Arctic National Park.

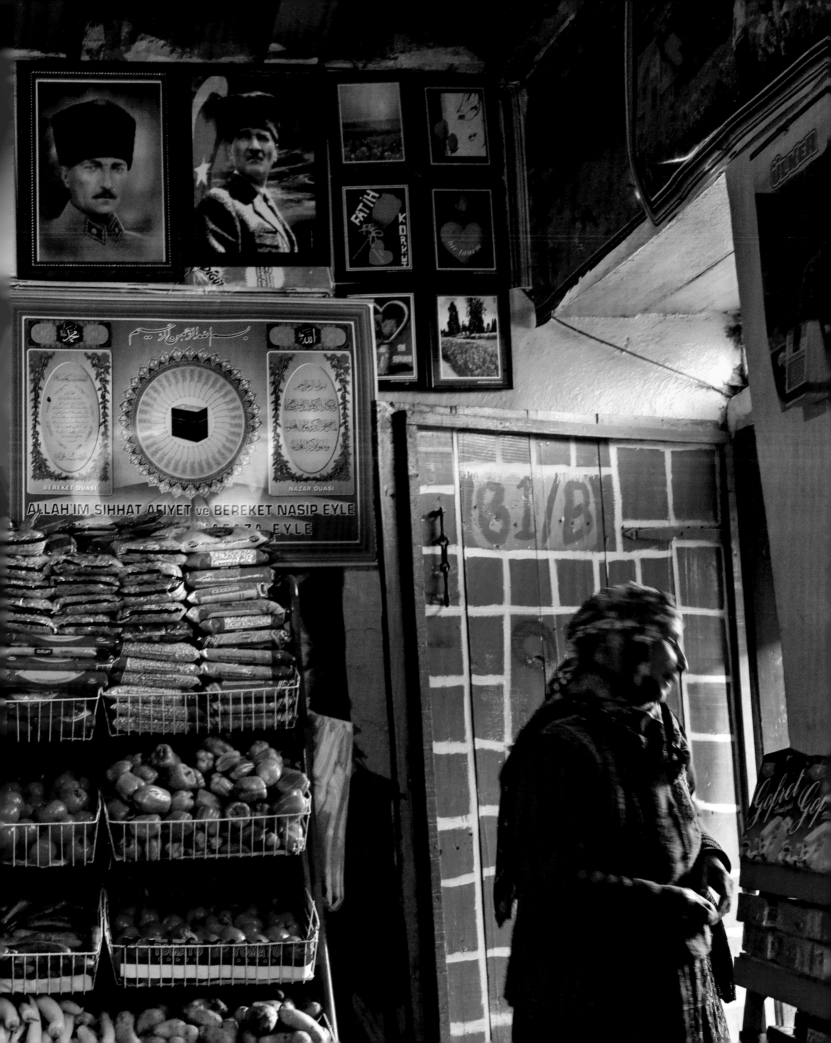

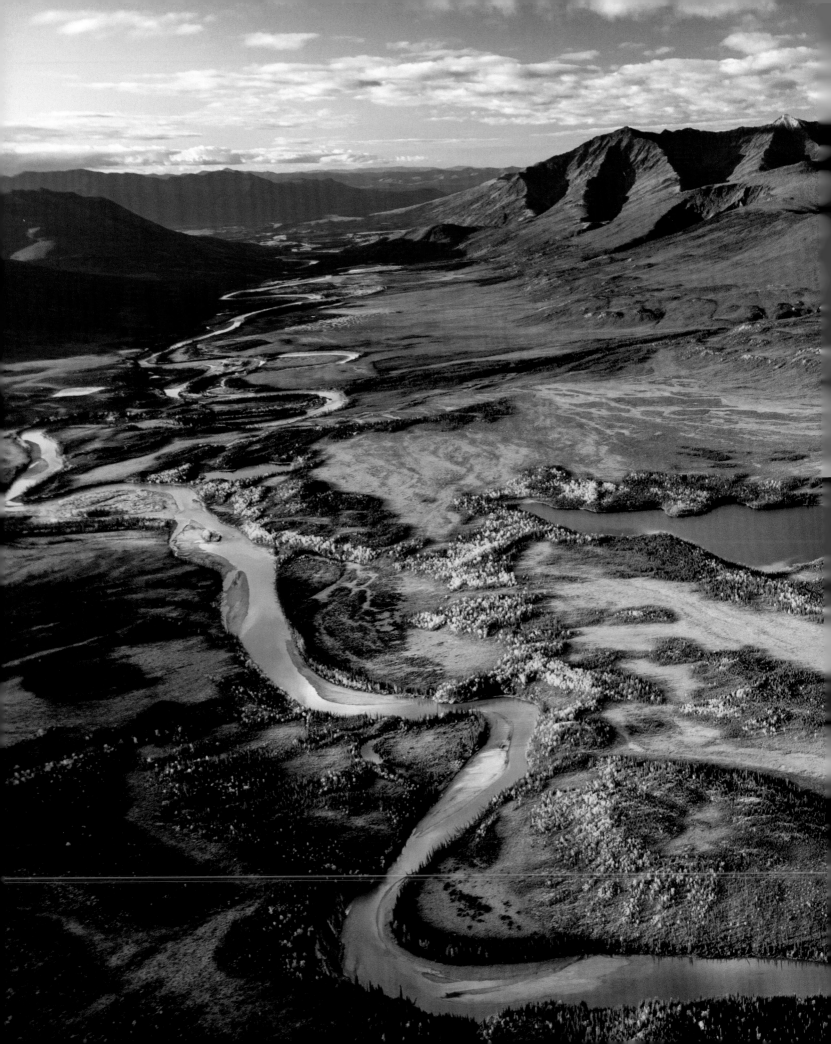

2009 I DAVID MCLAIN
Singapore
Bird cages dangle from poles in a public housing estate. The controversial custom of training birds for singing competitions thrives here. One dove may cost as much as $60,000.

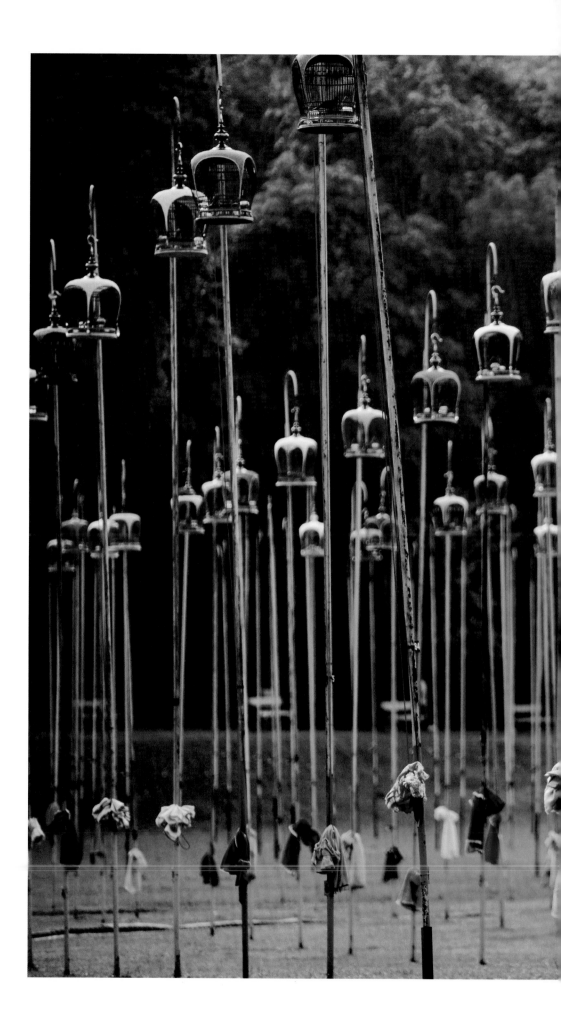

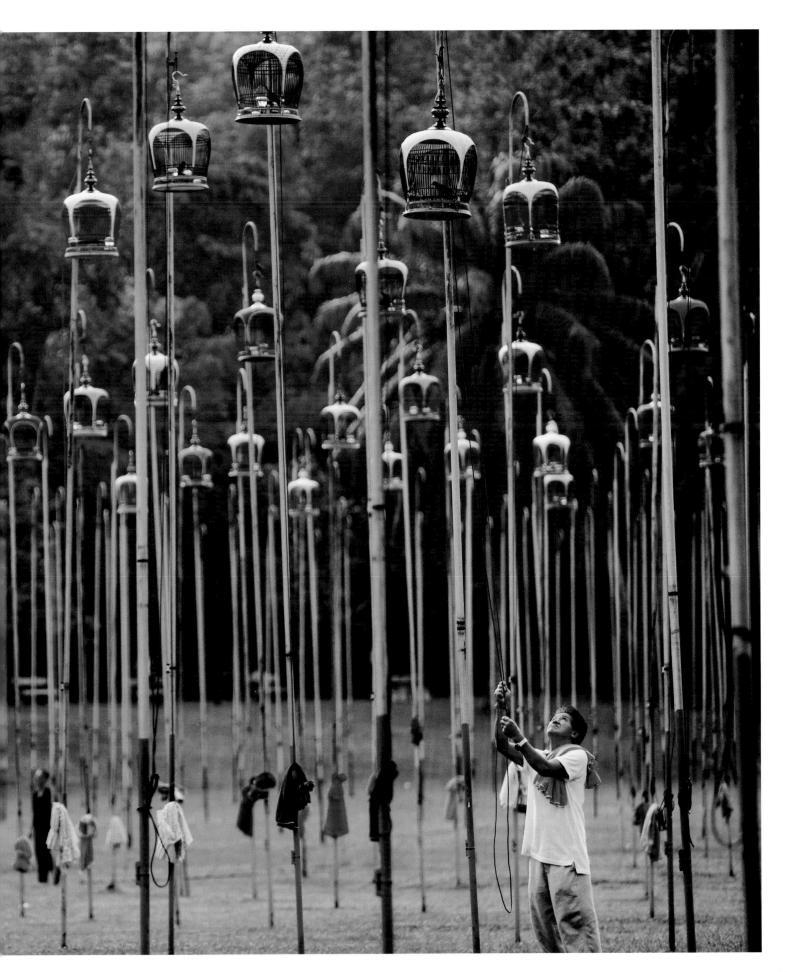

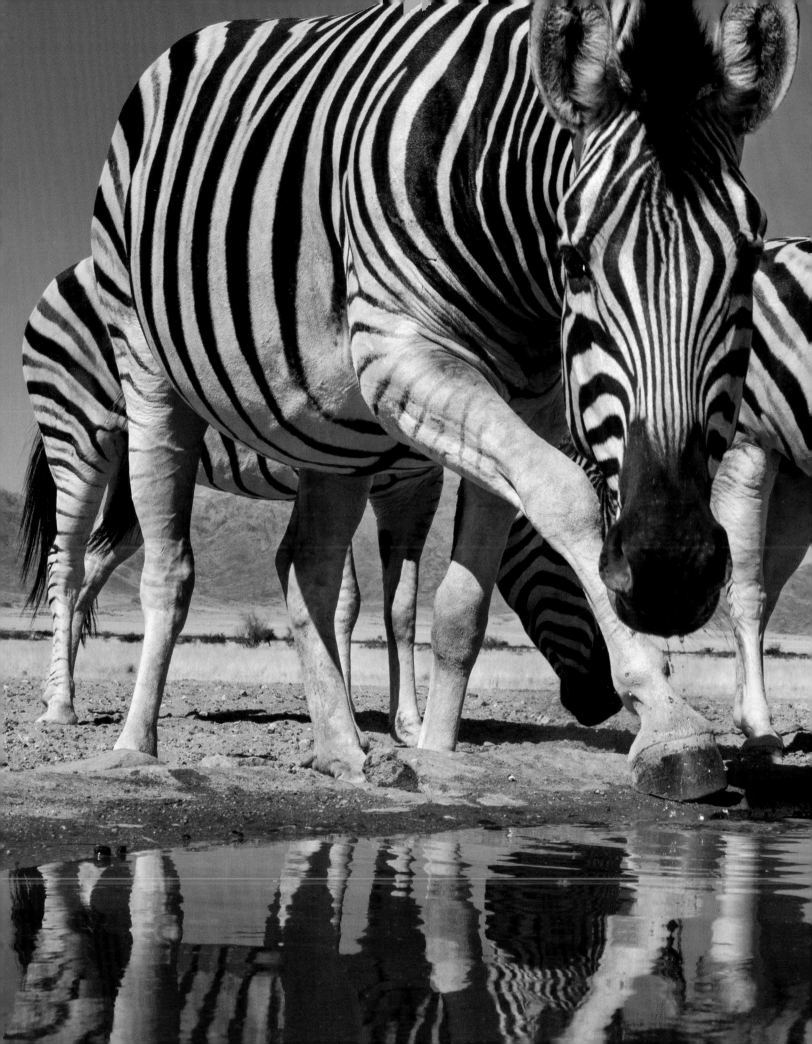

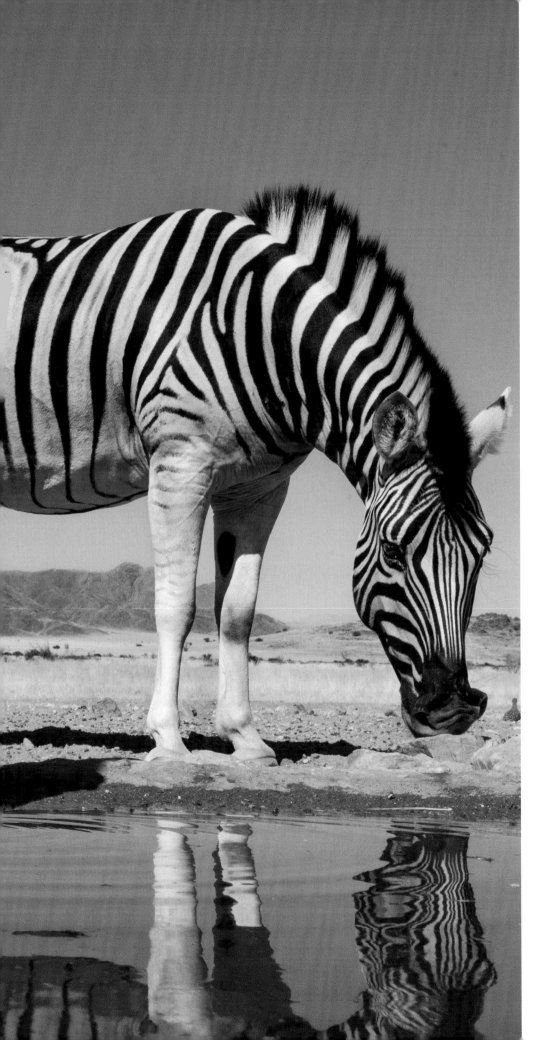

Opposite
2009 | FRANS LANTING
Namibia
Zebras stop for a drink at a water hole in the NamibRand Nature Reserve.

Pages 194-195
2009 | DAVID DOUBILET
Cairns, Queensland, Australia
Tightly packed hard corals vie for space and energy-giving sunlight in the Great Barrier Reef. Though highly vulnerable to changing sea chemistry, these reefs have persisted for millions of years.

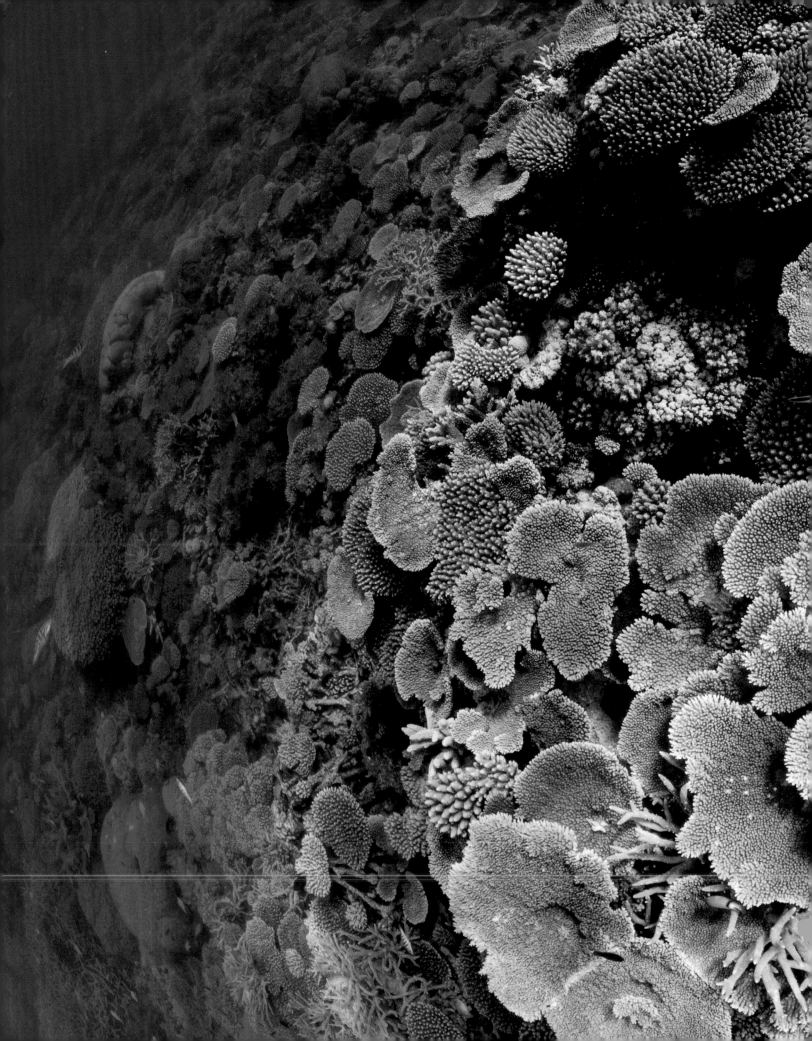

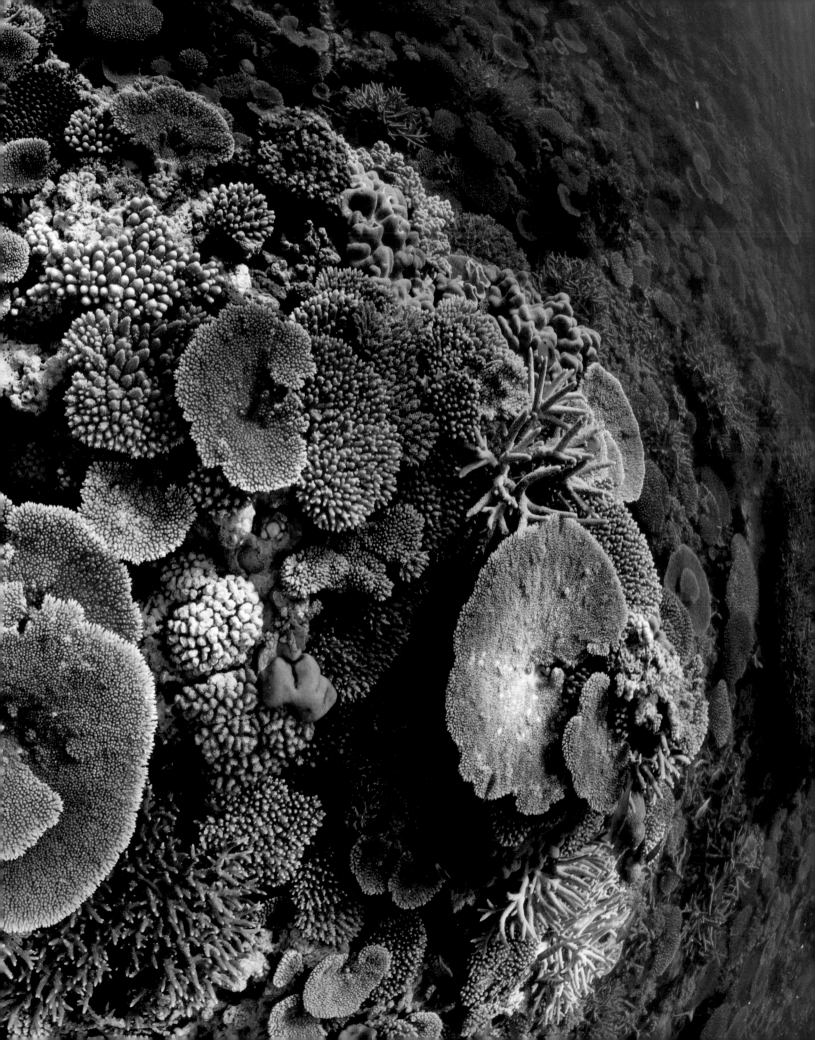

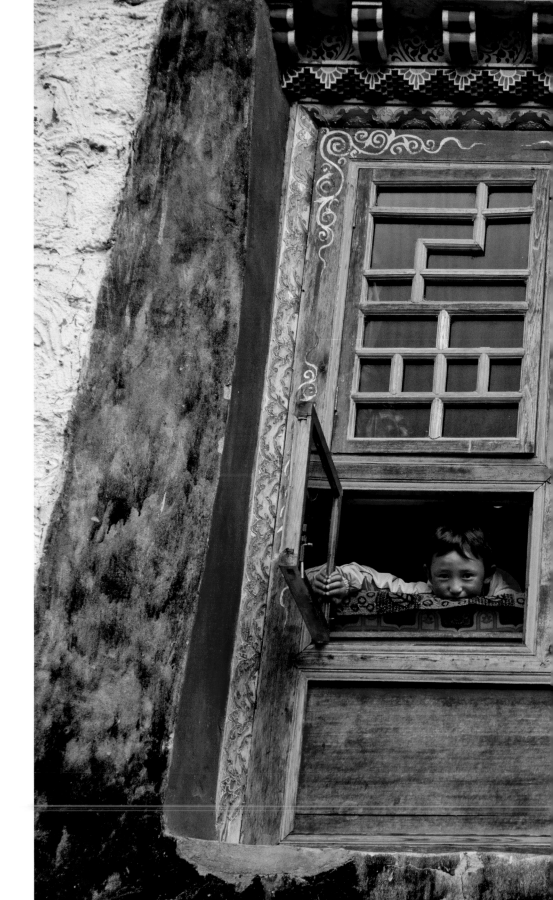

Opposite

2009 I MICHAEL YAMASHITA

Tibet, China

Tibetan children look out from windows of their house in the city of Zhaxigang.

Pages 198-199

2010 I KENNETH GARRETT

Cairo, Egypt

King Tut's funerary mask immortalizes his features in gold, glass, and semiprecious stones. This and other treasures from his tomb attract a constant swirl of visitors to Cairo's Egyptian Museum.

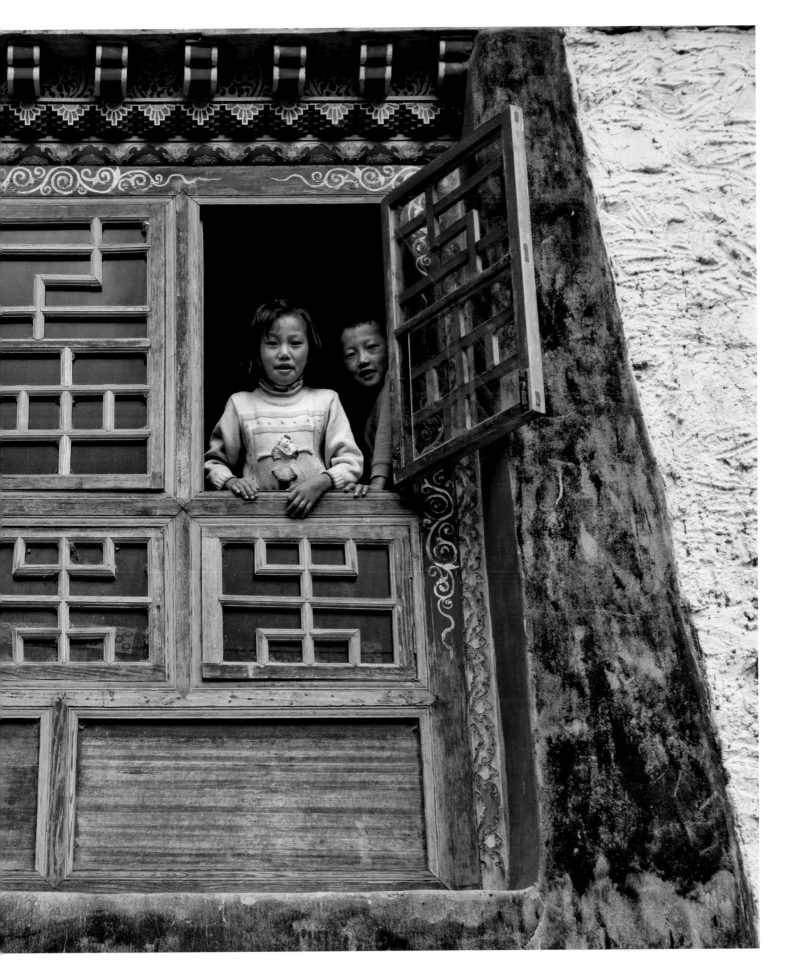

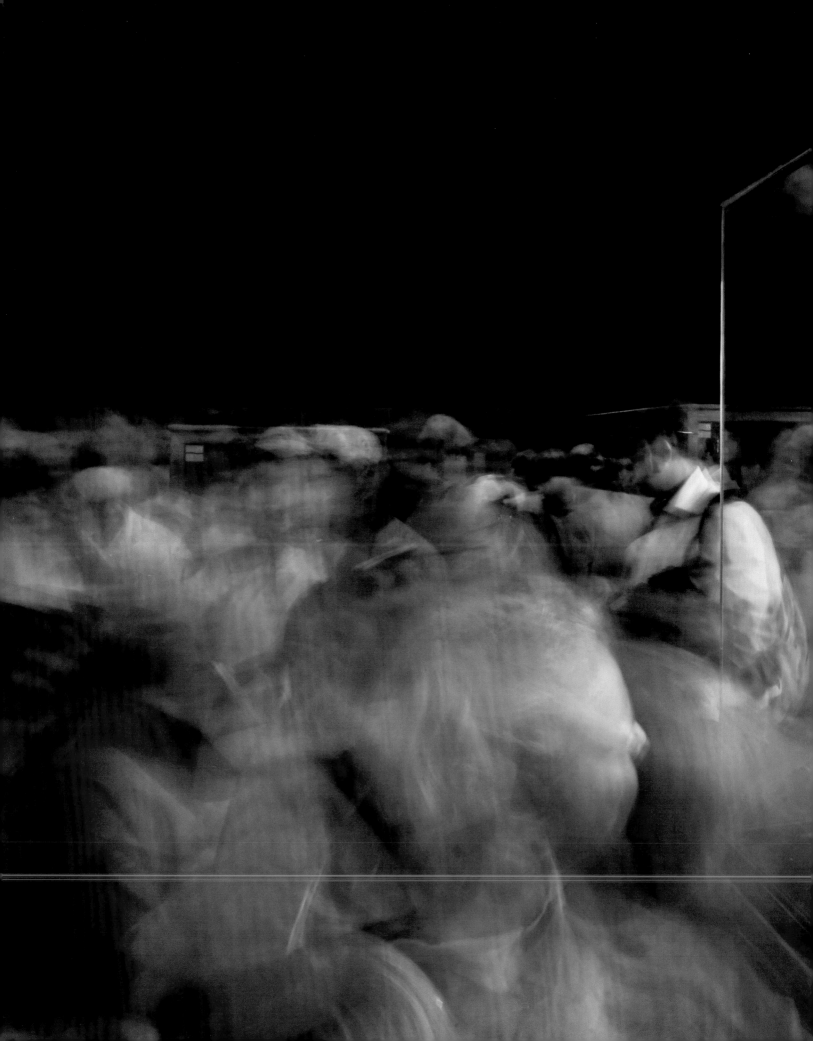

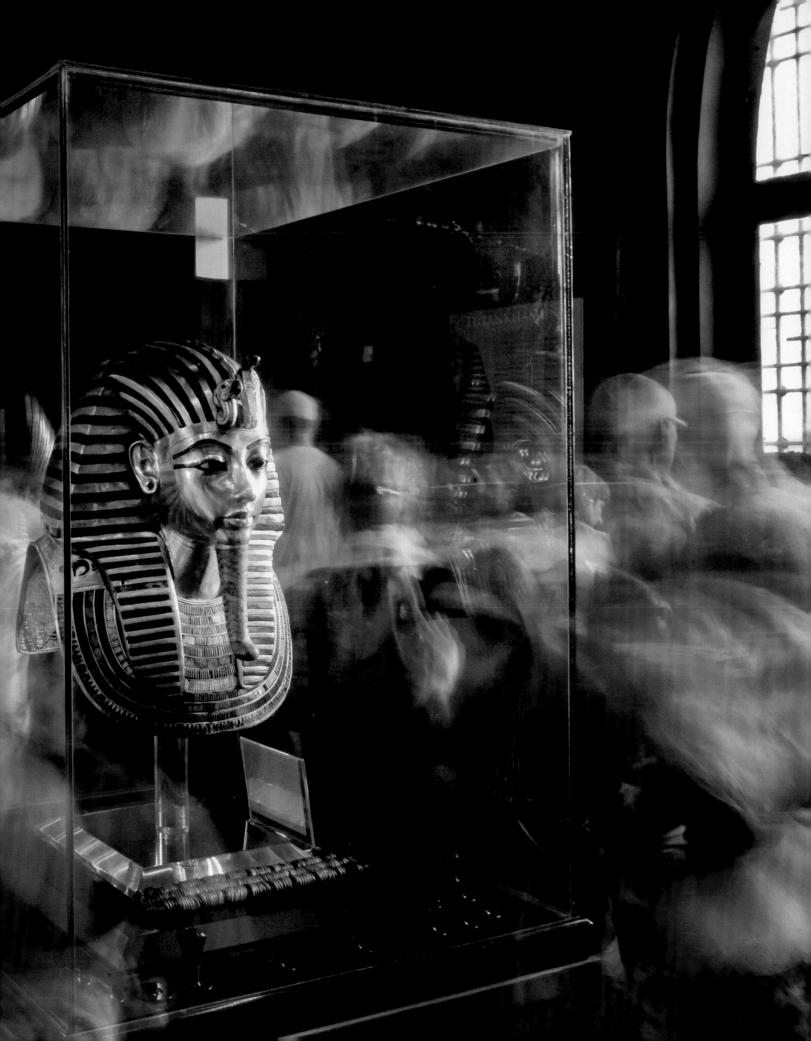

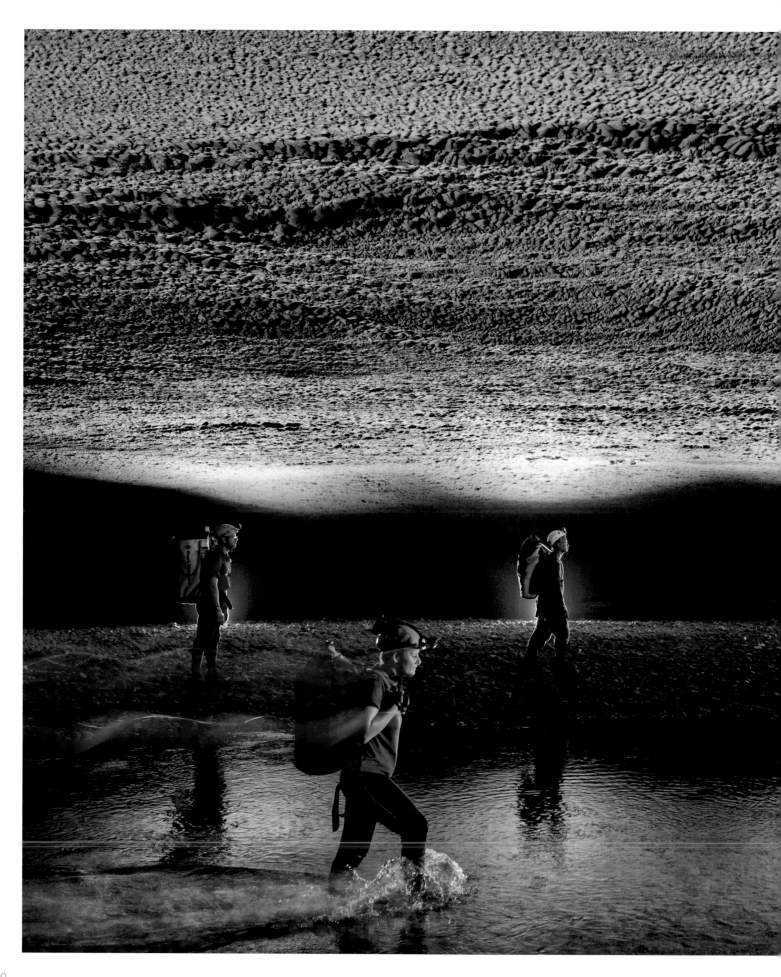

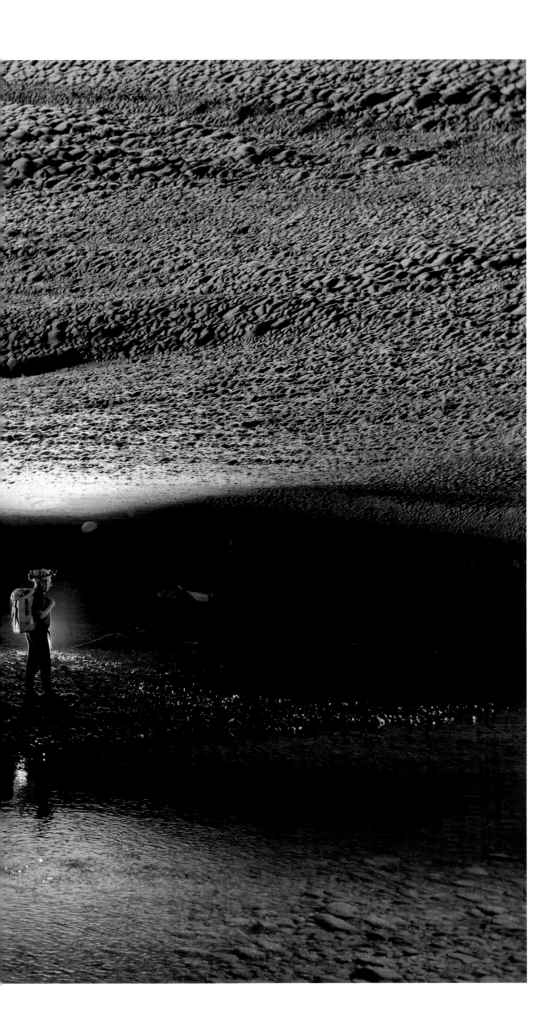

2010 I CARSTEN PETER
Vietnam
Cavers in the middle of Hang En Cave, located in Phong Nha-Ke Bang National Park, pass beneath a scalloped ceiling.

THROUGH
THE LENS

LYNN JOHNSON

I was working on a story about stress, documenting the lives of a trader on Wall Street, a female executive in a high-powered firm, and a single mother, when I was connected to Q.

Living in New York City, Q was training to be a police officer. On the day of her cadet ridealong, she didn't feel well and decided to stay home. That day ended up being 9/11, and the young man who took her place was killed. Q ultimately felt like she needed to right a wrong and signed up for the military.

She was sent to the Middle East where she was sexually attacked multiple times by her gunnery sergeant. How does a woman in the military cope with that? In the military, you are trapped. The people you're serving, the people watching your back, are also your attackers. The stress is relentless.

Q had the courage to let me be a part of her life, to be on the other side of my camera. But what I see in this image is a woman basically paralyzed by trauma. She would spend days on the couch, maybe eating a bowl of ice cream now and then. The experience destroyed her. The military was her identity and she had to create another one. It was a fraught journey.

The story of Q never ran in *National Geographic*, but I continued to follow her for years. She is starting to progress—she went back to college, bought a house, started to do better. But that experience, it distorts life forever. It destroys the identity of a woman. ∎

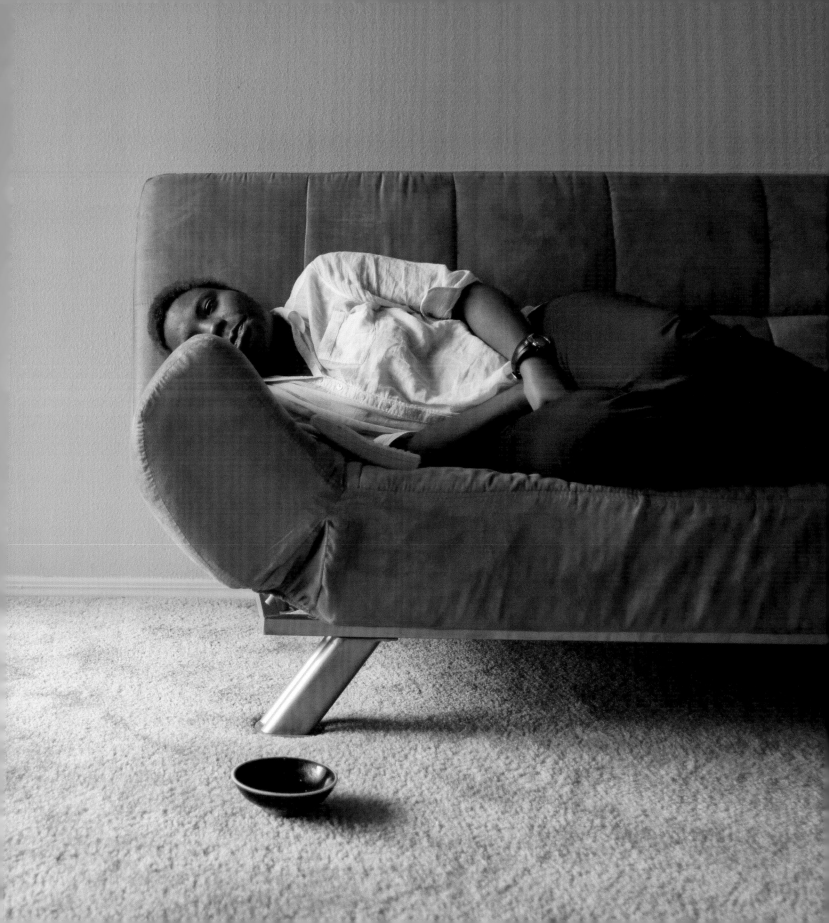

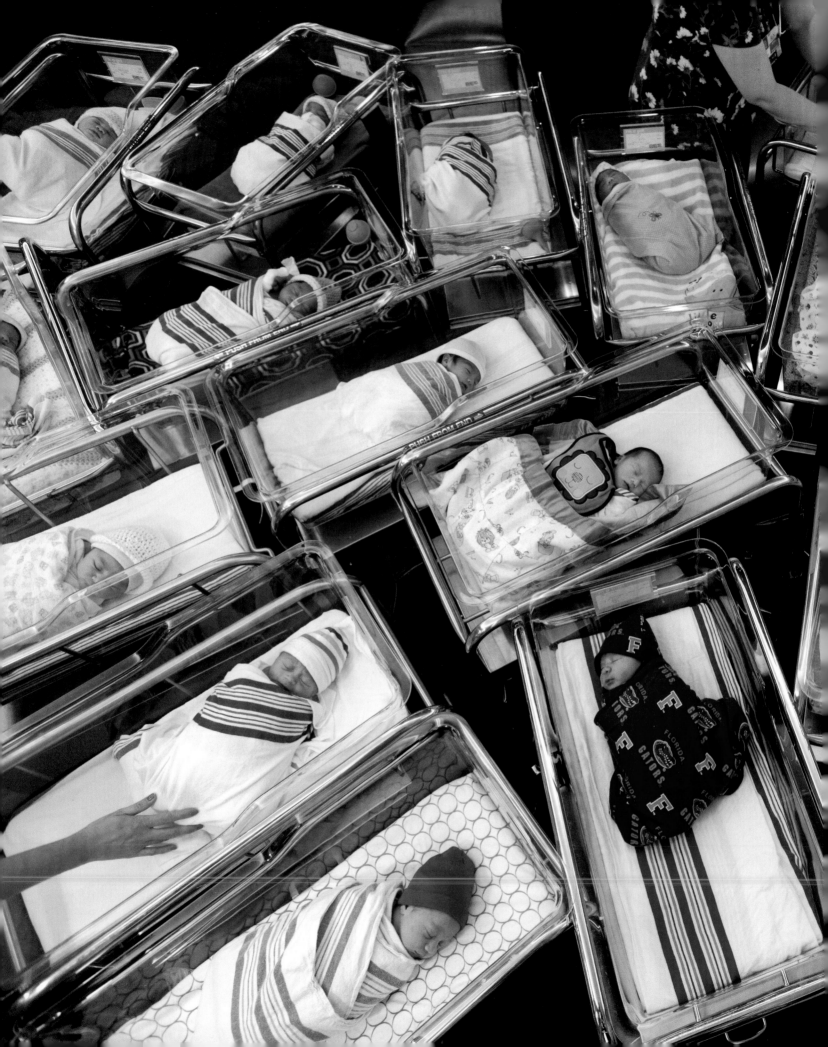

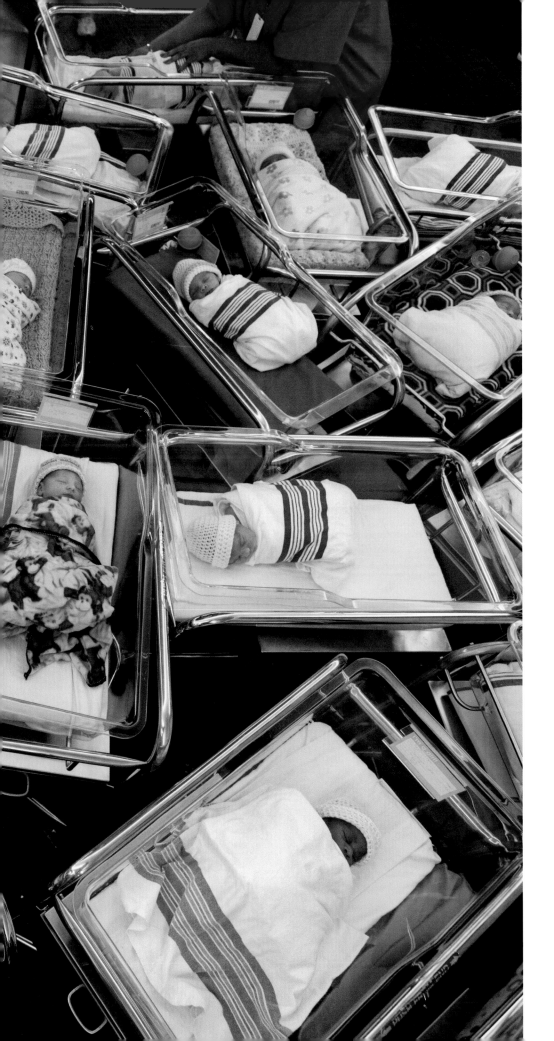

2010 I JOHN STANMEYER
Orlando, Florida, U.S.
Bundled newborns are arranged for a portrait at Orlando's Winnie Palmer Hospital, the second busiest birth facility in the U.S. By 2050, America's population is expected to top 400 million.

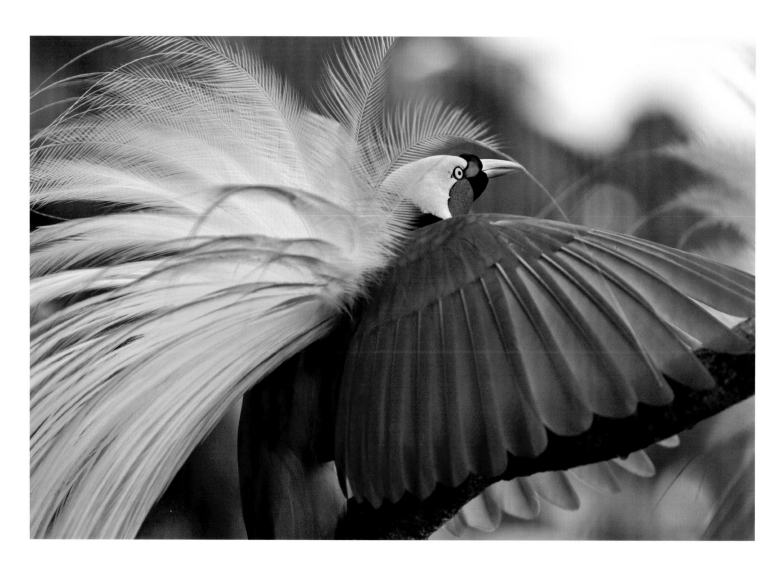

2010 I TIM LAMAN
Maluku Province, Indonesia
On Wokam Island, a greater bird of paradise
spreads its wings in a colorful display.

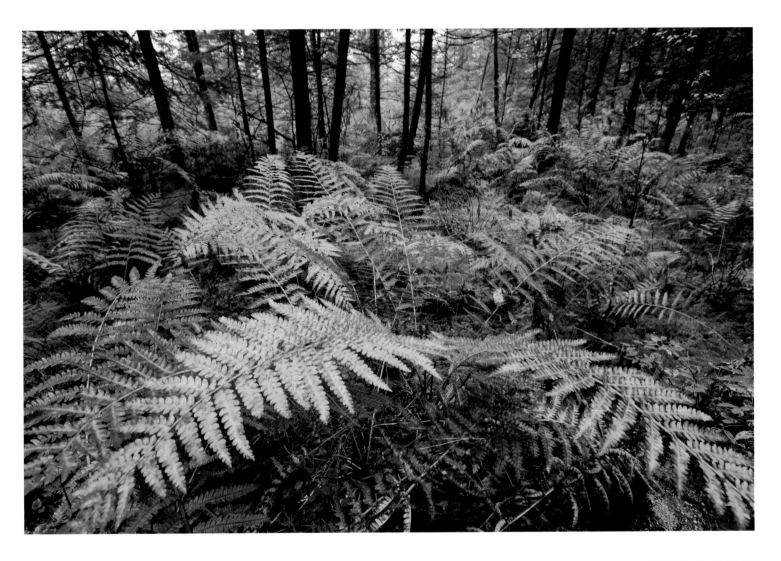

2010 I MICHAEL MELFORD
New York State, U.S.
Ferns in Adirondack Park change from summer's
green to autumnal reds, yellows, and oranges.

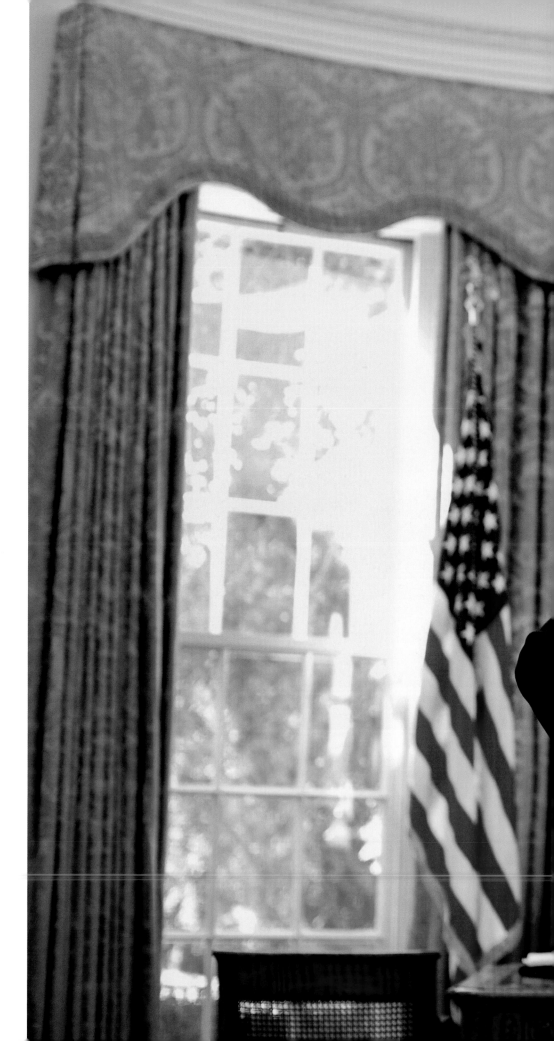

2010 I PETE SOUZA
Washington, D.C., U.S.
Following a call with German chancellor
Angela Merkel, President Barack Obama
takes a minute, hands on hips, in the
Oval Office.

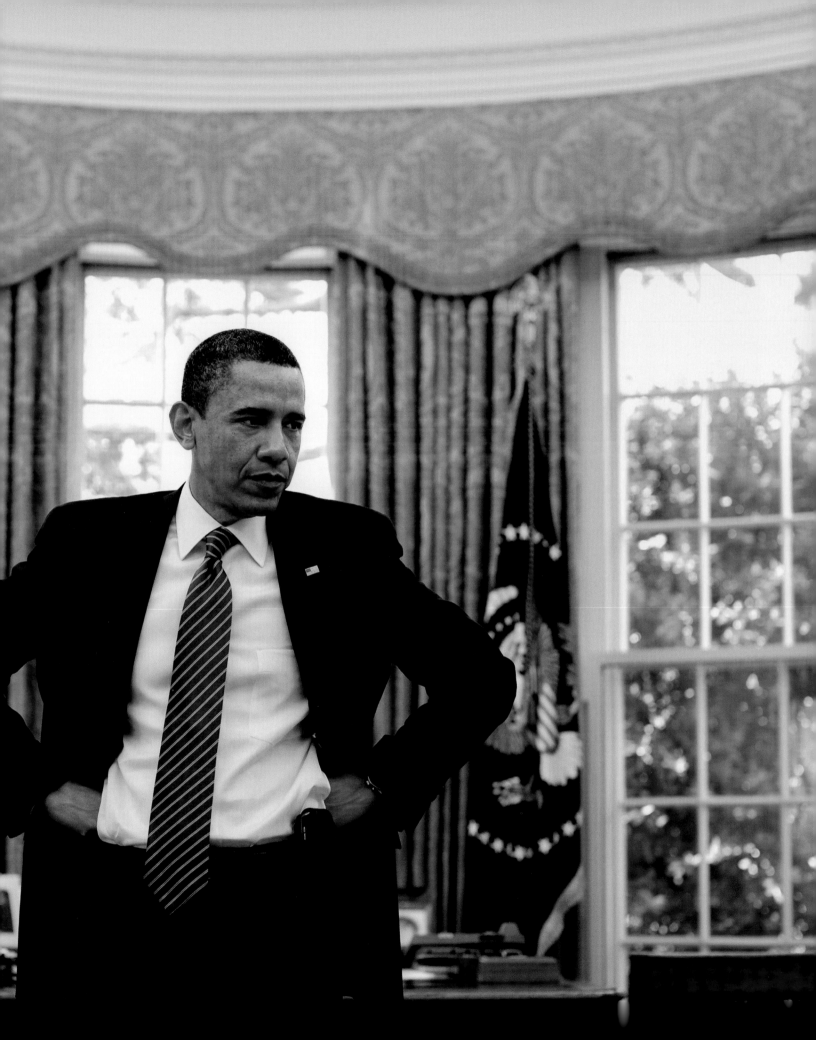

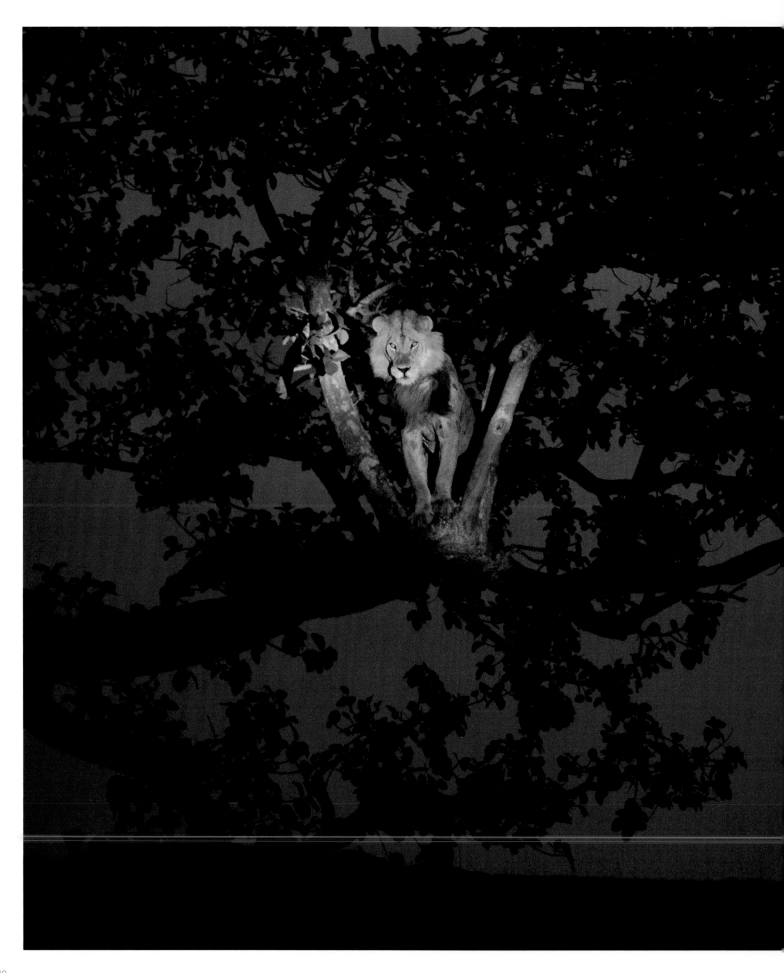

Opposite
2010 I JOEL SARTORE
Uganda
An African lion, illuminated by a spotlight, is woken from his perch in a tree within Queen Elizabeth National Park.

Pages 212-213
2010 I JOE MCNALLY
New York City, New York, U.S.
A landmark among Manhattan's iconic skyline, the Empire State Building uses bright lights at night only to celebrate holidays and special events.

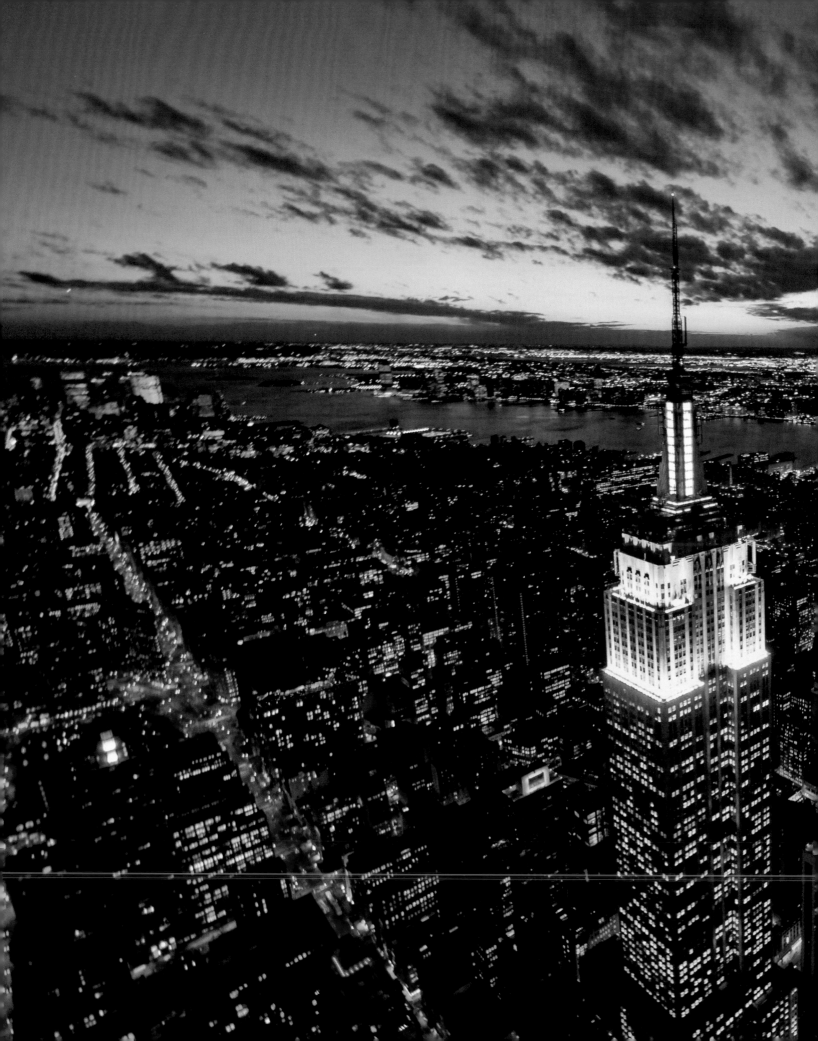

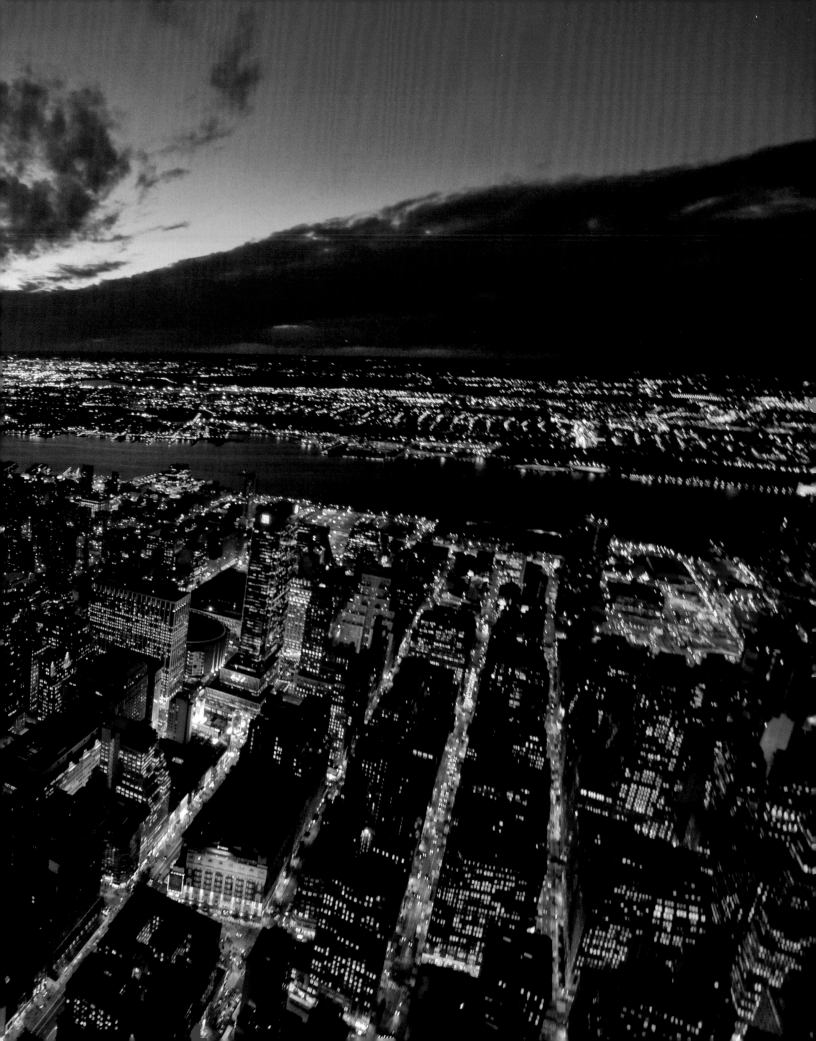

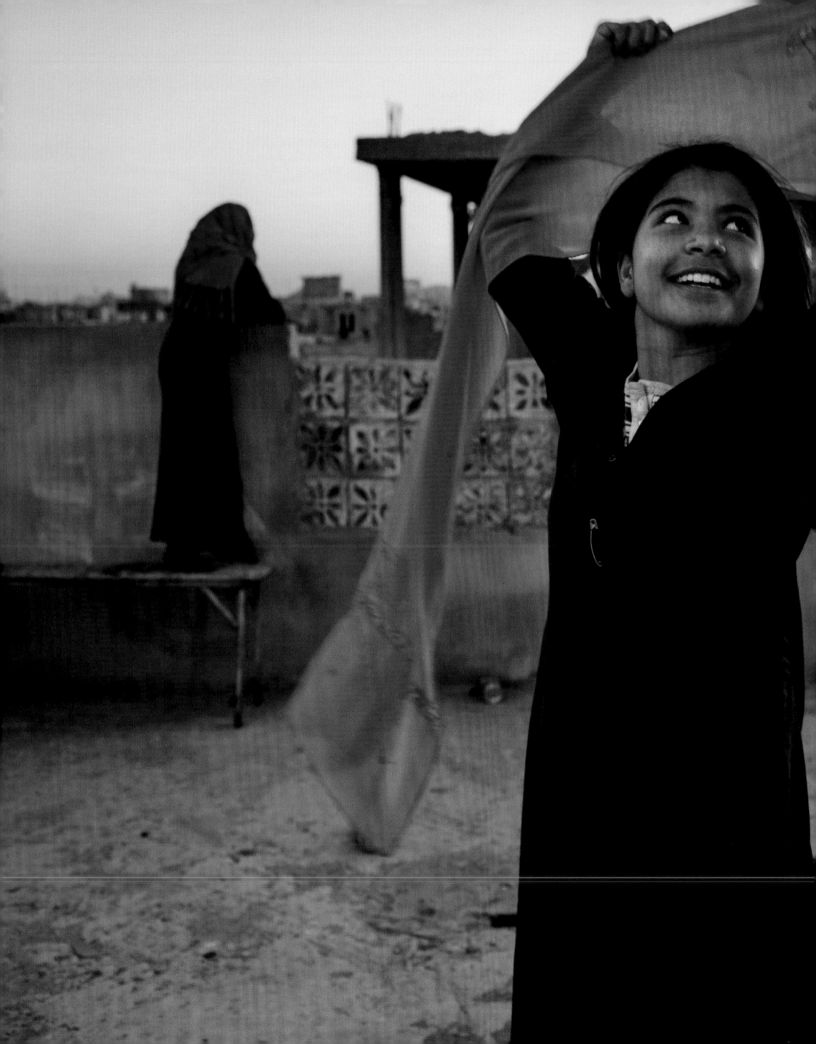

Opposite
2010 | STEPHANIE SINCLAIR
Sanaa, Yemen
A story of a child bride: At age 10,
Nujood Ali took a taxi to a courthouse,
fleeing her abusive husband. Today she
is divorced and back in school.

Pages 216-217
2010 | ERLEND HAARBERG
Iceland
A subglacial volcano erupts under the
Eyjafjallajökull ice cap as the northern
lights dance above the ash plume.

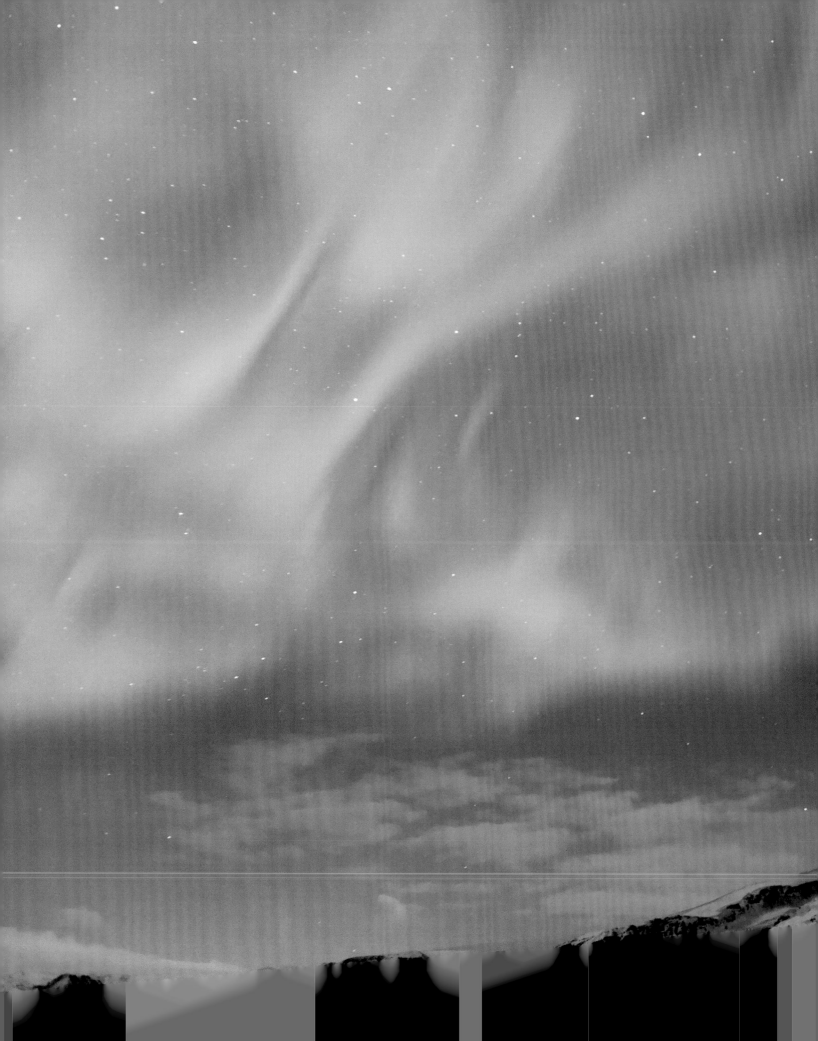

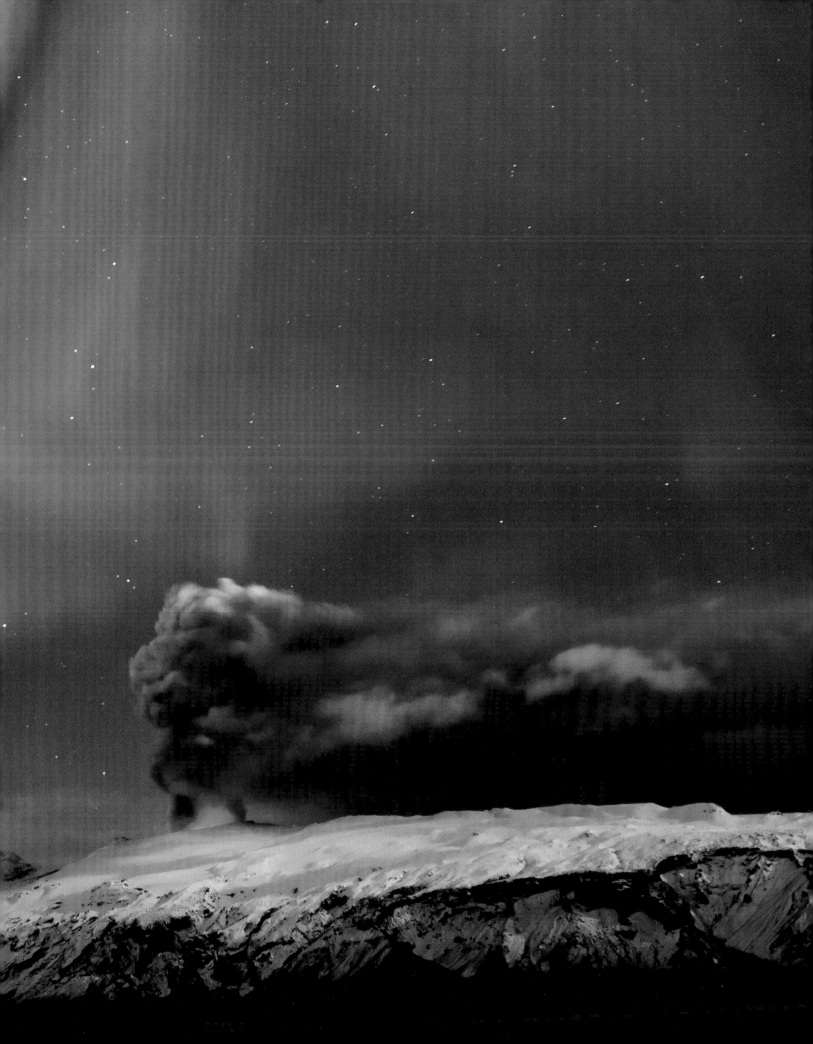

2011 −

-2015

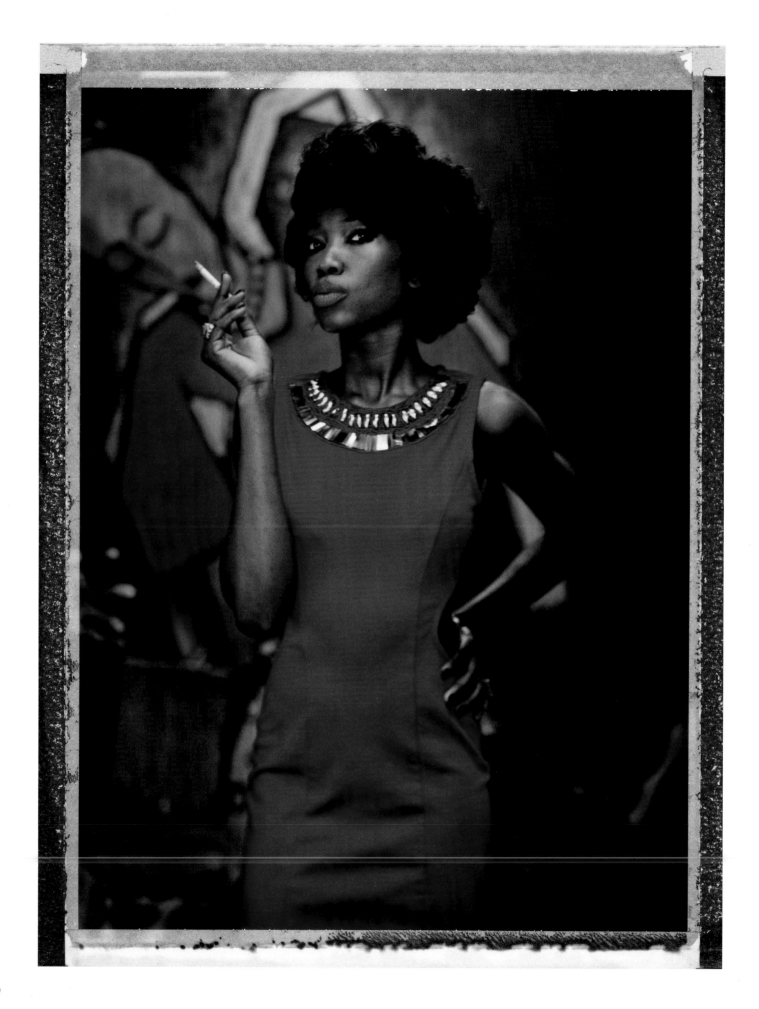

AS THE WORLD

hit a milestone—seven billion people alive on the planet, up one billion in only 11 years—and as voices and images propagated over laptops and cell phones, screens and earbuds, with more and more noise shared around the world, now silence and solitude grew all the more dear. The muffled nothingness we hear underwater, the throb of a sea jelly, the summer glow of fireflies, the steady breathing in and out of one astronaut tethered to one small vessel careening through our one planet's atmosphere: To moments such as these we turned, seeking respite from the noise.

Color and commotion erupted everywhere, in protest and in celebration. Fireworks spoke of new beginnings at each turn of the calendar. Flags of freedom, flowers of union—somehow amid the hubbub we were able to create one ideal image out of many. Even in our imprisoned lives, we could laugh and play. We shared candles in the dark. We found our way to places of wonder still, where the light shone down upon us—rare and undeserved moments of humility and awe.

Purpose arose out of enterprise. Tapping rubber trees, watering palm sprouts, toting baskets of salt, work served a larger purpose. Ingenuity sharpened our collective intelligence. We harvested power from an orange, reconnected the bones of eons back, dusted off artifacts revealing a long-lost civilization.

We trained our sights to galaxies beyond, and at the same time looked more deeply into this world we inhabit. A red fox peers through the grass. Insect eyes present a miracle. Corals glow beneath still waters. Musk oxen bulk up for the weather. Autumn leaves yellow and fall.

No matter our human numbers, nature persists. Mice and flowers, swans and lily pads remind us what we have to lose. As the years go by, it feels more and more like a race run underwater. Yet we take up the challenge, seeing ever more clearly what we must strive with all our hearts to protect. ◾

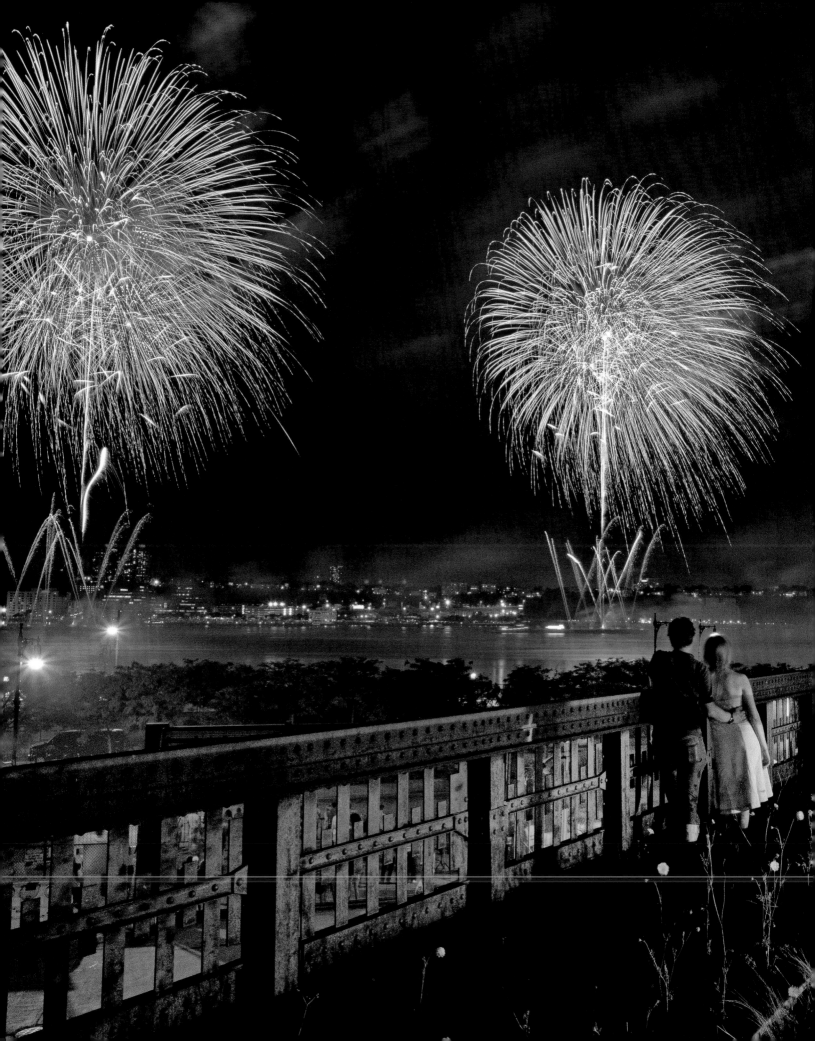

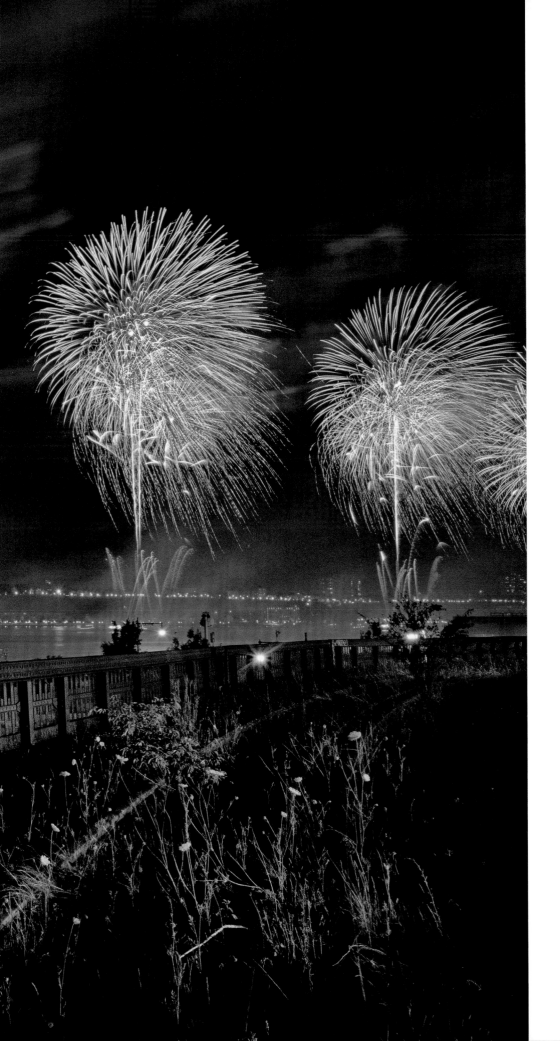

Opposite
2011 I DIANE COOK AND LEN JENSHEL
New York City, New York, U.S.
Standing on Manhattan's High Line in the
Chelsea neighborhood, a couple watches
Fourth of July fireworks burst above the
Hudson River.

Pages 218-219
2012 I PAUL NICKLEN
Yucatán Peninsula, Mexico
A diver explores a cenote—a deep water-
filled sinkhole—near the Maya ruins of
Tulum.

Page 220
2013 I ROBIN HAMMOND
Lagos, Nigeria
A 24-year-old woman poses at the
African Artists' Foundation in Lagos,
an example of the city's flourishing
cultural scene.

2011 I NANCIE BATTAGLIA
Eagle Bay, New York, U.S.
A crush of 1,902 canoes and kayaks gather on
Fourth Lake in the Adirondacks to attempt
to break a "largest raft" world record.

2011 I KLAUS NIGGE
Sisal, Yucatán, Mexico
Flamingos, fiercely loyal in wild flocks, move
in unison when there is a threat, as here,
when a research plane passes overhead.

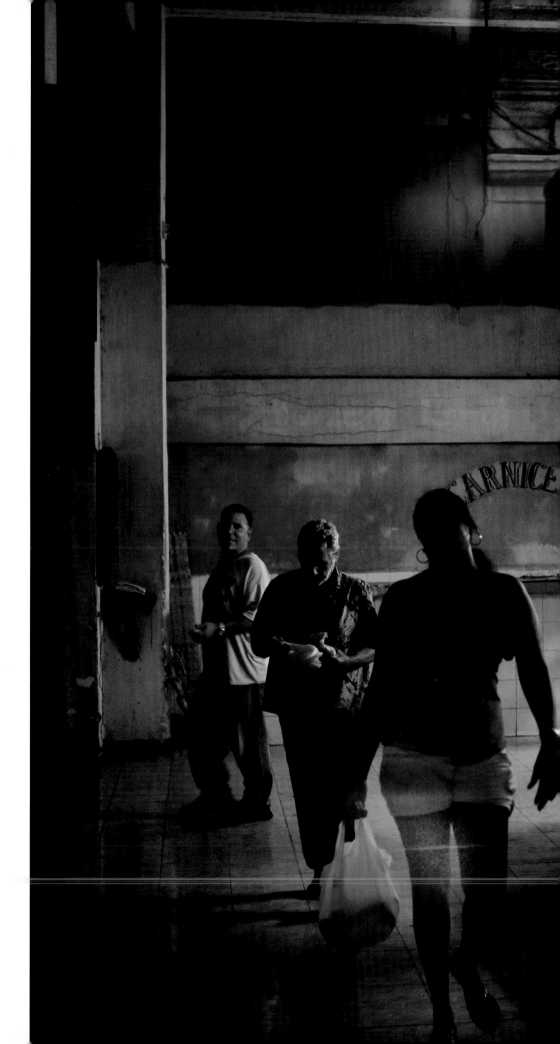

Opposite
2011 I PAOLO PELLEGRIN
Havana, Cuba
Cubans receive ration books to secure staples like rice, beans, and oil at low prices, but groceries are poorly stocked in markets, like this butcher shop in central Havana.

Pages 226-227
2011 I MURRAY FREDERICKS
Kati Thanda–Lake Eyre National Park, Australia
At first light, predawn colors are reflected and distorted by a rare rain puddle in the highly saline Lake Eyre.

Pages 230-231
2011 I JOEL SARTORE
Sofala Province, Mozambique
A pair of blue waxbills, *Uraeginthus angolensis*, perch on thin branches. The birds are a common sight in Gorongosa National Park.

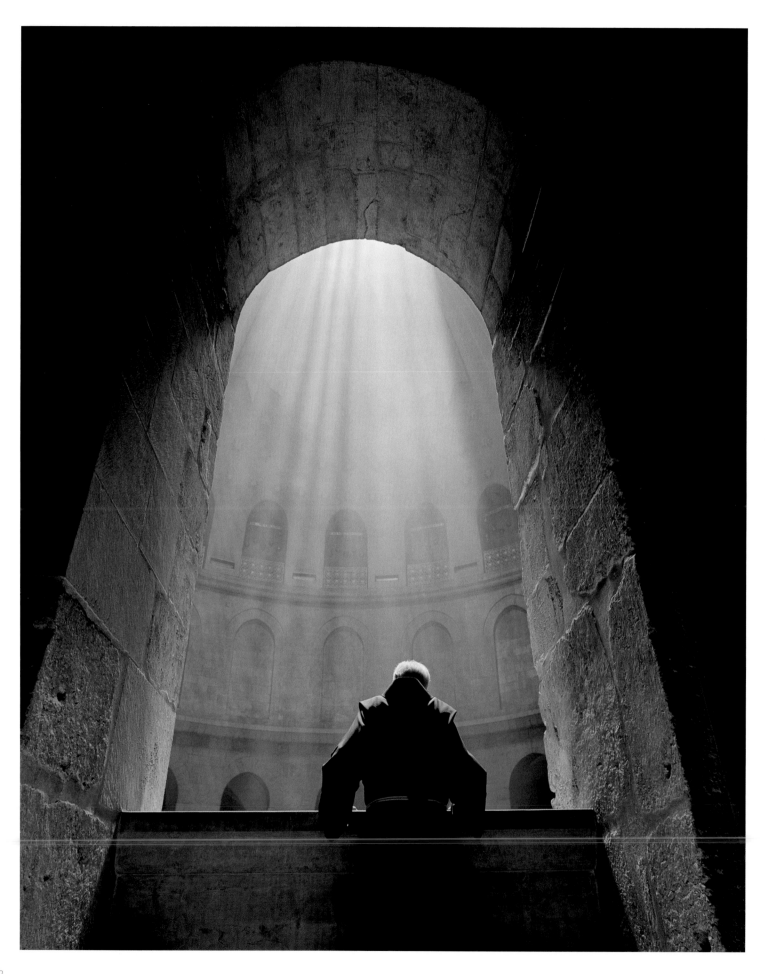

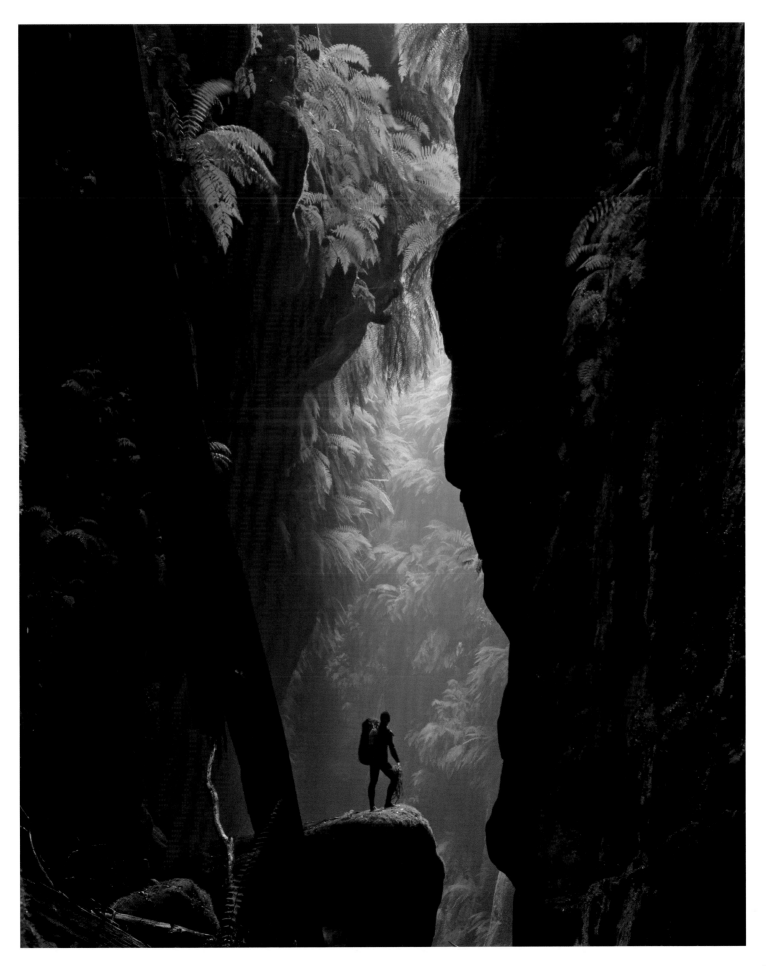

Opposite

2011 I ABELARDO MORELL

Grand Teton National Park, Wyoming, U.S.
Using a periscope lens at the top of a tent, photographer Abelardo Morell projects Mount Moran 90 degrees onto the ground, where grass and dirt show through the natural landscape.

Page 232

2011 I LYNN JOHNSON

Jerusalem, Israel
A Franciscan priest gazes at the Tomb of Christ in the Church of the Holy Sepulchre. Originally consecrated in A.D. 335, the church lies within the Old City of Jerusalem and maintains much of its ancient grandeur.

Page 233

2011 I CARSTEN PETER

New South Wales, Australia
Cascades of mammoth ferns flourish in the humid air trapped between the narrow walls of Australia's popular Claustral Canyon, which was first explored in 1963.

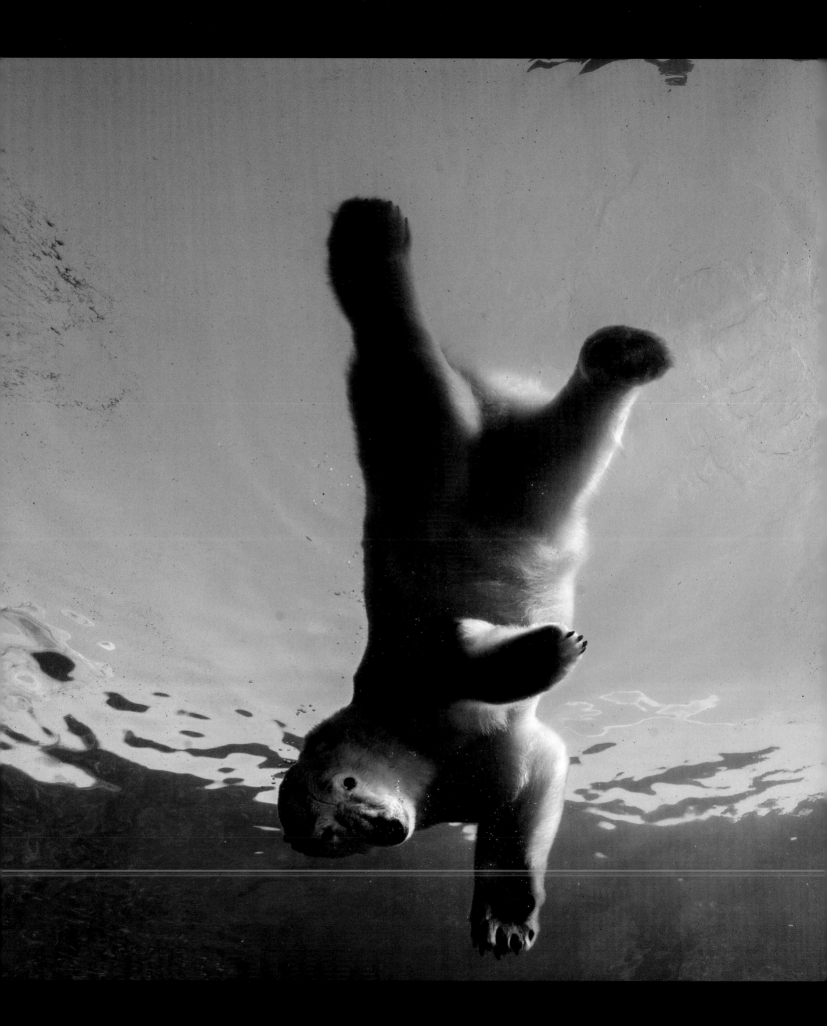

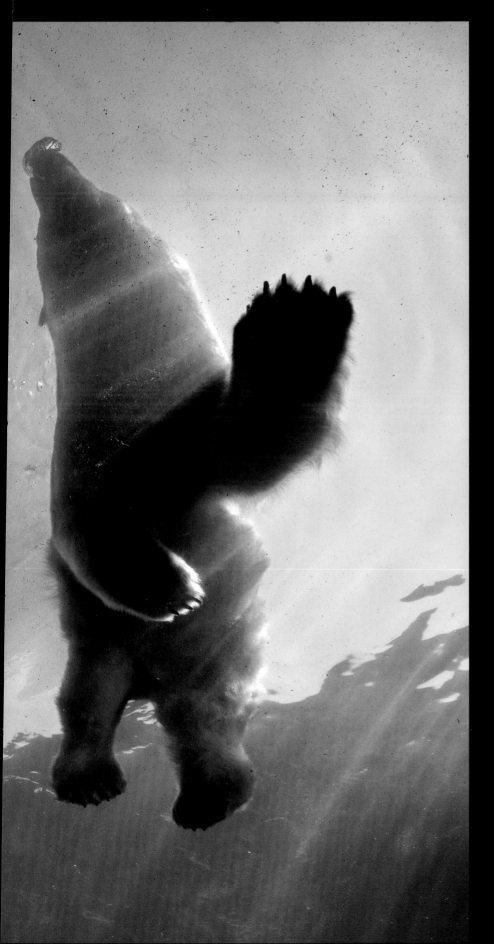

JOEL SARTORE

For a *National Geographic* magazine story on "New Zoos," I traveled far and wide to see the best in animal care around the world. Within the past few decades, good zoos have become true conservation centers, and it shows. Larger exhibits, complete with a variety of animal activities called "enrichment programs," have become commonplace.

The new polar bear space at the Columbus Zoo and Aquarium in Ohio was no exception. Inside a huge enclosure was a swimming hole, blue as the sky and filled with a school of trophy trout. Supposedly they were there for the bears to feed on—if only they could catch one. The trout seemed unconcerned, knowing they could easily swim circles around the lumbering white giants.

I marveled at it all, looking up through the clear ceiling of a dark, cool room built directly under the pond. As the bears seemed to practice a choreographed routine, I could see rays of light dancing across the faces of my fellow guests. All were smiling. ∎

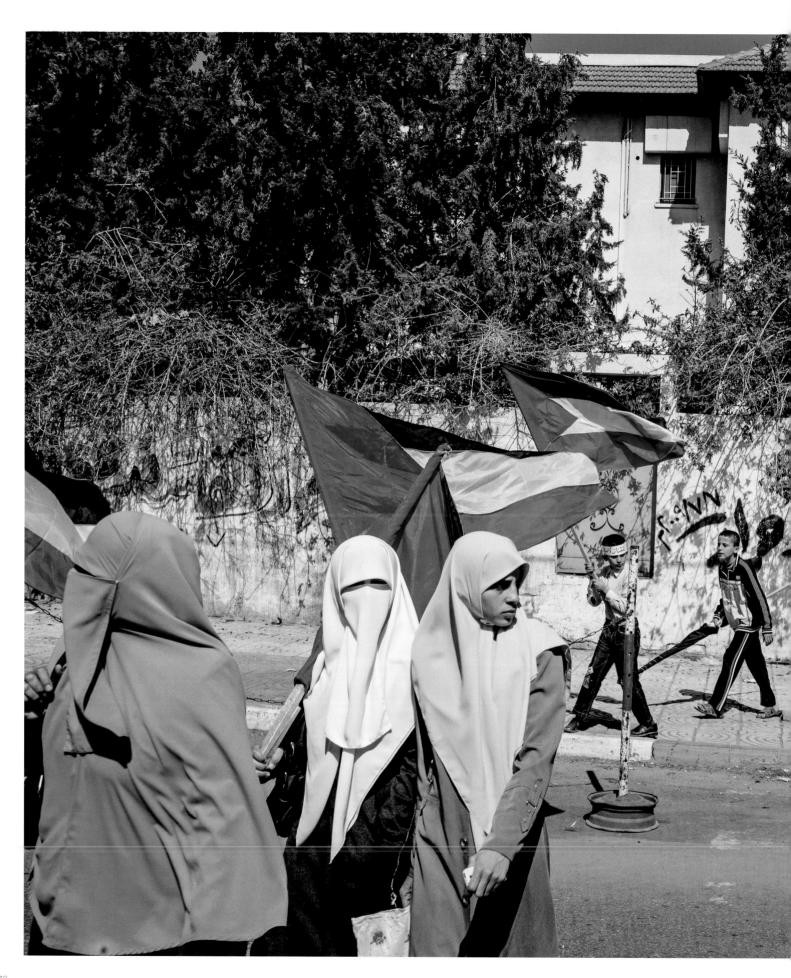

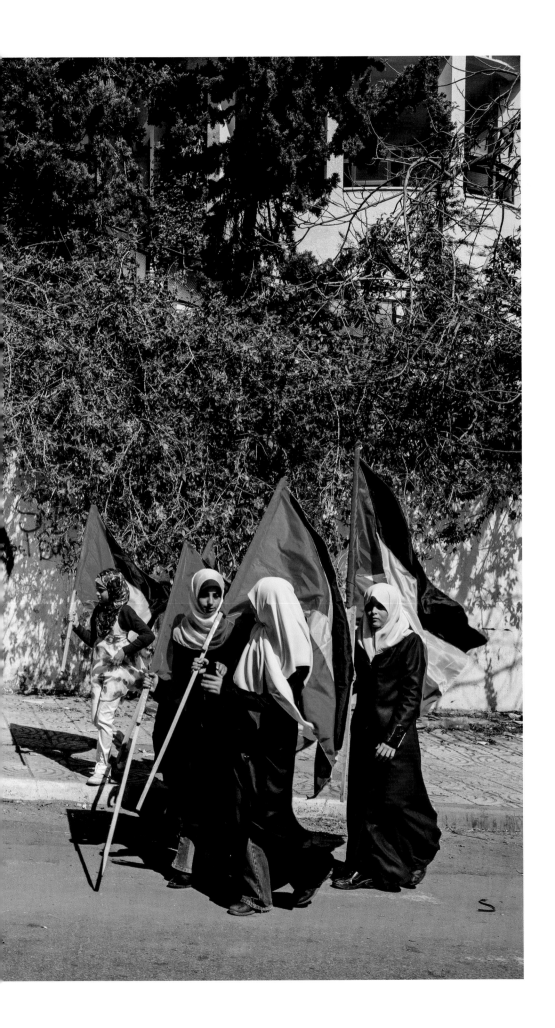

2011 | PAOLO PELLEGRIN
Gaza City, Gaza Strip
Carrying Palestine's flag, women of Hamas protest outside the Gazan parliament against the Israeli siege of Gaza.

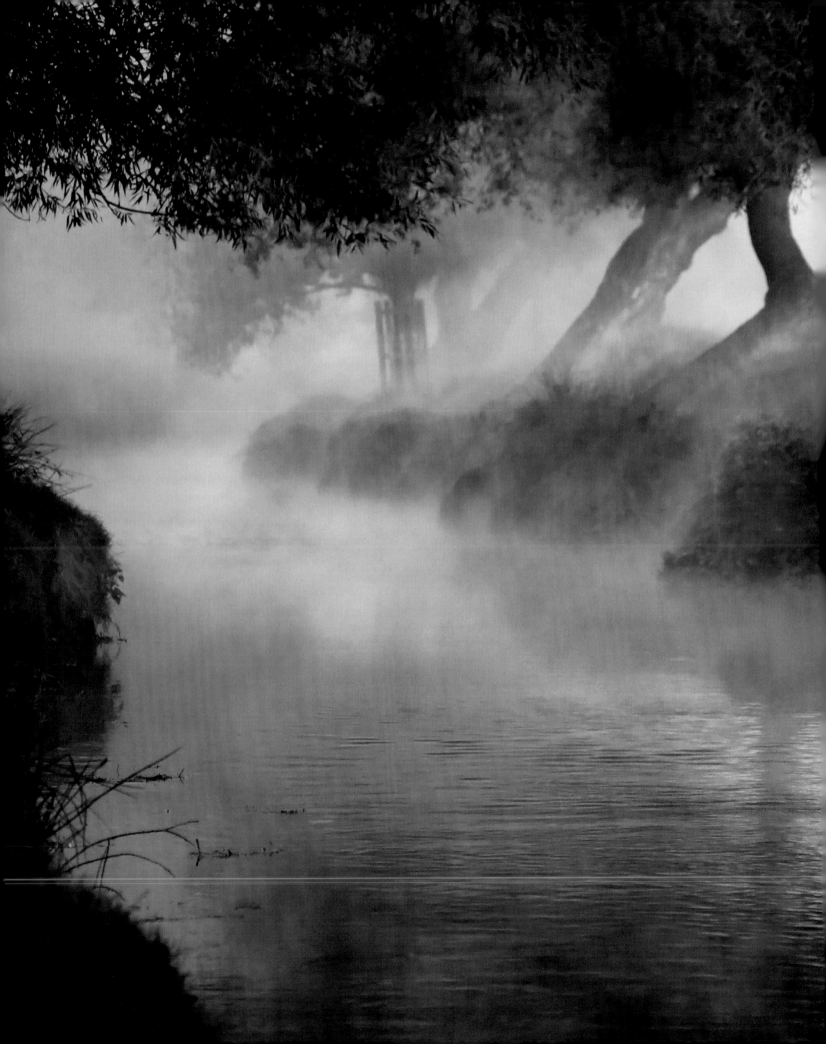

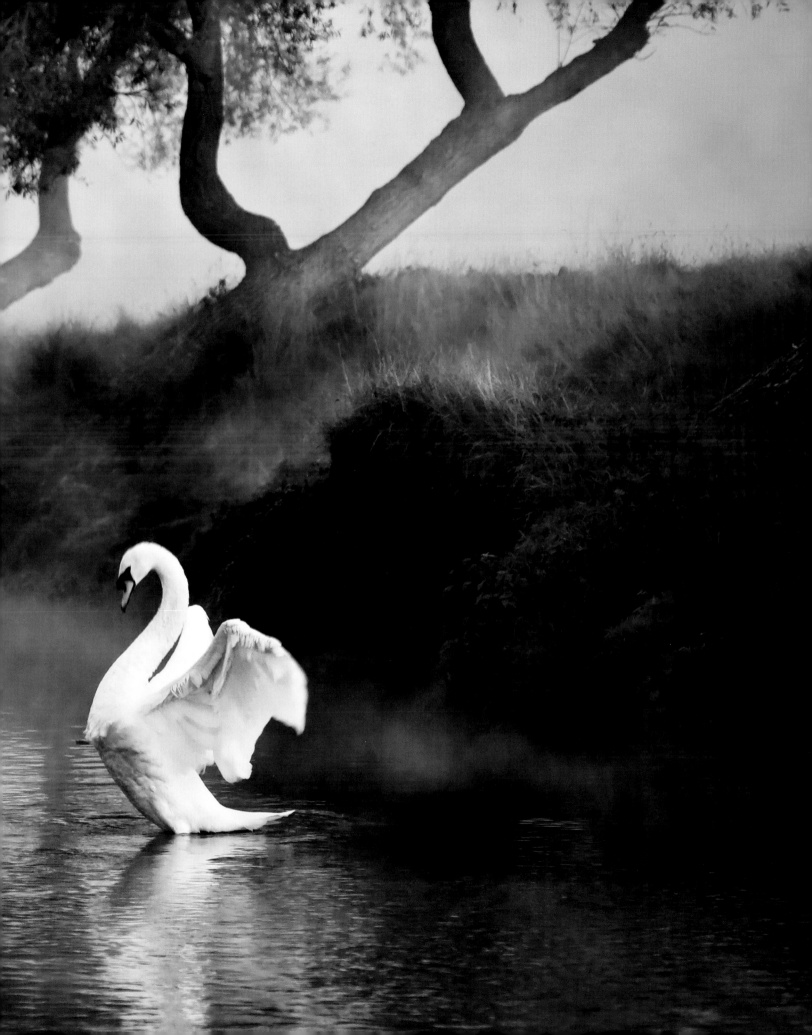

Opposite
2012 | CALEB CHARLAND
Maine, U.S.
Wedges of an orange generate enough current and electrical juice—3.5 volts—to power an LED. The fruit's citric acid helps electrons flow from galvanized nails to copper wire.

Pages 240-241
2011 | ALEX SABERI
London, England
A lone mute swan stretches its wings upon a brook as the mists of dawn filter through Richmond Park. By tradition, the British monarch has the right to claim ownership of unmarked birds of this species in open water.

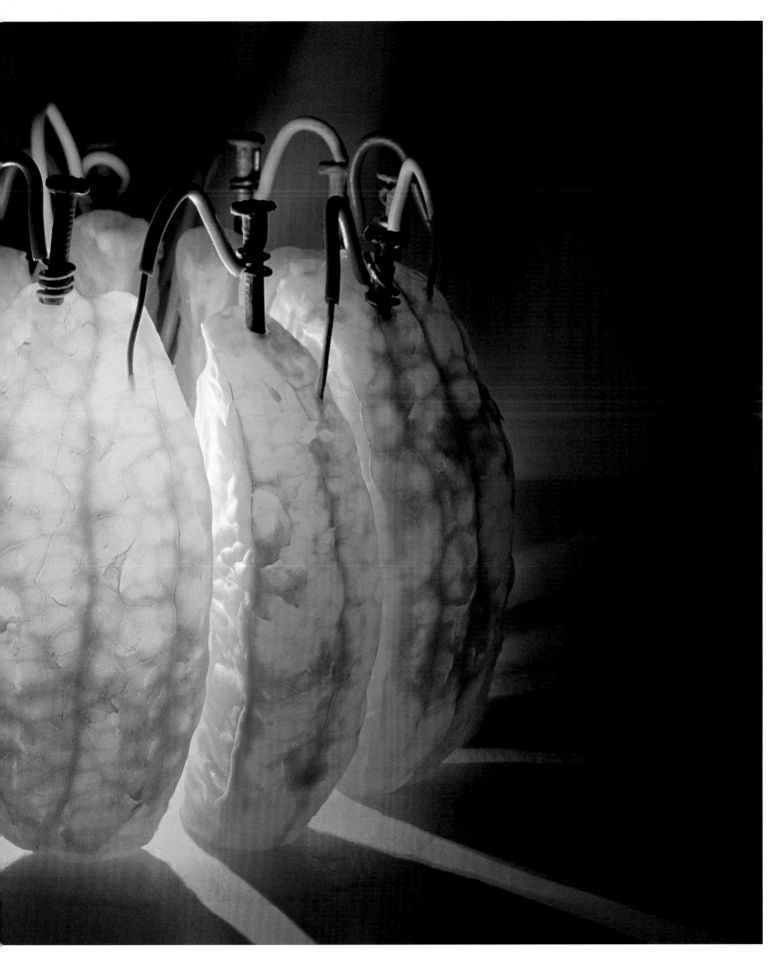

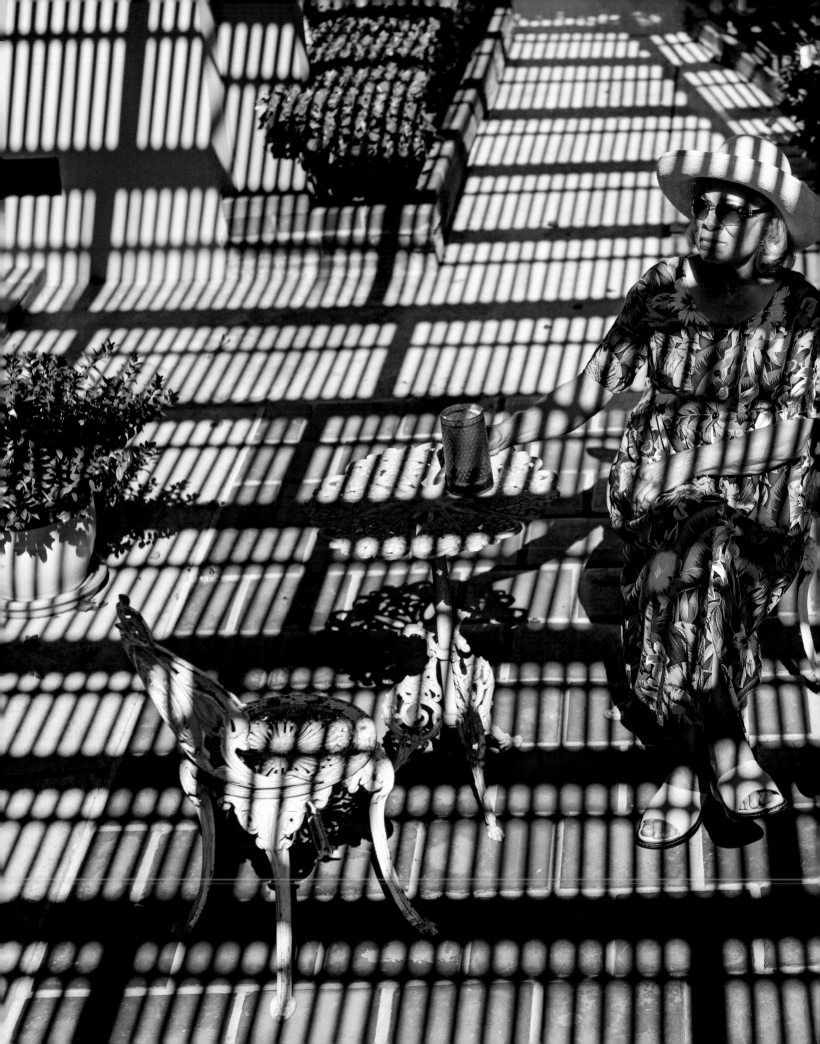

2012 | FRITZ HOFFMANN
San Diego, California, U.S.
Sitting near a rose garden, an 85-year-old woman relaxes beneath her patio lattice.

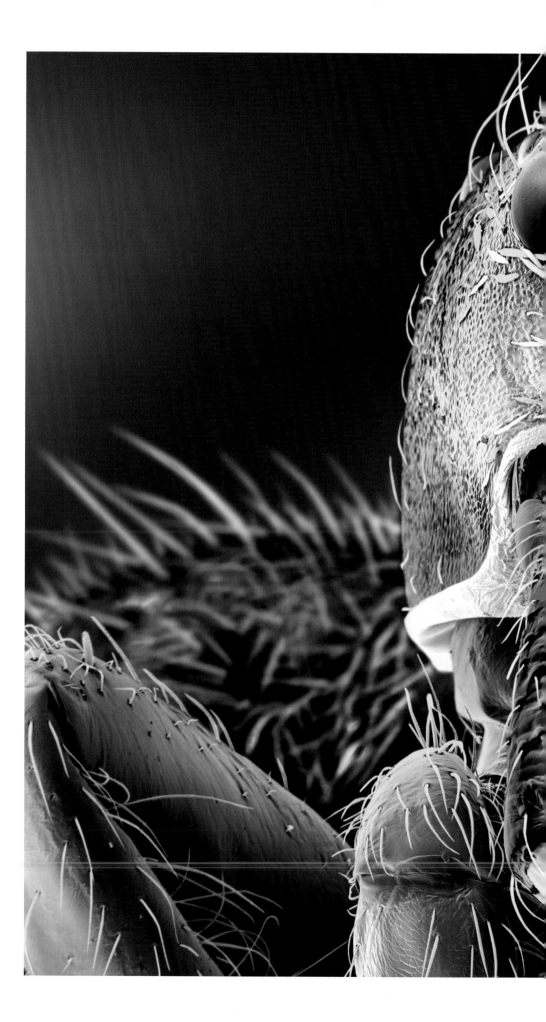

Opposite
2012 | MARTIN OEGGERLI
Switzerland
The jumping spider, a predator that can leap distances more than 10 times its size, has eight eyes in total with unique retinas that help it gauge distance, giving it an almost 360-degree view of its surroundings.

Pages 248-249
2012 | DAVE YODER
Atacama Desert, Chile
Light from the setting sun dances on antennae forming part of the Atacama Large Millimeter/submillimeter Array (ALMA).

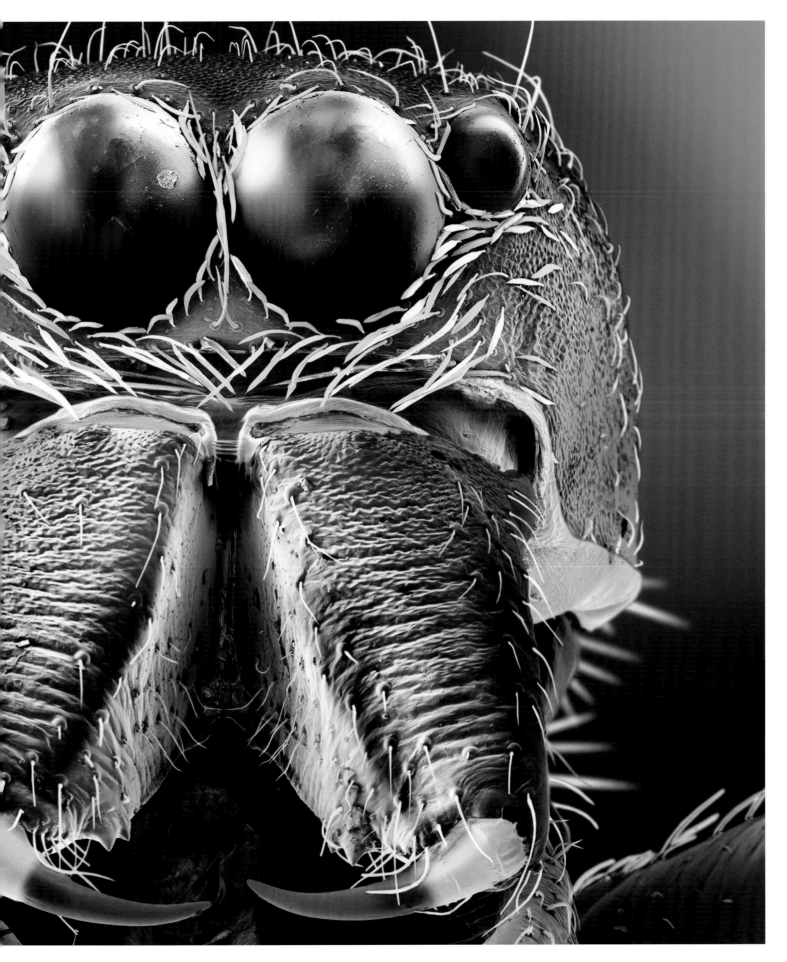

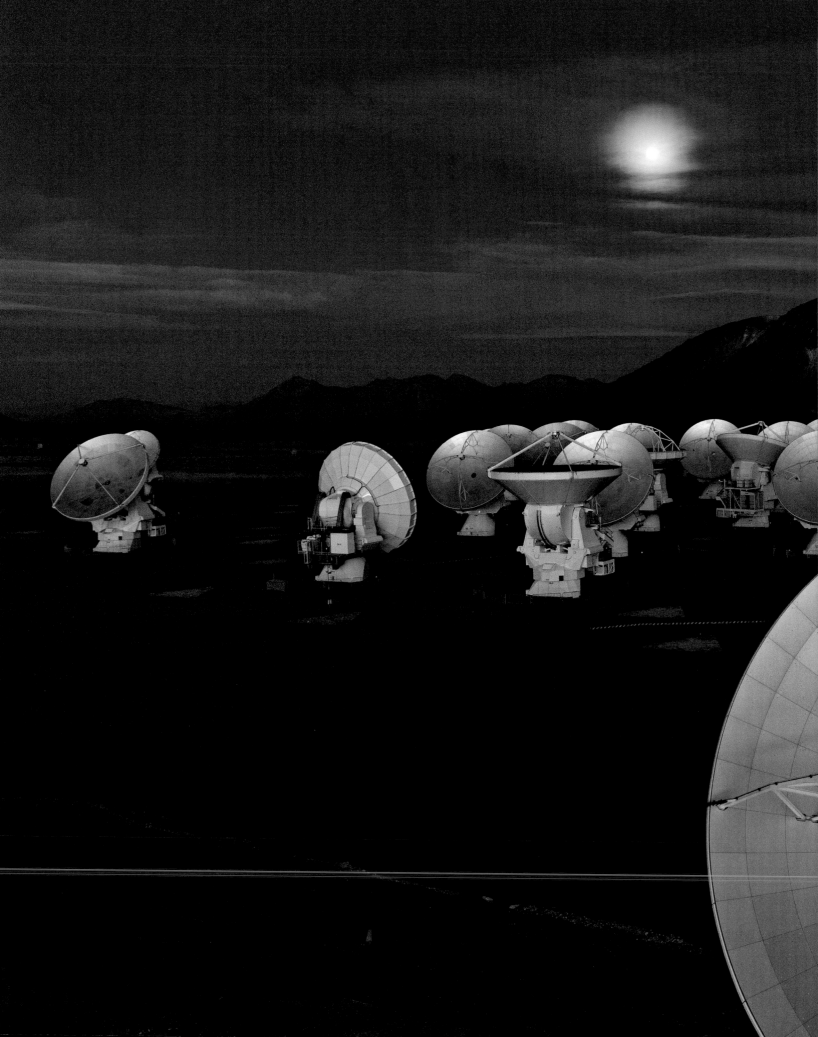

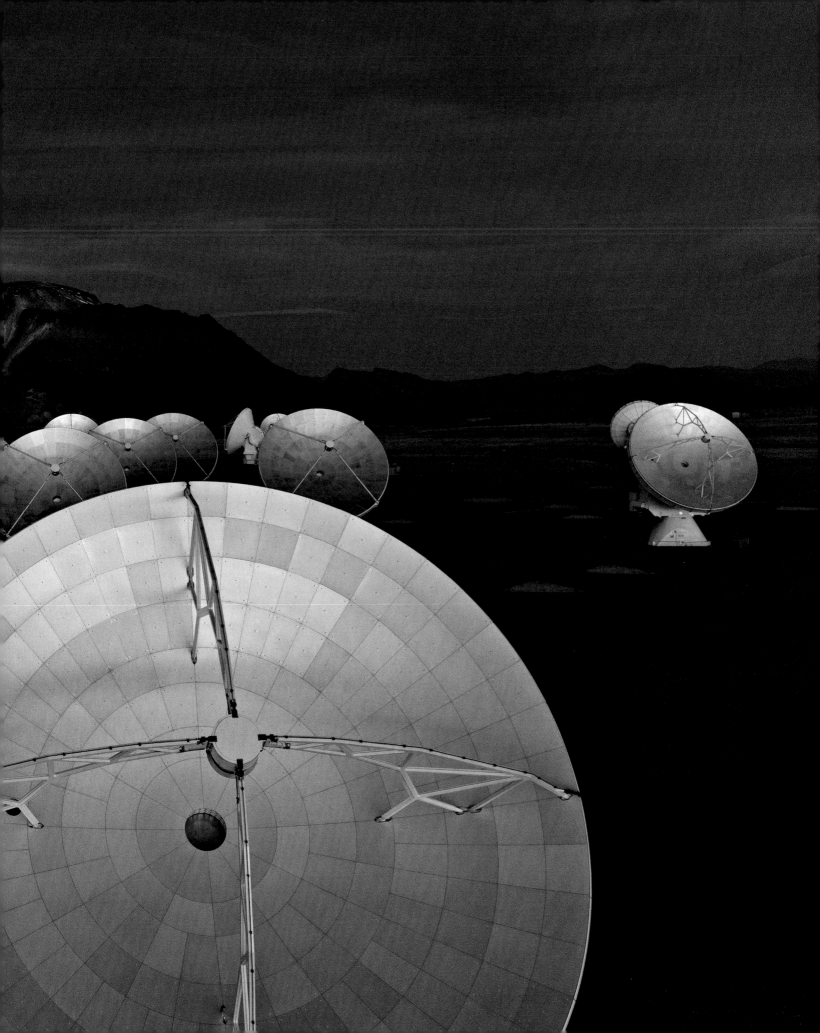

Opposite
2012 | SERGEY GORSHKOV
Wrangel Island, Russia
Two bull musk oxen size each other up.
During mating season, bulls engage in
frequent head-butting confrontations
to establish dominance.

Pages 252-253
2012 | STEPHANIE SINCLAIR
Sanaa, Yemen
Generators keep lights blazing as rela-
tives and neighbors fete a bridegroom
(in floral headscarf) at his wedding in
Sanaa's Old City.

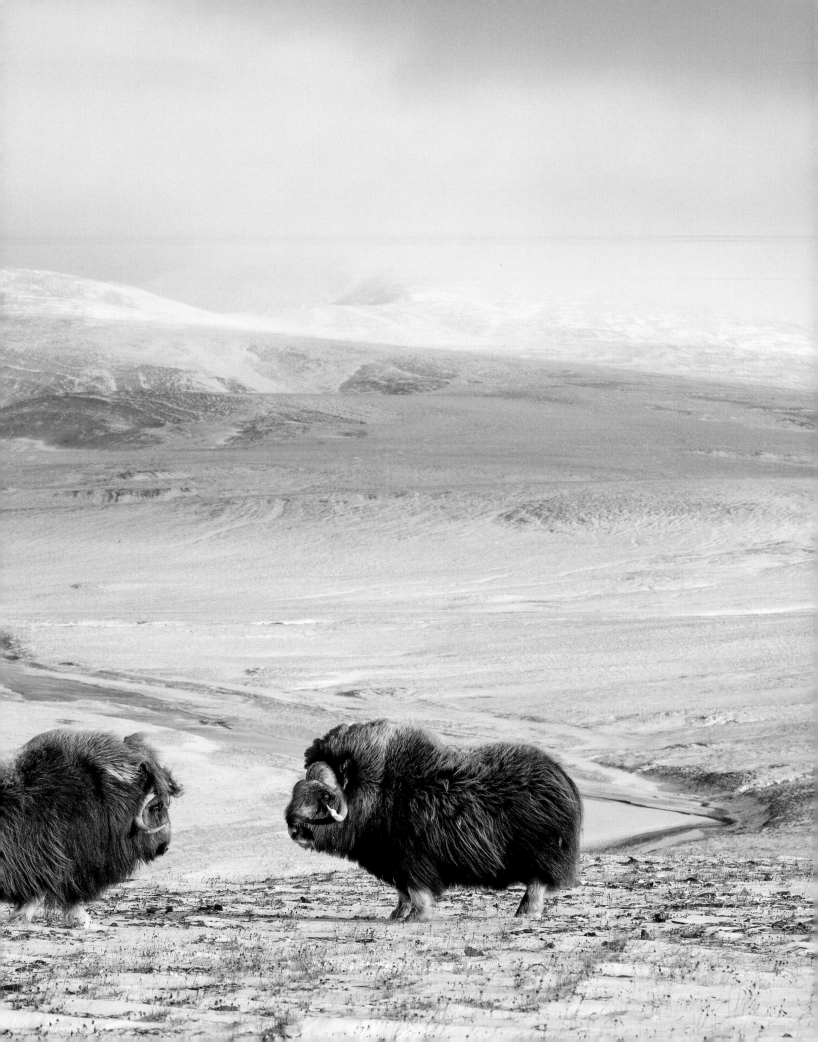

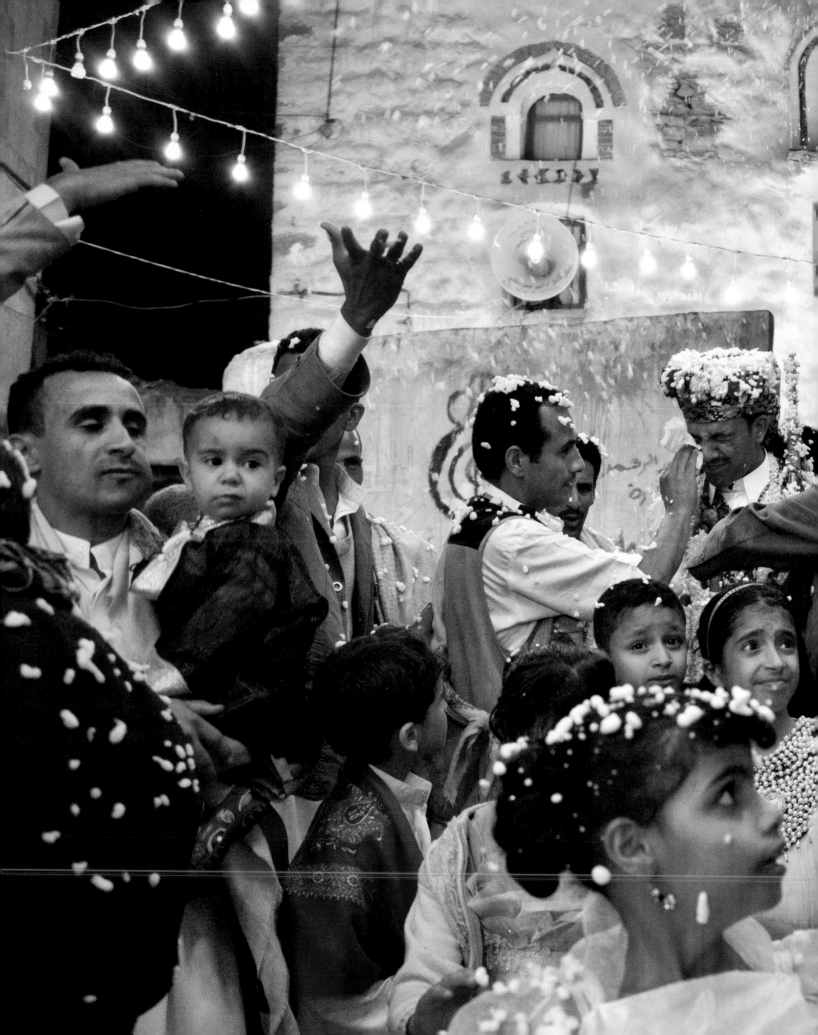

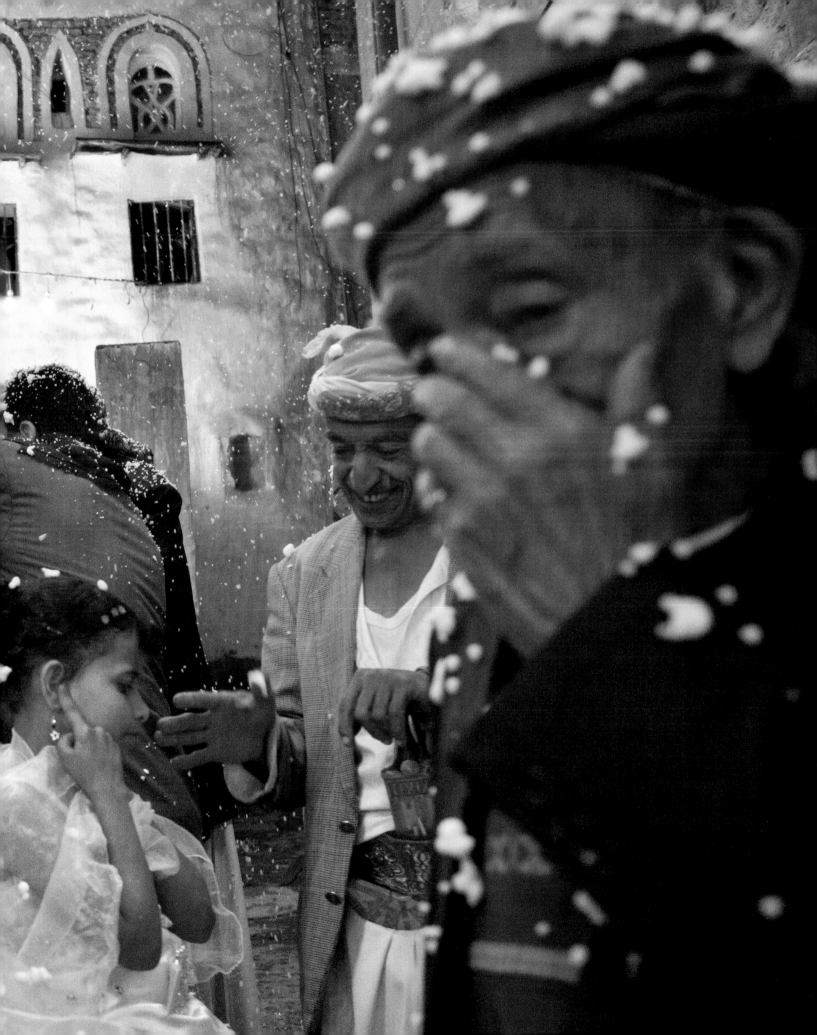

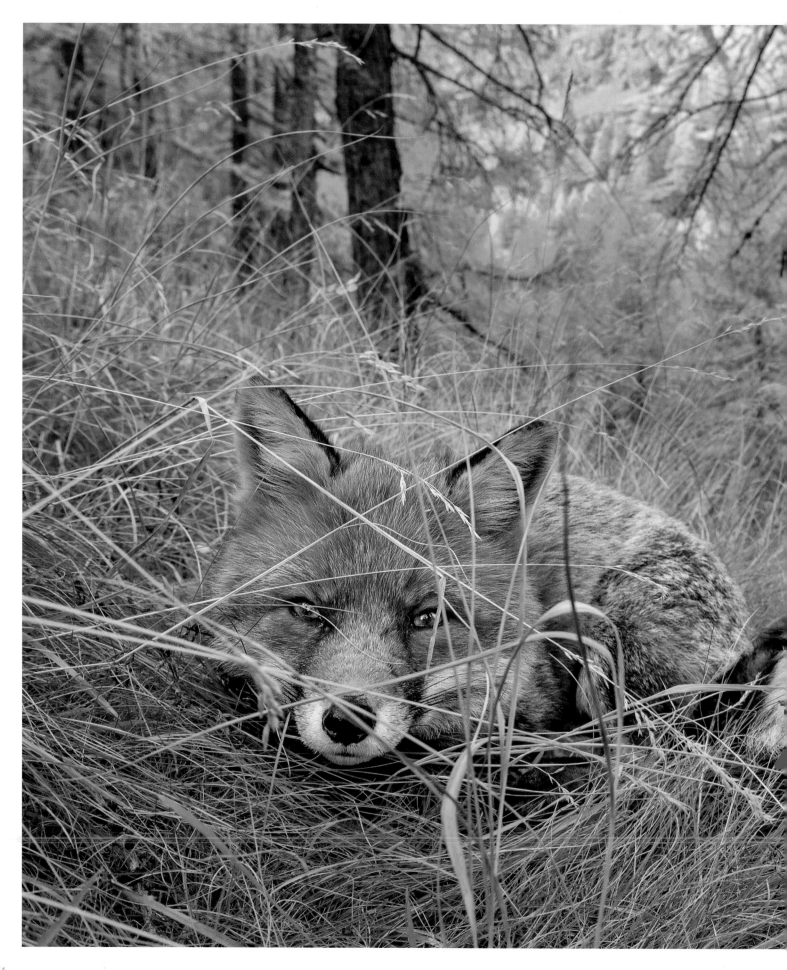

2012 I STEFANO UNTERTHINER
Valle d'Aosta, Italy
A red fox, *Vulpes vulpes*, lies in wait, camouflaged by the autumn woods in Gran Paradiso National Park.

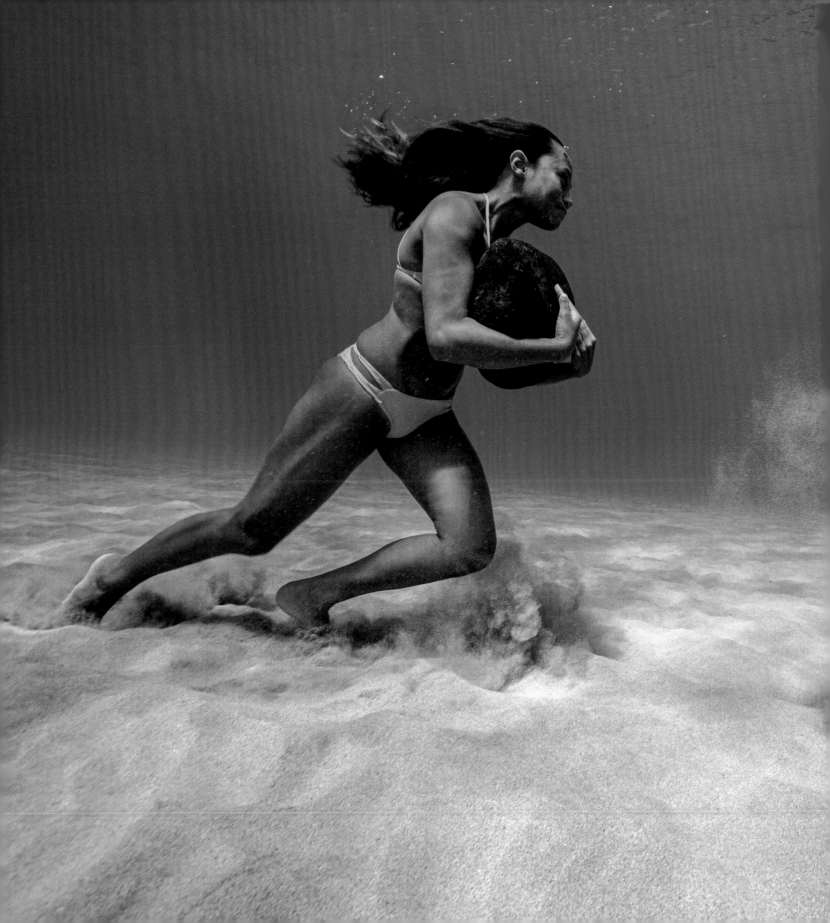

PAUL NICKLEN

Ha'a Keaulana, daughter of Brian Keaulana and granddaughter of the legendary Buffalo Keaulana, carries a 50-pound (22.7 kg) boulder while running across the seafloor as part of her surf-training regimen in Mākaha, Hawaii.

Her father helps surfers prepare for a four-wave hold-down in case of a wipeout in big surf. With 13-second intervals between waves, that adds up to about a minute underwater in the angry, swirling ocean—a very different experience from holding your breath in a swimming pool.

I was on scuba as I shot this moment, watching in awe at her power, grace, and natural ability underwater. I am grateful to have been exposed to this beautiful part of the world and the incredible people who live here. Ha'a is a true water woman and has salt water running through her veins, the epitome of what it means to be connected to the sea. ∎

2012 I SIMON MONTGOMERY
London, England
Cyclists pedal past the Olympic velo-
drome in Queen Elizabeth Olympic Park.
The sporting complex was originally
built for the 2012 Summer Olympics and
Paralympics.

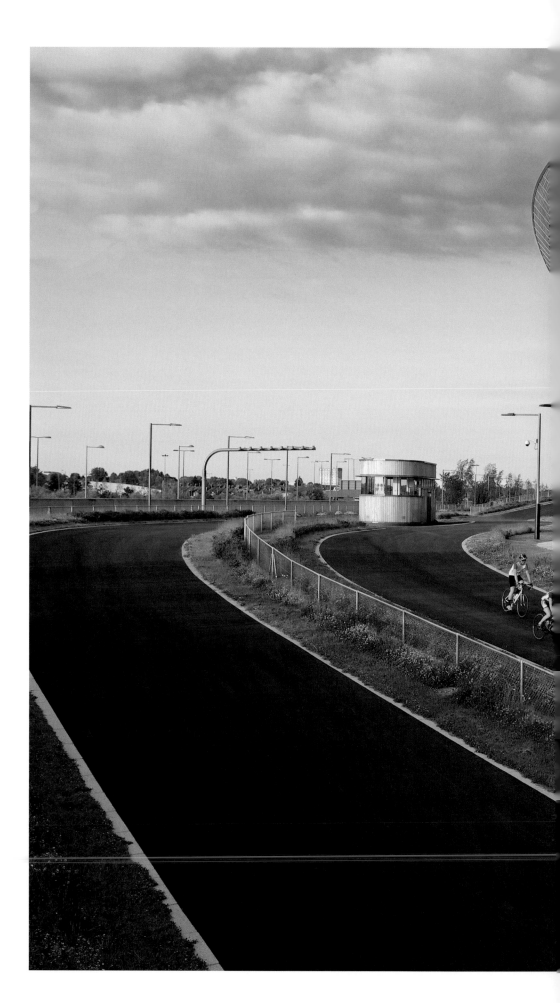

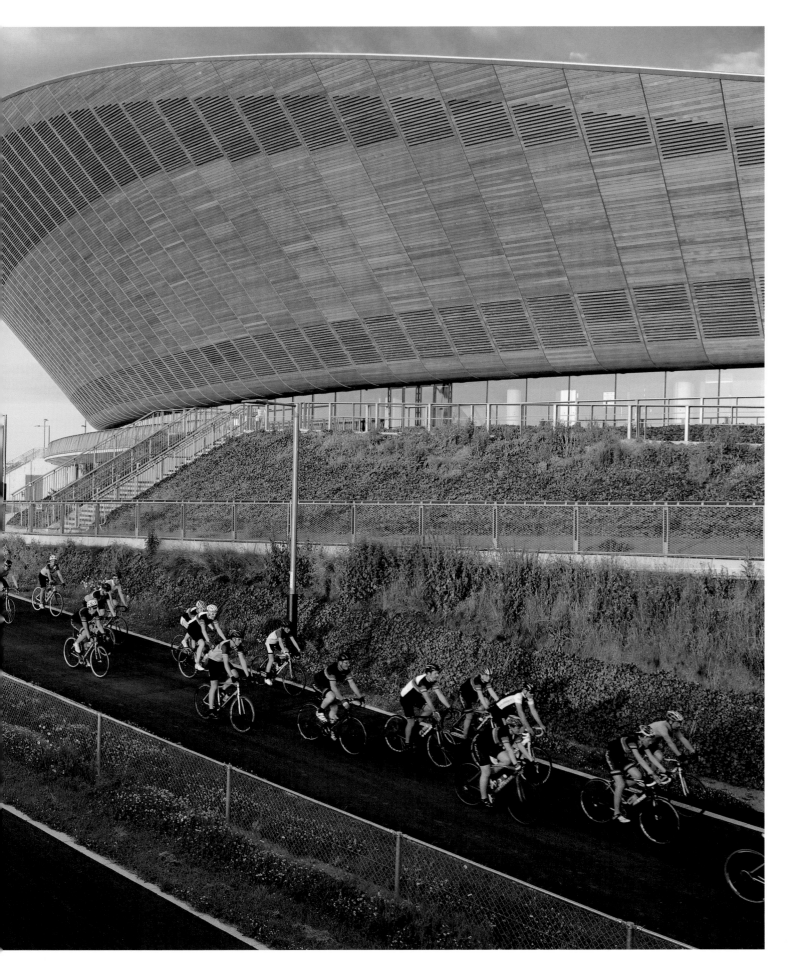

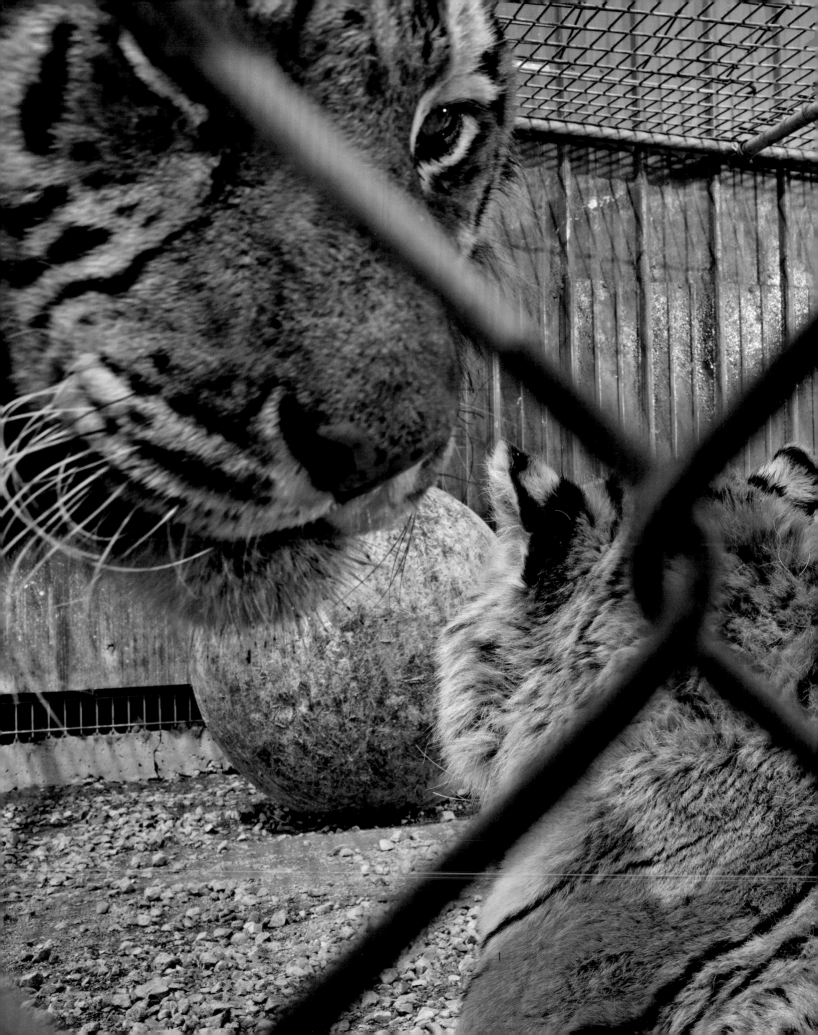

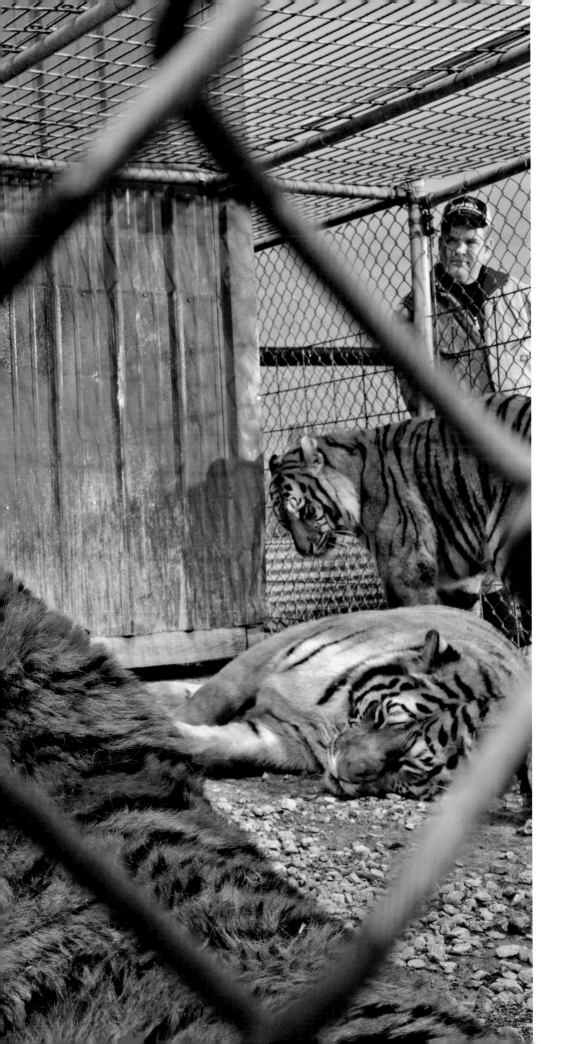

Opposite
2013 | VINCENT J. MUSI
Prospect, Ohio, U.S.
An exotic pet owner, Mike Stapleton, stands outside his enclosed tigers—at the time of this photo, he owned five—at Paws & Claws Animal Sanctuary.

Pages 262-263
2013 | DAVID DOUBILET
New Britain Island, Papua New Guinea
A garden of delicate coral is sheltered from storms in the lee of a nearby peninsula. Kimbe Bay's reefs help sustain local fishermen, some of whom still rely on traditional outrigger canoes.

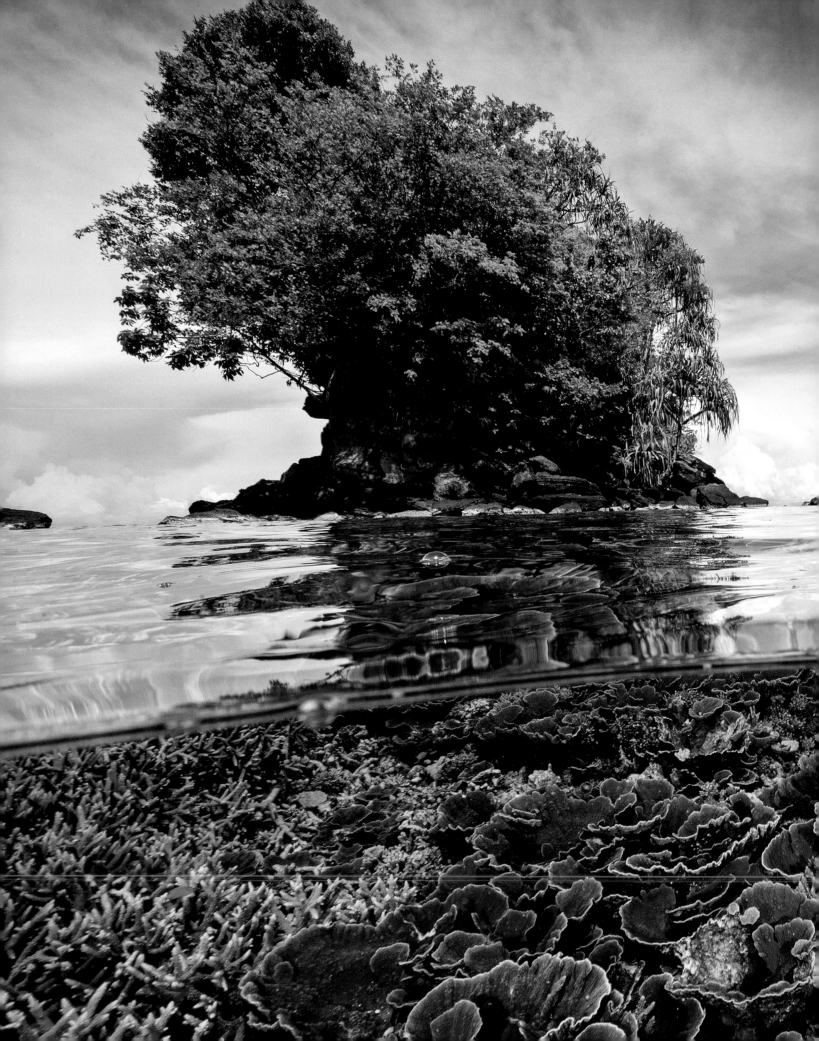

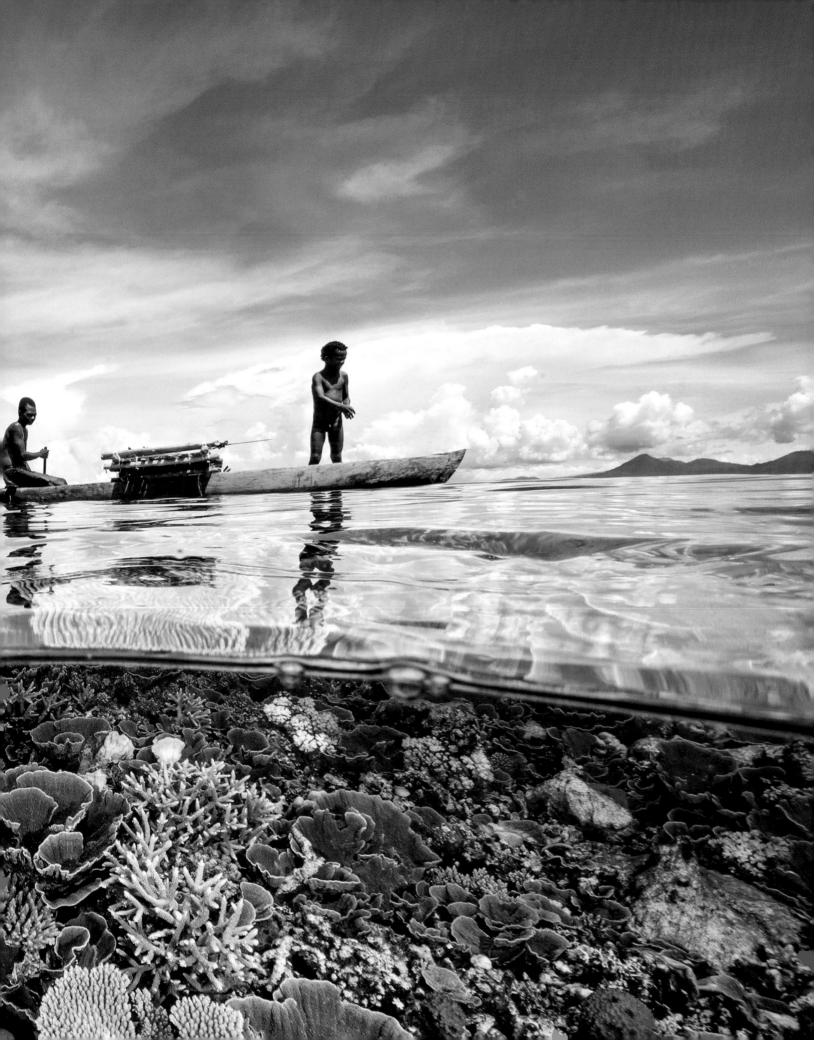

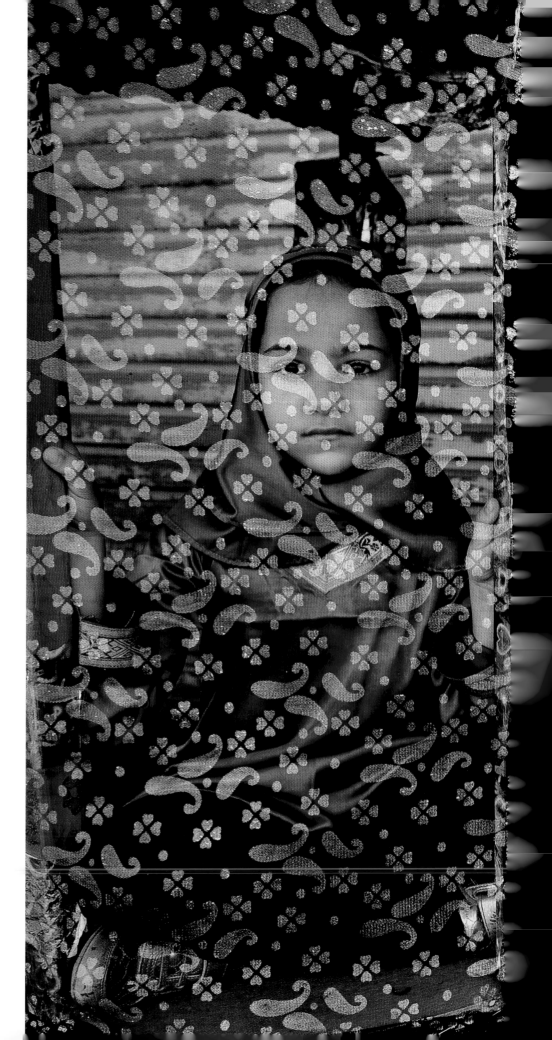

2013 I MOHAMMED AL-SHAIKH
Manama, Bahrain
In the village of Sanabis, two Shiite girls take part in an Ashura ceremony. The annual holiday commemorates the seventh-century martyrdom of Husayn, a grandson of Islam's founder, the Prophet Muhammad.

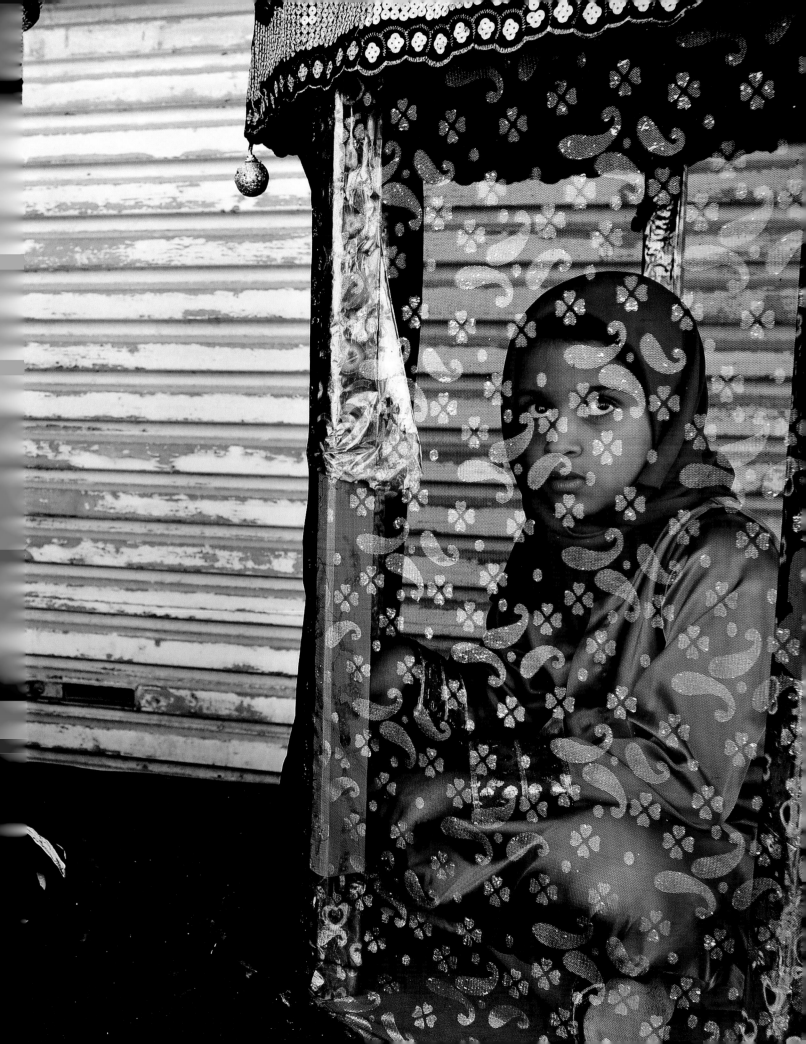

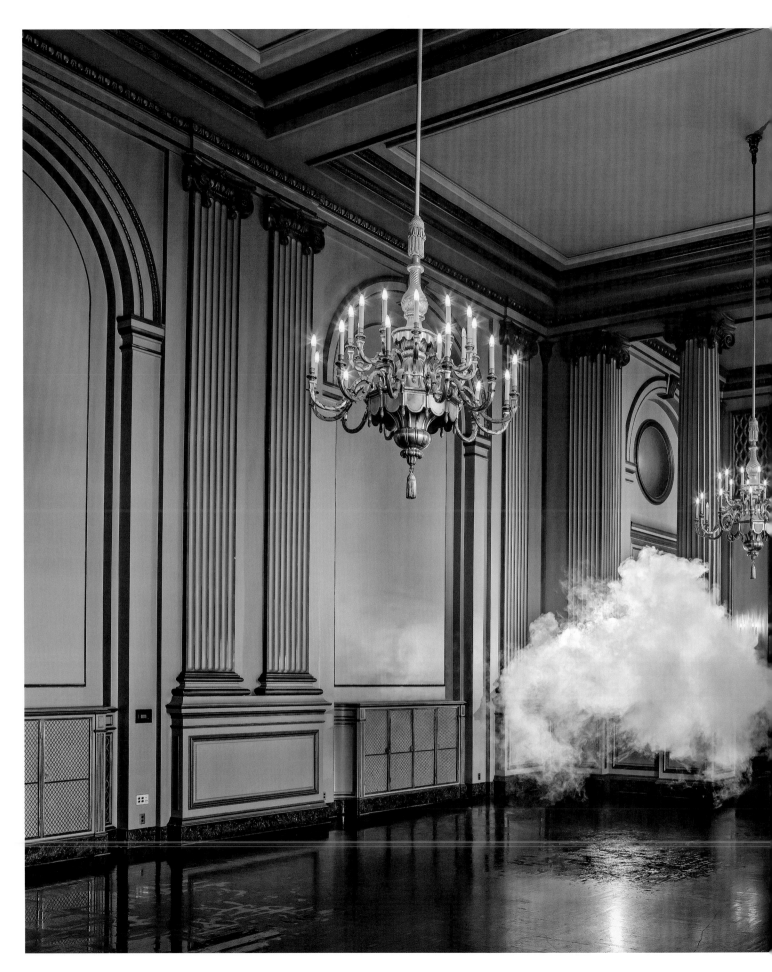

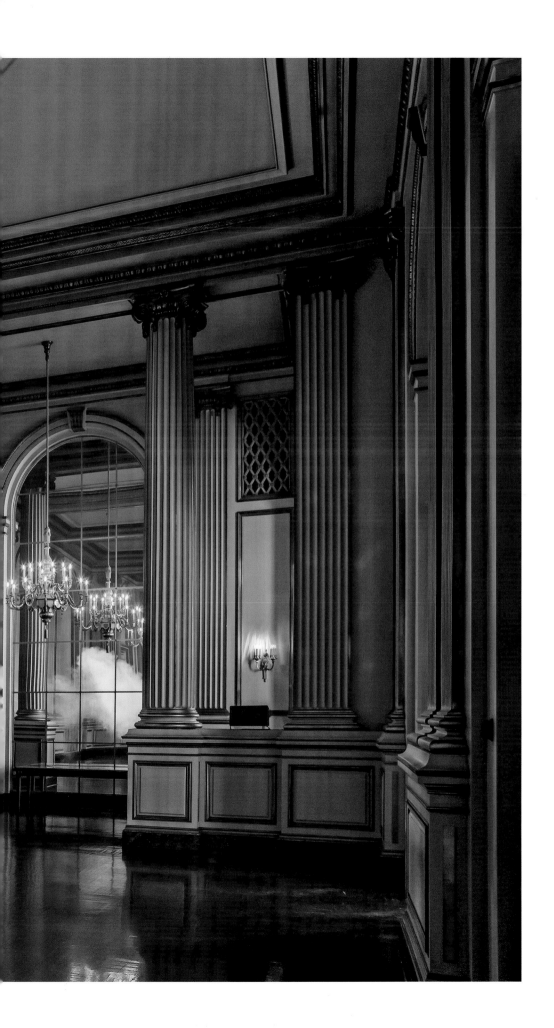

Opposite
2013 I BERNDNAUT SMILDE
San Francisco, California, U.S.
Like magic, a cloud—created as a temporary sculpture with just smoke and water—hovers for 10 seconds above the floor in the Green Room in the San Francisco War Memorial and Performing Arts Center.

Pages 268-269
2013 I ANDREA MARSHALL
Mozambique
A drifting jellyfish plays host to a small constellation of brittle stars. Scientists aren't sure why the two invertebrate species sometimes unite.

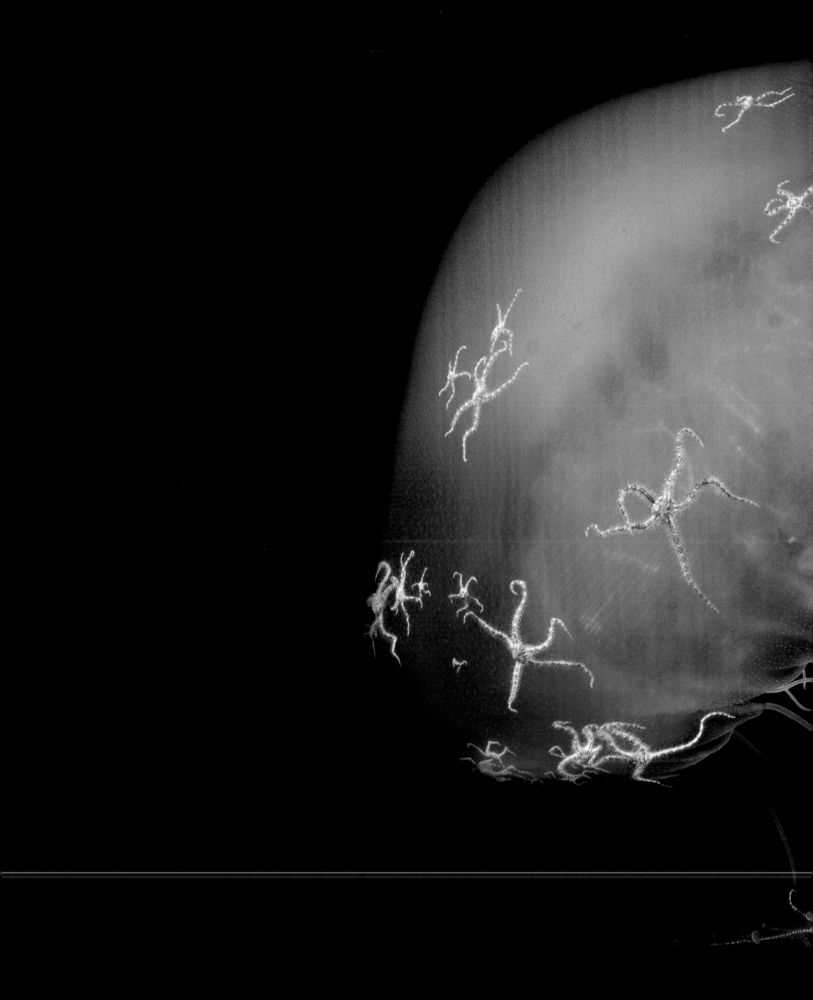

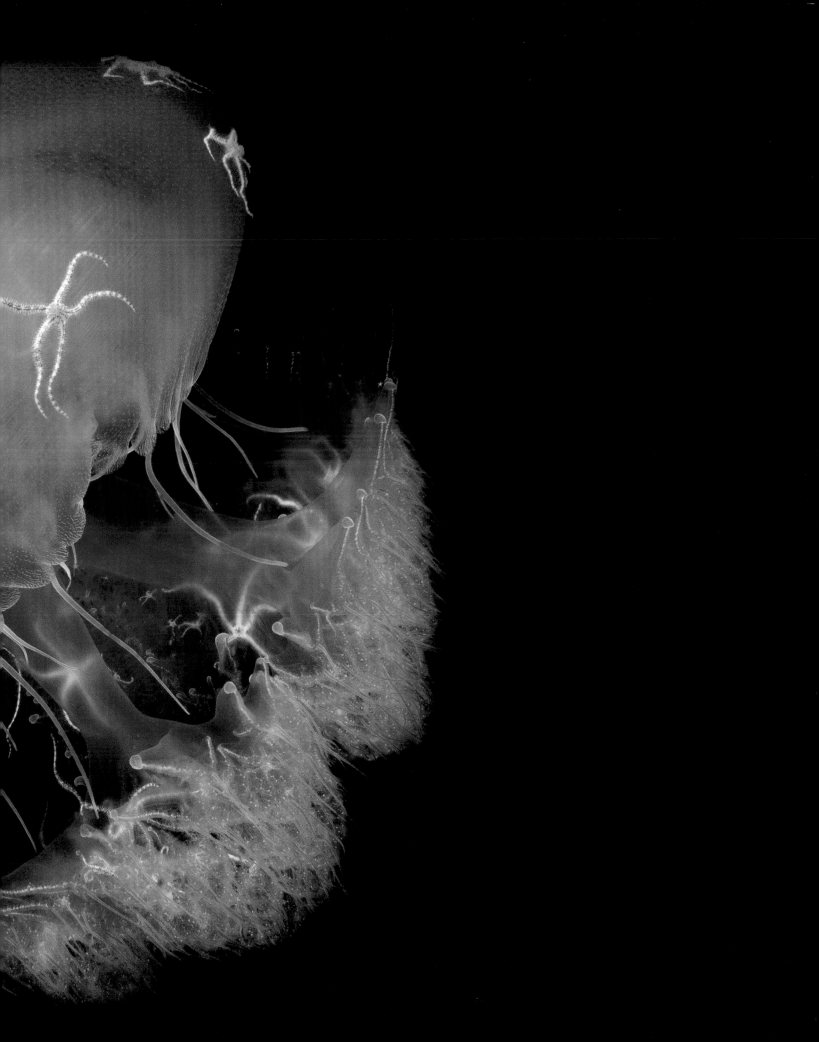

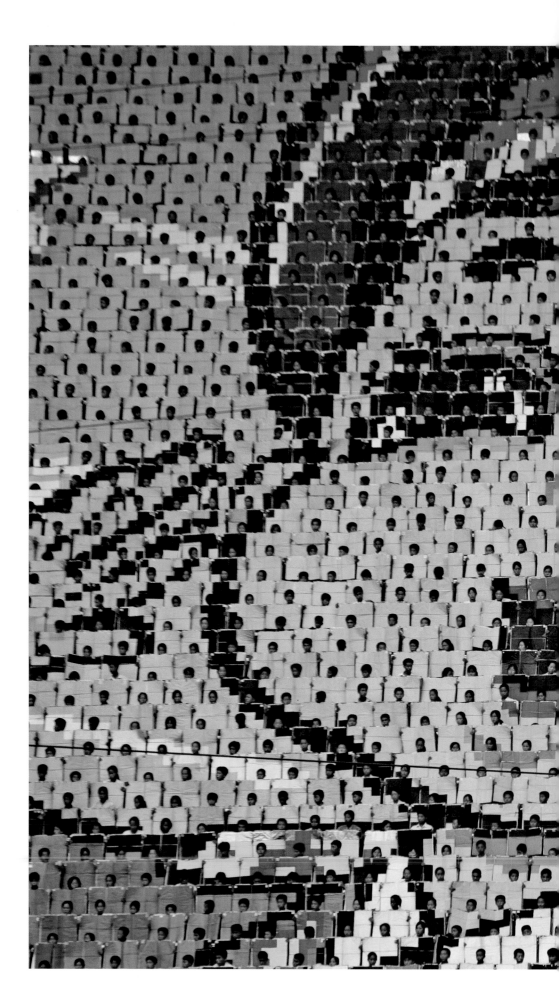

2013 I DAVID GUTTENFELDER
Pyongyang, North Korea
North Korean children flip colored paper to create a mass mosaic during a performance of the Arirang Mass Games at a stadium in Pyongyang.

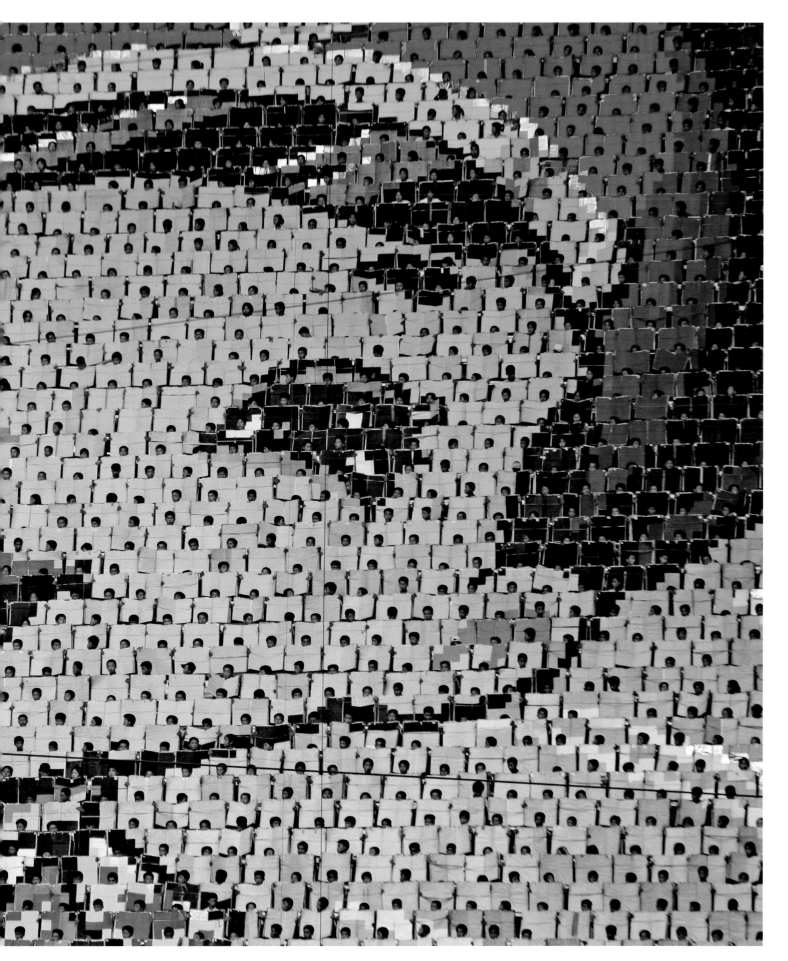

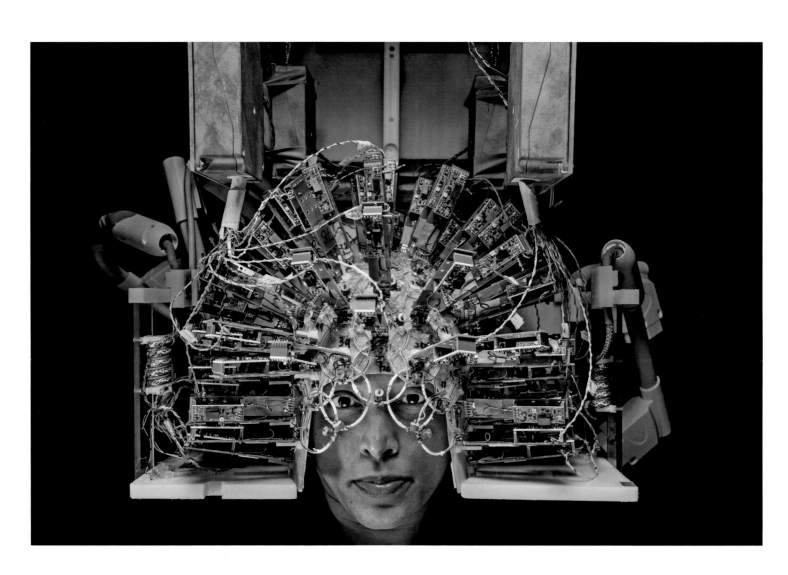

2013 | ROBERT CLARK
Charlestown, Massachusetts, U.S.
An engineer wears a helmet of sensors at
the Martinos Center for Biomedical Imag-
ing—part of a brain scanner requiring
almost as much power as a nuclear
submarine.

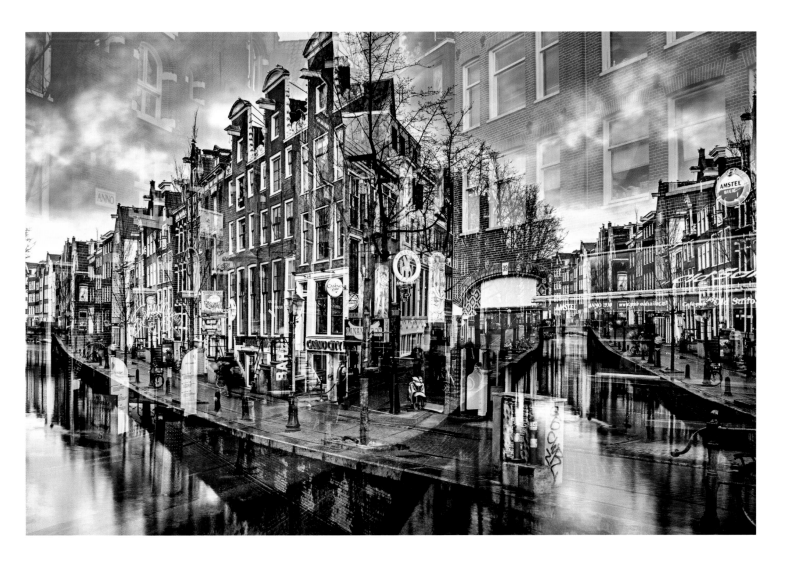

2013 | NICOLAS RUEL
Amsterdam, the Netherlands
By the canals of Amsterdam's famed red-light district, photographer Nicolas Ruel uses a double exposure to capture the neighborhood's layers—a metaphor for what goes on behind closed doors.

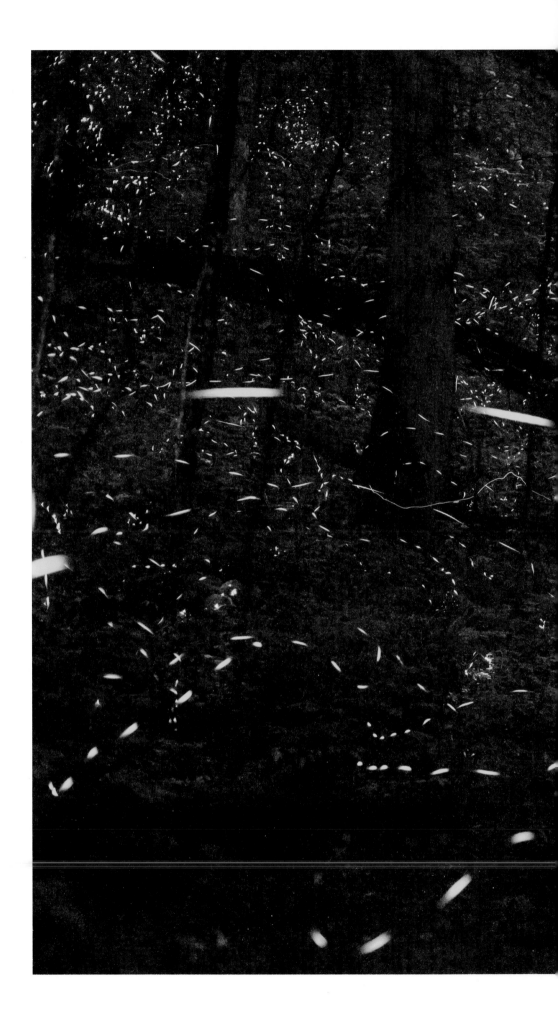

2013 I DAVID LIITTSCHWAGER
Tennessee, U.S.
Fireflies flash and streak through a
Tennessee summer night, putting on
a spectacular light show to seduce
prospective mates.

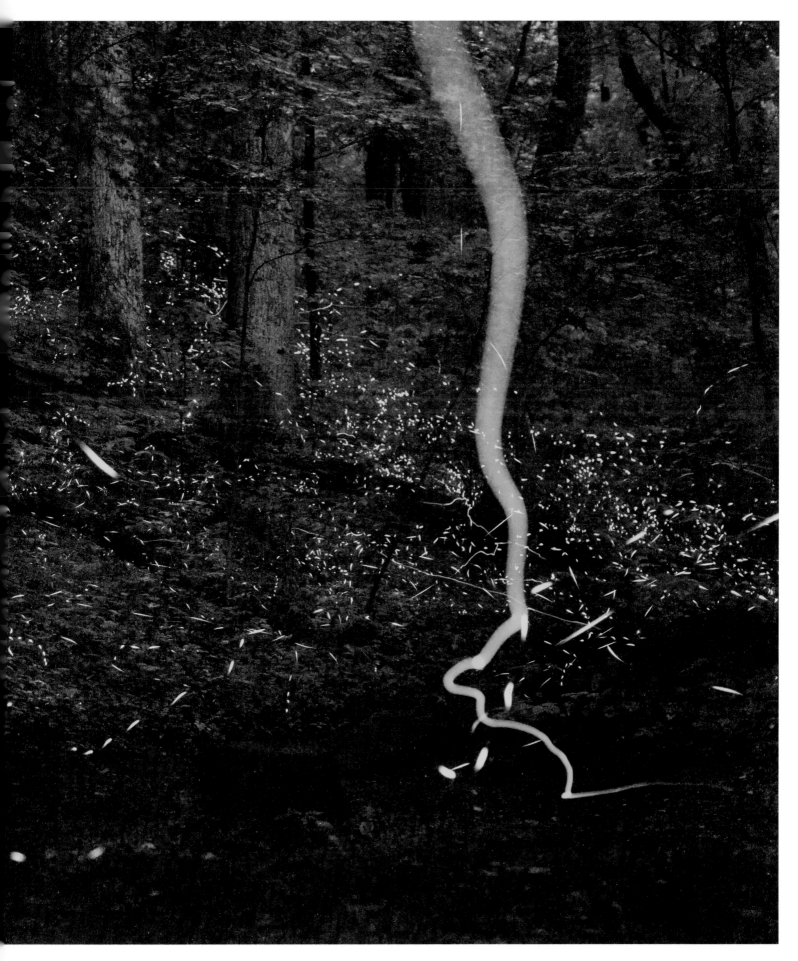

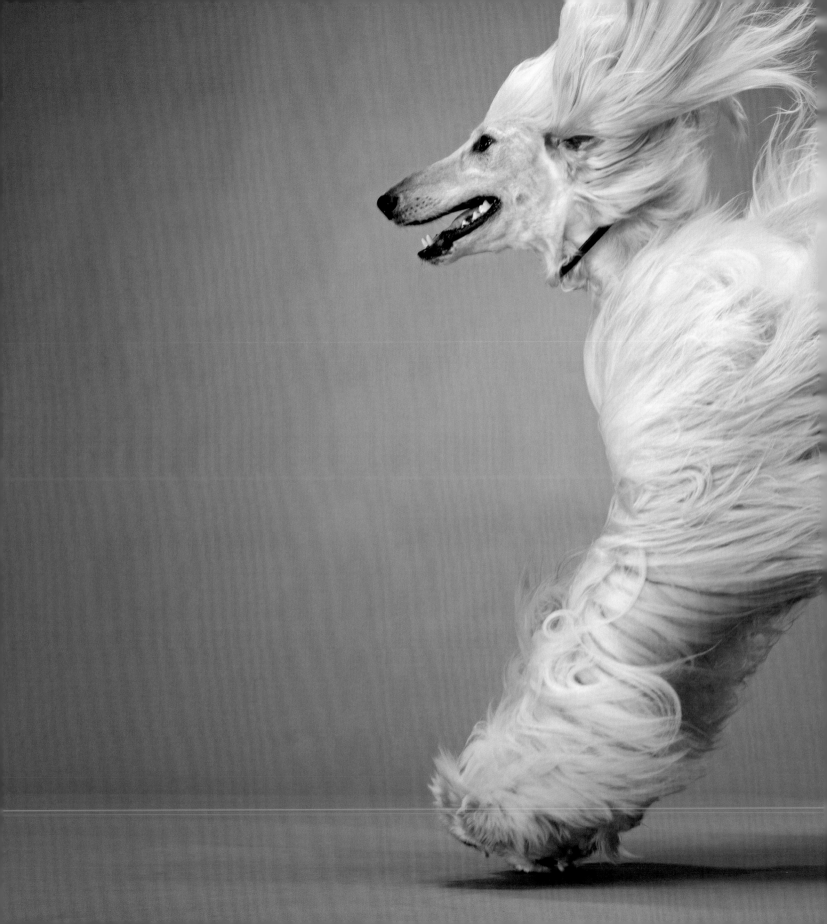

ROBERT CLARK

My first cover for *National Geographic* was fo
a story about the evolution of gray wolves
into today's modern domestic dogs; the title was
"From Wolf to Woof." When I was photographing
another story on dogs, nearly two decades later, we
decided to shoot portraits at the Westminster Dog
Show. The story was partly about the diversity o
breeds, and I knew the best place to get as many
breeds as you can in one location was the Westmin-
ster Show.

I set up a studio in a ballroom at the Hotel Penn-
sylvania, which is where most of the dogs stay fo
the show, and with my team I worked out how best
to create a strong lighting setup to show the differ-
ences in the dogs. The show is great, but one of the
best things to see is the lobby of the hotel, where
vendors, dogs, and owners go in and out, back and
forth. We made a selection of the dogs in the lobby
and invited them for a portrait session.

I found that some of the easiest dogs to shoo
were the Afghans. They are so athletic, as they spring
turn, and play. They look like models—thin and with
long hair. I remember thinking that if I ever have
room at home for a dog that could run, this would be
the breed. They're so beautiful, graceful, and fast—
could shoot them every day. But I live in a Brooklyn
apartment and my low-energy—some would say
lazy—French bulldog is the perfect fit for my family.

We made the mistake of leaving the ballroom
door open. Once this guy was off leash he was
gone, down the hall in a shot. It took us a good 10
minutes to find him and get him back into the stu-
dio. This image, for me, captures the spirit and fur
of the breed. ∎

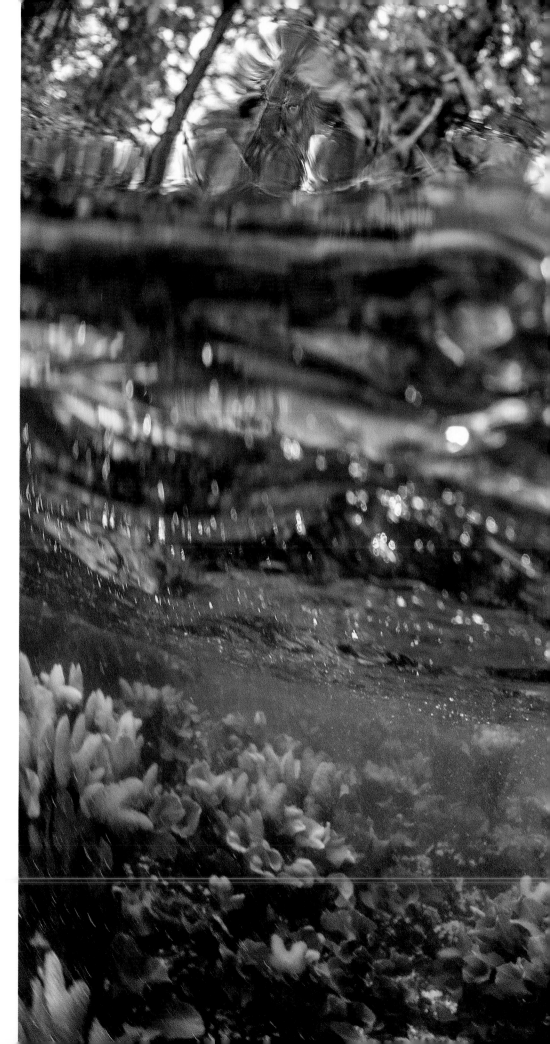

Opposite
2014 I IAN MCALLISTER
Pacific Wild, Canada
At Canada's western edge, beachcombing wolves swim between islands. This wolf takes a break from eating herring roe to investigate a half-submerged object: the photographer's camera.

Pages 278-279
2014 I JOHN STANMEYER
Jerusalem, Israel
Women participate in a holy fire ceremony to celebrate Easter at the Church of the Holy Sepulchre in Jerusalem's Old City.

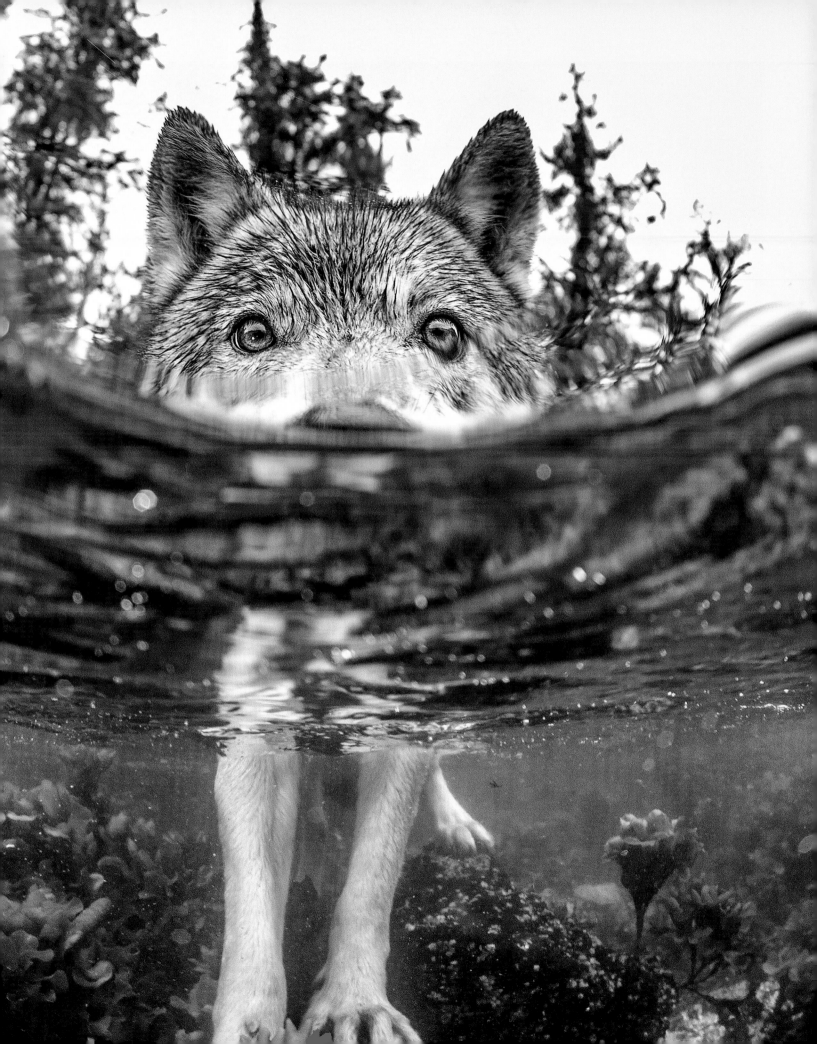

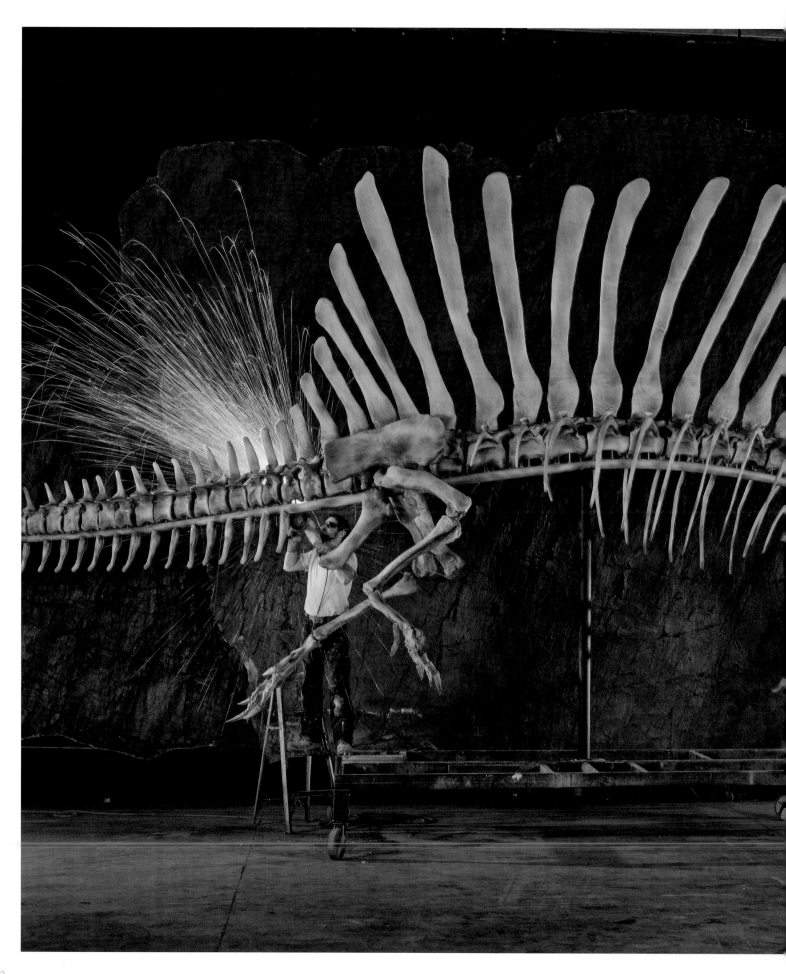

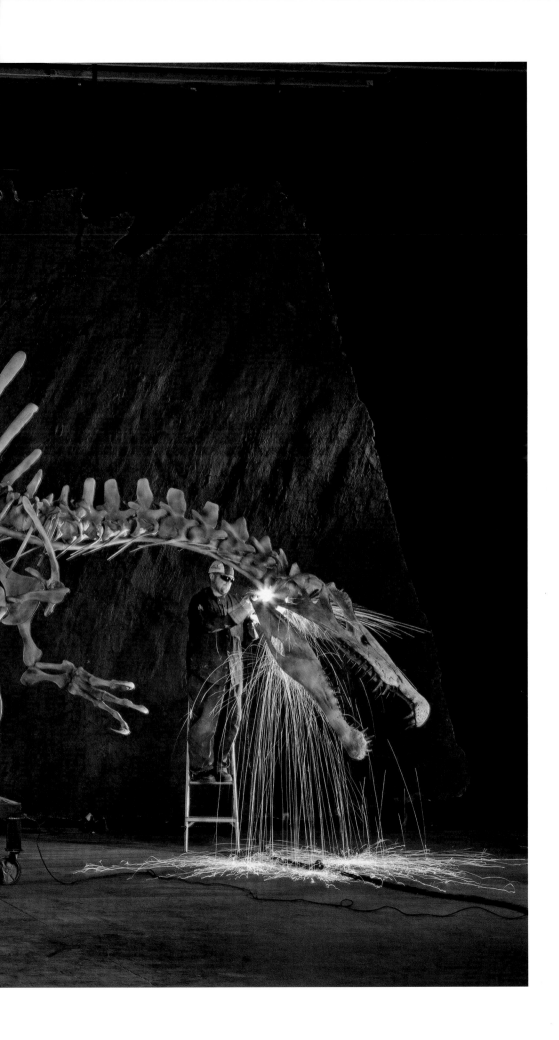

2014 I MIKE HETTWER
Canada
Exhibition workers put the finishing touches on a 50-foot-long (15.2 m) anatomically precise, life-size reconstruction of a *Spinosauraus aegyptiacus* skeleton created from digital models of the fossil bones.

Pages 284-285
2014 I LUCAS SANTUCCI
Greenland
A 65-foot (19.8 m) schooner, the *WHY*, cuts through ice near Greenland. The vessel's French crew took the ship from Greenland to Antarctica.

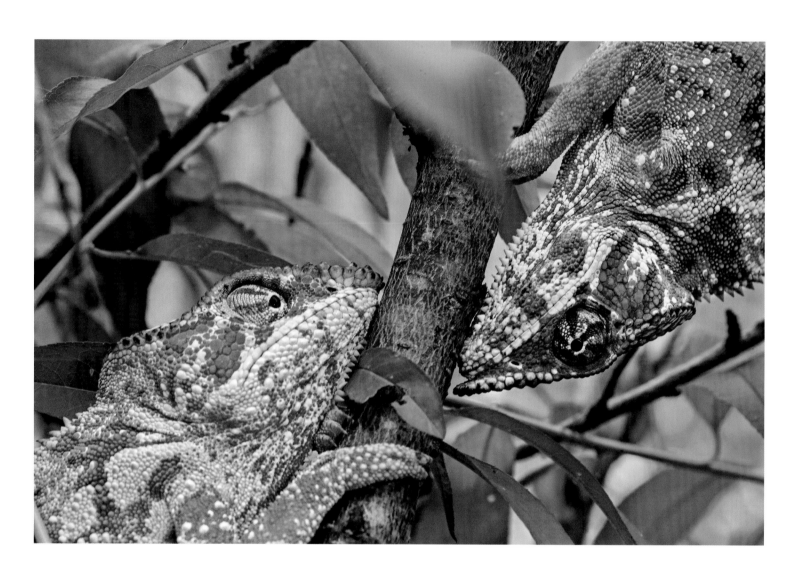

2014 I CHRISTIAN ZIEGLER
Madagascar
Two male panther chameleons, *Furcifer pardalis*, show off bold orange coloring, which communicates aggression. The species is rarely found in the wild.

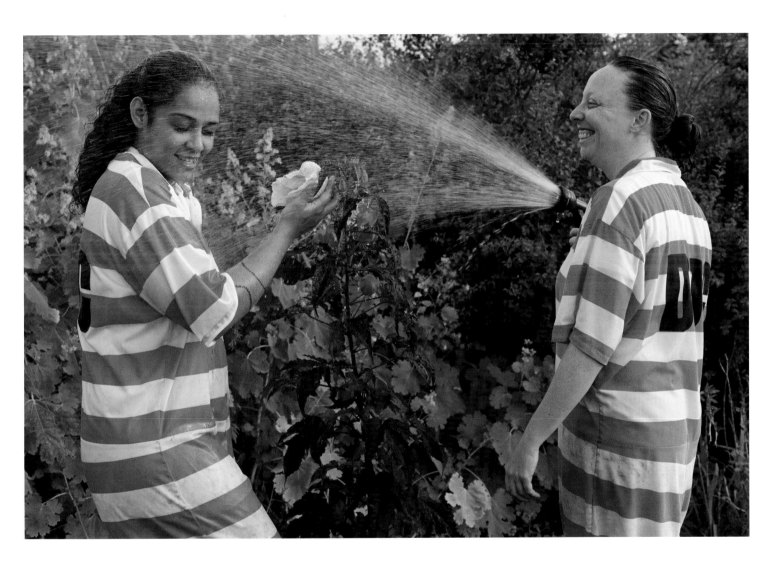

2014 I LUCAS FOGLIA
New York City, New York, U.S.
Inmates relax while working in a garden on Rikers Island, a New York City jail. Research suggests interacting with nature makes prisoners less violent.

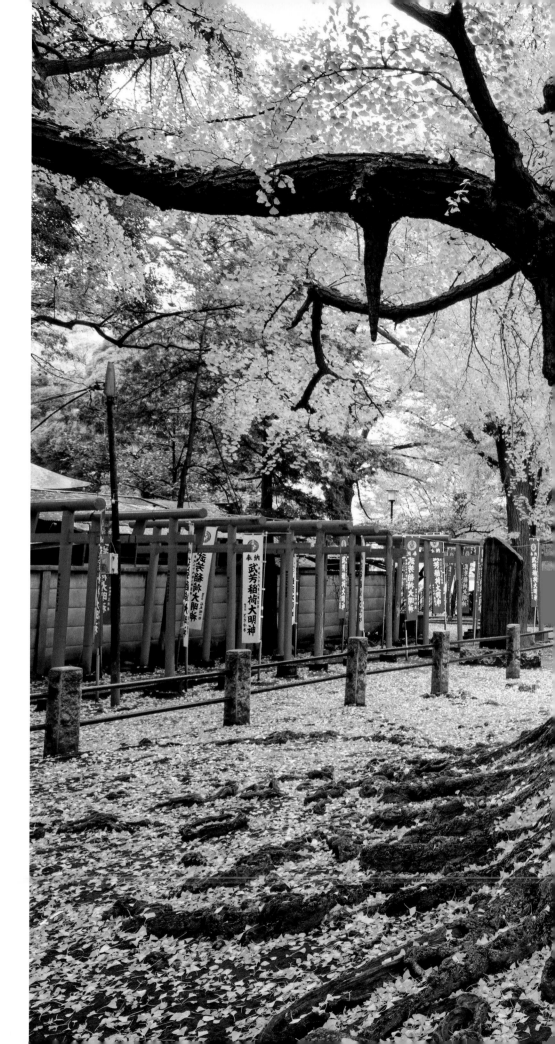

Opposite
2014 | DIANE COOK AND LEN JENSHEL
Tokyo, Japan
Tradition holds that this tree, which
stands in the courtyard of the Zoshigaya
Kishimojin Temple, brings fertility to
worshippers.

Pages 290-291
2014 | ROBIN HAMMOND
Liberia
A worker waters oil palm seedlings to
be planted on part of a 543,600-acre
(219,987 ha) lease in Liberia that will
produce cooking oil.

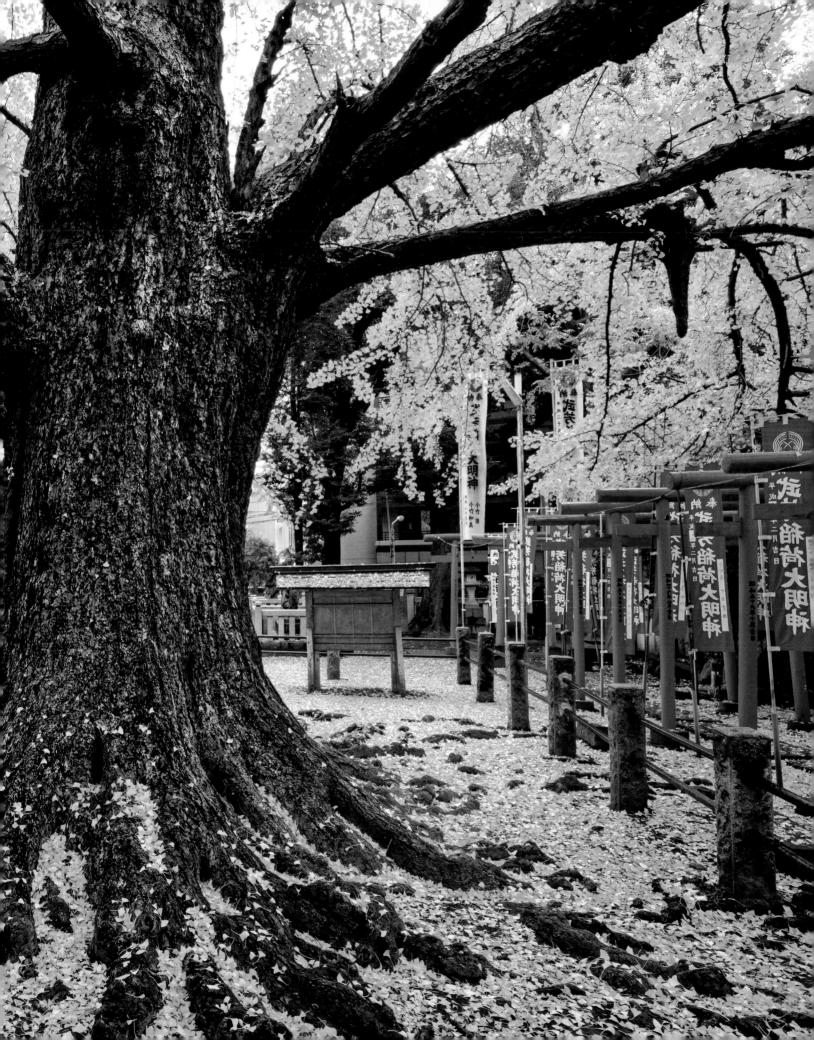

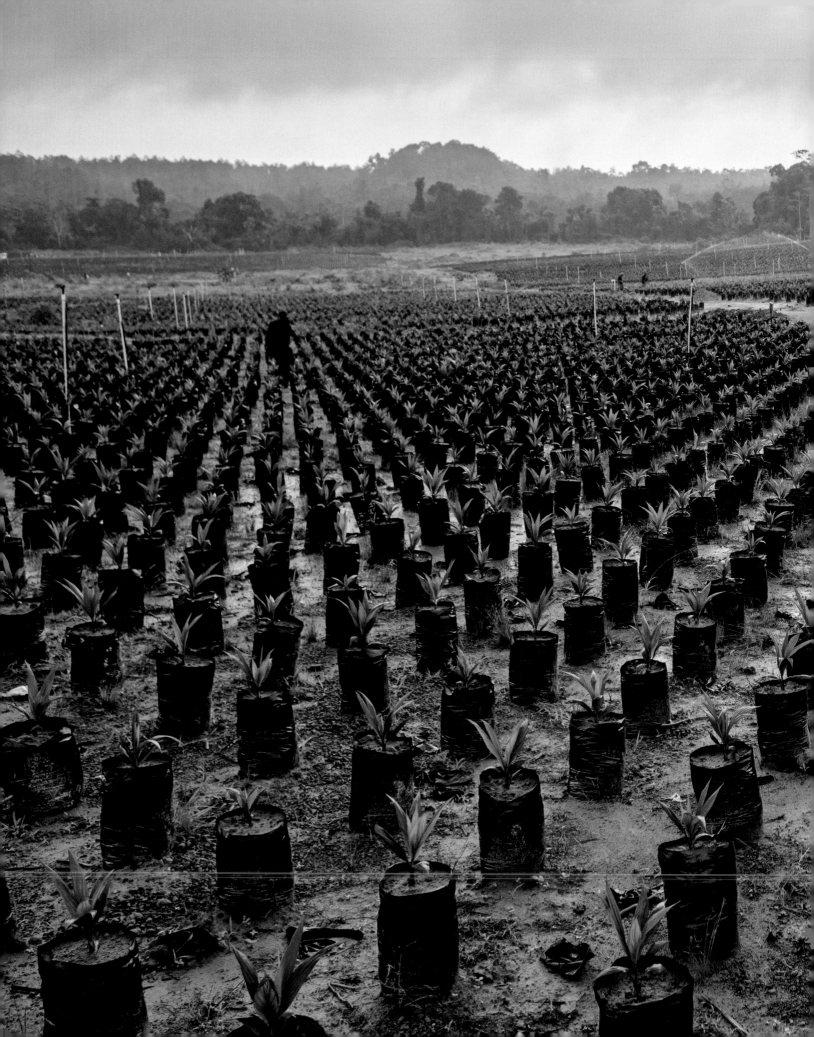

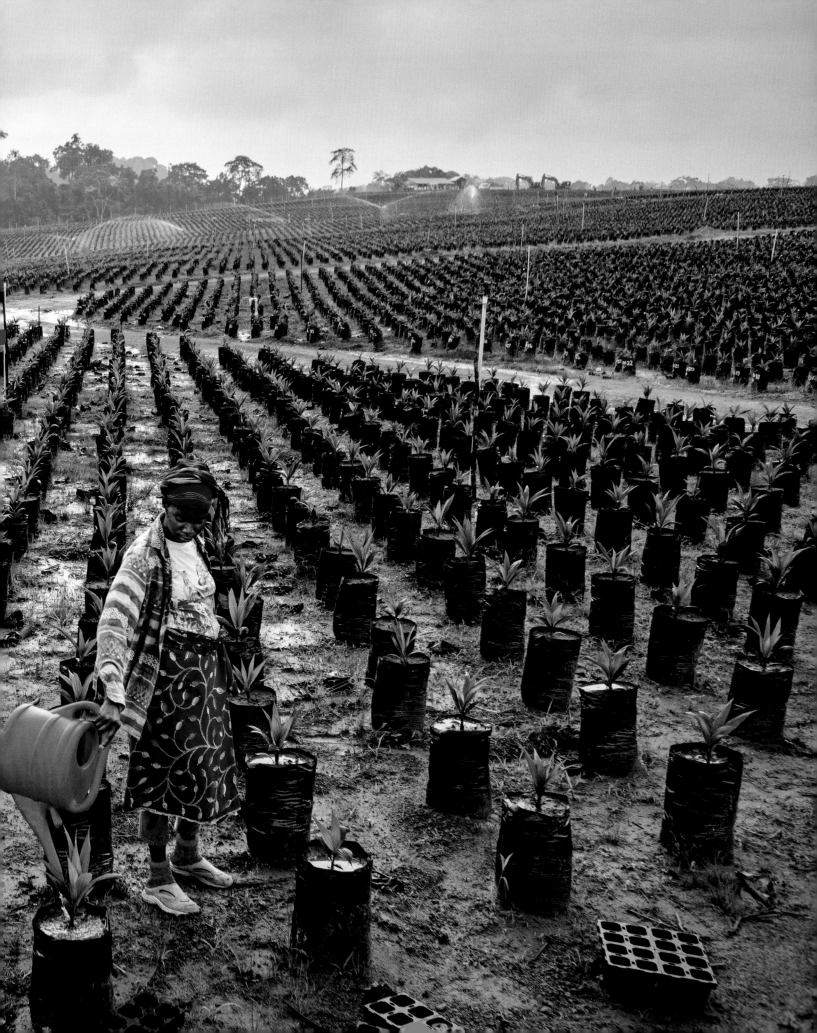

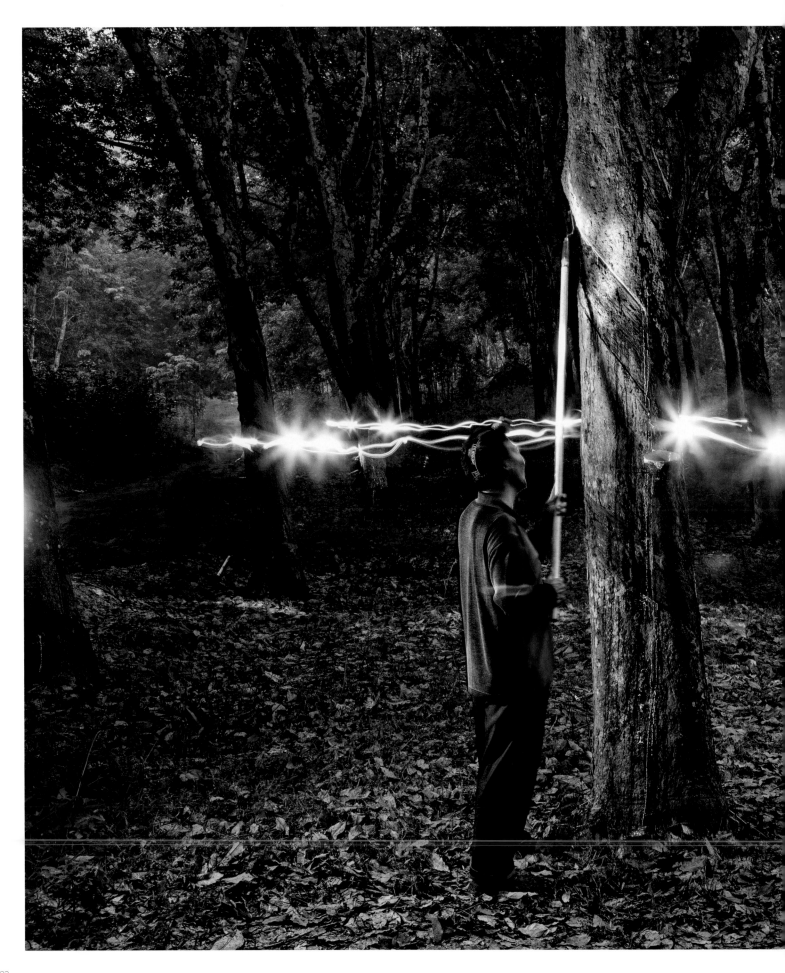

Opposite
2014 | RICHARD BARNES
China
Because rubber sap flows best at night, tappers in Xishuangbanna use headlamps to light the trees while they work.

Pages 294-295
2015 | KJELL LINDGREN
International Space Station (ISS)
Astronaut Scott Kelly is safely tethered to the ISS during a seven-hour, 48-minute space walk to reconfigure a cooling unit. Mere layers of a space suit shield him from radiation and other space hazards.

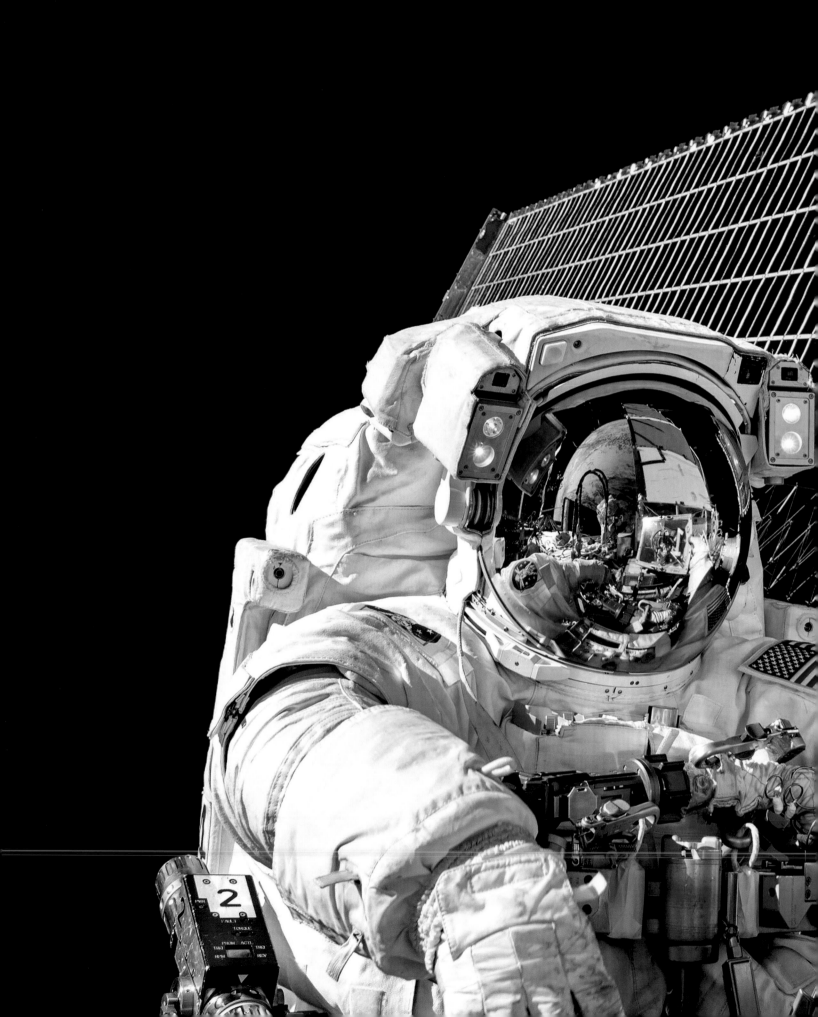

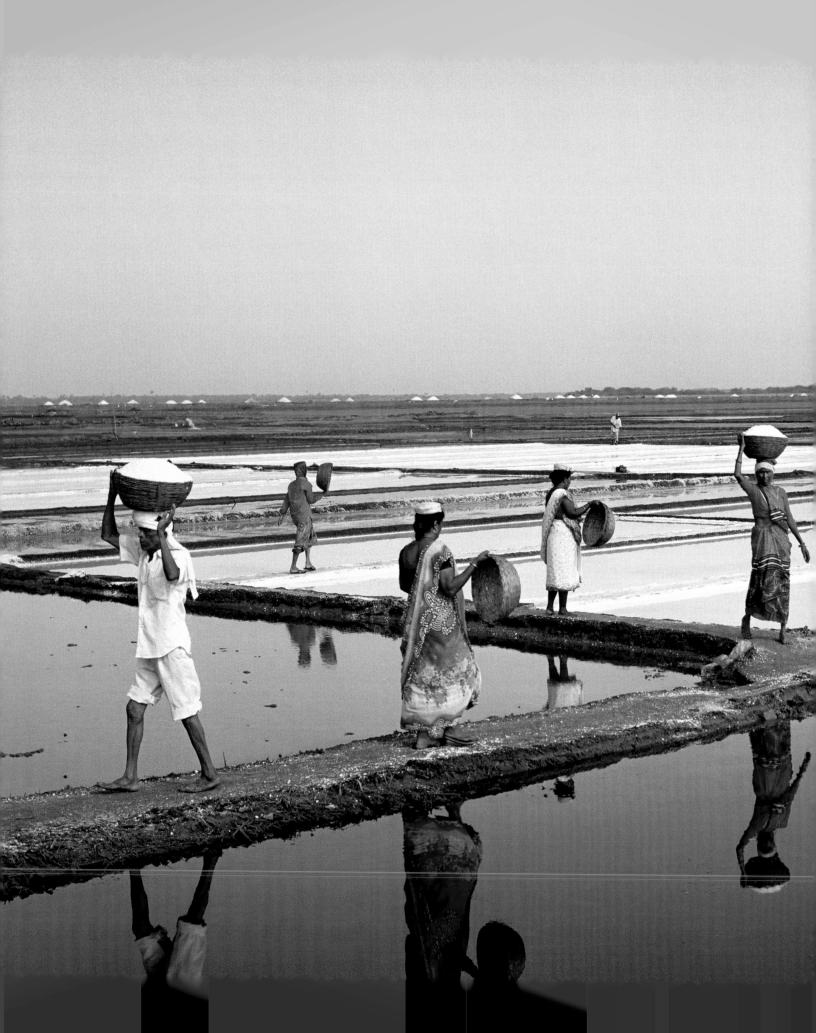

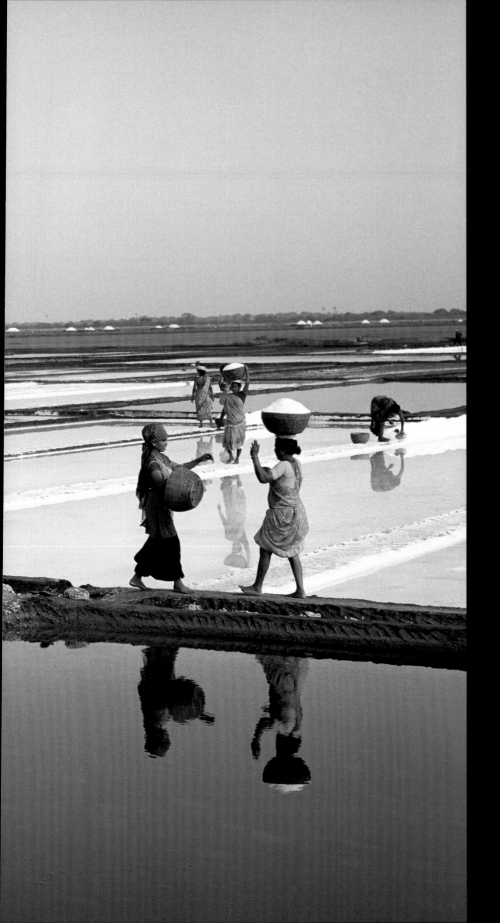

RENA EFFENDI

When I went on assignment for *National Geographic* to document the legacy of Mahatma Gandhi, I was terrified. Gandhi's social activism influenced the world in an epic way. The task of portraying this monumental figure felt daunting.

In search of Gandhi's spirit, I attempted to portray people in the places where his influence was most enduring. In the footsteps of Gandhi, I traveled along the path of the Salt March, where nearly a century ago he had walked in an act of resistance to the British colonial salt tax, laying the foundation for India's independence movement.

In Dharasana, I stood on a salt pan for several hours watching workers carry baskets of salt under the scorching sun. During their continuous movement I waited for a perfect alignment of their silhouettes and reflections in the water. Somewhere within two hours and 10 rolls of film, the moment finally came. It was a peaceful scene to observe, but I knew that here in 1930, Gandhi led a march of activists. He had trained his followers in Satyagraha, or "passive resistance," a campaign of nonviolent civil disobedience, but here they were savagely beaten. This was a pivotal moment in India's struggle for independence. As I stood there watching the salt workers glide gracefully along the tracks, I felt privileged to be revisiting this powerful historical topography. ∎

2015 I DAVID DOUBILET
Cozumel, Mexico
A diver floats beneath a mass of sargassum pierced by shafts of sunlight. Unusually large masses of sargassum have been washing ashore in the Gulf of Mexico, fouling beaches in tourist destinations.

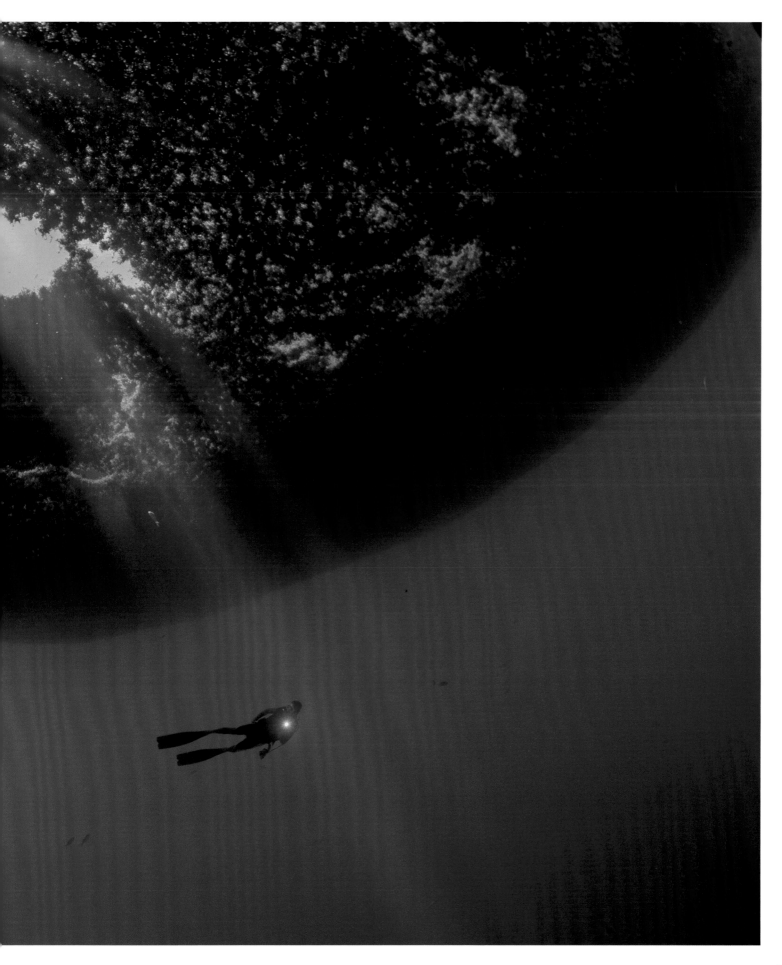

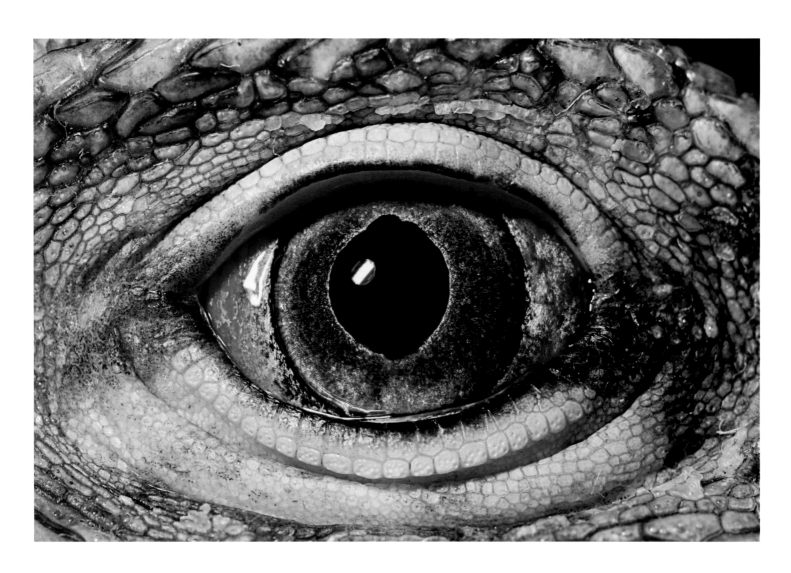

2015 | DAVID LIITTSCHWAGER
Studio Shot
The eye of a Cuban rock iguana (*Cyclura nubila nubila*) offers a window into a fundamental truth of evolution: Form follows necessity. Four types of cone cells in this creature's retina provide excellent daytime color vision.

2015 | LUCA LOCATELLI
Kalkar, Germany
A nuclear reactor was finished just before the
1986 explosion at Chernobyl, Ukraine. Never
used for fear of another nuclear power disas-
ter, it's now an amusement park with a ride in
what would have been the cooling tower.

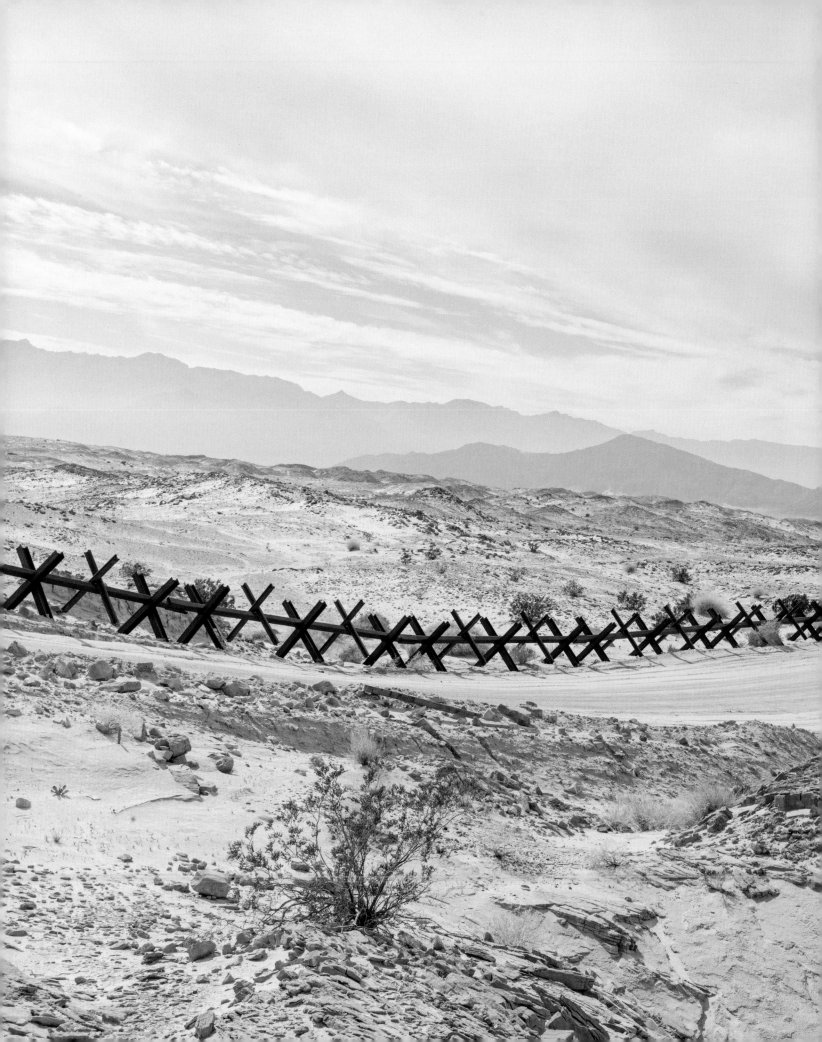

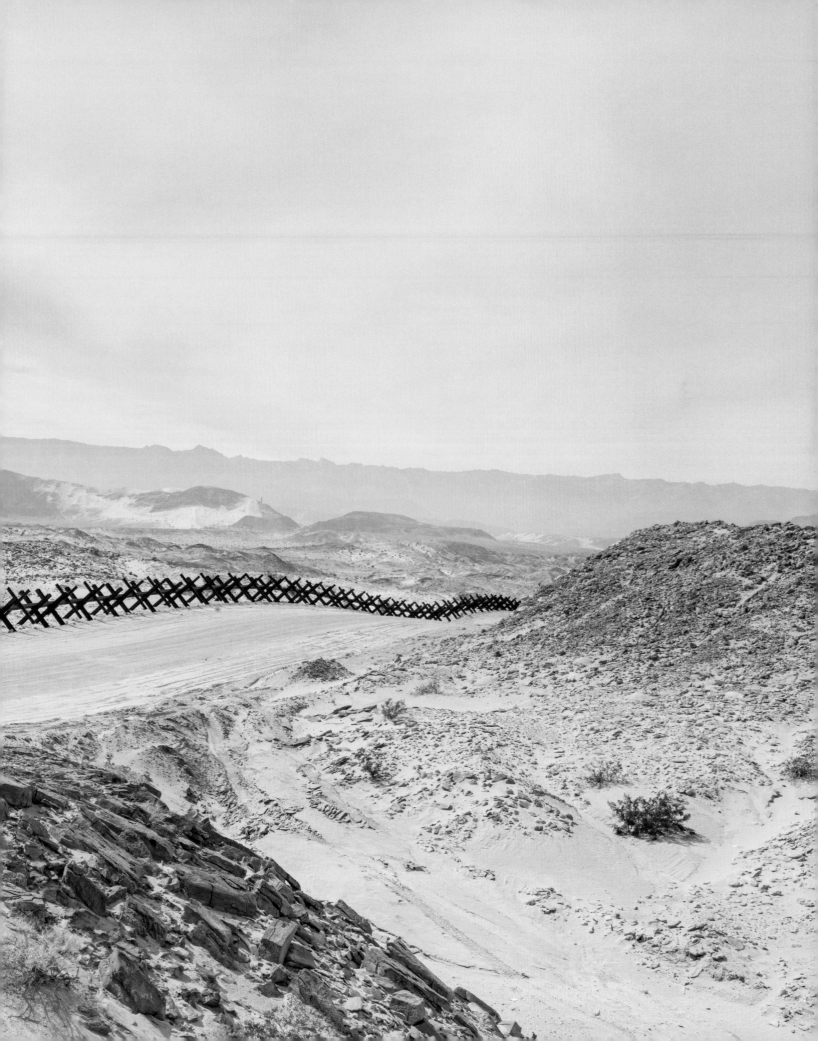

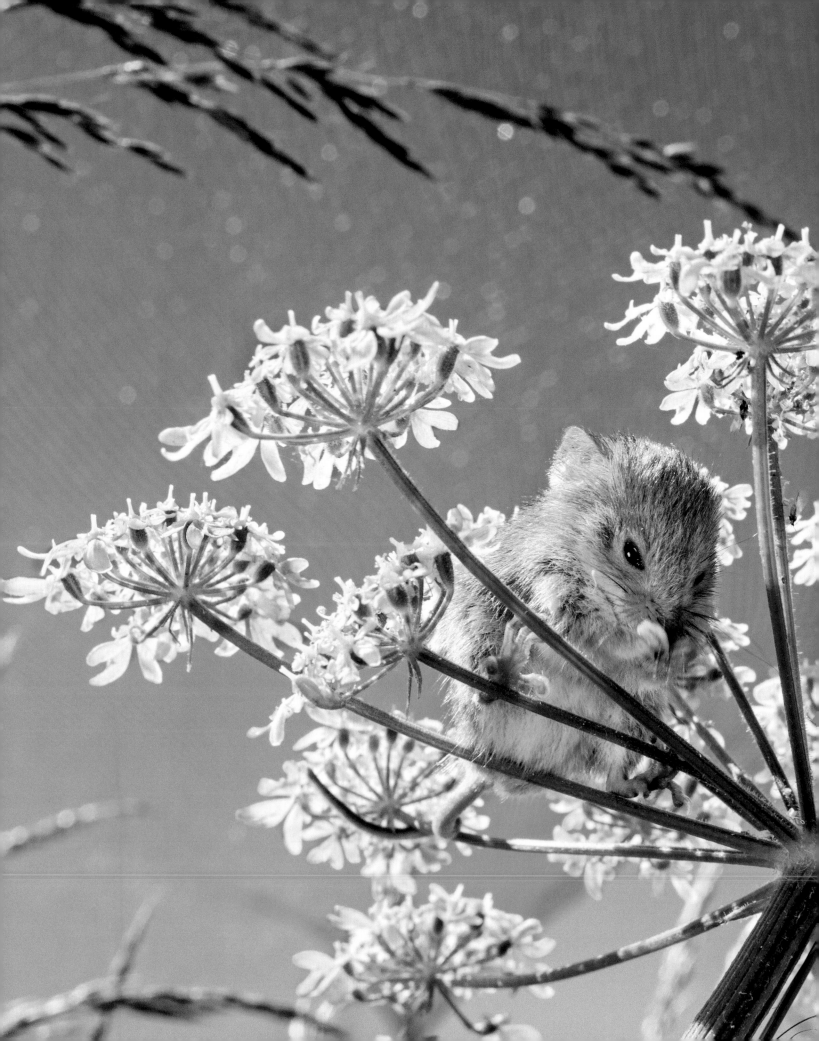

Opposite
2015 I NICK UPTON
Moulton, England
A harvest mouse—Europe's smallest
rodent—grooms itself on a hogweed
flower head in a meadow. This adult was
raised in captivity, microchipped, and
released as part of a study on how the
elusive species survives.

Pages 302-303
2015 I RICHARD MISRACH
Ocotillo, California, U.S.
In remote areas like this stretch, vehicle
deterrents are made of railroad ties and
often called Normandy barriers because
they look like World War II blockades.

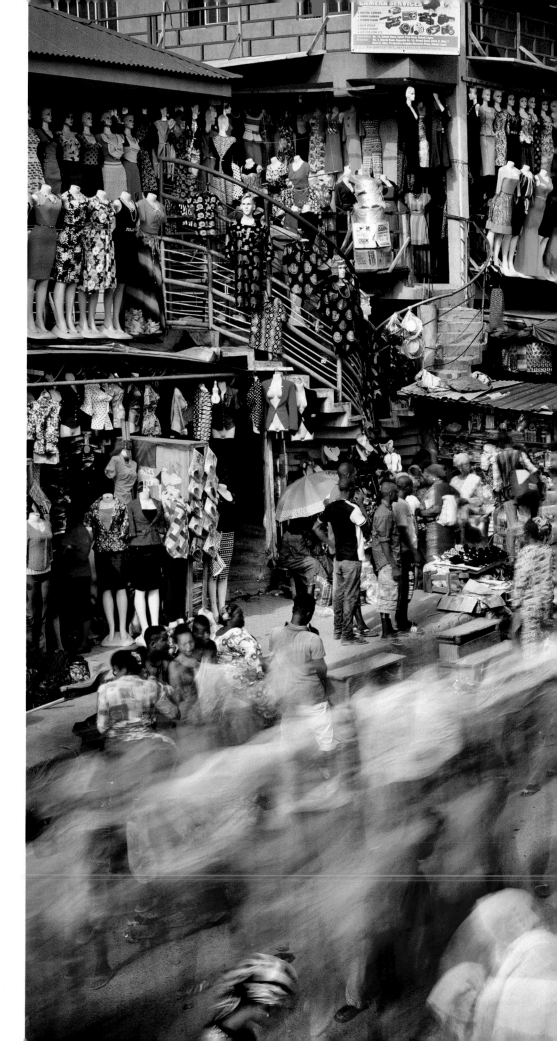

2015 I MARTIN ROEMERS
Lagos, Nigeria
Seen from a rooftop, the urban bustle of Lagos is a blurry mosaic of colors. Lagos—along with Cairo and Kinshasa—is one of three megacities that make Africa a rapidly urbanizing continent.

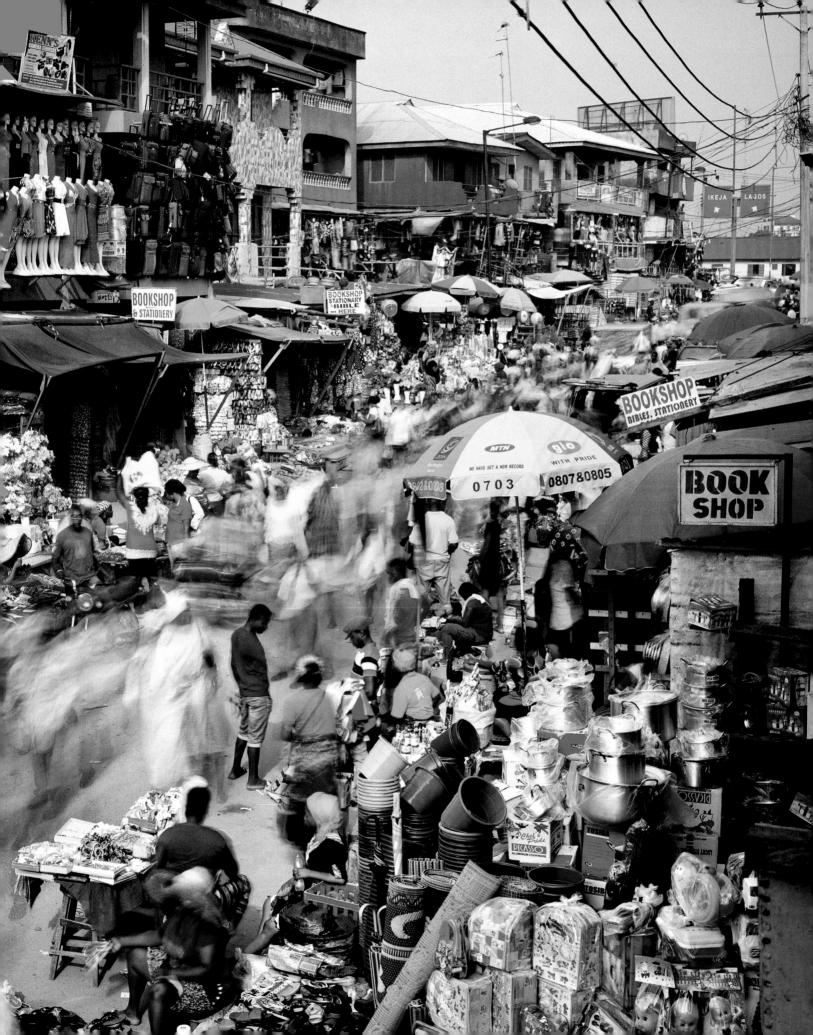

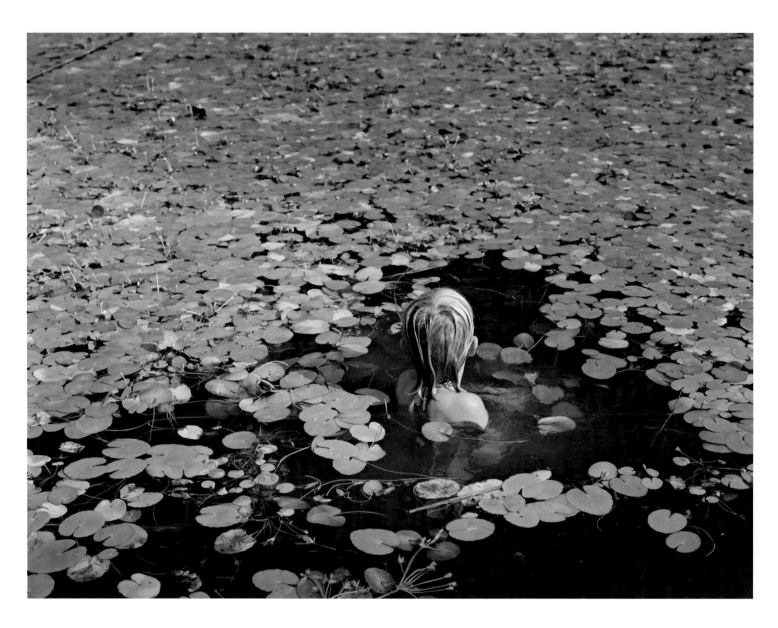

2015 I LUCAS FOGLIA
North Carolina, U.S.
A girl swims among lily pads in her family's
pond, where her father runs an outdoor
education center.

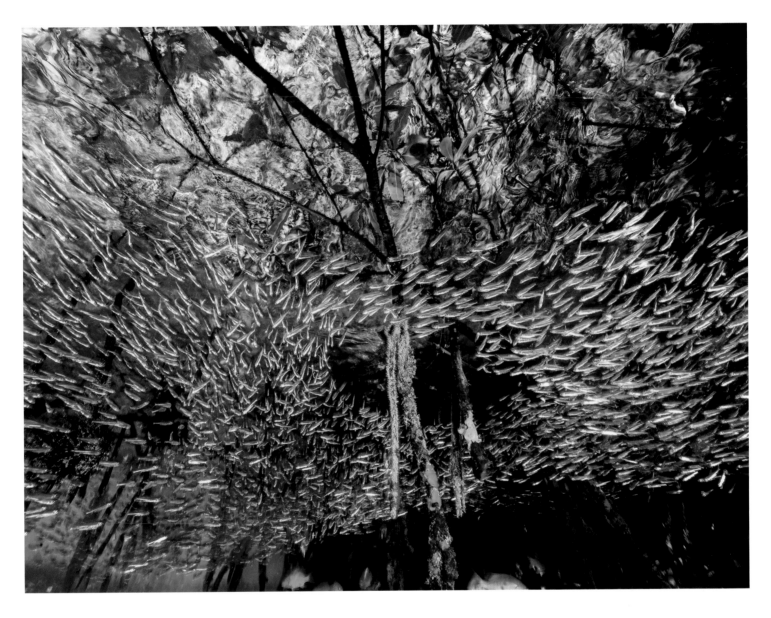

2015 I DAVID DOUBILET
Cuba
A dense forest of mangrove roots offers
welcome shelter for small silverside fish. The
fish form large schools to confuse predators.

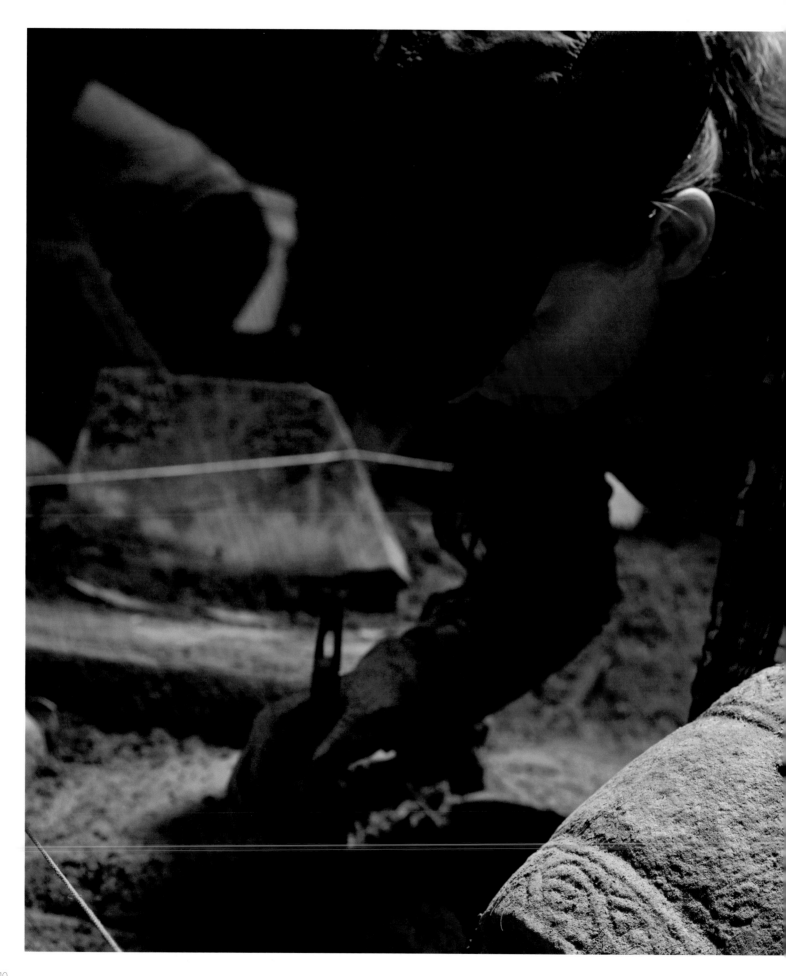

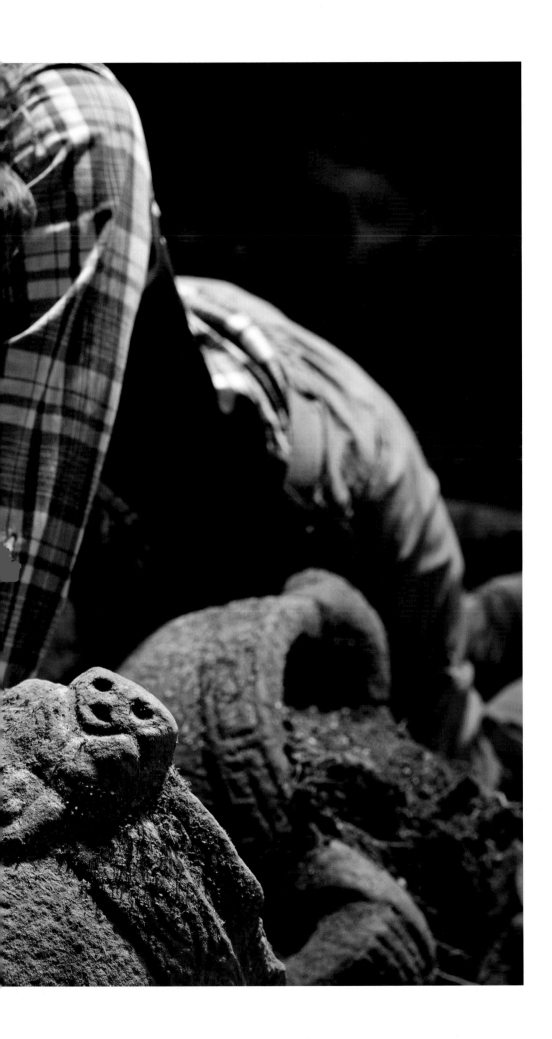

2015 | DAVE YODER
Honduras
An archaeologist works on the cache of
artifacts recovered during an excavation
of an ancient city, dubbed the Lost City
of the Monkey God.

CHAPTER FOUR

2016

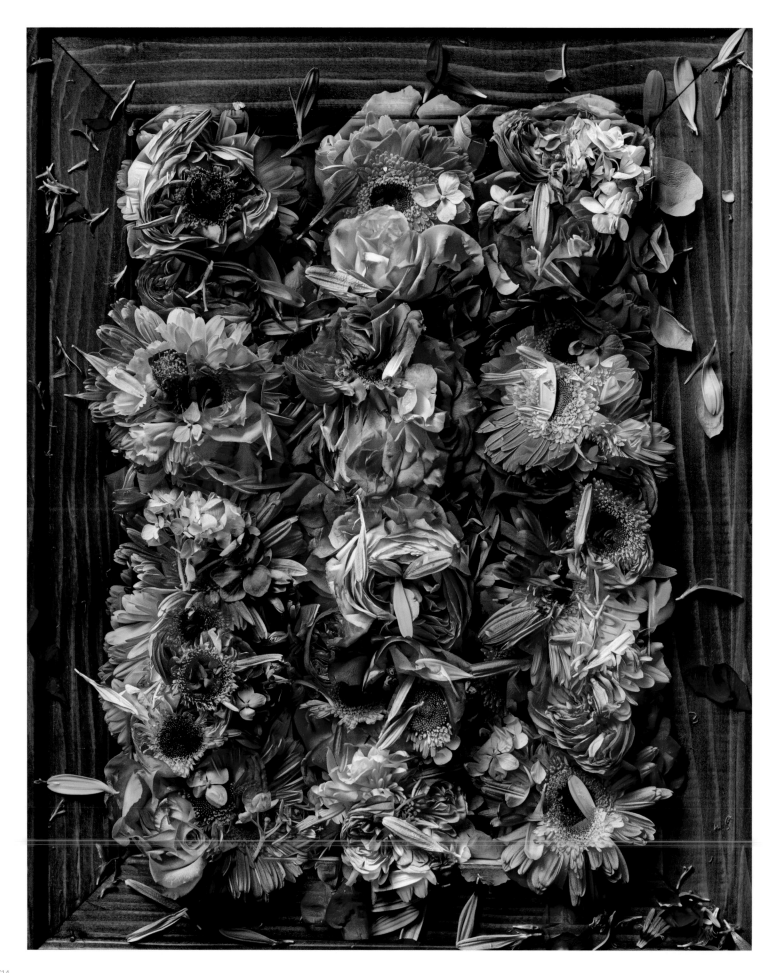

IDENTITY HAS

mattered amid the pulse and confusion of recent years. The clothes we wore, the games we played, the battles we fought, the hopes that drew us onward, the dreams we barely remember: In these, we found our way.

Tradition held steady to accommodate change. Food, flowers, and festivals marked the seasons. Children constructed masks of celebration, their faces and fierce colors telling the story even if the origins of the annual ritual have faded from view. Girls and boys—here kept separate, there side by side—proceeded into adulthood. Prom queens glowed with shy pride. Weddings still brought loved ones together, congregating into new families.

Anger boiled over while the world shut down. Some leaped into action, others stayed home, but circumstances forced everyone to rethink who they were and what they believed in. Even the water we drank took on the taint of civilization's errors. Scientists took the quest to the level of cells and molecules and atoms; engineers redesigned the landscape for safety, health, convenience. The fight for justice raged.

Lightning bolts and volcanic eruptions, the deep-blue water and the star-strewn sky—the natural world insisted on reminding us of its power beyond anything human ingenuity could devise. At the same time, we faced our own capability to tip the balance of nature. Jaguars, rhinos, polar bears, sea turtles: Beloved creatures, their numbers were dwindling, with human recklessness to blame. We sought from science pathways of reconciliation with nature, just as urgently as we clamored for reconciliation among ourselves.

Beauty uplifts us. Hope resurfaces. The simple joy of a child's shadow game brings a smile. Human beings can destroy, but we can also create in many colors. Imagination, knowledge, and wisdom propel us into the future. As we honor and learn from the past, we shape what is yet to come—our good fortune and our responsibility. ■

Opposite
2016 | TRAN TUAN VIET
Hanoi, Vietnam
Decoratively dyed bundles of incense dry in Quang Phu Cau, a commune in Hanoi. The aromatic material—burned to mark life events and connect with the spirit realm—has been a hallmark of Vietnamese culture for thousands of years.

Pages 312-313
2016 | REYNOLD RIKSA DEWANTARA
Indonesia
Mount Bromo, on the volcano-dotted island of Java, erupted for exactly one year, from November 12, 2015, to November 12, 2016. During that time, the cone emitted varying levels of ash and heat.

Page 314
2016 | ABELARDO MORELL
Newton, Massachusetts, U.S.
An image forever in bloom: A tight pack of flowers and petals are displayed in a wood frame.

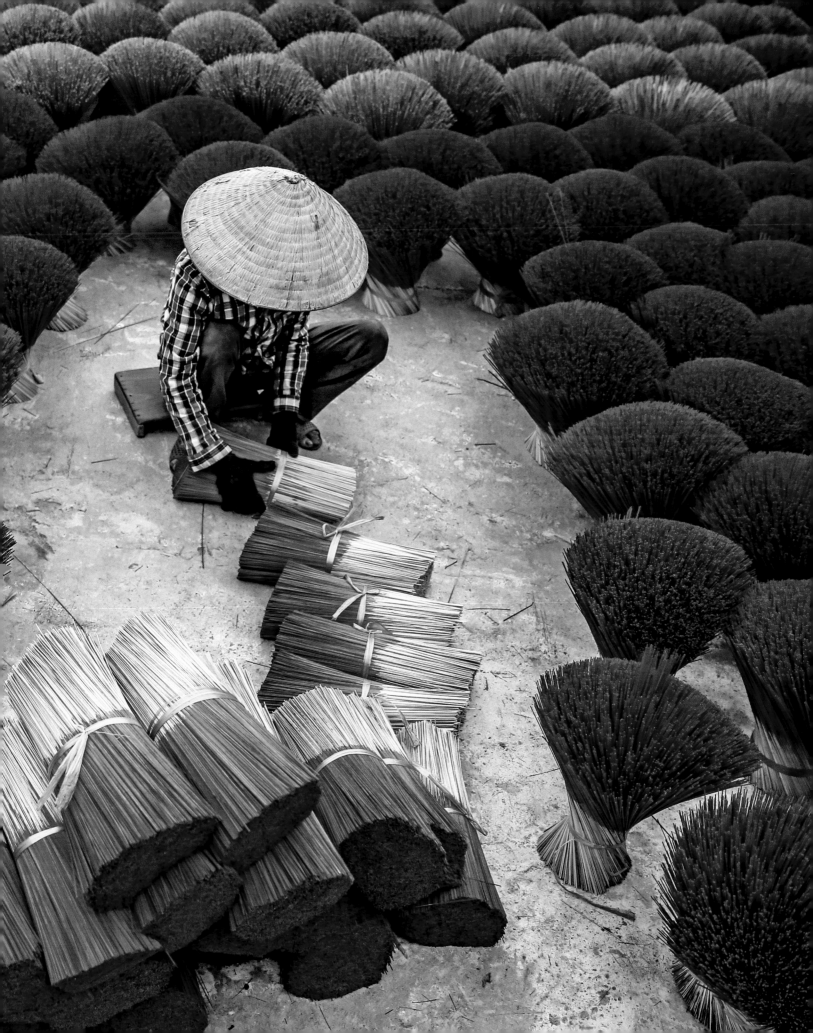

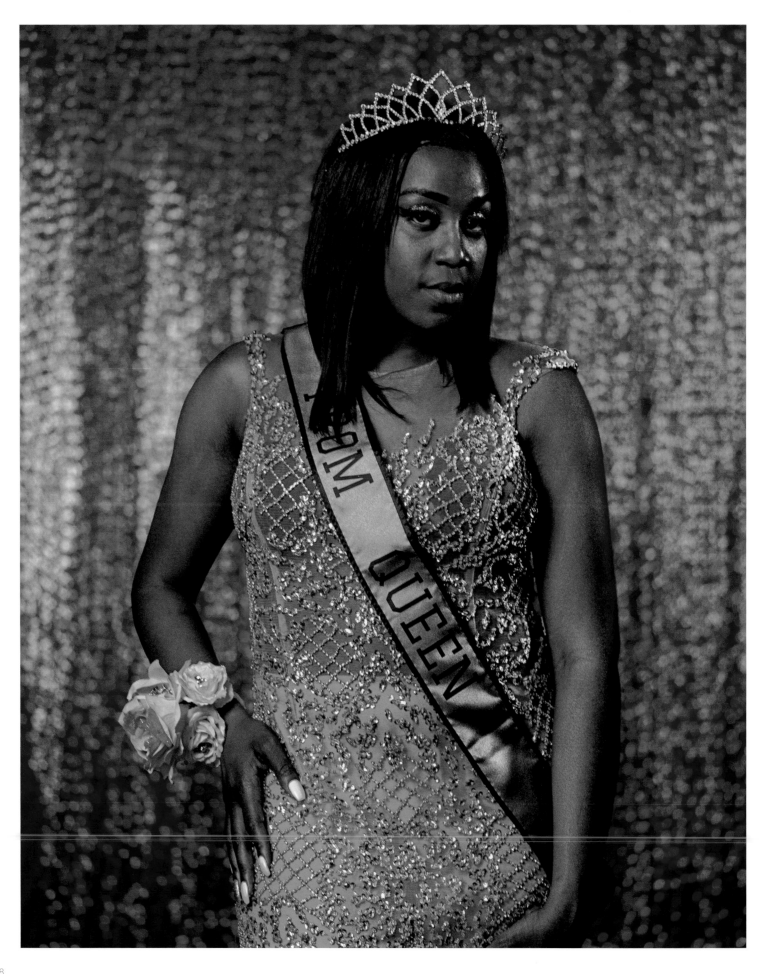

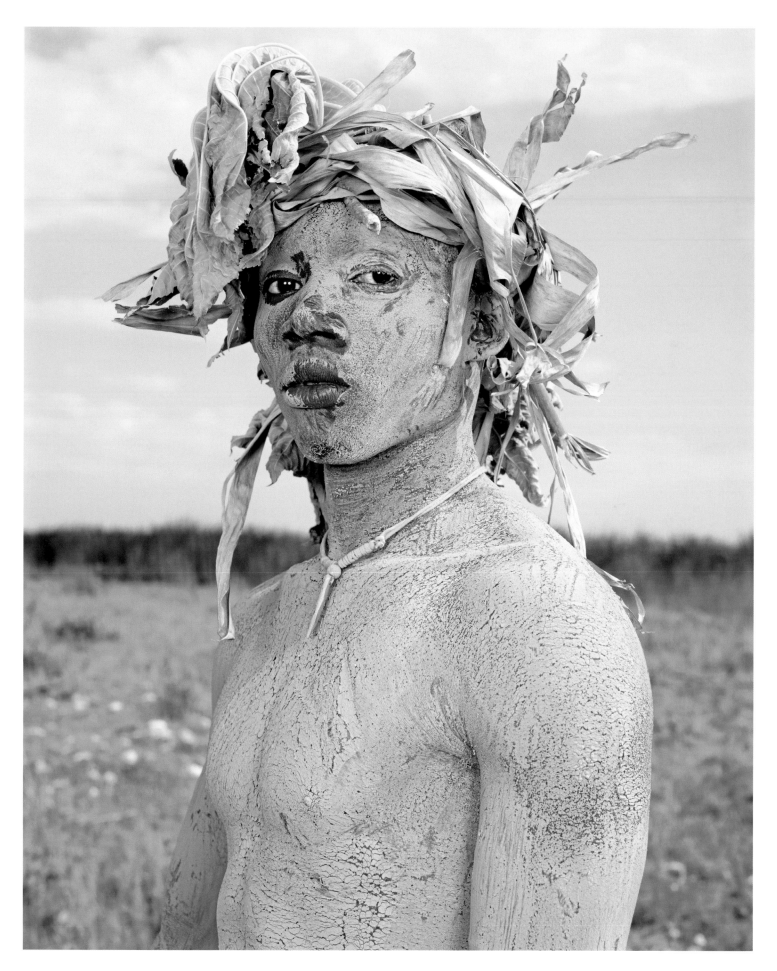

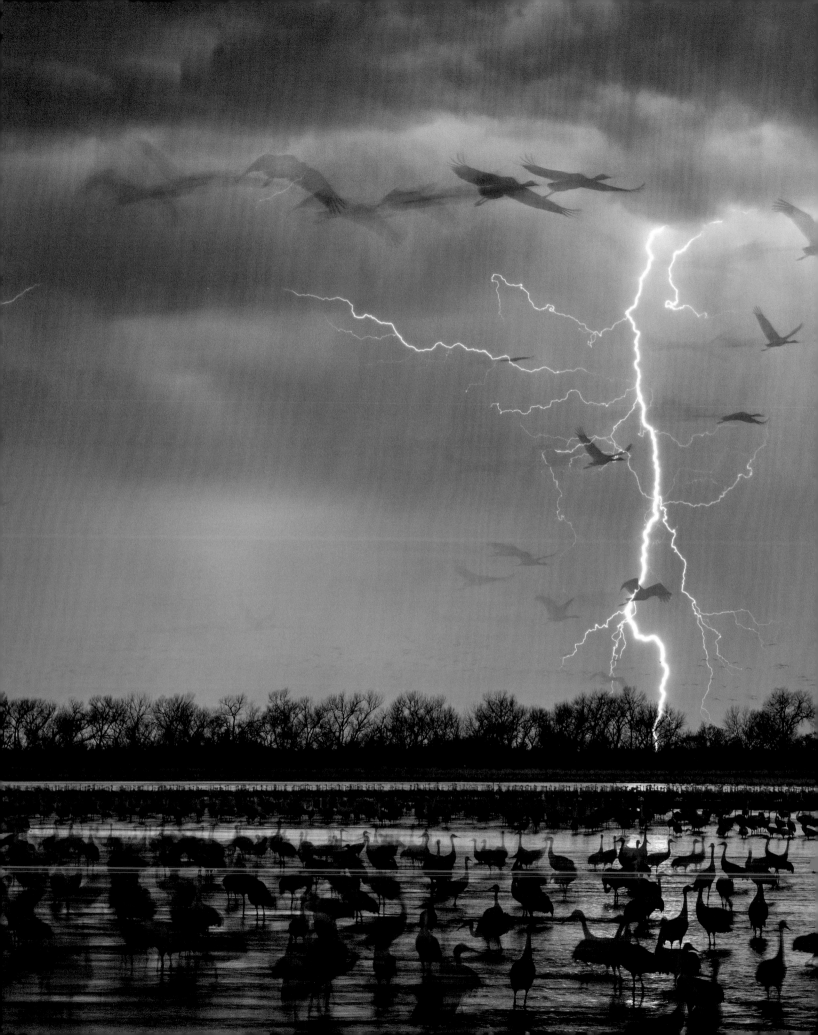

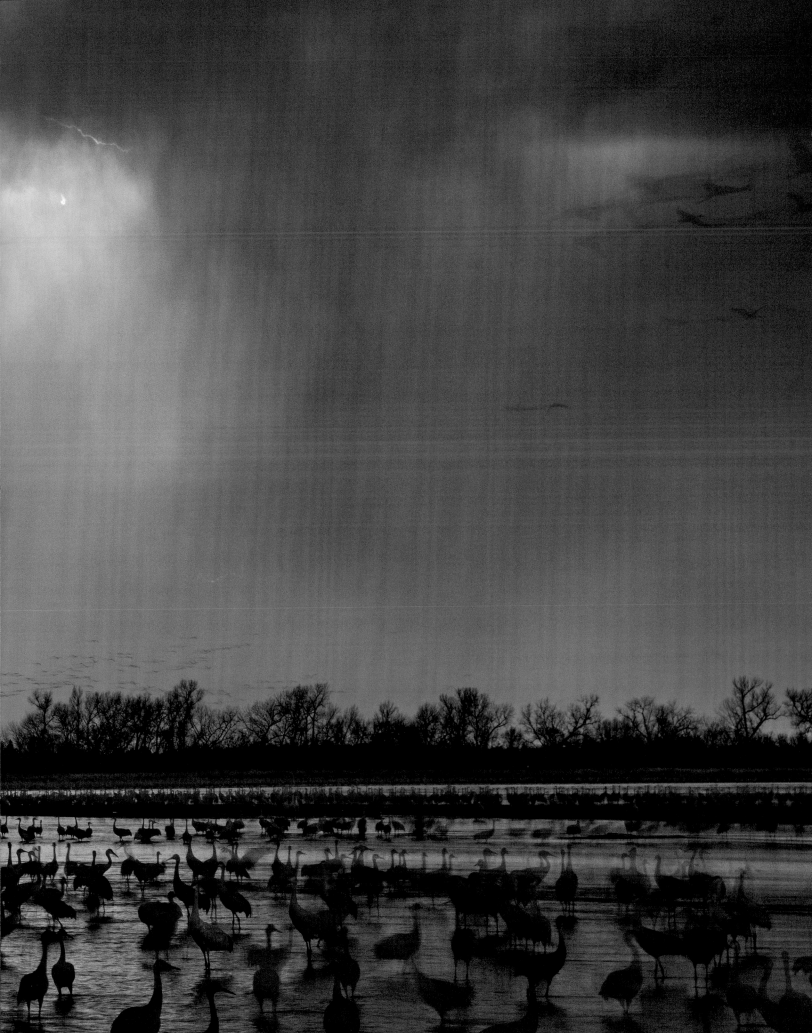

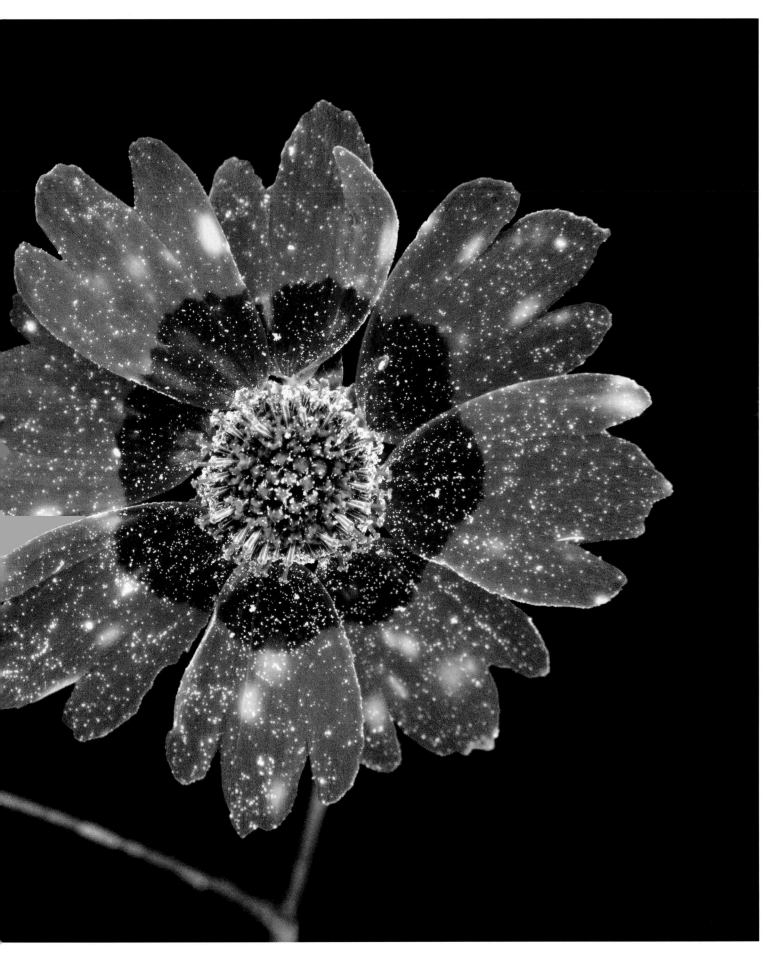

2016 I MATHIEU FOULQUIÉ
France
With mating season under way, two common toads get intimately acquainted in the shallow section of the Lez River. Their reproductive embrace—with the male atop the female—is called axillary amplexus.

HANNAH REYES MORALES

For a story on lullabies and bedtime rituals, I visited this kindergarten in Ulaanbaatar in the winter, and I got there during nap time. Everything was quiet, except for a mobile phone playing "Buuvein Duu," a Mongolian lullaby, as an air purifier hummed in the background.

The kindergarten was located in one of the most air-polluted places in the world—that week, the levels were hazardous outside. The classrooms are one of the only places where children can breathe purified air as they rest.

One of the teachers told me that often children from turbulent homes have a hard time sleeping. She sings "Buuvein Duu" to those children as a way to soothe them and to encourage much needed sleep. Studies have found that trauma causes disruption in sleep. But sleep can help heal trauma, and the lullaby is a bridge to reach that healing.

We think of lullabies as simple, soothing songs that put children to sleep, but they hold so much more. They are part of the fabric from which we make safer spaces where dreams can unfold. ∎

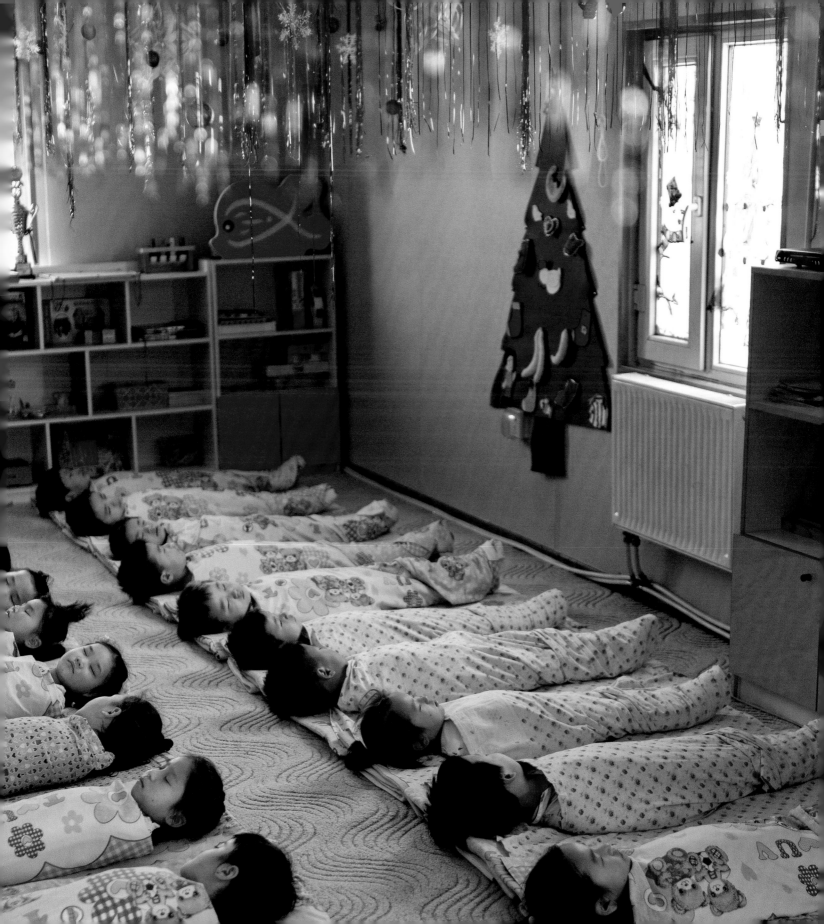

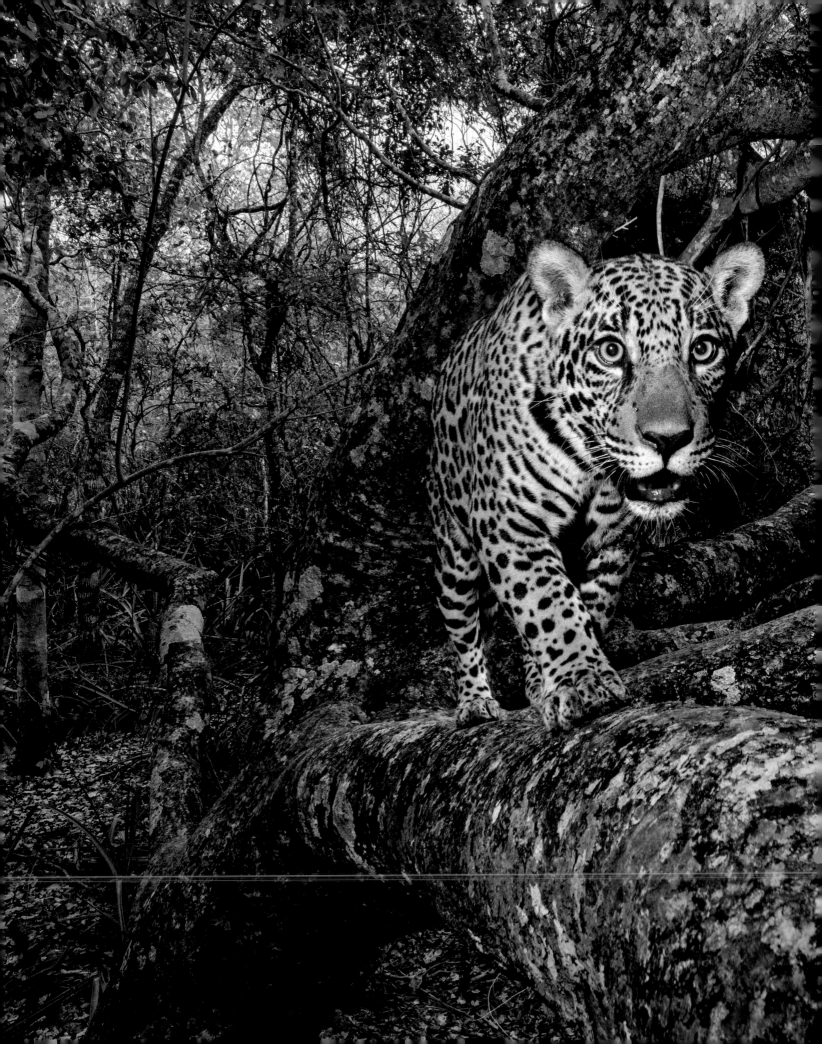

Opposite
2016 I STEVE WINTER
Mato Grosso, Brazil
A 10-month-old jaguar cub is caught in the infrared beam of a camera trap as it returns to the safety of a tree in Brazil's Pantanal region, the world's largest tropical wetland.

Pages 330-331
2016 I PAUL NICKLEN
Qaanaaq, Greenland
Pants made of polar bear fur identify an Inuit man as a seasoned hunter. With sea ice thinning every year, his dogsled journeys have grown increasingly hazardous.

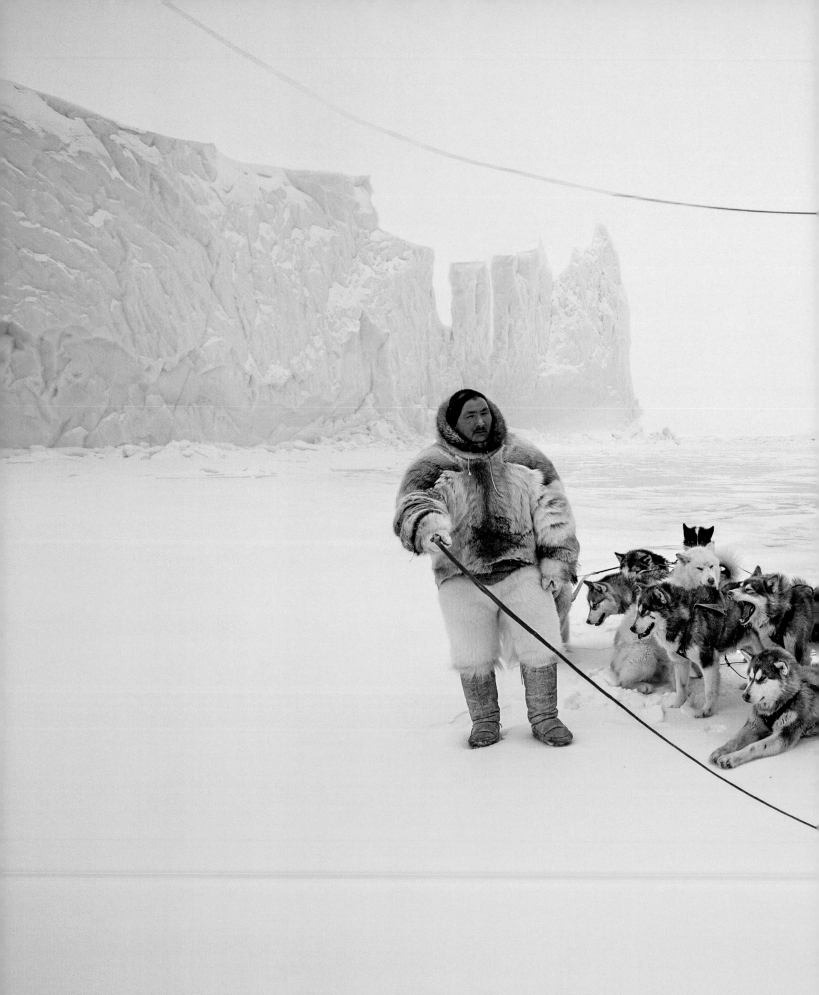

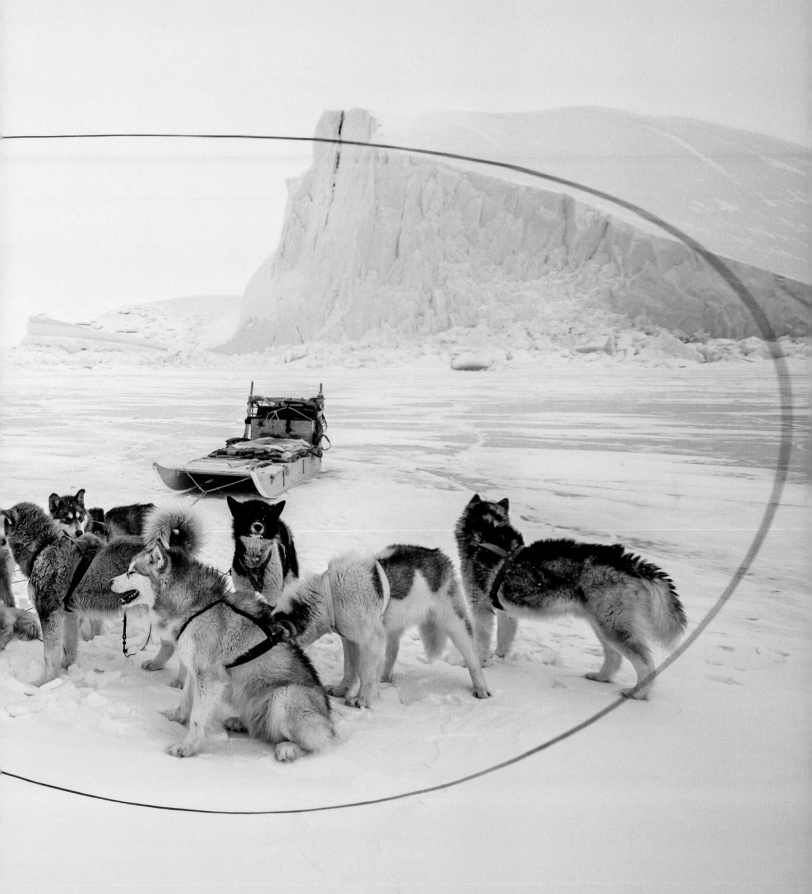

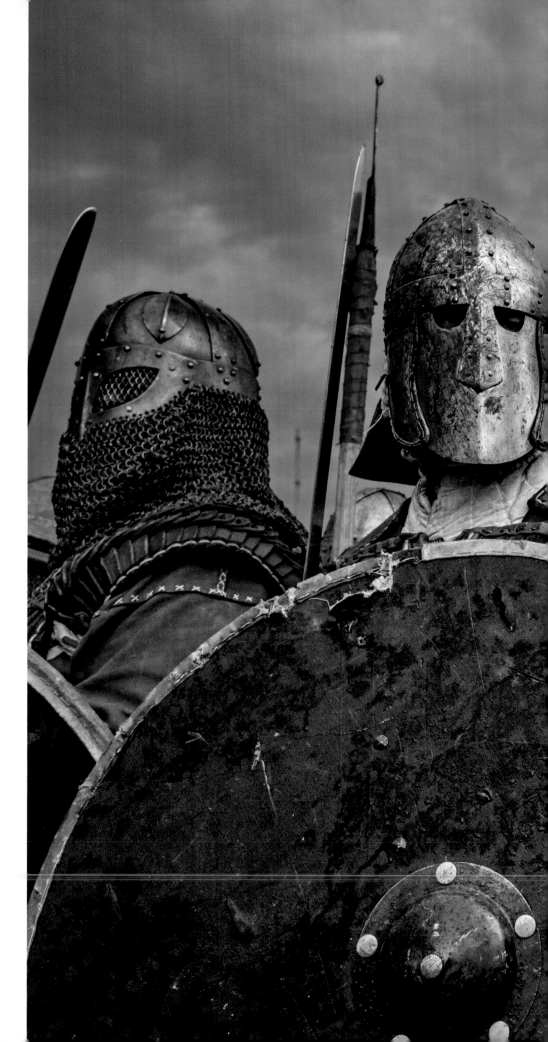

2016 I DAVID GUTTENFELDER
Wolin, Poland
Reenactors don armor in preparation for
close combat during the annual Festival
of Slavs and Vikings. Historically, Scandi-
navian boys were trained for battle and
socially conditioned for bloodshed.

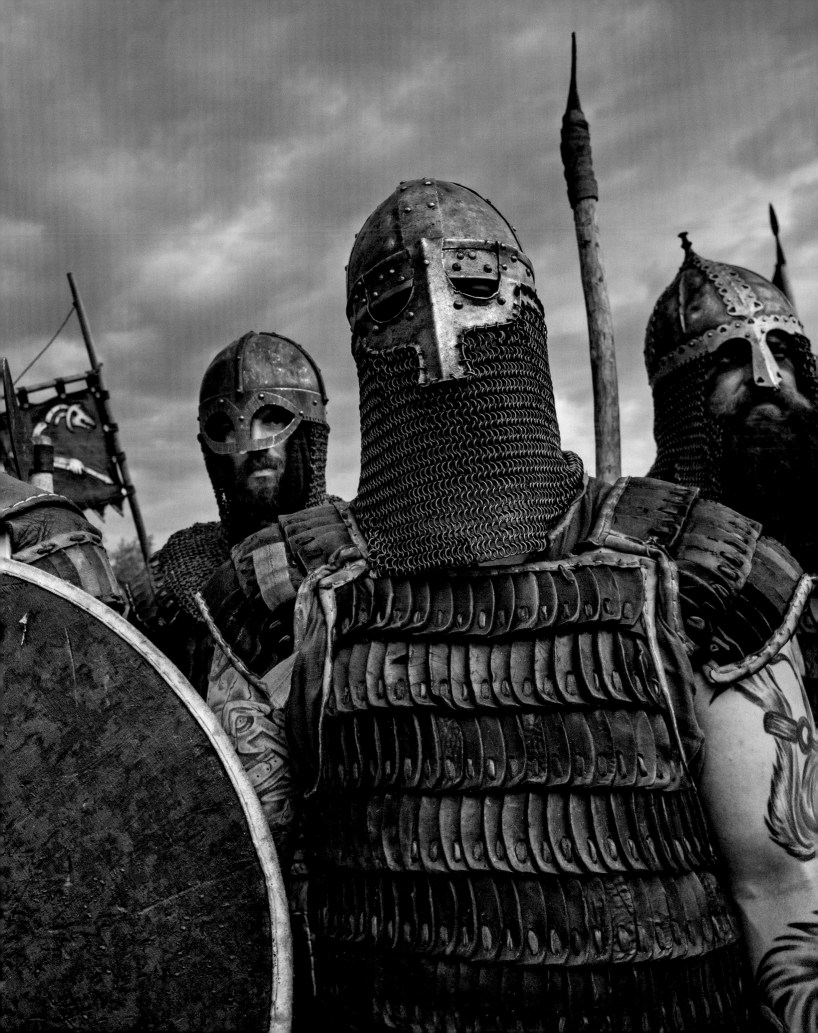

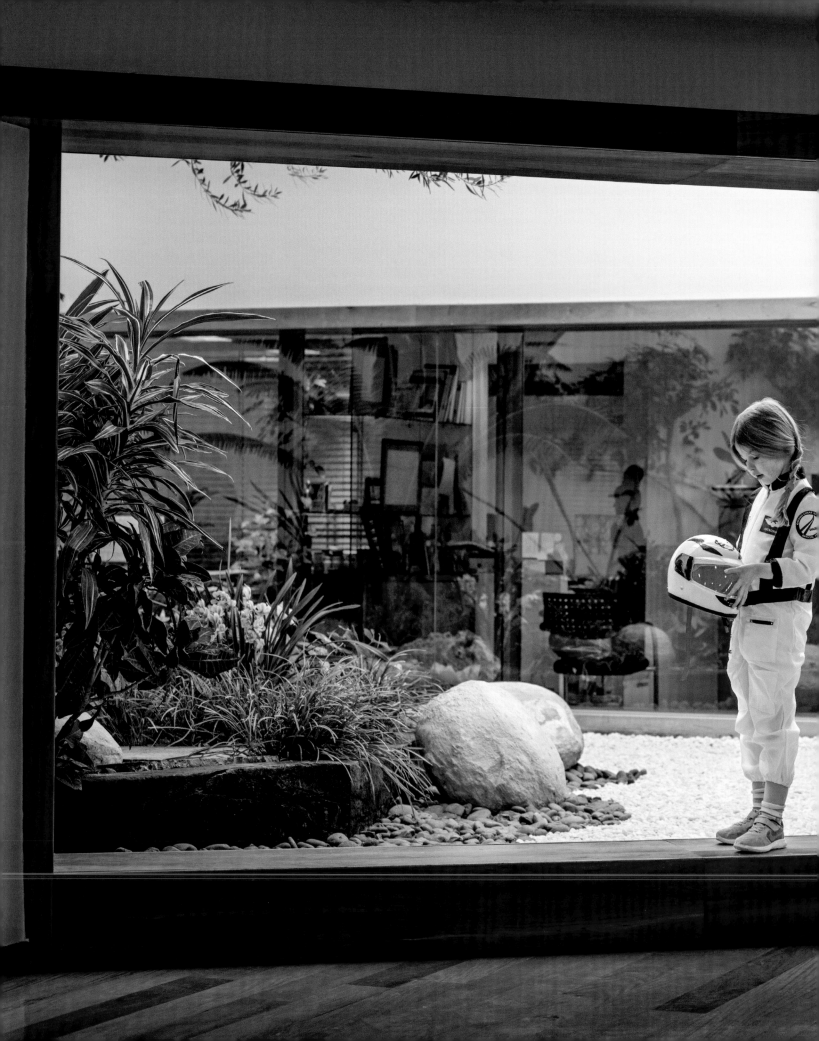

2017 | VINCENT FOURNIER
Tel Aviv, Israel
Wearing her official space suit costume at SpaceIL team headquarters, a seven-year-old girl is enthusiastically tracking the Israeli organization's progress—and contemplating spacefaring as a future career path.

2017 | MIKE TYKA, ALEXANDER MORDVINTSEV, CHRISTOPHER OLAH, AND MIT CSAIL
Google Headquarters, California, U.S.
Google's network of artificial neurons generates an image of its "dreams" through DeepDream, a program that enables the network to build its own algorithm-fueled dreamscape.

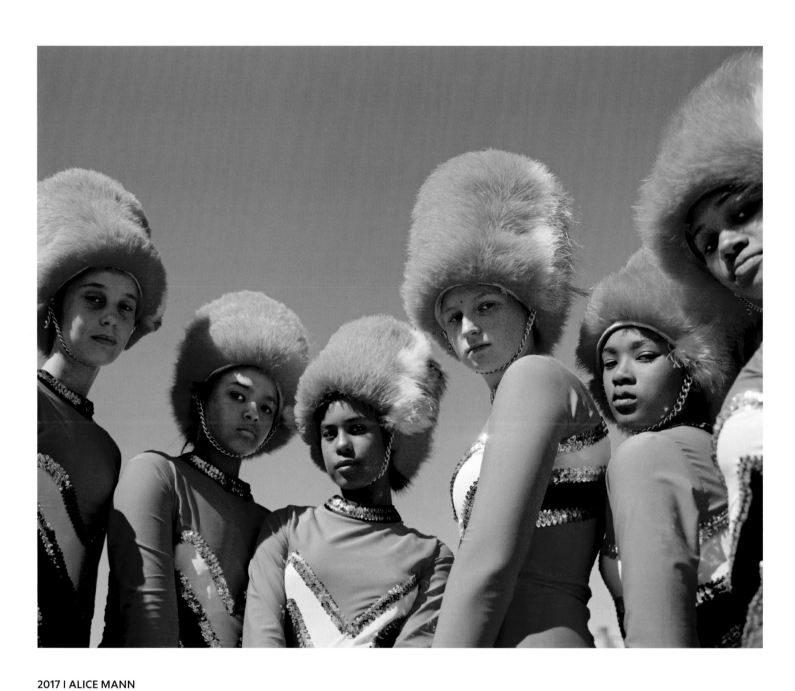

2017 I ALICE MANN
Cape Town, South Africa
There are no days off for "drummies."
On a national holiday, Fairmont High School
Drum Majorettes gather to practice
elaborate routines.

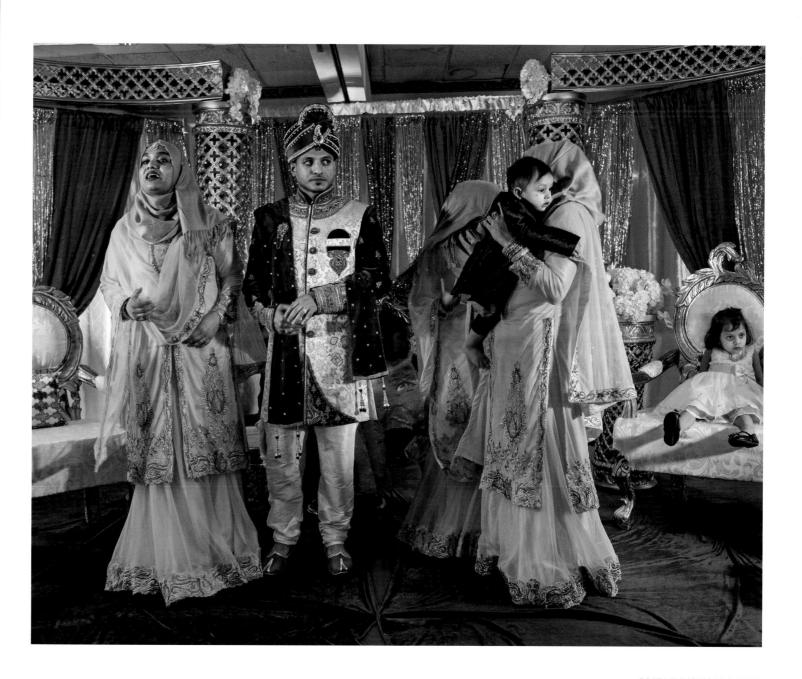

2017 I LYNSEY ADDARIO
Roseville, Michigan, U.S.
After a traditional Bengali wedding, a
groom waits with his new sisters-in-law for
his bride to arrive for photographs.

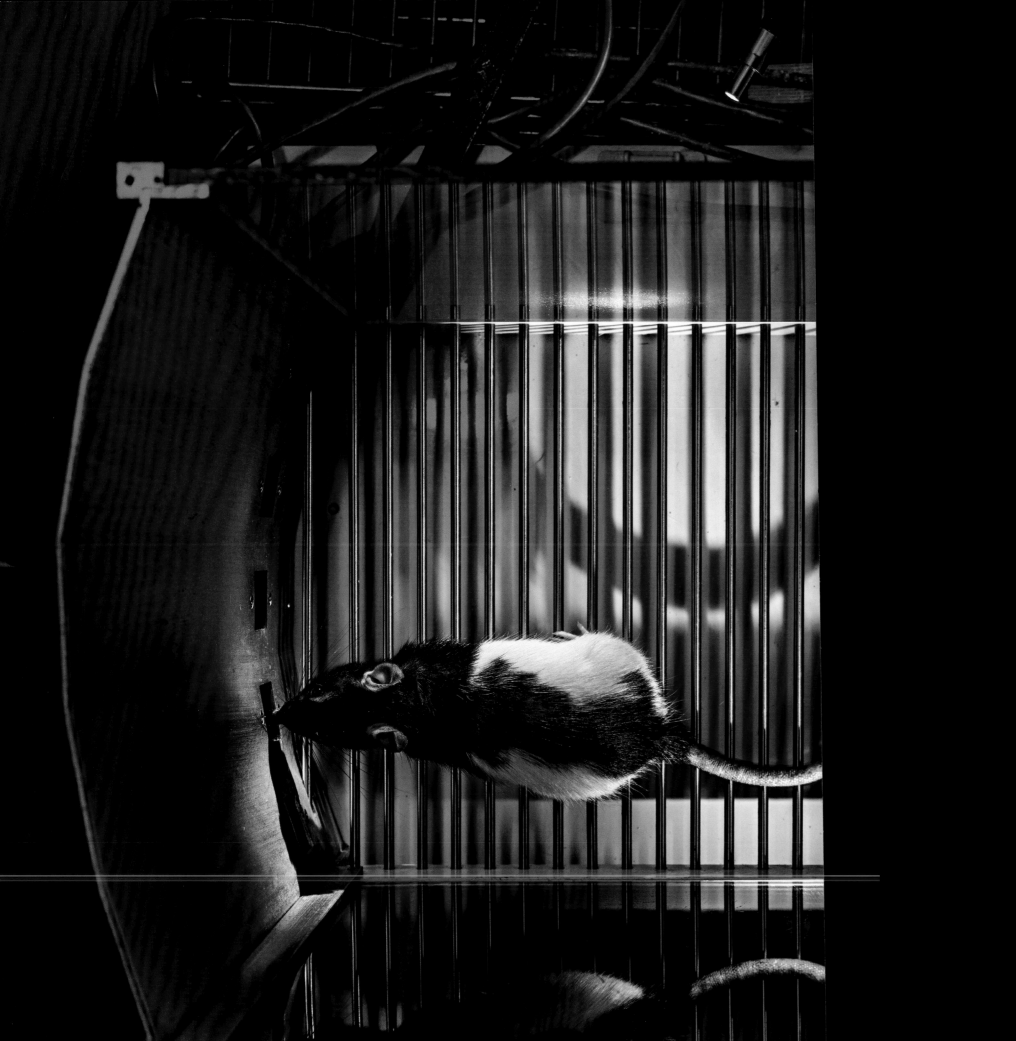

2017 | MAX AGUILERA-HELLWEG
Vancouver, British Columbia, Canada
A rat, in a simulation of a slot machine, is lured by the same types of flashing lights and throbbing sounds that keep humans playing in casinos.

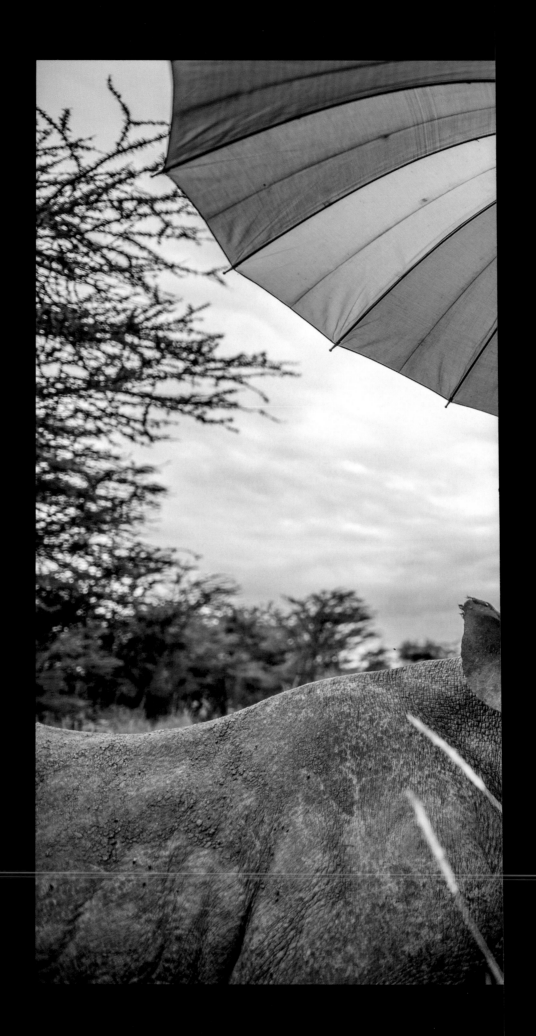

THROUGH
THE LENS

AMI VITALE

Kamara is nuzzled by a black rhino, Kilifi, that he hand-raised along with two other baby rhinos in northern Kenya. Kamara spent 12 hours every day watching over the vulnerable orphaned animals.

This area was once home to one of the densest black rhino populations. Today, most locals have never seen a rhino. In just two generations, this animal has been poached almost to extinction. We imagine wildlife roaming the open plains of Africa freely. The reality is that they need to be guarded and protected around the clock.

For hundreds of years, rhino horn has been used around the world to treat illnesses. It is believed to have miraculous healing powers, but it is actually just composed of keratin, the same material in our fingernails and hair. Nevertheless, today rhinos continue to be killed—by illegal poaching—for their horns, which can be sold on the black market for three times the price of gold.

We are witnessing extinction on our watch. It's likely that if the current trajectory of killing continues, elephants and rhinos, along with a host of lesser known plains animals, will be functionally extinct in our lifetime.

Much needed attention has been focused on the plight of wildlife, but very little has been said about the Indigenous communities on the frontlines. The best protectors of these animals are the people who live alongside them. ∎

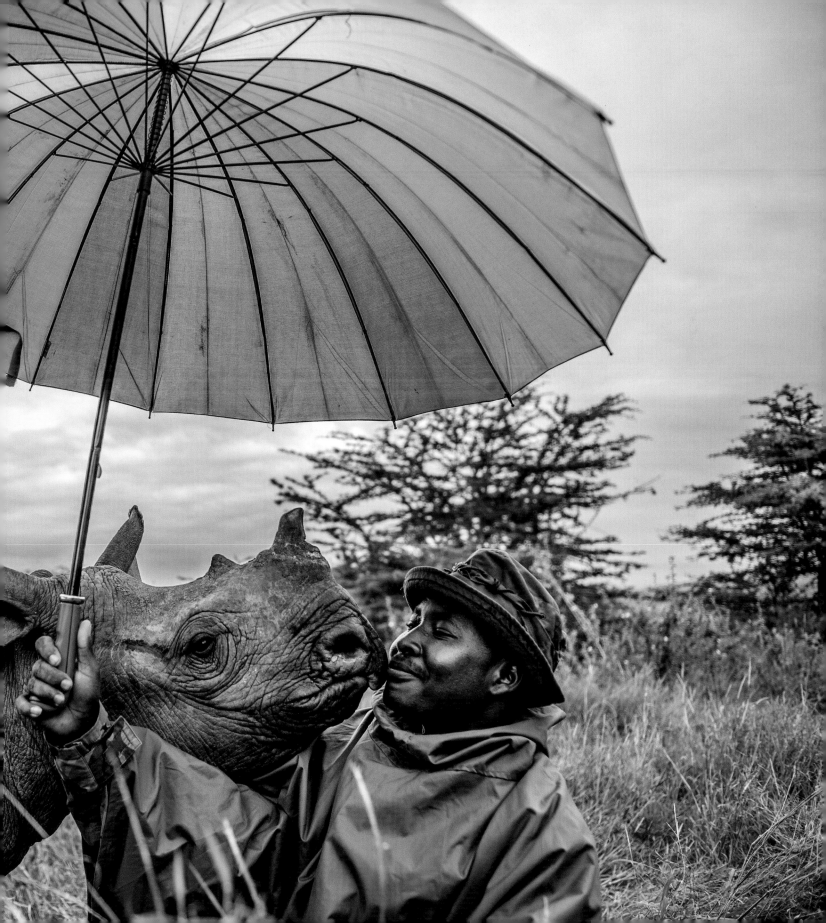

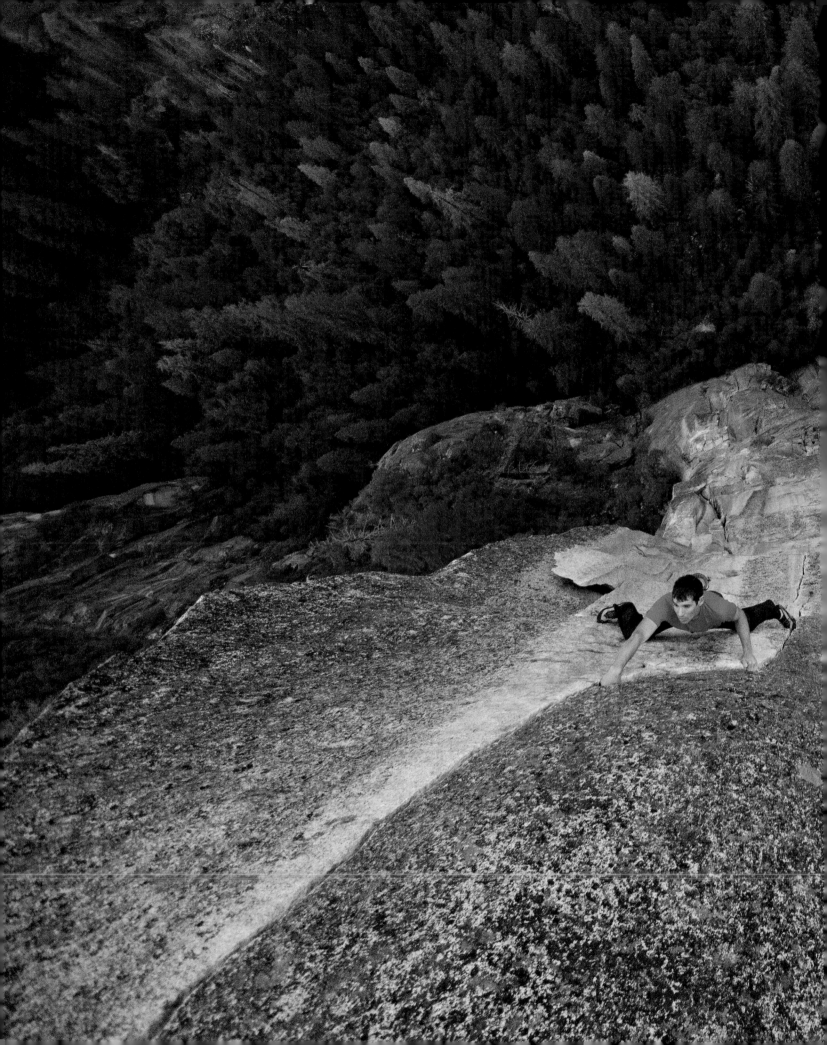

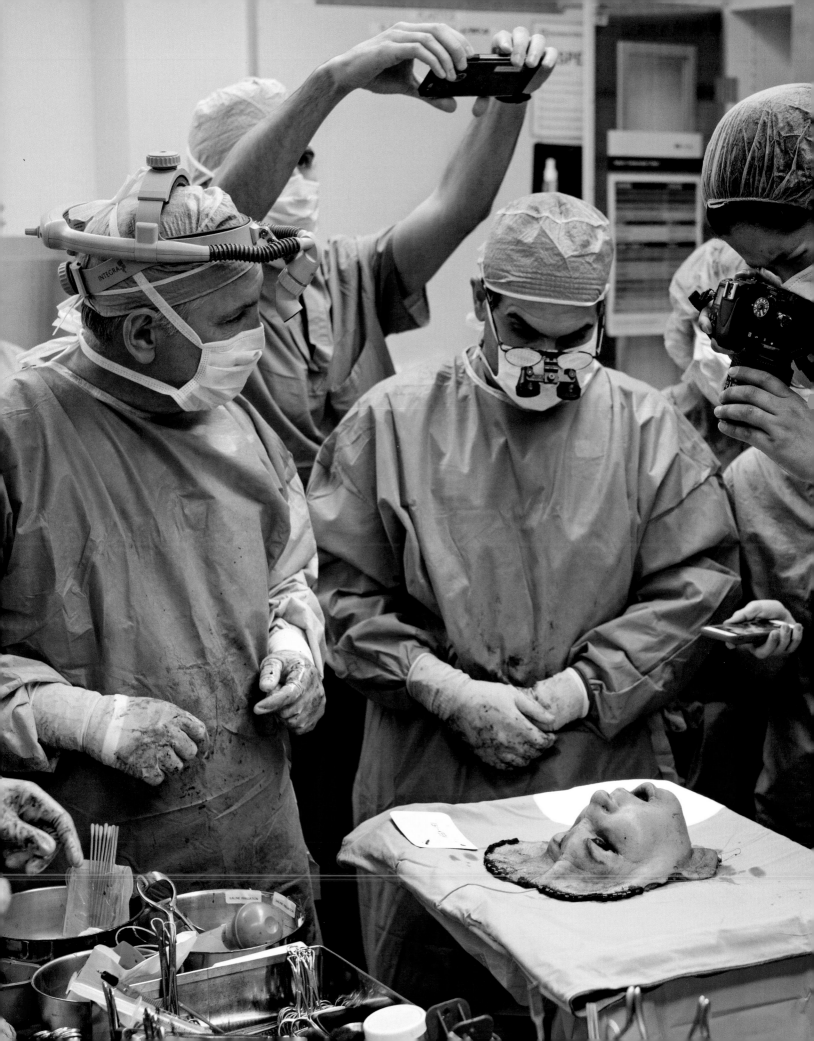

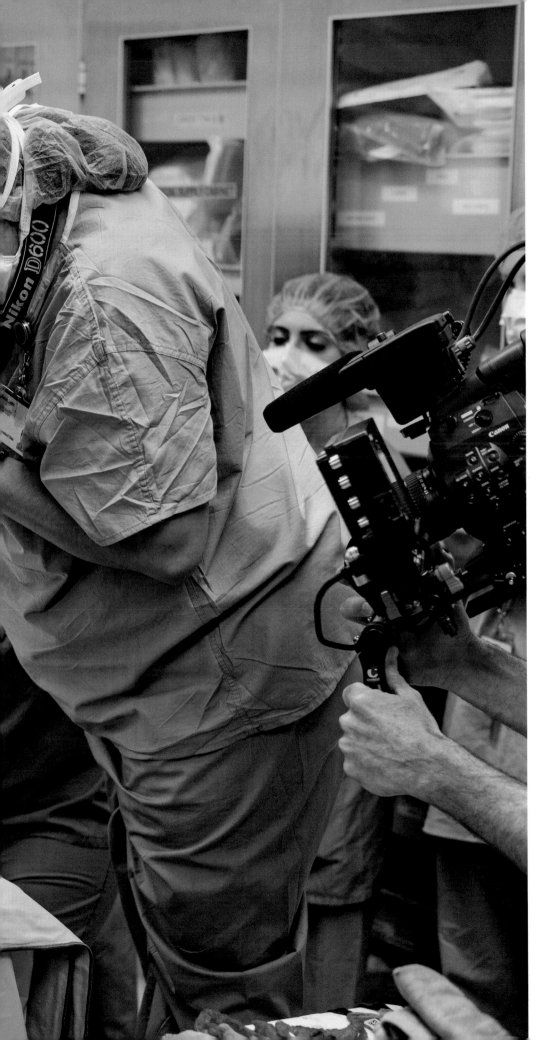

Opposite

2017 | XAVI BOU

Iceland

Using a layering technique, a photo illustration showcases the zipperlike patterns of northern fulmars soaring above the Skógafoss waterfall at their nesting site in Iceland.

Pages 350-351

2017 | LUCA LOCATELLI

Dubai, United Arab Emirates

Visitors make their way down steps and across suspended bridges inside the Green Planet, a biodome and tourist attraction that shelters rainforest habi-tat, including 3,000 species of plants and animals.

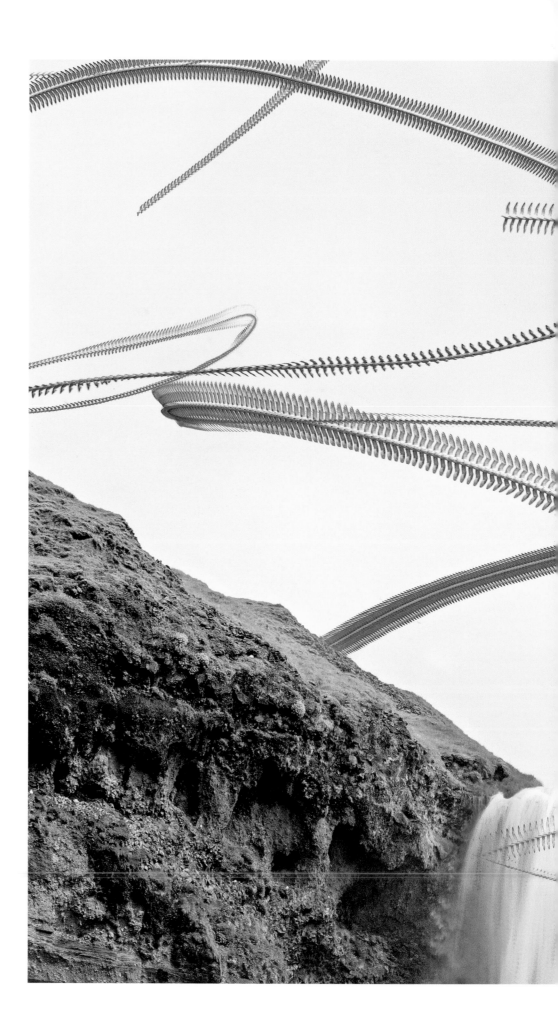

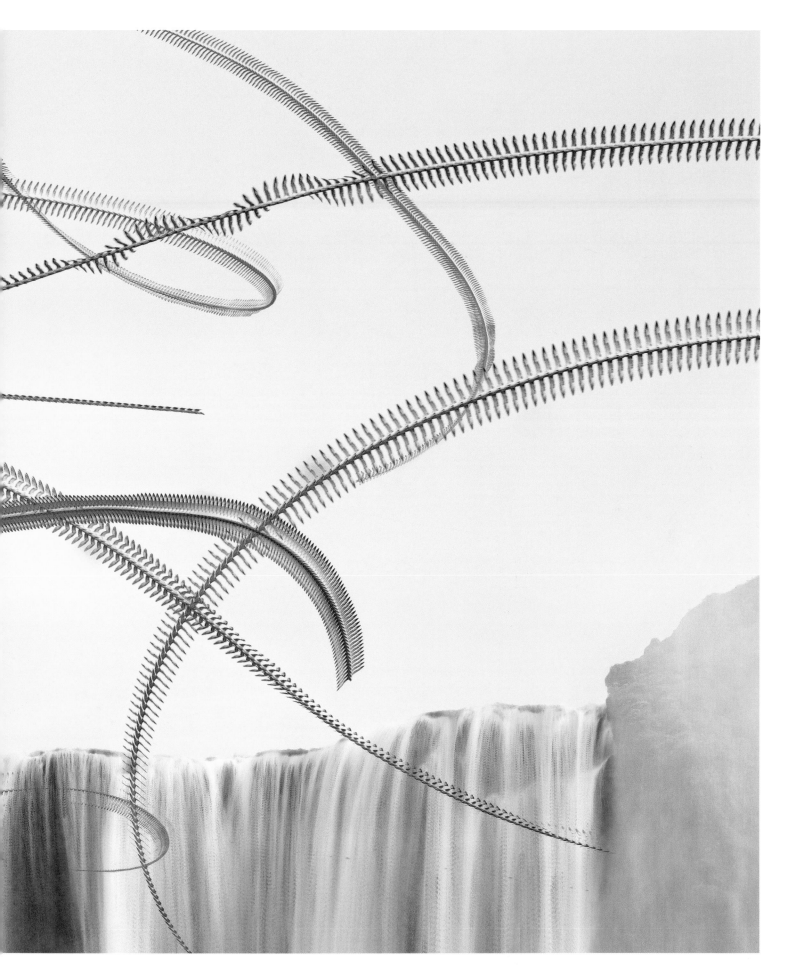

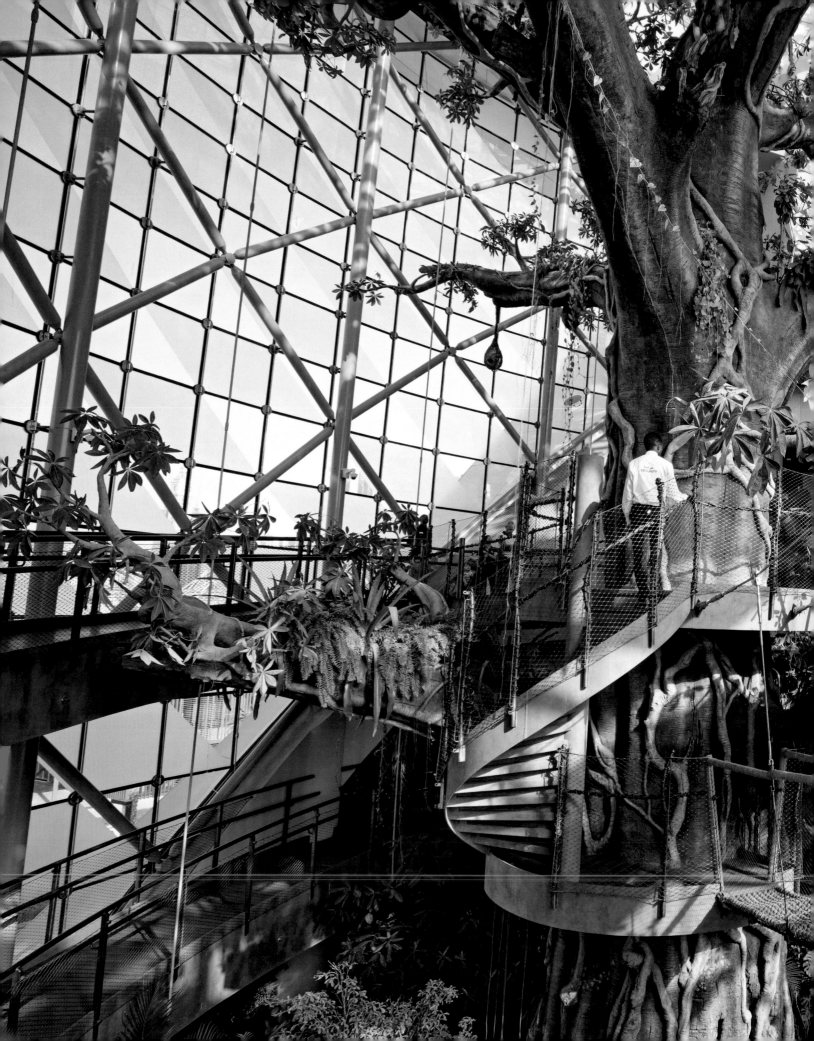

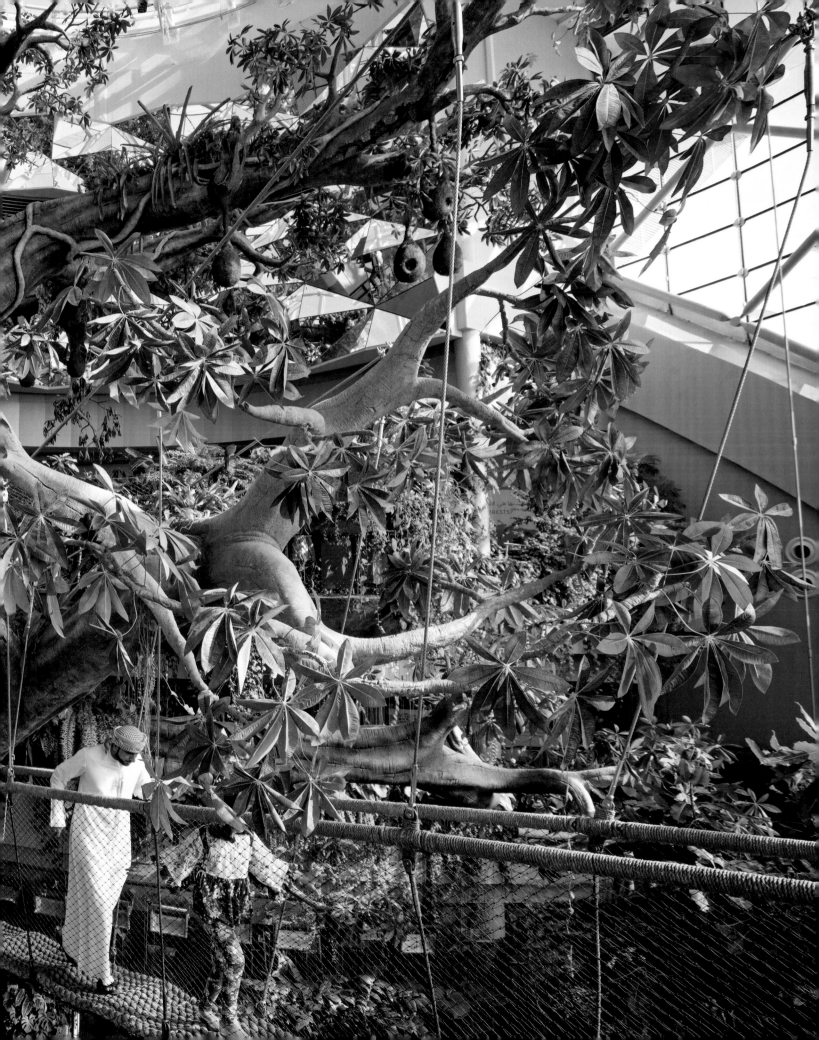

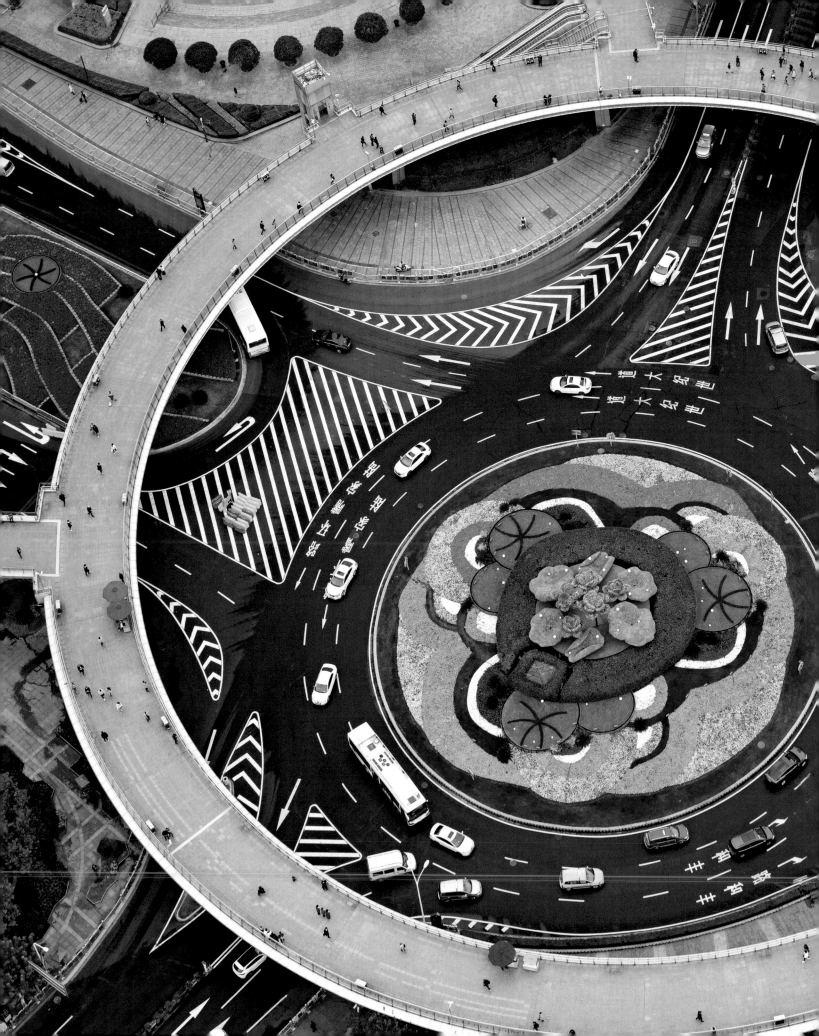

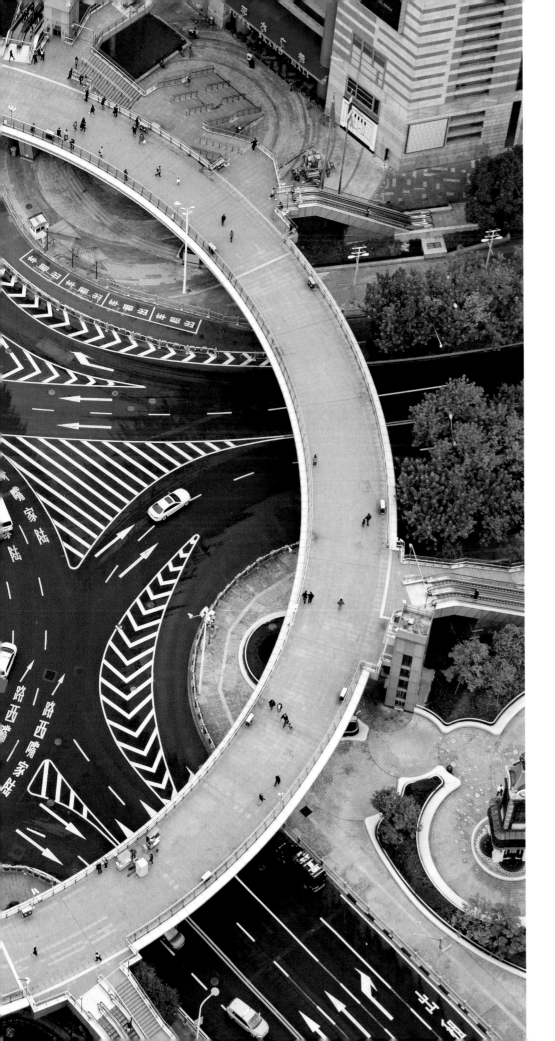

2018 I ANDREW MOORE
Shanghai, China
An elevated walkway allows pedestrians to survive the Mingzhu Roundabout in Pudong and navigate their way to sprawled-out office buildings and shopping malls around the circle.

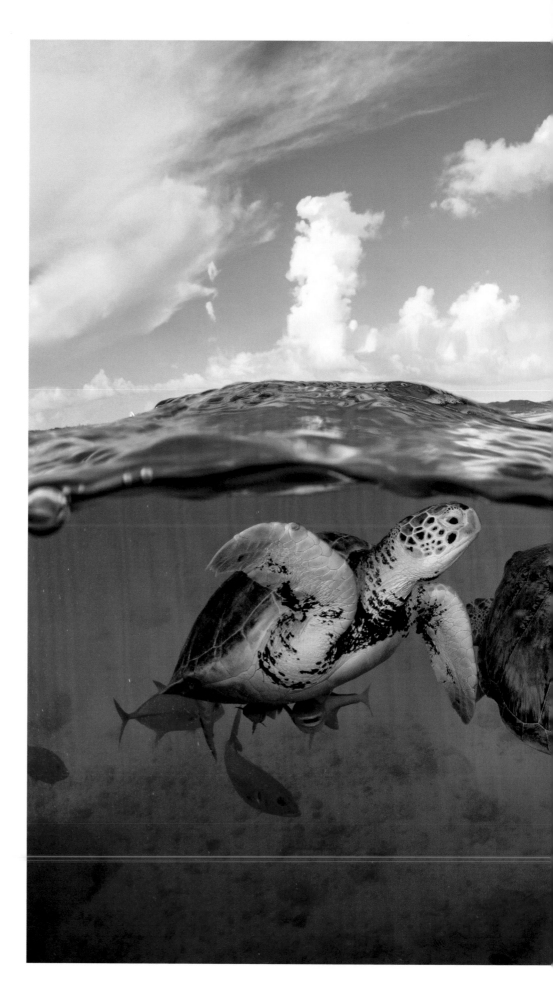

Opposite
2018 | THOMAS P. PESCHAK
The Bahamas
Green turtles congregate near a dock. Now endangered, the species was once so numerous that during Columbus's day "it seemed the ships would run aground on them."

Pages 356-357
2018 | PAOLO VERZONE
Orlando, Florida, U.S.
The Holy Land Experience, a Christian-based theme park in Orlando, features period reenactors and a replica of the Dead Sea Scroll caves.

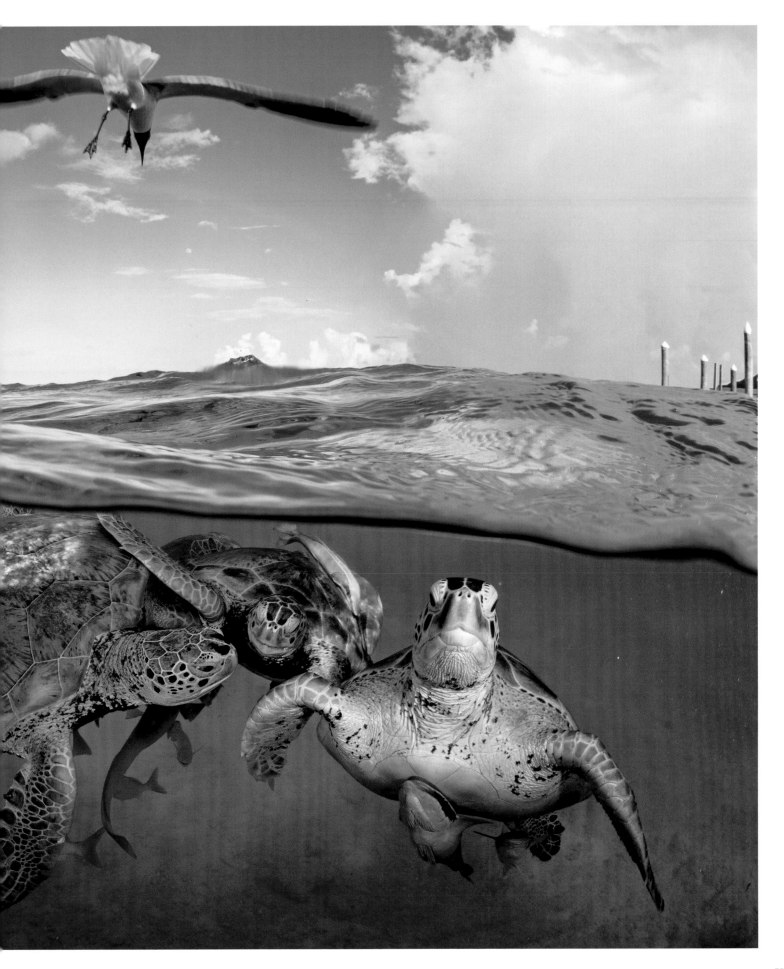

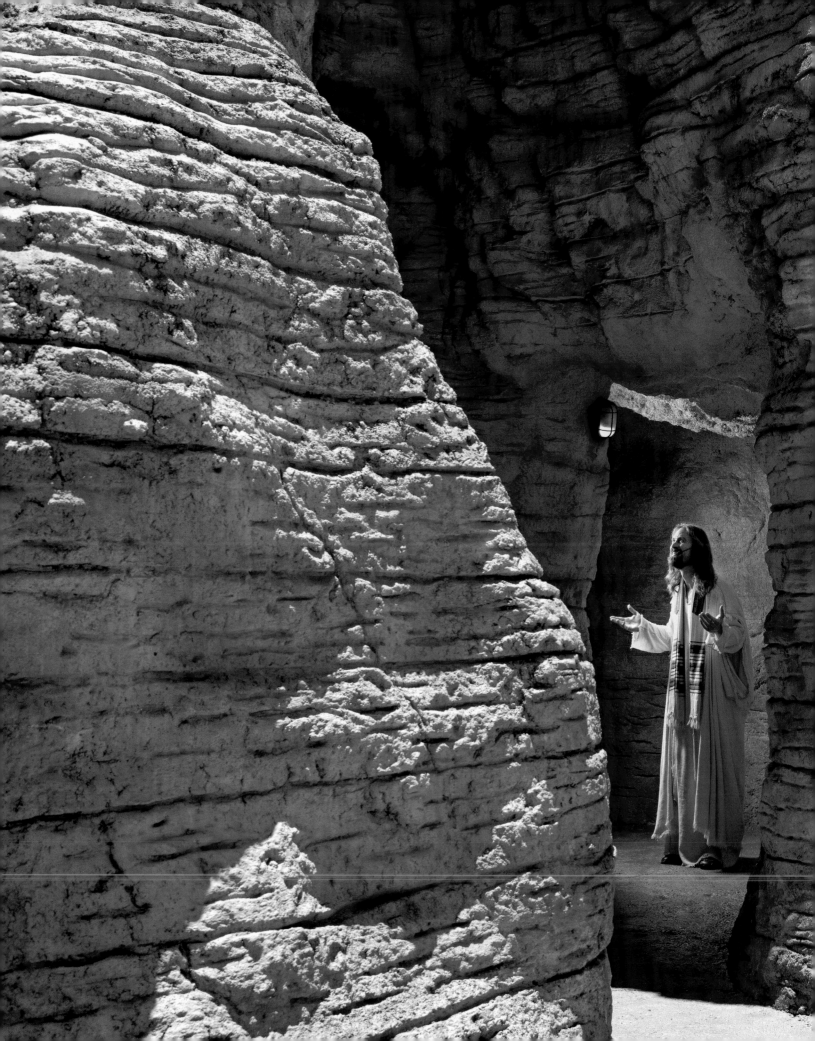

EVGENIA ARBUGAEVA

Most of my work is connected to the Russian Arctic, where I am originally from. I was drawn to places that don't show anything when you Google them. In these remote locations, I see beautiful landscapes and very brave people who have made this their home, even in the harshest, most extreme environments.

This photograph was part of a story about a young couple who had been living in a remote meteorological station and lighthouse for four years. What a romantic idea, living with a loved one on the edge of the world.

Before I visited them, I asked what I could bring, knowing that food supplies are sent only once a year by icebreaker ship and that they live on canned or dried foods and grains. Mindful of the fact that I would be traveling to them on a 14-hour snowmobile journey, they gave me a very precise list.

I wrapped apples and other fruits in my coats and jackets so they would survive the road, and when I arrived the young woman began wrapping the apples so carefully in newspaper to keep them from freezing. She was doing it as if they were precious, like crystal. It reminded me how much we take for granted.

In one shot, these two apples somehow symbolized the couple's romantic journey, the beautiful January light of the Arctic, and the reality that these were truly golden apples. ■

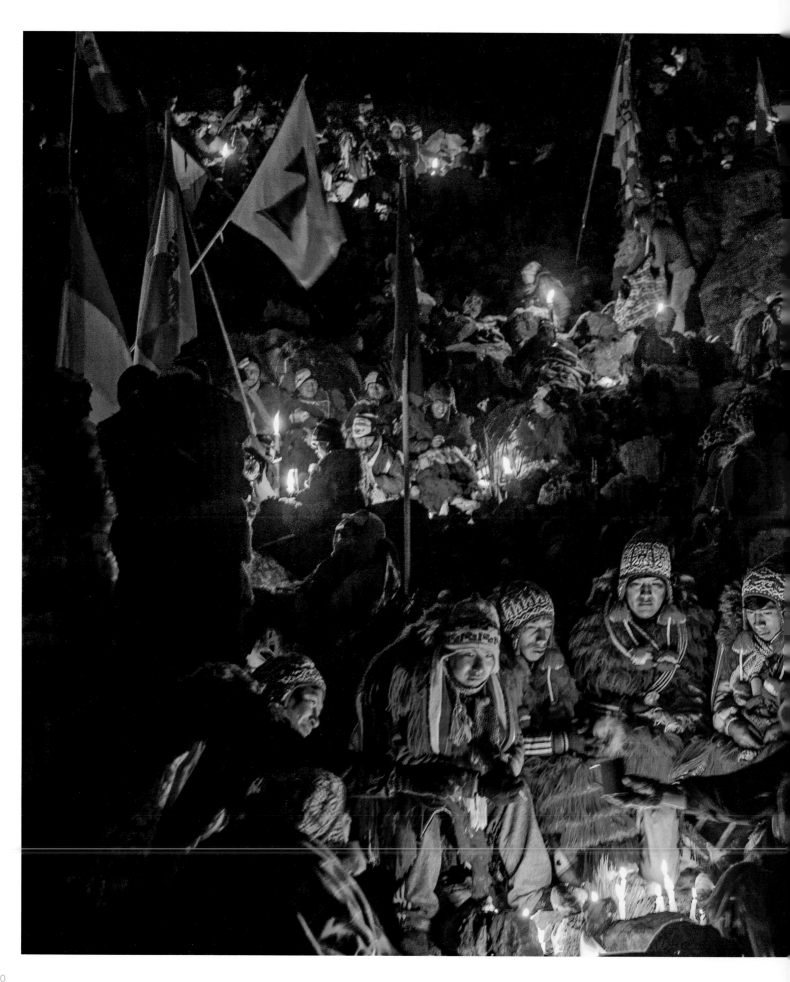

2018 I PETE MULLER
Cusco Region, Peru
Huddling around candles before dawn, men from Peru's Quispicanchi nation celebrate Qoyllur Riti below a glacier. Pilgrims believe the glaciers hold healing properties, but because the ice has receded so dramatically, cutting pieces of it is now banned.

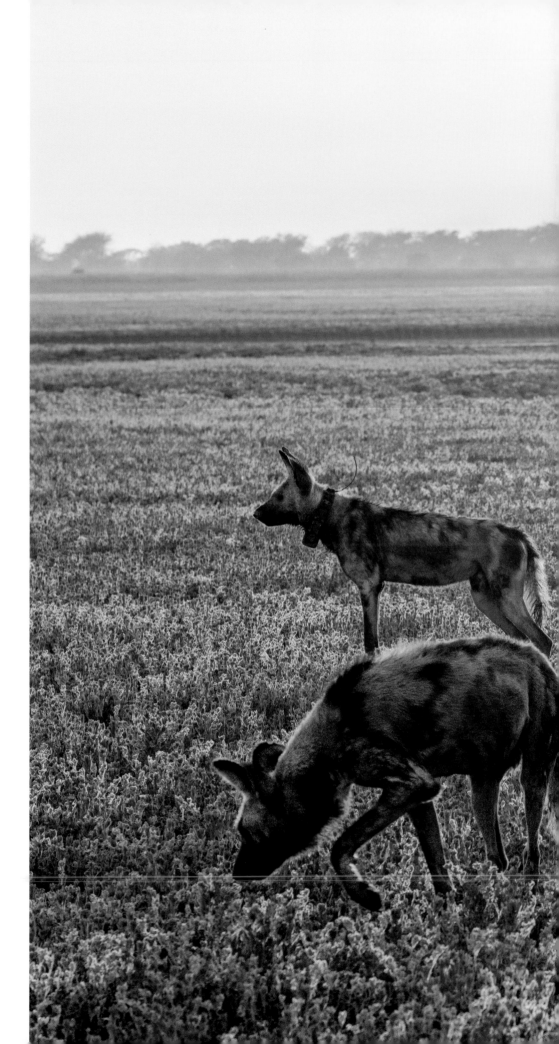

Opposite
2018 | CHARLIE HAMILTON JAMES
Mozambique
Once entirely lost to Gorongosa, a pack of 14 African wild dogs from South Africa were released in the national park to help naturally balance the ecosystem as prey populations boomed.

Pages 364-365
2018 | PASCAL MAITRE
Agadez, Niger
An Izala school educates about 1,300 students. Izala is a back-to-basics Islamic reformist movement that adheres to conservative practices, such as women covering their faces and the separation of sexes, but also prizes education.

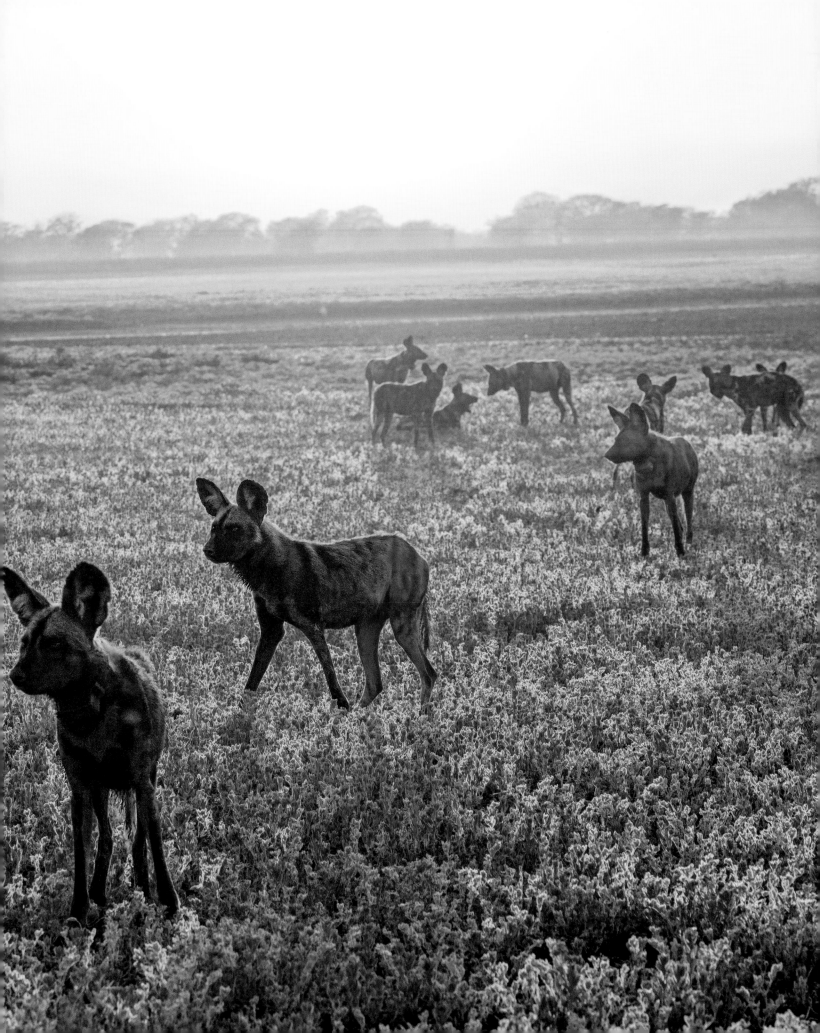

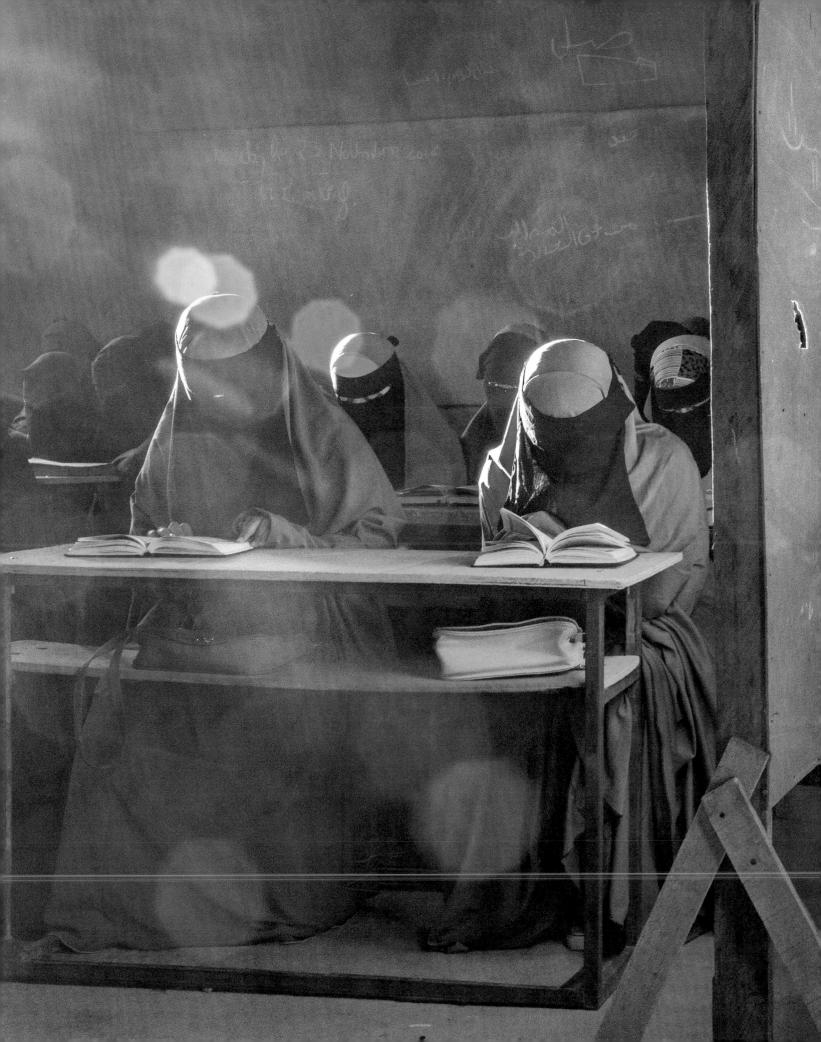

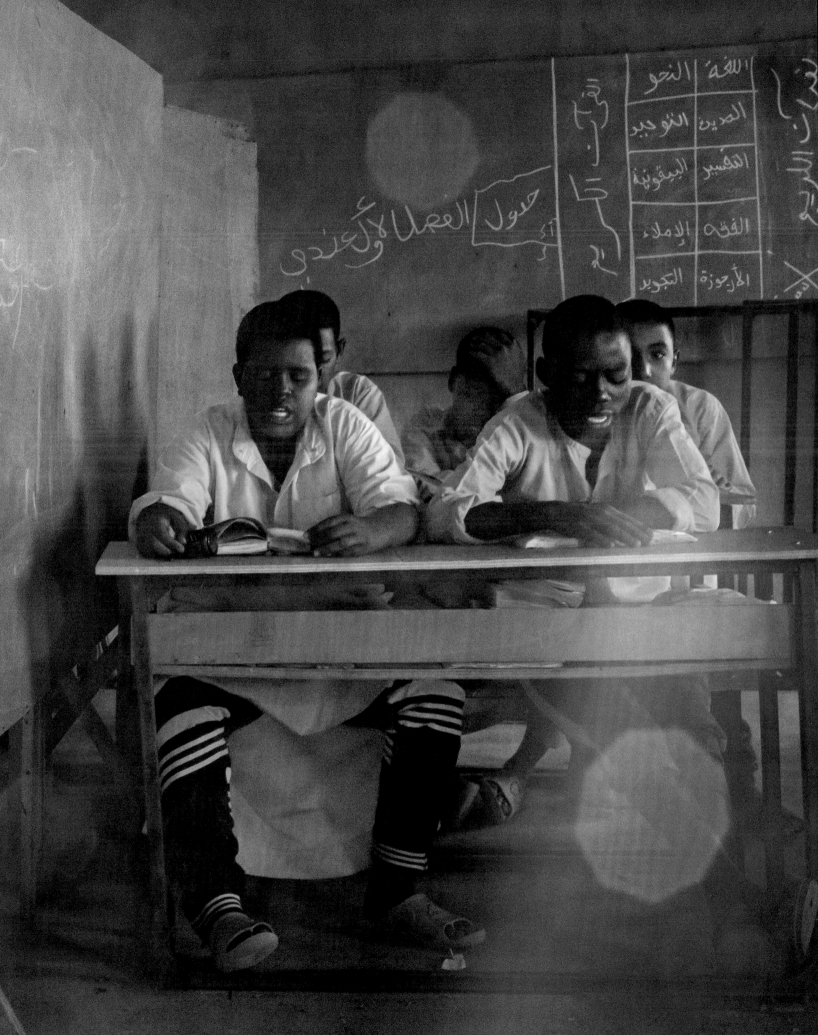

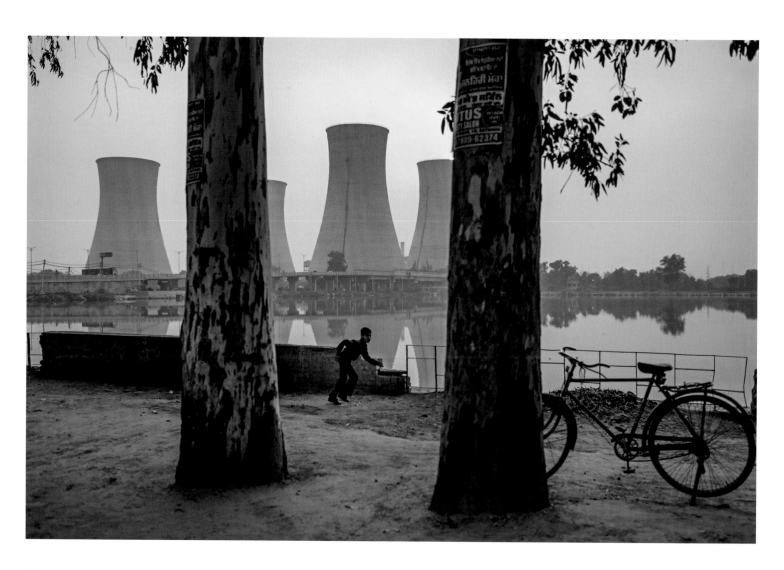

2018 I JOHN STANMEYER
Bathinda, Punjab, India
The Guru Nanak Dev coal-burning power plant
shut down in 2017 after 43 years. It helped power
the state's mammoth irrigation needs, but it also
blanketed the city in coal ash, causing health
issues and damage to local ecosystems.

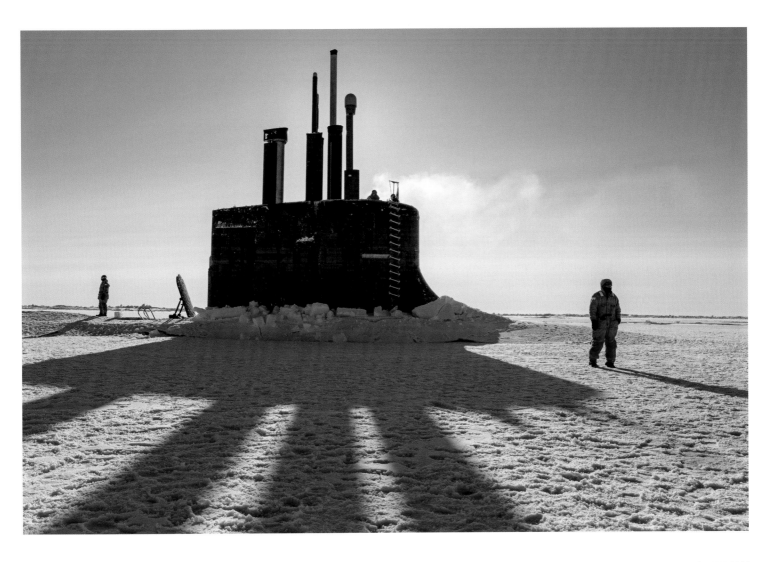

2018 I LOUIE PALU
Beaufort Sea, Arctic
The attack submarine U.S.S. *Connecticut* protrudes through an ice floe in the Beaufort Sea. For decades, the U.S. and Russian navies have jockeyed for position in the Arctic. Now China is ready to enter the fray, investing in icebreakers and technology to melt ice and open shipping lanes.

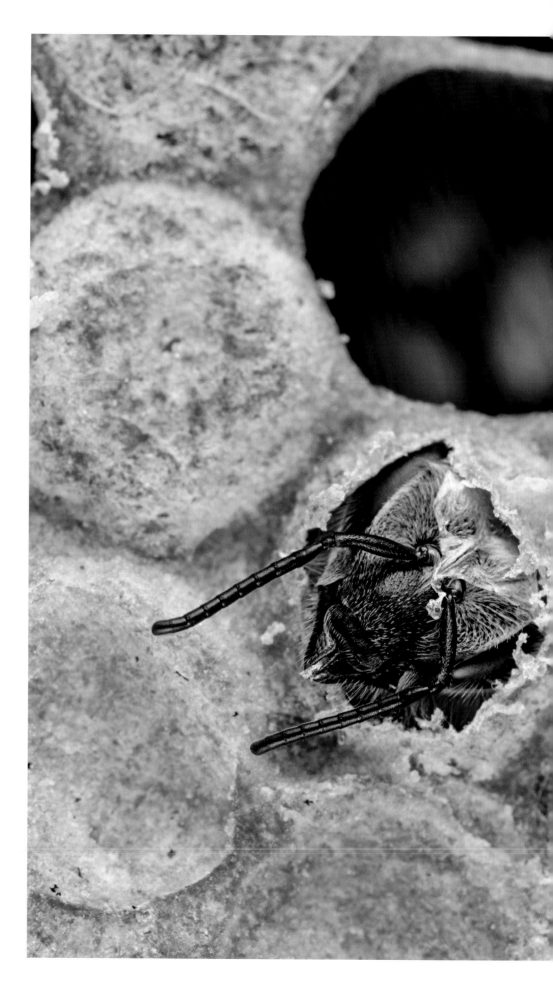

Opposite
2018 | INGO ARNDT
Langen, Germany
Newly formed bees chew their way out of wax-covered cells. Like butterflies, bees go through several life stages. From the larval stage, it takes weeks for a fully formed bee to emerge.

Pages 370-371
2018 | PAOLO VERZONE
Cambridge, England
A conservator examines a Hebrew text at the Cambridge University Library, which houses some 200,000 Jewish manuscripts discovered at a medieval synagogue in Cairo, Egypt.

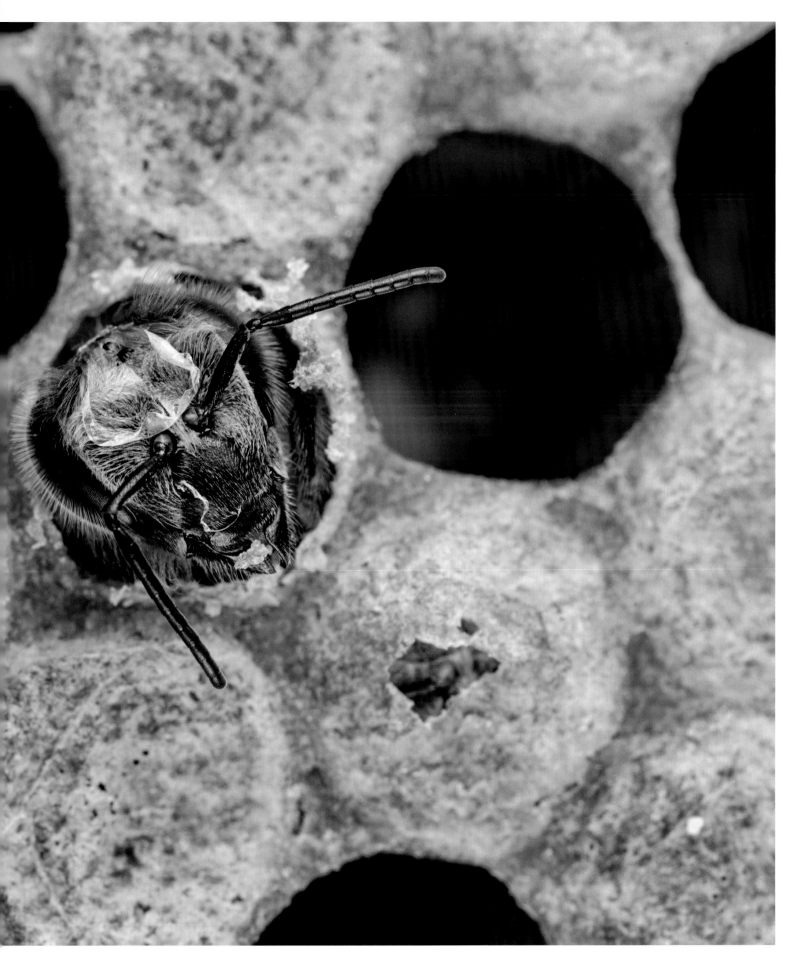

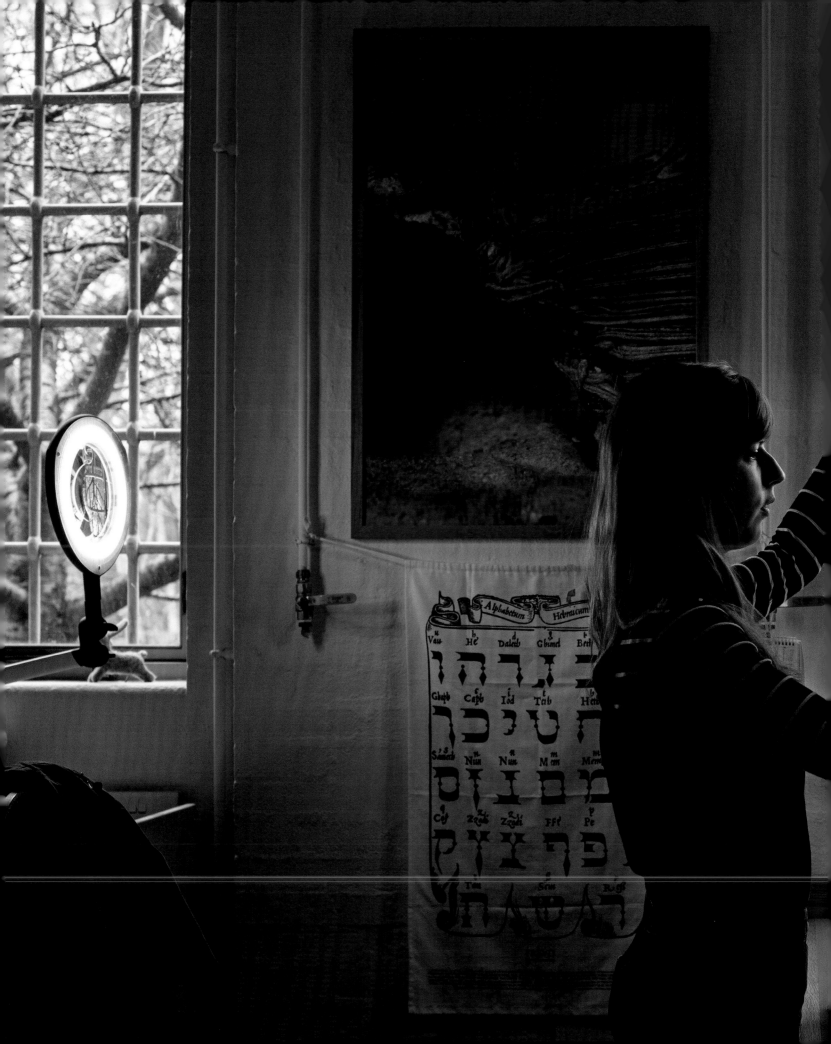

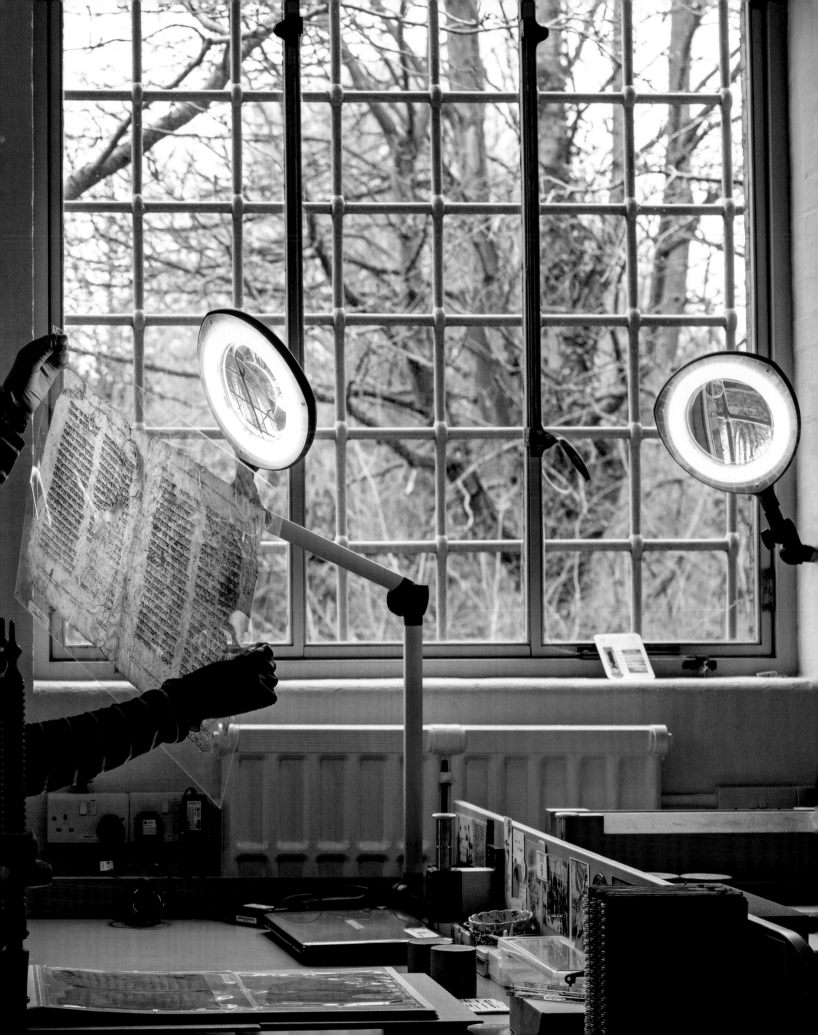

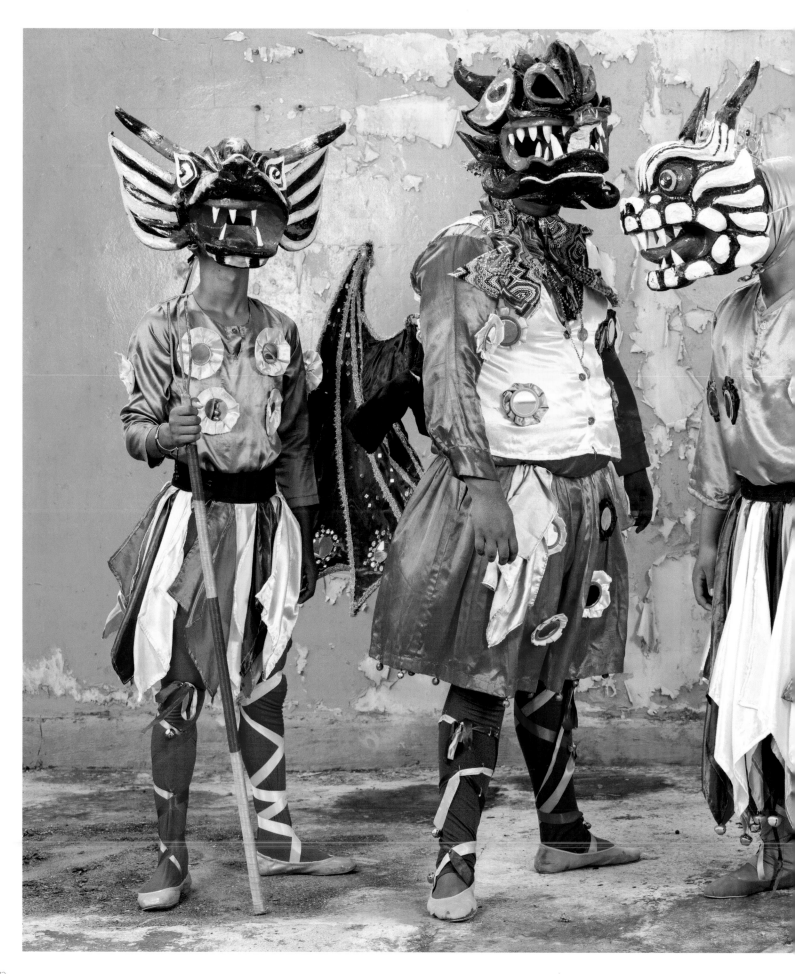

2018 I CHARLES FRÉGER
Chepo, Panama
Teenagers dress in colorful outfits decorated in mirrors and papier-mâché masks to celebrate the Corpus Christi tradition, as well as honor the legacy of Bayano, the Cimarron king who led one of the biggest slave uprisings in the Americas in the 1550s.

ANAND VARMA

The first time I pitched hummingbirds as a story to *National Geographic* magazine it was rejected. The photo editor said every image of a hummingbird had been taken already. And she had a point: How do I show these creatures in a way no one has ever seen before?

Through access gained from my friend, researcher Chris Clark, I spent hours and weeks in the field studying hummingbirds. I gained an understanding of the scientists and of the crazy tools and techniques they were using to learn about these incredible birds. What came of it was a story about the science of hummingbirds and the modern tools used to uncover their secrets.

This image is a recreation of an experiment used to discover how hummingbirds orient themselves. Scientists were trying to understand the tools that hummingbirds use to help fly through tight spaces and through the world using a feeding syringe and an optical illusion.

For me, the image perfectly encapsulates this intersection between the familiar and the mysterious. You don't need to know about the science behind the experiment to immediately be stopped in your tracks and ask, "What is going on here?" There's something familiar, and something very weird. That is the crux I'm always trying to balance: How do you take something you thought you knew and show something entirely new? My hope is to spark a sense of wonder about the known and unknown. ∎

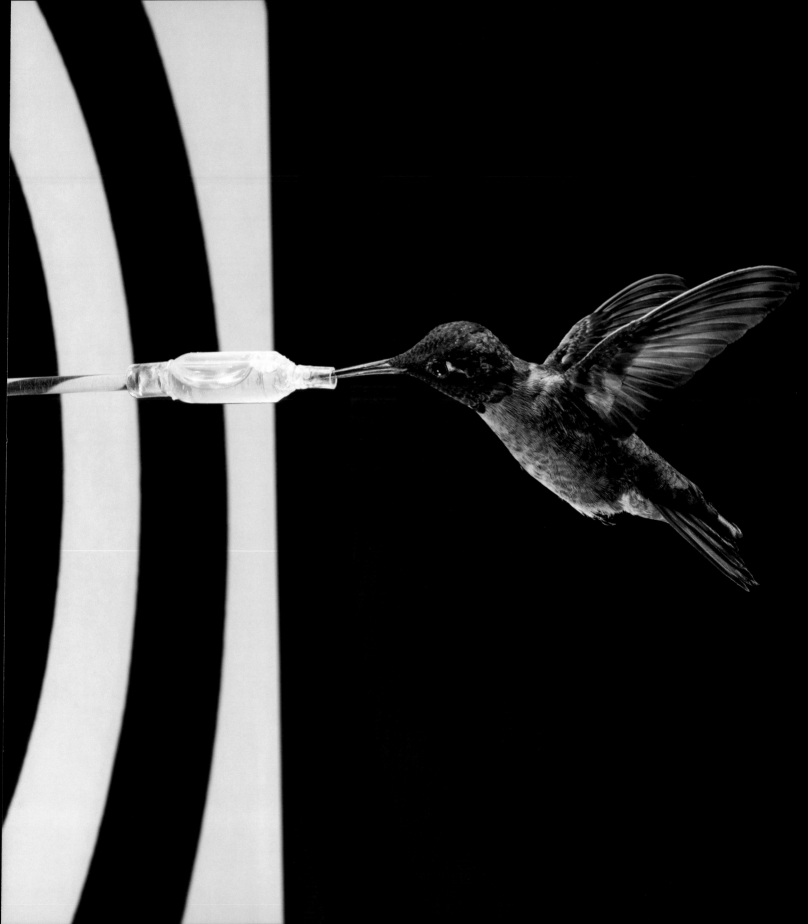

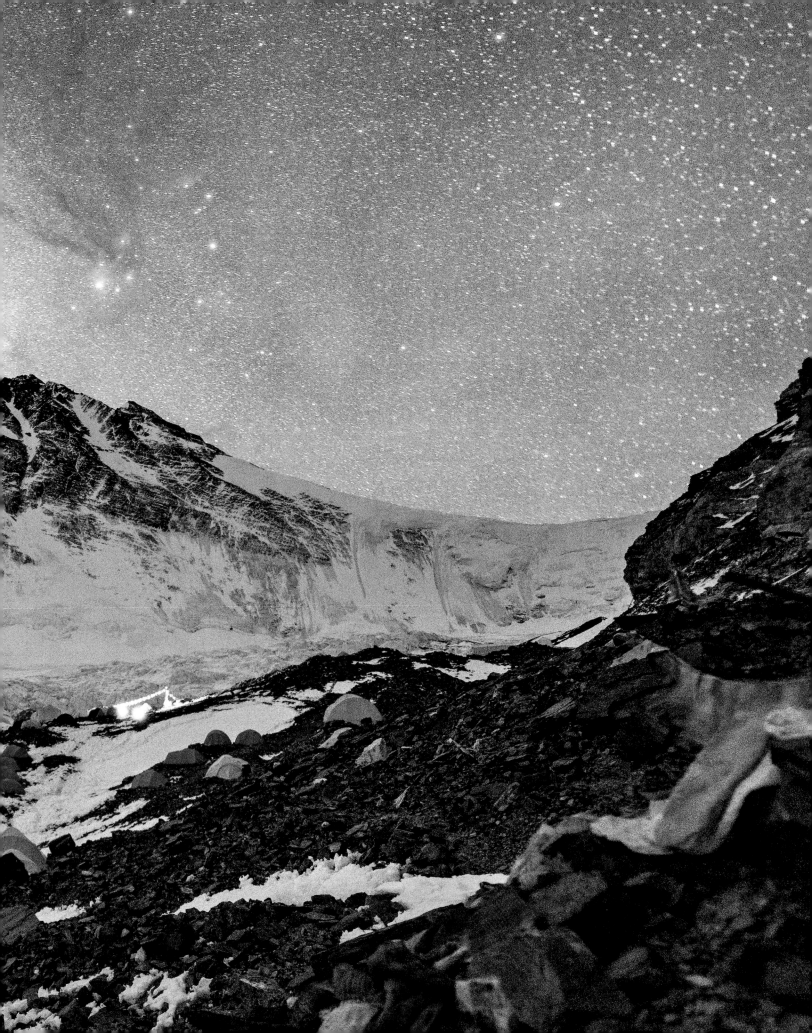

Opposite

2019 I DANIEL OCHOA DE OLZA

Colmenar Viejo, Spain

A young girl poses in an altar during the festival of La Maya, which marks the arrival of spring.

Pages 376-377

2018 I RENAN OZTURK

Everest, Tibet

The top of the world seems as distant as the Milky Way from Mount Everest's Advanced Base Camp, where more than 200 people sprawl across the glacial moraine. The summit is the rightmost peak.

Pages 380-381

2019 I MARTIN OEGGERLI

Basel, Switzerland

Moist lips are rich in microbes. A woman pressed her mouth on a petri dish to let her microbiome grow. Days later, a colony bloomed. People who often kiss each other will develop similarities in their oral microbiomes.

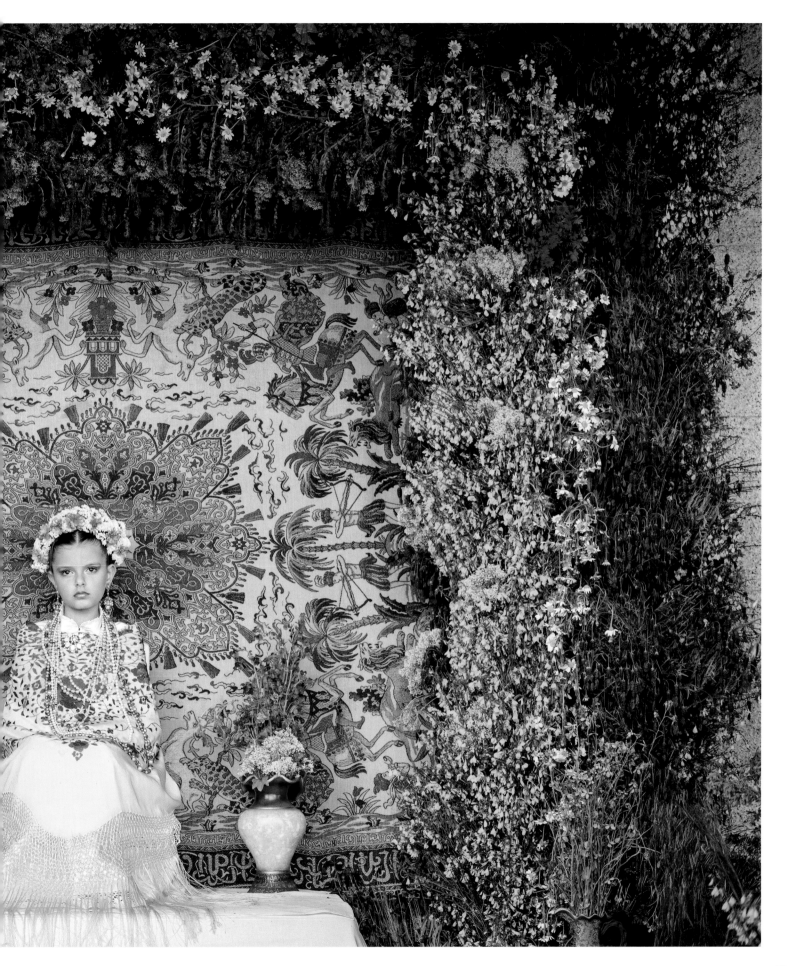

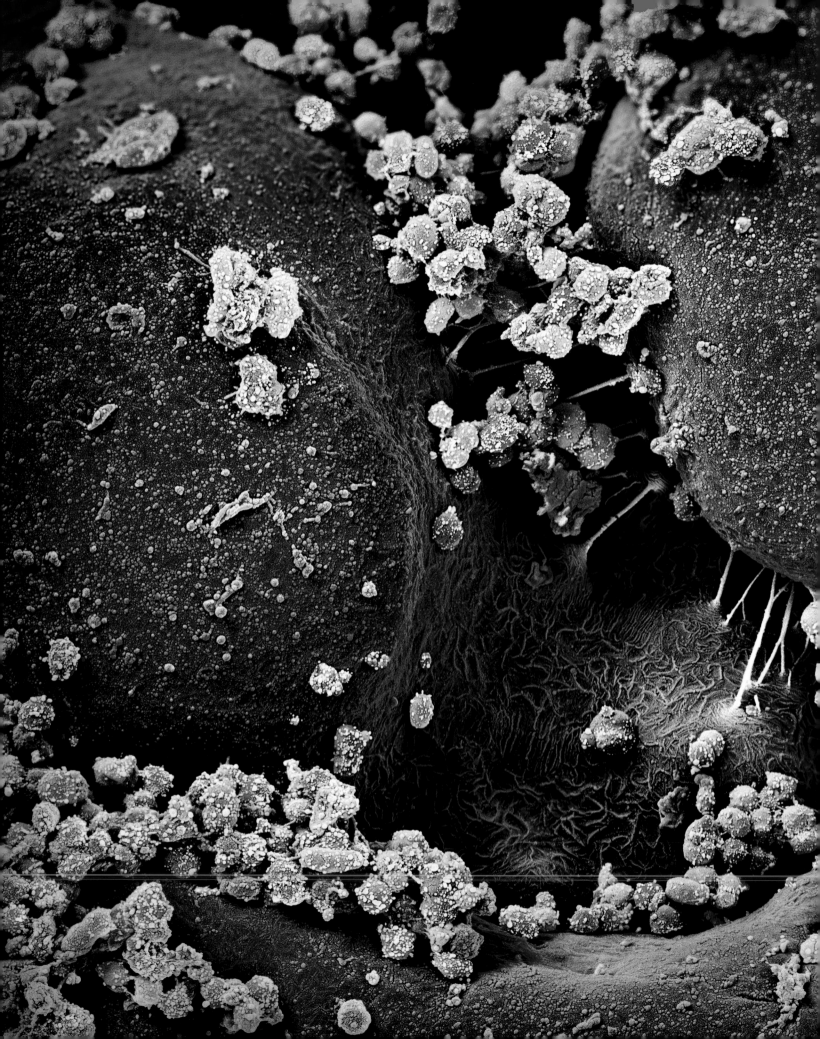

Opposite
2019 | LYNSEY ADDARIO
Camp Lejeune, North Carolina, U.S.
U.S. marines must be able to carry one another if necessary. USMC Cpl. Gabrielle Green hefts a fellow marine as they ready for deployment on a Navy ship. Of the 38,000 recruits who enter the corps each year, about 3,500 are women.

Pages 384-385
2019 | SPENCER LOWELL
Kazo, Japan
Pound, a robot made by Kawada Robotics, helps assemble change dispensers at a Glory factory. Each robot is part of a human-robot team that works together to build the product.

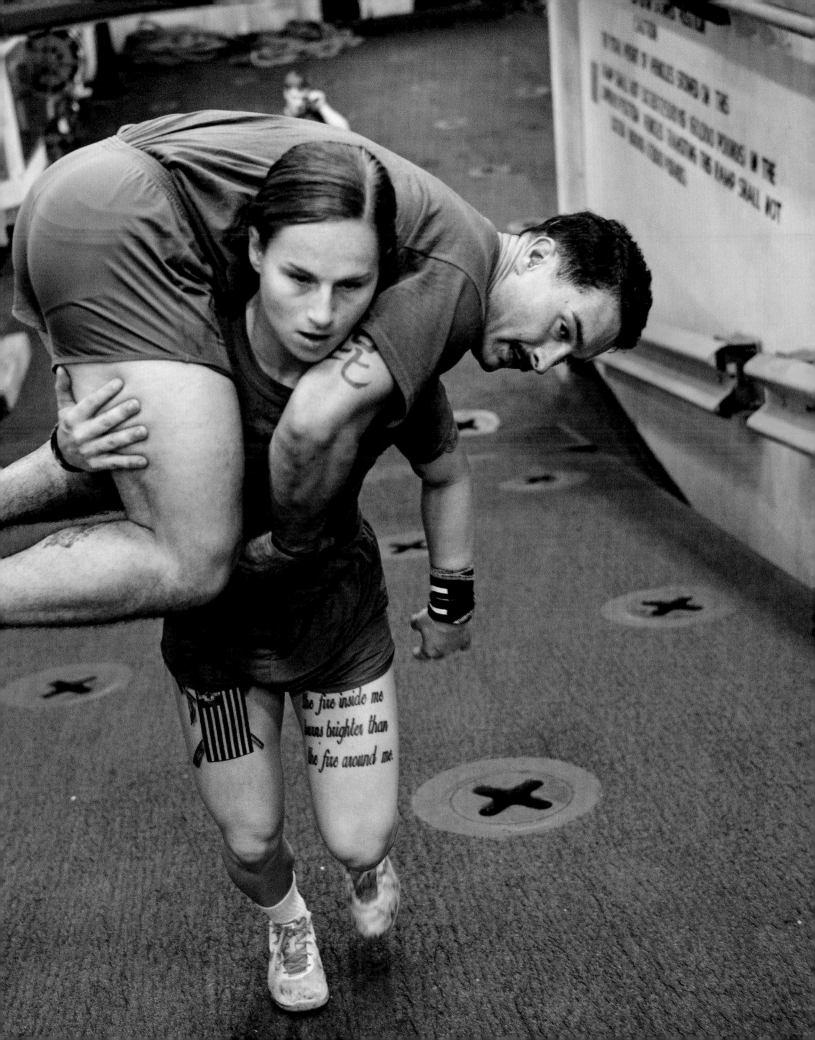

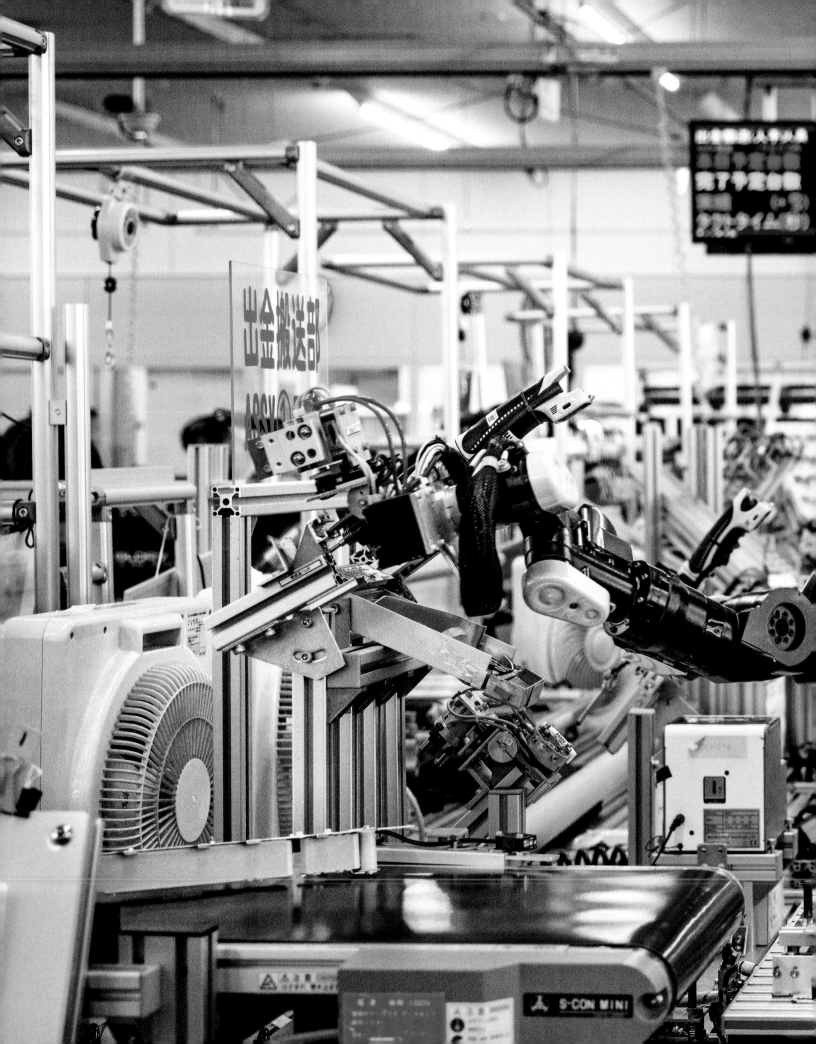

2019 I ANDREA FRAZZETTA
Sardinia, Italy
Three generations of women prepare *culurgiones*, a traditional dish of the Ogliastra area. The pasta dough is shaped into pockets and stuffed with potato, pecorino cheese, and mint.

2019 I RENAN OZTURK
Everest, Tibet
The tinkling of bells accompanies yaks hauling propane and other supplies to Mount Everest's Advanced Base Camp.

ROBIN HAMMOND

I was honored to be asked to work on *National Geographic* magazine's race issue, but as a human rights photojournalist, I was surprised to be shooting a science story. Or, more accurately, a story that explained how our ideas of race are not grounded in science at all. But how could we bring together race and genetics in a visually compelling way?

I was fortunate to be working with Kurt Mutchler, the senior science editor at the magazine. Kurt is an ideas guy. He sent me several of his own photos of DNA projected onto the faces of colleagues at the National Geographic headquarters: A, C, G, and T, the "letters" of the DNA code that represent its chemical makeup, repeated over and over across human shapes in the dark.

I packed a portable projector for a flight to Kenya, along with Kurt's ideas. In a shed at a community center outside Nairobi, I fiddled with the projector. I needed a dark space for this to work, but not so dark that we would lose this young man's face altogether in a lettered mask. The shed had a small window that let in just enough light to illuminate one side of his face, while the other fell into darkness. It took a lot of trial and error, but eventually we arrived at the right photo. Many of *National Geographic*'s best photographs are a collaboration between editors and photographers. My name appears alongside this image, but the creative mind behind this work was Kurt. ∎

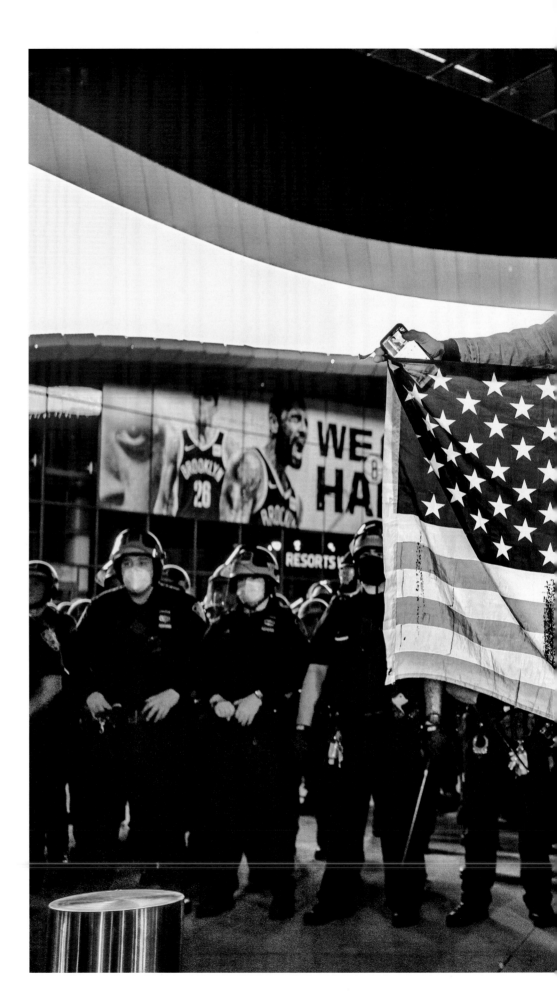

2020 I RUDDY ROYE
Brooklyn, New York, U.S.
The protests after George Floyd's death sparked a global conversation about race, policing, and social justice. Here, a man who goes by the name Royal G stands in front of a phalanx of police officers holding a flag with Floyd's words "I can't breathe."

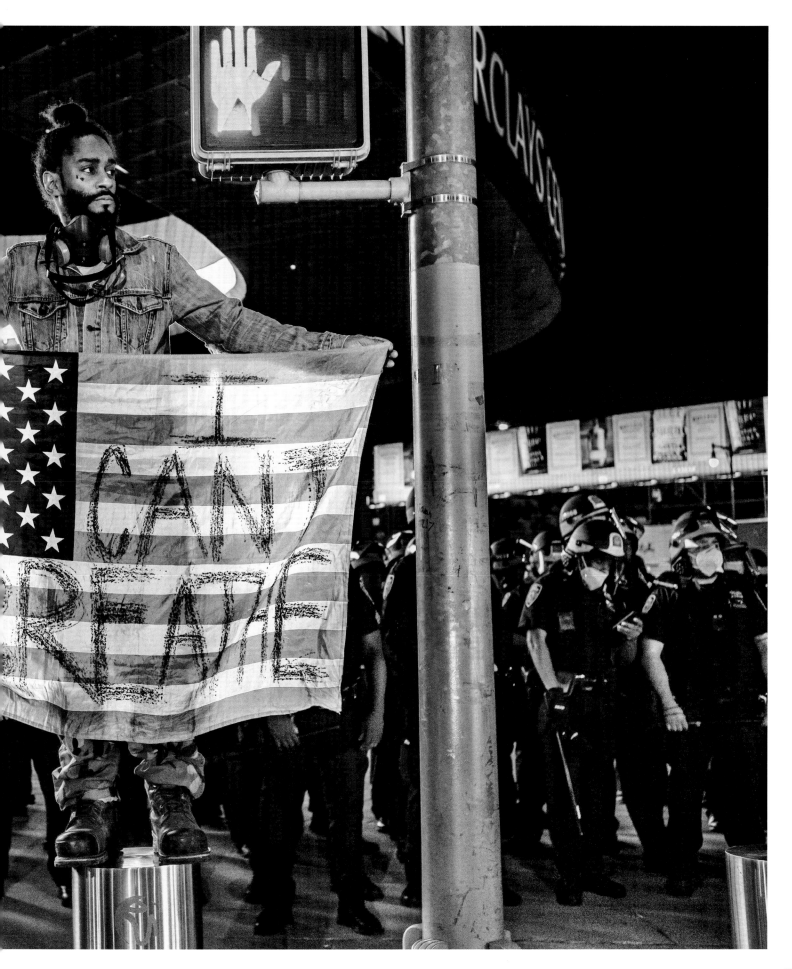

Opposite
2020 I GABRIELE GALIMBERTI
Milan, Italy
A couple, who normally live apart, look out the window of their home where they stayed together while in quarantine from the deadly COVID-19 pandemic that swept through the world.

Pages 394-395
2020 I REUBEN WU
Utah, U.S.
Drones circle above striated sandstone formations, creating brilliant circles of light.

2020 I DINA LITOVSKY
Los Angeles, California, U.S.
The basketball court at Pecan Recreation Center is a skateboard spot especially popular with beginners. In the past decade, more girls have taken up the sport, and the number of full-time professional women has doubled.

2016 I REBECCA HALE
Washington, D.C., U.S.
Bei Bei, a giant panda that was born at the
Smithsonian National Zoo in 2015, stretches
from rock to rock in his enclosure.

2020 | JONAS BENDIKSEN
Nesoddtangen, Norway
Boe, four, plays a shadow monster game with her mother, Anna, before bedtime. Boe's father and mother were challenged to find ways to keep her entertained during the early days of lockdown due to the coronavirus pandemic.

Opposite
2020 I REUBEN WU
North Wales, United Kingdom
Illuminating the Moel Tryfan quarry required a methodical sort of painting with drone light to emphasize the rock faces' intricate contours.

Pages 404-405
2020 I LYNN JOHNSON
Chapel Hill, North Carolina, U.S.
A mother soothes her 10-month-old daughter before researchers scan her brain at the University of North Carolina. By regularly scanning the brains of babies who might develop autism, scientists hope to pinpoint brain changes that could lead to an early diagnosis.

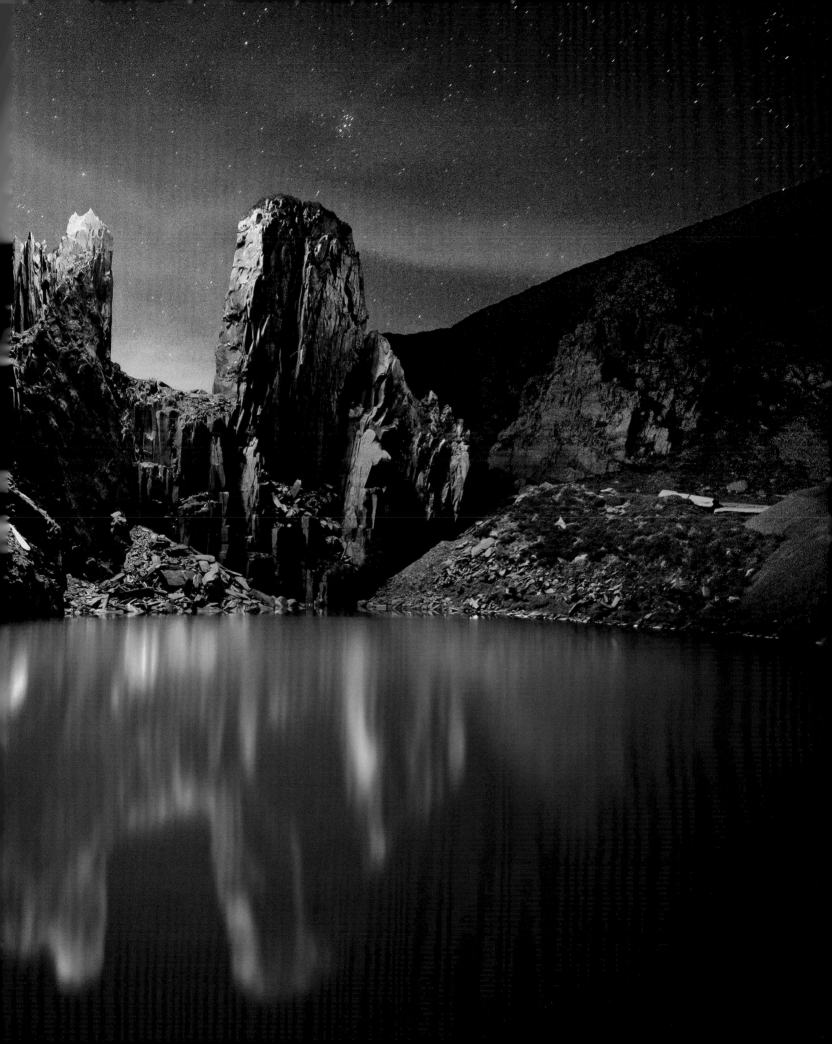

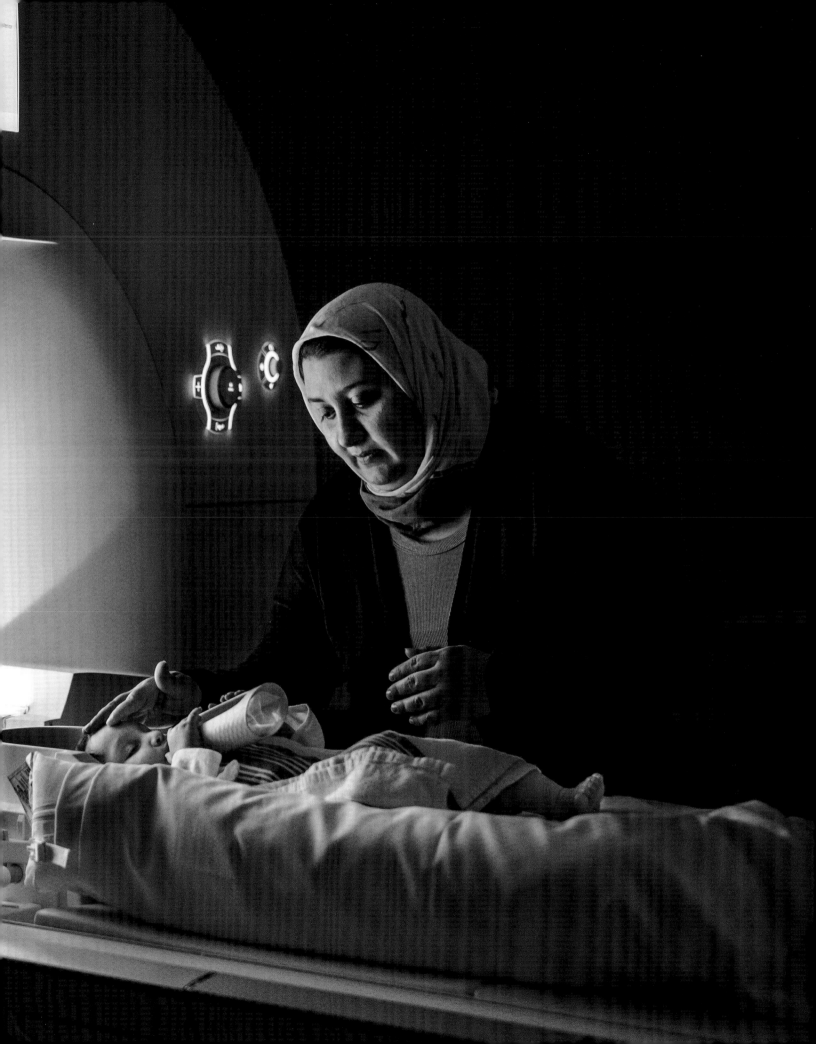

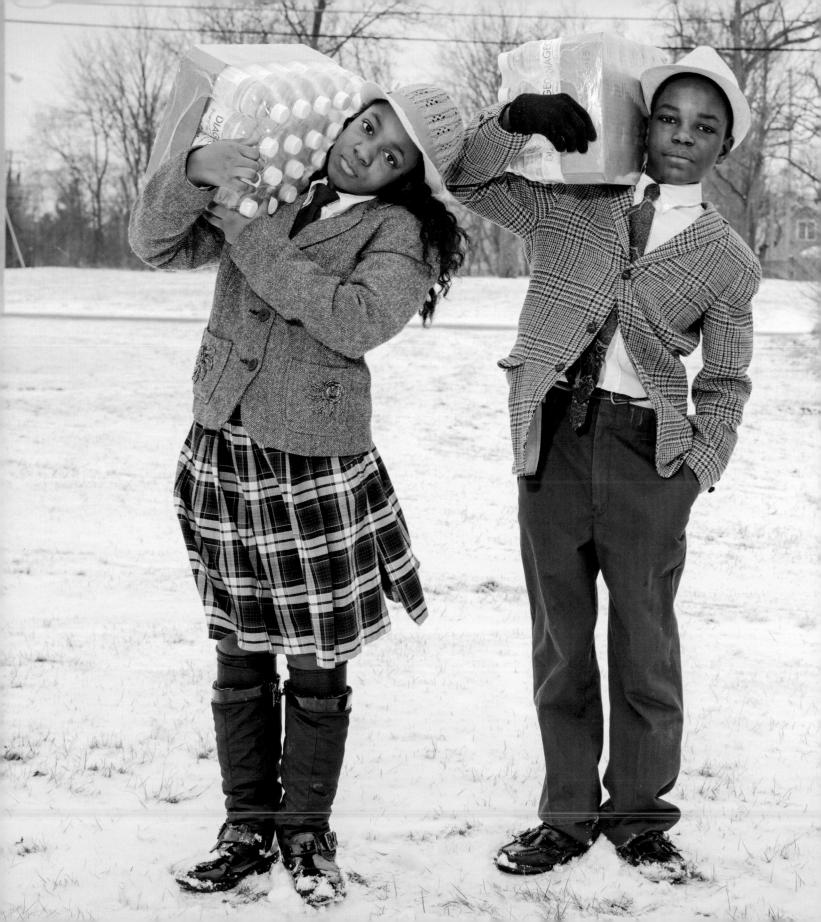

WAYNE LAWRENCE

In early 2016, I was asked to go to Flint to put a human face to the water crisis there. Visiting the local firehouses where residents went for their daily supply of bottled water seemed like the perfect place to start. I made the portrait of the Abron siblings after a brief chat with their mother, who was waiting in the family car. She mentioned that she homeschooled her children but had them wear vintage uniforms that she'd find thrifting to instill in them a sense of pride. The portrait of Julie, Antonio, and India Abron was the first successful one I made there and set the tone for what I was trying to accomplish.

The federal disaster in Flint exposed an estimated 12,000 children to lead-tainted water and a possible related outbreak of Legionnaires' disease. Alarmingly, records show that state officials had switched to bottled water long before addressing the contaminations. It took months before residents began noticing the odd taste and smell of their water.

Everyday tasks like bathing, toothbrushing, and cooking had become difficult chores as people could no longer trust the water flowing into their homes. Bottled-water dispensaries became the only way many of the city residents could have access to potable water. ■

Opposite

2020 I NICHOLE SOBECKI

Nairobi, Kenya

A mural reads "Let's fight Corona together!" on a stall in the impoverished Kibera neighborhood. In communities such as this, where hundreds of thousands of people live in close quarters and depend on one another, self-isolation and social distancing are difficult to put into practice.

Pages 410-411

2021 I BRENT STIRTON

Democratic Republic of the Congo

Some of the nearly 600 elephants that recently arrived from Uganda move across the grassland in Virunga National Park. Until their arrival, the park's population hovered at about 120 as a result of poaching and violence in recent years.

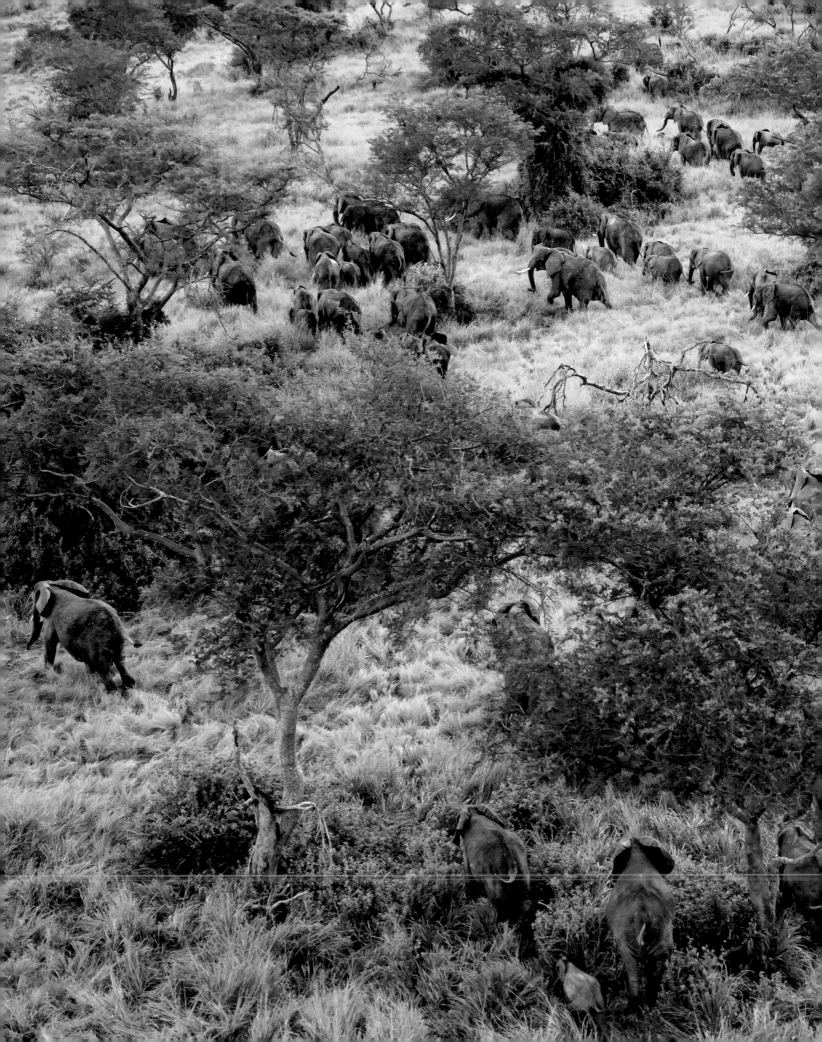

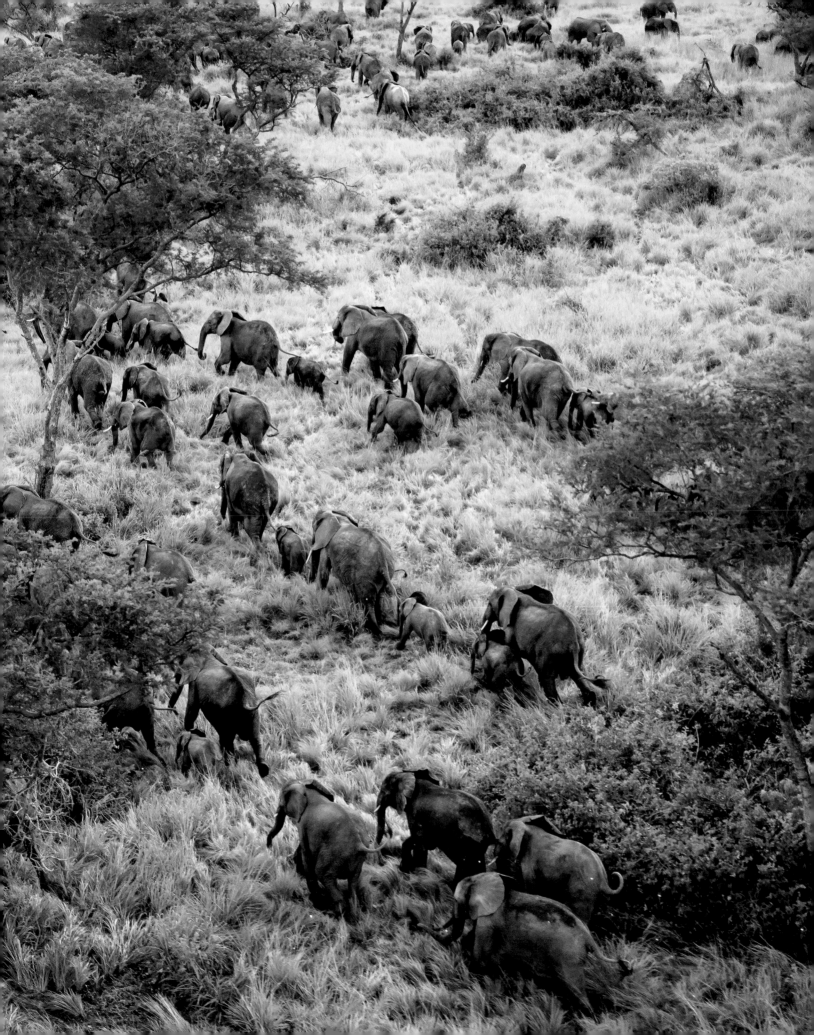

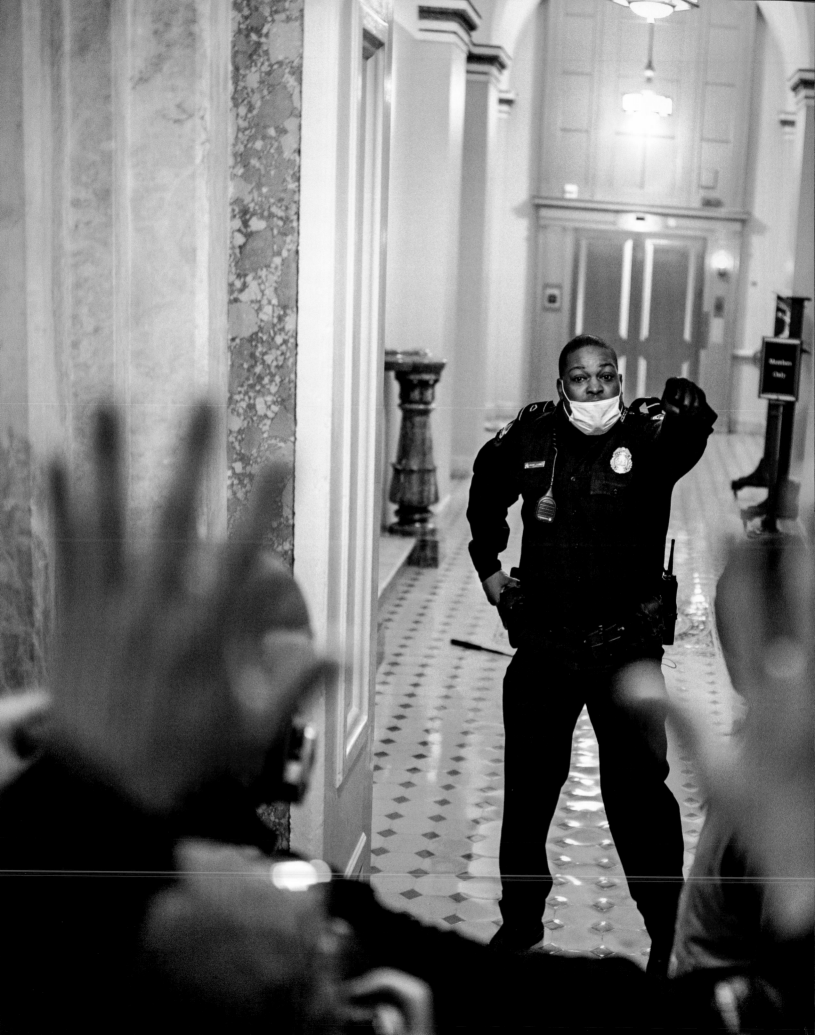

2021 I ASHLEY GILBERTSON
Washington, D.C., U.S.
Capitol police officer Eugene Goodman was awarded the Congressional Gold Medal after leading violent rioters away from lawmakers during the January 6 attack at the nation's Capitol building.

2021 I DAVID CHANCELLOR
Northern Kenya
An adult desert locust is one of the most destructive migratory pests in the world. Since January 2021, Kenya has experienced its worst locust invasion in 70 years. Experts are concerned the infestation could push 25 million East Africans into hunger.

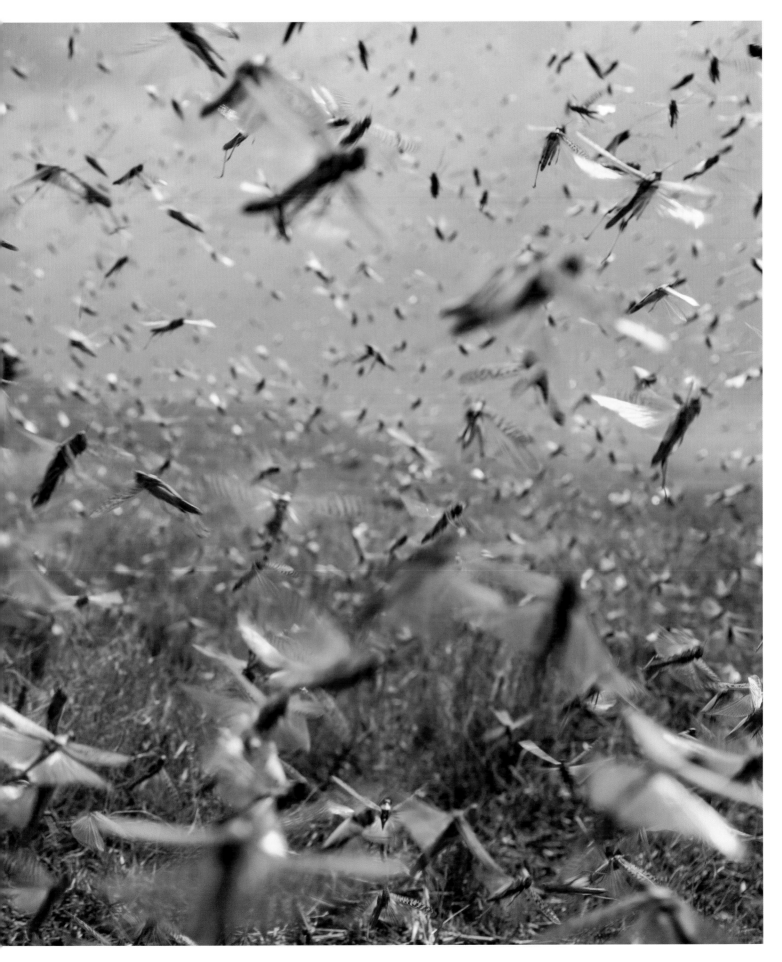

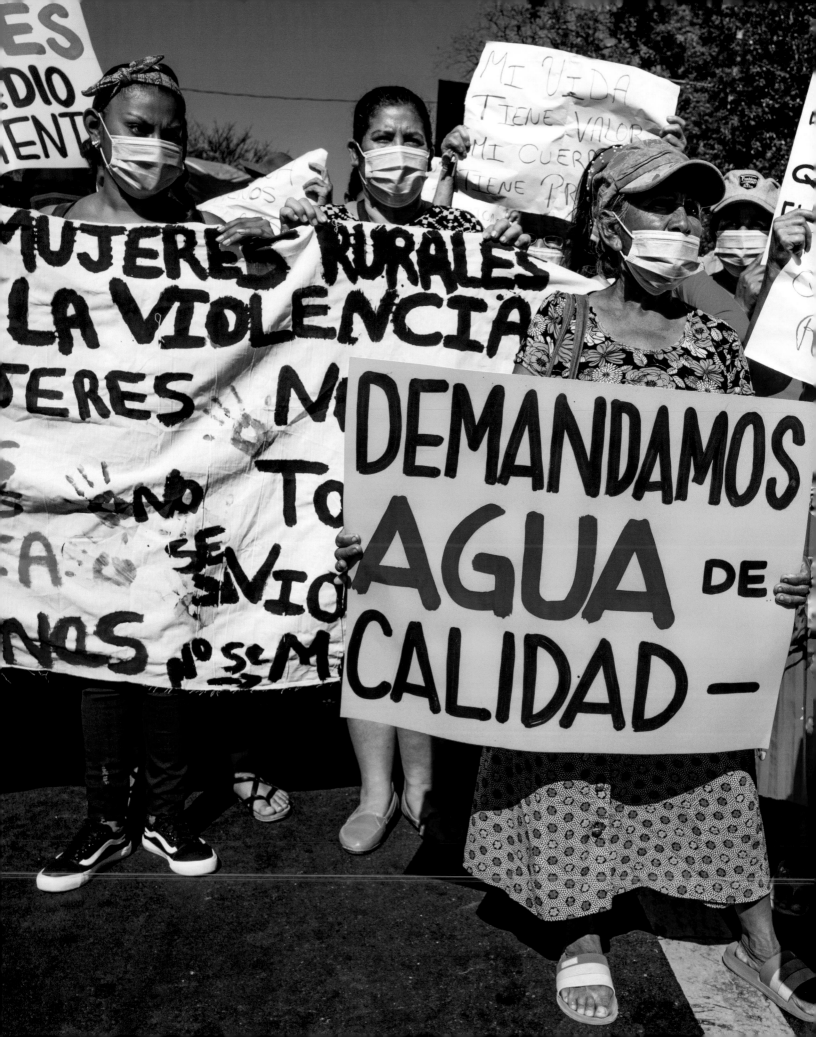

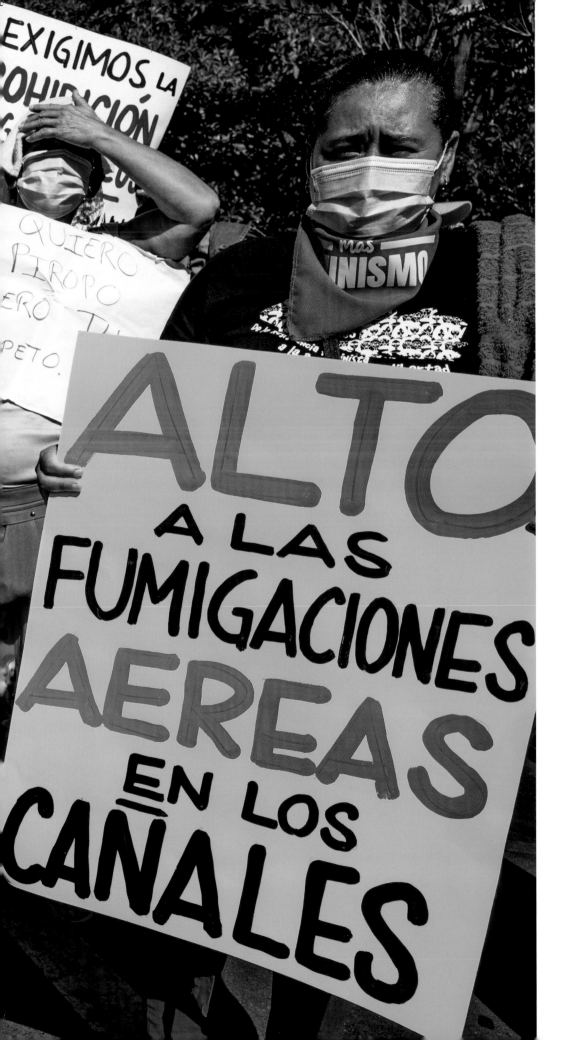

Opposite
2021 I ANA MARÍA ARÉVALO GOSEN
Santo Tomás, El Salvador
At an International Women's Day march, a protester carries a sign reading "We demand quality water." Women have become the fighters against sexism and the water shortages that are plaguing El Salvador.

Pages 418-419
2021 I STEPHEN WILKES
Washington, D.C., U.S.
A composite photograph of President Joe Biden's 2021 inauguration captures the historic day, from President Donald Trump's departure in Marine One to the evening's memorial lights commemorating those who could not attend the ceremony due to the pandemic.

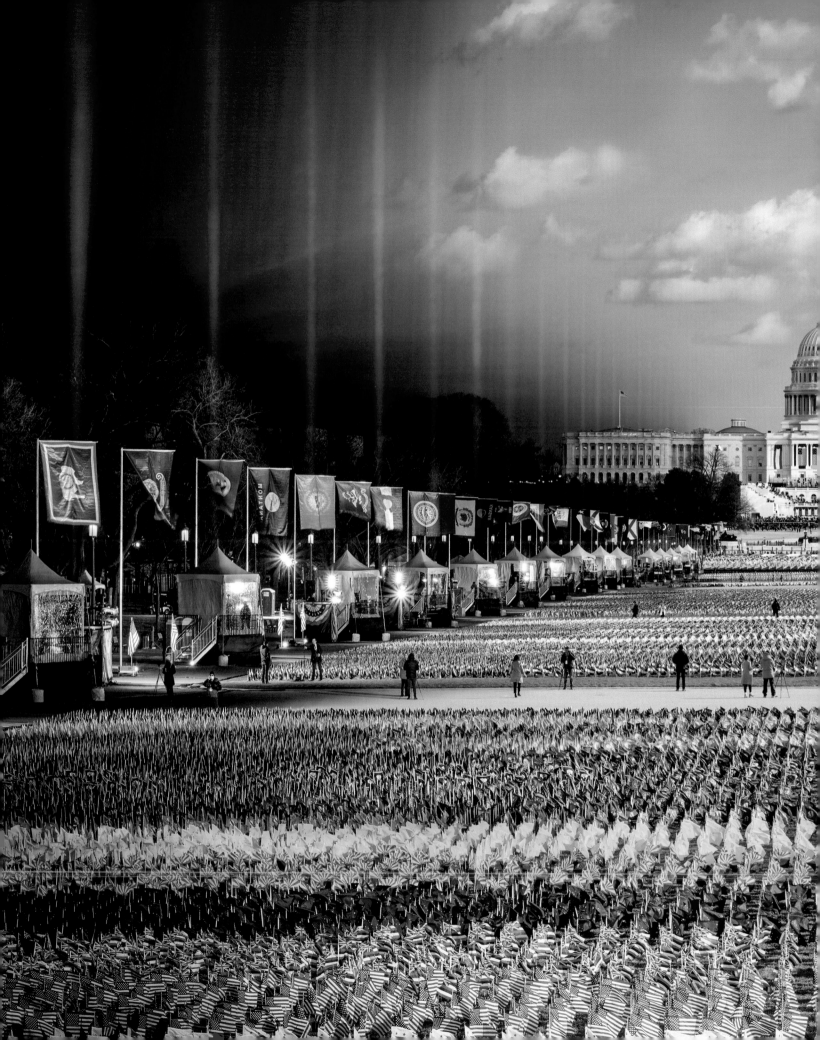

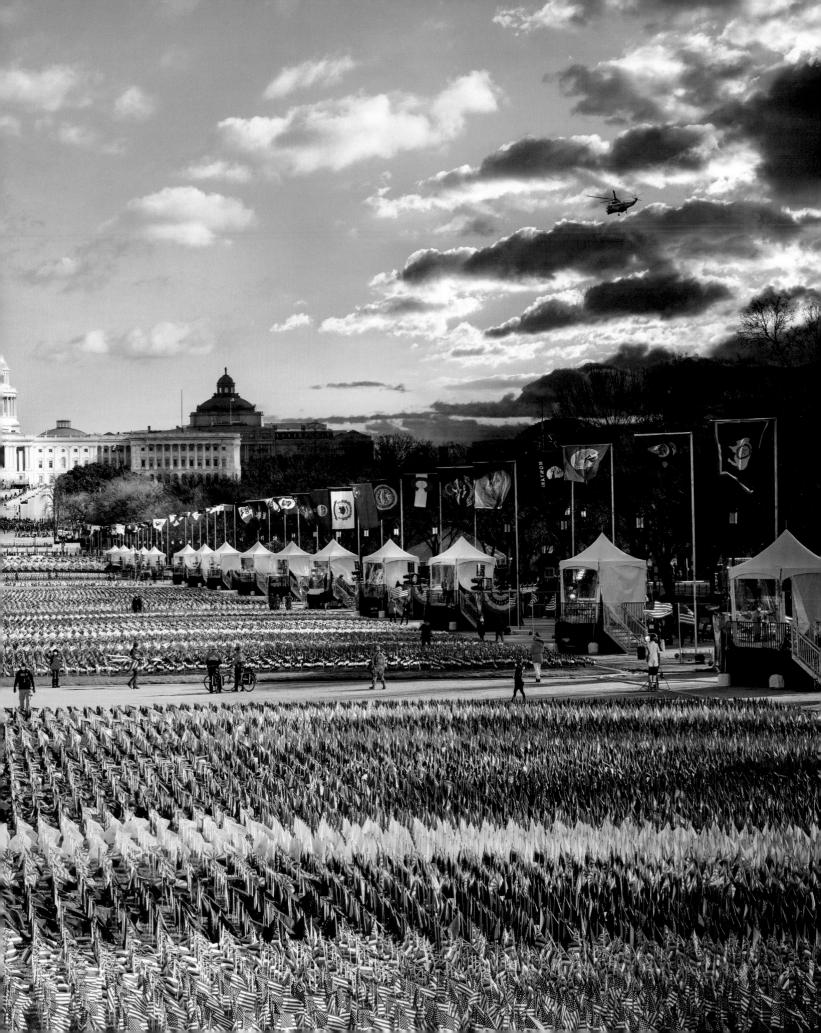

ABOUT THE
IMAGE COLLECTION

The National Geographic Image Collection is one of the world's most significant photography archives. Its tens of millions of images capture the planet (and beyond) as explored by scientists, adventurers, writers, and photographers, from the 19th century through today.

The men who founded the National Geographic Society in 1888 did not aspire to create a world-class photo archive; at the time, photography was more in the province of pulp publications than scholarly journals. But photographers with interesting images began bringing them to National Geographic.

Some Society board members thought that photos were so lowbrow that in 1906, after the magazine published George Shiras's pioneering shots of wild animals at night, two resigned in disgust. But Society president Alexander Graham Bell and magazine editor Gilbert H. Grosvenor embraced the use of photos, which ever since have been at the core of the magazine's identity and mission.

As early 20th-century explorers and contributors traveled the world, they made images or purchased them from local sources and brought them to *National Geographic*. The photos formed unruly heaps on editors' desks—until 1919, when the Illustrations Library (today's Image Collection) was established. Meticulous librarians cataloged every photograph and artwork, filing them with typed field notes and organizing them geo-

graphically: first by continent, then country, then city, and finally by photographer.

The Image Collection's dedication to preserving history through photographs has made it an invaluable resource, and an essential reference to vanishing worlds. Governments, curators, and academics often find in our archive the only photographic record of a nation's early history, a lost culture, or an extinct species.

The archive houses important images made by a who's who of photographers: 20th-century shooters such as Margaret Bourke-White, Mary Ellen Mark, Ansel Adams, and Alfred Eisenstaedt, as well as the leading photographers of today. It's also a visual record of some of humanity's greatest achievements: Amelia Earhart's flights and Jacques Cousteau's dives, Jane Goodall's findings about chimpanzee behavior and Bob Ballard's discovery of the wreck of the *Titanic*.

A vault at National Geographic's headquarters holds 11.5 million physical objects: photographs, transparencies, negatives, albums, glass plates, and autochromes, the first form of color photography. The film collection includes 500,000 films and videos. And the digital collection stores almost 50 million images on servers, with nearly two million images added to the archives every year.

Every addition to the Image Collection tells a piece of our world's story and furthers Alexander Graham Bell's mission for National Geographic: to illuminate "the world and all that is in it." ■

CONTRIBUTORS

LYNSEY ADDARIO has been covering conflict and humanitarian crises around the Middle East and Africa for two decades. Her compelling work has taken her to war zones and disasters in Afghanistan, Iraq, Libya, Lebanon, Darfur, South Sudan, Somalia, the Democratic Republic of the Congo, and Yemen, among other places.

STEPHEN ALVAREZ is a photographer, filmmaker, and explorer who produces global stories about exploration, adventure, culture, and archaeology. He has taken his camera to shoot stories from the highest peaks in the Andes and in the depths of the deepest cave in the world. In 2016 Alvarez founded the Ancient Art Archive, a nonprofit foundation dedicated to using photography and technology to preserve and share humanity's oldest artworks.

EVGENIA ARBUGAEVA was born in Tiksi, a town on the shore of the Laptev Sea in the Republic of Yakutia in Russia. The work of Arbugaeva, a photographer and National Geographic Society Storytelling Fellow, often looks into her homeland—the Arctic—discovering and capturing remote worlds and the people who inhabit them.

IRA BLOCK is a classic National Geographic photographer who is a master at capturing landscapes, people, artifacts, and complicated concepts. His technical skills in lighting and composition are superb, but Block is also able to draw interest and integrity from any subject matter.

ALEXANDRA BOULAT (1962–2007) was a French photographer and the co-founder of the VII Photo Agency. Trained in graphic art and art history at the École des Beaux-Arts in Paris, she spent the last year of her life covering the conflict in Gaza.

JIMMY CHIN, a premier rock climber, is able to carry a camera where few dare to go, capturing endeavors of the world's most extreme athletes while participating in breakthrough expeditions from Yosemite to Oman to Everest. His film *Free Solo* won the Oscar for Best Documentary Feature in 2019.

ROBERT CLARK is a freelance photographer based in New York City. He is known for his innovation. Clark once traveled the United States for 50 days with only a cellphone camera to document its beauty and diversity. He is building an extensive visual study of the science of evolution.

JODI COBB was a staff photographer for *National Geographic* for more than three decades. Whether examining the beauty and cruelty of the Japanese geisha's ancient traditions, exposing the tragedy of human trafficking, or exploring the hidden world of the women of Saudi Arabia, Cobb has searched for humanity in some of the world's most complex and impenetrable environments.

DIANE COOK AND LEN JENSHEL are two of America's foremost landscape photographers and have interpreted culture and

environment for more than 25 years. The husband and wife team captures both beauty and impermanence in landscapes from Greenland's melting glaciers to New York City's boroughs.

JASPER DOEST is a Dutch photographer who creates visual stories that explore the relationship between humankind and nature. A true believer in the power of photography to initiate change, Doest is an International League of Conservation Photographers Senior Fellow and a World Wildlife Fund ambassador.

DAVID DOUBILET is an acclaimed underwater photographer and conservationist who has spent five decades exploring the world's waters. Doubilet's images express a tireless effort to create a visual voice for the ocean and to share its wonders with people on the surface.

RENA EFFENDI was born and raised in Baku, Azerbaijan. A social documentary photographer, her work is an eloquent testimony to human dignity and resilience. Beginning with her work covering the human cost of oil, her photographs often showcase the fragility of life and environmental decay.

PETER ESSICK started with National Geographic as a summer intern and launched into a career as an influential photojournalist and nature photographer. Some of his favorite and most rewarding stories show the impact of human development and the enduring power of the land.

MELISSA FARLOW has a background in newspaper reporting and specializes in long-form narrative photography. She has worked extensively in the American West, documenting wild mustangs and wilder ranchers, and road-tripped South America to chronicle life along the Pan-American Highway.

KENNETH GARRETT has been searching out profound images that give us a glimpse of our past and tell us who we are today. Whether taken in a museum or an isolated location forgotten by time, his imagery emphasizes sites of major discoveries worldwide.

DAVID GUTTENFELDER is a photojournalist who reports on global geopolitics and conservation. Until recently, he spent his entire career living outside his native United States. Guttenfelder has also been an industry leader in smartphone photography and social media reporting.

REBECCA HALE's work ranges from portraiture to still photography illustrating complex scientific and cultural stories. A staff photographer for *National Geographic,* in the course of her fieldwork she has gone around the world, where she has had to re-create her studio in the middle of cornfields and anatomy labs.

ROBIN HAMMOND documents human rights and development issues around the world. He works on long-term projects in difficult conditions and on undercover investigations to illustrate incidents of oppression, exploitation, discrimination, and violence.

FRITZ HOFFMANN is an American photographer known for documentary-style narratives

that portray society, culture, the environment, and global economics. He is recognized for his photography work in China, which began in 1994.

CHARLIE HAMILTON JAMES is a Britain-based photographer and filmmaker who specializes in natural history and wildlife subjects. His zeal for conservation led him to spend more than two decades exploring Peru's Amazonian rainforest and becoming immersed in the local culture.

LYNN JOHNSON is known for shooting elusive subjects—language, disease, rape, water—and for asking tough questions. Dedicated to exploring the far reaches of the human condition, she spends maybe two months a year at her home in Pittsburgh, packing that camera bag over and over.

ED KASHI's work has been recognized for its compelling rendering of the human condition. A sensitive eye and an intimate relationship to his subjects are the signatures of his work. In addition to his own filmmaking and assignments, Kashi is an educator who mentors students of photography.

KAREN KASMAUSKI is a filmmaker, photographer, project manager, and educator. Over two decades as a photographer, she has covered human migration, viruses, aging, and genetics. Her assignments have taken her from the rainforests of Malaysia to the megacities of India and beyond.

MATTIAS KLUM has risen to the status of international superstar in the fields of nature photography and activism. After experiencing the secret lives of plants and animals on the most intimate level, Klum became an avid environmentalist, using art as a tool to effect change.

TIM LAMAN is a field biologist, wildlife photographer, and filmmaker, on top of holding a Ph.D. in ornithology from Harvard University. By doggedly tracking birds and orangutans through the tropics, Laman gained a reputation for getting images of nearly impossible-to-capture subjects.

FRANS LANTING's photographs often hold meaning that goes beyond the initial visual beauty. He is a world-renowned wildlife and landscape photographer, speaker, and creative collaborator. His artistic partners have included an Aboriginal painter and composer Philip Glass.

WAYNE LAWRENCE is a St. Kitts–born, Brooklyn-based visual artist whose work, rooted in the documentary tradition, seeks to illuminate the complexities of the human experience. His work navigates ideas of community, purpose, and the human relationship to our natural and adopted environments.

SARAH LEEN is the founder of the Visual Thinking Collective. A photographer and photo editor, she was also the first female Director of Photography at *National Geographic* magazine. She has published 16 stories in the magazine and had five covers over 20 years.

DAVID LIITTSCHWAGER is a freelance photographer who has lived in San Francisco,

California, for the past 21 years. His work focuses on natural history, particularly the plethora of underwater life in our vast oceans.

LUCA LOCATELLI is an environmental photographer and filmmaker focused on the relationship between people, science, technology, and the environment. The aim of his work is to open discussions about our future on the planet.

GERD LUDWIG is one of the foremost photographers covering Eastern Europe. His long-term projects have focused on the reunification of Germany; cultural shifts in the former Soviet Union; and coverage of the Chernobyl nuclear disaster, which brought him deep into the contaminated zone.

STEVE MCCURRY, recognized universally as one of today's finest image makers, is best known for his evocative color photography. In his images, McCurry captures the essence of human struggle and joy. He often works in regions tormented by conflict and war.

DAVID MCLAIN is a photographer and filmmaker who has spent years researching, producing, and shooting feature-length assignments around the world. His work has been included in multiple cover stories for *National Geographic*, as well as the number one *New York Times* best-selling cookbook *The Blue Zones Kitchen*.

JOE MCNALLY is a seasoned photojournalist known for being incredibly versatile and excelling in any assignment. His career has spanned 35 years and 60 countries. McNally's searing portraits of 9/11 first responders became the exhibit *Faces of Ground Zero*, seen by nearly a million people.

MICHAEL MELFORD is on a mission to share the wonders of the natural world with others, and to help them see the beauty that surrounds us. Through his photography, he hopes to preserve our natural landscapes and wildlife for future generations.

HANNAH REYES MORALES is a Filipina photographer and National Geographic Explorer whose work documents tenderness amidst adversity. Her photography, both visceral and intimate, takes a look at how resilience is embodied in daily life. Based in Manila, she explores through her photos the universal themes of diaspora, survival, and the bonds that tie us together.

VINCENT J. MUSI has been a regular contributor to *National Geographic* since 1993, covering subjects from the Texas Hill Country and the oldest temple on Earth, to hurricanes, volcanoes, and mummies. A specialist in animal portraits, his work includes projects on domestication, intelligence, and cognition.

IAN NICHOLS is a wildlife photographer whose work has focused on great apes. A trained biologist, he mixes photography with research. Mentored by his father, National Geographic photographer Michael Nichols, Ian is now emerging with his own developed body of work and aesthetic vision.

MICHAEL "NICK" NICHOLS, a native of Alabama, is an award-winning photographer

whose work has taken him to the most remote corners of the world. He became a staff photographer for *National Geographic* magazine in 1996 and was named Editor-at-Large in January 2008.

PAUL NICKLEN is a Canadian-born polar specialist and marine biologist who spent his childhood among the Inuit people, who taught him to survive in icy ecosystems. Much of his work focuses on polar wildlife and climate change. Nicklen founded the conservation organization SeaLegacy to turn his art into action.

RICHARD OLSENIUS's photographic career spans 50 years of seeing the world in a special way. His stories have taken him across the nation, to adventures in the Arctic, to forgotten landscapes in the American heartland, and from South America to Europe to Asia.

RANDY OLSON, a master at telling deeply human stories, is a photojournalist whose beat covers the whole world. He celebrates the diversity of humankind while documenting threats to cultures, resources, and the natural world. Randy has completed more than 30 projects for National Geographic.

THOMAS P. PESCHAK was originally trained as a marine biologist but retired from science to become an environmental photojournalist after realizing that he could have a greater conservation impact with photographs than with statistics. His stories take readers into underwater worlds.

CARSTEN PETER specializes in going to extremes: scuba diving in a glacier on Mont Blanc, crossing the Sahara on a camel, caving in Borneo. Always searching for where nature is still pure, he devises innovative techniques to capture never-before-seen images from some of the scariest environments on the planet.

JIM RICHARDSON is a photographer, writer, speaker, teacher, and champion of unsung people, places, and issues. His stories mirror these concerns, documenting the essentials of a healthy planet, neglected landscapes, and the lives of uncelebrated peoples, small towns, and wee islands.

JOEL SARTORE is a versatile photographer and conservationist who documents a world worth saving. His much loved animal portraits come from the Photo Ark, a multiyear mission to document species threatened with extinction. Sartore's hallmarks are a sense of humor and a midwestern work ethic.

STEPHANIE SINCLAIR is known for gaining unique access to the most sensitive gender issues, particularly through the Too Young to Wed project. She has produced in-depth reporting on human rights in the Middle East, using her work to inspire social justice and intercultural exchange.

BRIAN SKERRY, a specialist in marine wildlife, has spent more than 10,000 hours underwater over the past 30 years. His creative images tell stories that not only celebrate the mystery and beauty of the sea but also help bring attention to the many issues that endanger our oceans.

NICHOLE SOBECKI is a photographer and filmmaker based in Nairobi, Kenya. She aims to

create images that demand consideration for the lives they represent—their joys, challenges, and ultimate humanity. She believes a well-told story can cut through the noise, deepen empathy, and inspire a more conscious world.

JOHN STANMEYER is a photographer and filmmaker who uses his camera to tell the story of humanity at a crossroads. Through visual storytelling, Stanmeyer aims to distill the complex issues that define our times and present them in poetic and understandable narratives.

MAGGIE STEBER has worked in 64 countries—including covering Haiti for more than 30 years—focusing on humanitarian, cultural, and social stories. In 2013 she was named as one of 11 Women of Vision by *National Geographic* magazine.

GEORGE STEINMETZ is best known for his exploration and science photography. As a photographer, he sets out to reveal the few remaining secrets in our world today: remote deserts, obscure cultures, and new developments in science. His innovative aerial shots are captured using drone and paragliding technology.

MARIA STENZEL is a multimedia journalist who has covered the environment, science, and Indigenous cultures for 20 years. Her assignments have taken her from the rainforest to the Arctic and from Madagascar to the Andes. But for Stenzel, Antarctica—and its frozen underworld of big seas, icebergs, and the largest concentration of wildlife on Earth—is the place that keeps calling her back.

BRENT STIRTON is a South African photographer with an extensive history in the documentary world. His work has taken him to more than 100 countries. His focus is the well-being of the planet, and through his photography he hopes to offer a glimpse of our human commonality—what unites us and what we must guard against in order to offer a viable future for our children.

MARK THIESSEN has been a photographer with National Geographic since 1990. Thiessen has documented wildland firefighters in a decade-long project that takes him to the front lines of wildfires every summer. He is also a certified wildland firefighter.

AMY TOENSING is a photojournalist and filmmaker committed to telling stories with sensitivity and depth. For more than two decades, she has been known at National Geographic for sharing intimate stories about the lives of ordinary people.

TOMASZ TOMASZEWSKI specializes in journalistic photography. A regular contributor to National Geographic for more than 30 years, he has held exhibitions in the United States, Canada, Israel, Japan, Brazil, Madagascar, the Netherlands, Germany, Italy, Indonesia, and Poland.

ANAND VARMA's photographs tell the story behind the science of complex issues. Varma worked on a variety of field projects while pursuing a degree in integrative biology and now uses photography to help biologists communicate their research.

PABLO CORRAL VEGA is an Ecuadorian photojournalist, writer, artist, and cultural manager known for photography that is filled with sympathy and solidarity for his subjects. In even the darkest of circumstances, his photographs share a sense of hope and an affirmation of life.

AMI VITALE, best known for her international news and cultural documentation, has been praised as a humane and empathetic storyteller. Her wildlife assignments include Kenya's last rhinos, rescued pandas, and man-eating lions. She has traveled to more than 90 countries.

ALEX WEBB is known for his complex and vibrant color photographs of serendipitous or enigmatic moments. His photography often leads him to places with sociopolitical tensions. Over the past 45 years, his work has led him to places as varied as the U.S.-Mexico border, Haiti, and Istanbul.

STEPHEN WILKES's defining project is "Day to Night": epic cityscapes and landscapes recorded from a fixed camera angle for up to 30 hours. Blending these images into a single photograph takes months to complete. Wilkes has worked in photojournalism and film and is based in New York City.

STEVE WINTER is a conservation photojournalist and an expert in big cats. He once spent six months sleeping in a tent at minus 40°F (-40°C) to track snow leopards. Winter feels a great responsibility to not only show and excite readers about his subjects but also give them a reason to care.

CARY WOLINSKY has been making photographs since he was 12 from a darkroom in his childhood basement. He is best known for his international, historical, scientific, and cultural photographic essays, which have been featured in *National Geographic* since 1977.

MICHAEL YAMASHITA, a third-generation Japanese American, is a landscape and location photographer and filmmaker with extensive expertise in Asian cultures. He has specialized in retracing the paths of famous travelers, including Marco Polo and the Chinese explorer Zheng He.

DAVE YODER was born in America but grew up at the foot of Kilimanjaro in Tanzania and now chases human-interest projects from his base in Milan, Italy. His assignments have taken him on a search for a lost Leonardo da Vinci masterpiece and inside Pope Francis's Vatican.

CHRISTIAN ZIEGLER is a photojournalist and filmmaker specializing in natural history and science-related topics. His aim is to highlight species and ecosystems under threat and share their beauty and importance with a broad audience. A tropical ecologist by training, he has worked in tropical rainforests on four continents.

ACKNOWLEDGMENTS

The book you hold in your hands exists only because of the tremendously talented National Geographic photographers who have spent years in the field shooting remarkable stories to share with the world. Back at headquarters, we thank our collaborators at the Image Collection, as well as *National Geographic* magazine, including senior director Patricia Edmonds, director of visuals and immersive experiences Whitney Johnson, photo editor Julia Andrews, senior image archivist Susie Riggs, and, of course, the editor in chief of *National Geographic,* Susan Goldberg. To the thoughtful and talented creative team behind these pages, a heartfelt thanks for capturing 21 years of National Geographic—and the world's—history. On the book's team, thank you to project lead and senior editor Allyson Johnson, to Susan Hitchcock for lending your poetry to each chapter's introduction, to brilliant designer Nicole Miller, to the talented team of photo editors—Adrian Coakley, Meredith Wilcox, and director of photography Susan Blair—and to senior production editor Judith Klein. This book would not have been possible without each of you.

ILLUSTRATIONS CREDITS

ABOUT THE COVER

2021 I STEPHEN WILKES
Washington, D.C., U.S.
A day-to-night view of thousands who gathered in front of the Lincoln Memorial for the March on Washington for Jobs and Freedom, held to honor the 57th anniversary of the March on Washington and to protest racial and social injustice. In this image you can see then Vice President-elect Kamala Harris on-screen on one side, the family of George Floyd on another, Dr. Martin Luther King, Jr.'s son and granddaughter speaking, BeBe Winans singing, and the Reverend Al Sharpton on the center-back screen. March participants are proudly gathered, wearing masks to prevent the spread of COVID-19, in every corner of the frame. It took photographer Stephen Wilkes more than 16 hours to capture the full effect of the march.

Since 1888, the National Geographic Society has funded more than 14,000 research, conservation, education, and storytelling projects around the world. National Geographic Partners distributes a portion of the funds it receives from your purchase to National Geographic Society to support programs including the conservation of animals and their habitats.

Get closer to National Geographic Explorers and photographers, and connect with our global community. Join us today at nationalgeographic.com/join

For rights or permissions inquiries, please contact National Geographic Books Subsidiary Rights: bookrights@natgeo.com

ISBN 978-1-4262-2237-5

Printed in Canada

21/FC-PCML/1

POWERFUL PHOTOS
MAKE THE BEST STORIES.